Fashion in Multiple Chinas

Chinese Styles in the Transglobal Landscape

Edited by
Wessie Ling and Simona Segre Reinach

BLOOMSBURY VISUAL ARTS
LONDON • NEW YORK • OXFORD • NEW DELHI • SYDNEY

BLOOMSBURY VISUAL ARTS
Bloomsbury Publishing Plc
50 Bedford Square, London, WC1B 3DP, UK
1385 Broadway, New York, NY 10018, USA

BLOOMSBURY, BLOOMSBURY VISUAL ARTS and the Diana logo
are trademarks of Bloomsbury Publishing Plc

First published in Great Britain by I.B.Tauris & Co. Ltd 2018
This paperback edition first published by Bloomsbury Visual Arts 2020

Series design by BRILL
Cover image: Shanghai, April 2010. Italian TV star Maddalena Corvaglia
posing with a sculpture of a young woman revolutionary soldier in the tourist
area of Taikang Road. (© Daniele Mattioli)

A catalogue record for this book is available from the British Library.

A catalogue record for this book is available from the Library of Congress.

ISBN: HB: 978-1-3501-5069-0
PB : 978-1-3501-4802-4
ePDF: 978-1-8386-0851-4
eBook: 978-1-8386-0850-7

Series: Dress Cultures

Typeset in Joanna MT by OKS Prepress Services, Chennai, India

To find out more about our authors and books visit www.bloomsbury.com and
sign up for our newsletters.

Dr. Wessie Ling is Reader in Fashion Studies at Northumbria University. A cultural historian and visual artist, she uses academic writing and visual art practice to examine cultural identities in the production of fashion and cultural property of fashion. She is the author of *Fusionable Cheongsam* (2007) and Co-Investigator of the Arts and Humanities Research Council (AHRC, UK) project, *Writing and Translating Modern Design Histories in East Asia for the Global World* (2012-4), ASEAN Research Fellow at the Research Institute of Languages and Cultures of Asia (RILCA) at Mahidol University (2018) and Rita Bolland Fellow for Textile and Fashion Study at the Research Centre for Material Culture in National Museum of World Cultures, the Netherlands (2018/9). She co-edited a special issue for Modern Italy on transcultural exchange between Italy and Asia, and ZoneModa Journal on Global Fashion. She has also published in *European Fashion: The Creation of a Global Industry* (2018), Visual Anthropology, World Futures. The Journal of New Paradigm Research, among others. Her artworks have been exhibited in Saint Dominic's Priory (2016, Newcastle Upon Tyne), Oxfordshire Visual Arts Development Agency (OVADA) (2015, Oxford), Danson House (2013, Bexleyheath), the Brunei Gallery (2012, London: SOAS), Saltram House (2012, Plymouth: National Trust) and the Victoria and Albert Museum (2011, London), among others.

Simona Segre Reinach is a cultural anthropologist and Associate Professor of Fashion Studies at Bologna University. She has written extensively on fashion from a global perspective in books such as *The Berg Encyclopedia of World Dress and Fashion* (2010), *The Fashion History Reader* (2010) and *Fashion Media: Past and Present* (2013). She is a member of the Editorial Board of Fashion Theory, Critical Studies in Fashion and Beauty, The International Journal of Fashion Studies, Anthem Studies in Fashion, Dress and Visual Culture and China Matters. She has done field work in China on Sino-Italian joint ventures contributing to a collaborative study in Cultural Anthropology. In Italy she authored: *Orientalismi. La moda nel mercato globale* (2006), *La moda. Un'introduzione* (2010), *Un mondo di mode* (2011), *Exhibit!* (2017) and *Biki: French Visions for Italian Fashion* (2019, Italian and English edition). She curated the fashion exhibitions 80s-90s Facing Beauties: Italian Fashion and Japanese fashion at a Glance (Rimini Museum, 2013) and Jungle: The Imagery of Animals in Fashion (Torino, Venaria Reale, 2017). She is Editor in Chief of Zonemoda Journal.

'This impressive book re-frames all general and many specialist understandings of Chinese fashion. It turns on its head nearly everything I was taught and have imagined about dress in China, from the period of Mao to the present day.'
— Peter McNeil, Distinguished Professor in Design History,
University of Technology, Sydney

Dress cultures

Series Editors: Reina Lewis & Elizabeth Wilson

Advisory Board: Christopher Breward, Hazel Clark, Joanne Entwistle, Caroline Evans, Susan Kaiser, Angela McRobbie, Hiroshi Narumi, Peter McNeil, Özlem Sandikci, Simona Segre Reinach

Dress Cultures publishes the best international scholarship in the study of dress practices historically and in the contemporary world. Bringing into creative dialogue a wide range of approaches, titles in the series explore the aesthetic and social relationships between dress, fashion and the body. Our authors investigate dress within material culture, as a field to be explored sociologically and politically, and from the perspective of economics and local and globalised fashion industries.

Published:

CONTENTS

LIST OF FIGURES

ACKNOWLEDGEMENTS

Much of the thinking behind this book began from a research project entitled *Writing and Translating Modern Design Histories in East Asia for the Global World* (2012–14) funded by the Arts and Humanities Research Council (AHRC). We are indebted to principle investigator Yuko Kikuchi with whom Wessie worked closely on the project. Through exchanges and comparative studies with a group of East Asian design history scholars, we have found that plurality and multiple practices underline the development of design histories in East Asia. Embryonic ideas between us, as co-editors of this book, on a critical framework for the study of Chinese fashion in the transglobal landscape arose from a seminar on *Design Histories and Design Studies in East Asia: Towards a Creation of a Global/ Transnational Framework for Design Histories* (2011) at the University of Brighton, funded by Design History Society. It was not until we organised a panel for the International Convention of Asia Scholars (ICAS, 2013) on the manufacturing of new luxury in Chinese fashion that we regarded it as a new interconnecting force of the global, the transnational, and the diaspora that was worthy of a book. We are thankful to the participation of Juanjuan Wu and Xi Gu, panel members, as well as contributing authors here, and to our early conversations, which have blossomed in this volume.

As editors, we are very grateful to series editors Reina Lewis and Elizabeth Wilson for their enthusiastic response to the idea of this book. We would also like to thank Philippa Brewster at I.B.Tauris for her encouragement and effective guidance through every process, bringing the book to fruition. Our gratitude goes especially to the authors, who have patiently, constructively and promptly responded to our labourous demands and feedback. Many thanks to Angelique Neumann for her

dedication to the manuscript and Rory Gormley and his team for their devoted preparation for the book launch in LaSalle, Singapore. We are most grateful for the Research Publication Grant from Design History Society (United Kingdom). Last but not least, our heartfelt thanks go to photographer Daniele Mattioli whose fantastic image is a generous gift to our book cover. We are also thankful to Maddalena Corvaglia, the celebrated model who has enlivened the cover of the volume.

The editors and publishers wish to thank the copyright holders for permission to reproduce the images in this book.

— Wessie Ling and Simona Segre Reinach

1

FASHION-MAKING IN THE TRANSGLOBAL LANDSCAPE

Wessie Ling and Simona Segre Reinach

READING CHINESE FASHION

Much has been written about the transformation of China from a clothing manufacturing site into a fast-rate, fashion-consuming society. However, little investigation has been made into the making of contemporary Chinese fashion, a process that often involves a borderless entanglement from manufacturing to circulation, to retailing and branding. Recent studies on contemporary Chinese fashion have allowed us some reflection on the subject. Central to these studies is the attempt to make sense of it in the definition of modernity, identity, cultural and creative economy and global circulation. Revealed within are the tremendous cultural and economic dynamics that are at times challenging to articulate. Precisely, what is Chinese fashion? Whose Chinese fashion is it? Why does it matter – and to whom? These are just some of the questions to unpack before Chinese fashion can be discussed and analysed.

At first glance, the formation of contemporary Chinese fashion offers a compelling example of cultural, economic and political entwinement across the globe. On closer examination, Chinese modernity in the twenty-first century cannot be merely underscored by Chinese hybridity typified between China and the West. Rather, it entails a power dynamic

between China and the rest of the world, whereby constant negotiation is expected. While some consider that fashion designers are more concerned with the aesthetic of surfaces, rather than the specifics of cultural context and the logic of politics,[1] the case of China, however, reveals cultural and political context as the very defining point of the making of its fashion.[2]

There is no linear way to read the formation of contemporary Chinese fashion, despite efforts in this direction, for different reasons both the People's Republic of China (PRC) and the globalised (Western) fashion systems.[3] Chinese fashion consists of multiple and, at times, contradictory processes in its making. The first preconception often goes to the absence of fashion in pre-Reform era, putting the debate between fashion and costume at the forefront. The post-colonial theory of fashion studies,[4] however, has demonstrated in various ways that fashion was not separate from costume – that is the weakness of a binary take; costume versus fashion, tradition versus modernity and the transformation of what once went under the label of 'costume' within the logic of global designers from different backgrounds. Studying the process of fashion-making in China suggests going further, applying a more embracing approach in contemporary fashion theory; that is, to consider the multiple and interrelated factors entailed in the process under the rubric of a transglobal landscape. Developing concordantly is the growing academic field of fashion in which it is taken as a major topic of enquiry in social and cultural theory, and analysis devoted to it is the understanding of this complex arena.[5] In this volume, China is taken as an example to unpack the complexity of: (1) identity formation in the making of contemporary fashion; and (2) the dynamics of fashion-making in the transglobal landscape.

CHINESE FASHION IN SCRUTINY

When it comes to Chinese fashion, questions on its stereotypical image, history and varieties arise that demand scrutiny for understanding of the subject. The need to unpack has led us to propose three interconnected concepts: (1) common belief; (2) time; and (3) space. The first concerns the conflicting perceptions that the West and China itself have on Chinese

fashion; the second is the debate on the 'origin' of contemporary fashion in China and its relation to the past; the third is the geographic and cultural diversity of Chinese creativity. At heart within this conceptual framework are the common belief that Chinese fashion refers only to material production, the conflicting relationship between Chinese fashion and its historical past, and the transcultural, transglobal map that defines contemporary Chinese fashion(s), all of which intertwine and cross paths with one another. Discussing one topic, as individual chapters will show, opens up the others; it is precisely their interconnection that gives rise to the usefulness of this approach.

Common belief: material versus symbolic production

A hegemonic construct of the Eurocentric matrix, reinforced by the narratives typical in the age of fashion outsourcing, distinguishes between fashion and garment production, disavowing any creativity – which is the very essence of fashion – by the countries devoted only to the manufacturing of garments for the global market.[6] China is, of course, the most relevant in this case. The split between material and symbolic production of fashion,[7] postulated by Western fashion systems as a tenet of the globalised industry, is in fact not easy to trace, especially in China. The two are interconnected, impossible to disentangle. Since 1978, Chinese engagement in making in volume and signing international agreements – from joint ventures to all forms of global collaboration – has contributed to the image of China as a manufacturing site. In fact, the very reason that makes China the factory of the world also made it possible to attain the level of high-quality production in a short space of time. The case of China is further complicated, with respect to other outsourcing production venues, by the fact that since the year 2000 the country has become the major market for international brands, many of which are also manufactured in China. Since the first years of the Open Door Policy, producing fashion on both the material and symbolic level represented a real challenge for China; not only was it eager to re-align itself with the Western world but also to excel as a country that can master aesthetic knowledge[8] as a form of soft power for nation branding/building,[9] as well as profit from the creative economy.[10] Leading to this is the conflicting (cultural) identity

of Chinese fashion. Since the Beijing Olympic Games in 2008 and the Shanghai Expo in 2010, the development of the cultural industry has become as much a priority for the Chinese government[11] as has upgrading the quantity and quality of production and foreign investments. China is very keen to earmark creativity as a distinguished progression in the post-Reform era, thus fashion, as part of the cultural industry, has been taken as a fast route to achieving such national, and henceforth global, recognition. Apparent in the context of China are the parallel development of material and symbolic production in fashion and the birth of a global consumer society.

Time: is there fashion before 1980s China?

Although it is understood that the concept of fashion in China only started in the early 1980s,[12] the history of fashion in China under the Cultural Revolution and before 1949 had a significant impact on the development of contemporary Chinese fashion,[13] as well as that outside of the PRC.[14] The imposition of the meaning of fashion as defined by Western scholars[15] confused rather than clarified the formation of Chinese fashion. When the Eurocentric view of costume versus fashion and the subsequent debate between tradition and modernity[16] are imposed onto China, a more complicated picture is revealed. It is not useful to uphold the opposition between the modernity of Western fashion and the traditional fixed costumes found in other sartorial systems, at least for China. It is not a valid and heuristic model in particular dynamics between so-called costume and fashion as expressed in different historical periods of China. From early 1900 to 1949, hybridity between East and West was at its height. Instead of opposing European fashion to Chinese costume, there was a tendency to forge a mixed aesthetic, totally embedded into and responding to the troubled politics of the time.[17] During the Cultural Revolution (1966–76), there was a(n) (almost) complete block on China's relations with the outside world and fashion was considered a bourgeois outcome. A new sartorial image – that is, the Mao suit and its (unsuccessful) feminine version, the Jiang Qing dress[18] – aimed for both an alternative to Western modernity and the rejection of Chinese traditions. The attempt to despise Western bourgeois culture led to what could be seen as

'the strange world of socialist fashion'.[19] In the first years following the Open Door Policy (1978), the time lag of fashion trends represented both renewed Chinese interest in fashion and the constraints on them in mastering its language. At the beginning of the 1980s, the sole model on which to reconstruct Chinese fashion appeared to be a somehow naive blend from Hong Kong, Japan, Korea and Europe. With the expiration of the Multi-fibre Agreement (MFA) in 2005, the flow of cheap Chinese garments to Europe and the USA started to disrupt the Euro-American fashion industry, forging the image of China as the enemy of the liberal (Western) economy as well as its position as the world's manufacturing site.

Space: one versus multiple China(s)

Nonetheless, the influence of sartorial traditions in nearby Chinese cities and settlements such as (post-)colonial Hong Kong, the diasporic Chinese production in Taiwan, Singapore, Macau and the USA are all part of the reality of contemporary Chinese fashion. The more powerful China becomes in the global arena, the more the interaction there is from other Chinese regions. Adding to this is the stratification of Western fantasies about China, which has, by and large, a significant part to play in the façade of contemporary Chinese fashion. All of which has shaken, redefined and reshaped its formation. Even the complex geography of Chinese settlement has complicated the meanings of the apparently fixed garments such as the infamous qipao, the controversial 'national' dress in many Chinese cities, calling into question the meaning of Chinese fashion.

Further to this, fashion as an outcome of transnational exchange and encounter, has proved to be one of the most powerful tools to present a convincing national identity.[20] It is not by chance that France, probably the most direct example of the link between fashion and its national identity since the time of Louis XIV, has recently devoted an exhibition – Fashion Mix[21] – in the Musée National de l'Histoire et de l'Immigration to acknowledge foreign contributions to the construction of Parisian fashion for the first time. Consideration of foreign input, be it from within or outside of other Chinese cities and settlements, in the study of contemporary Chinese fashion has become all the more

imperative given the transcultural and transglobal exchanges and networks involved in its making.

Inasmuch as no fashion system is developed in isolation,[22] the production of textiles and apparel has historically been underpinned by the global context,[23] such as that in China.[24] The general belief that globalisation leads to the dissolution of national borders[25] has actually shored up differences and enforced diversity.[26] The pressure to define a fashion identity for individual cities cannot merely be a market force because of its resonating effect, and it is crucial for the development of fashion creation.[27] The same holds true for China.[28] While there may not yet be agreement on how it should be defined, the question has repeatedly been asked in recent times.

As it unfolds, Chinese fashion cannot be represented as a single-facet phenomenon, due partly to the opening of the PRC to the global stage and partly to the circulation of transglobal and transcultural creative labour.[29] The rise of contemporary Chinese fashion is the result of the interplay amongst different elements: economy, politics, geography and cultures. Here in this volume, the idea of multiple Chinas has taken China in its multiple on various scales and levels to articulate the formation of contemporary fashion: the identities of Chinese fashion within and outside of the mainland, the mechanics of the fashion system, the creative practices and operations and the geographic spread of China.

MULTIPLE CHINAS: MULTIPLE FASHIONS

The plurality of Chinese fashion that perpetuates through the notion of multiple Chinas pervades the volume. This is exemplified by the nine chapters, which fall neatly into three arenas: the PRC fashion industry; fashion in other Chinas; and Chinese fashion and the West – all of which point to the making of contemporary Chinese fashion. They are by no means exhaustive in mapping the operations of Chinese fashion across the globe, yet individual chapters provide a lucid lens to articulate the interplay between the internal and external forces that shape contemporary Chinese fashion. Manifested in them are the three intertwined concepts that are intrinsic to our understanding of Chinese fashion.

While it is widely acknowledged that China's increased contact with the world gave rise to the diversification of its clothing styles since the 1980s, Finnane and Sun (Chapter 2) point out such a context beyond the Reform Era. Even during the Mao years, Chinese vestimentary choice was already shaped by China's world context. Autarchy was limited, international relations and foreign trade in textile and apparel production were operative, cultural infiltration from Russia, Albania and the USA through books, magazines and cinema flourished, and the varieties of clothing style were permeated by a diverse range of pattern books. The production of transnational Dacron further reveals just how Chinese manufacturing managed to diversify fabric styles in an autocratic regime. The multiplicities of style and choice in textiles and apparel in China are evidently not exclusive to the post-Reform era, once again opening to debate the meaning and origin of fashion in China. Following on such lines of thought, Zhao (Chapter 3) skilfully illustrates the mechanics of Chinese fashion production whose development has made inroads into the current operation of PRC fashion. The image of low-cost and quality deflated Chinese production still has a strong hold, however, and Zhao reveals the capability of the PRC fashion system at various production levels. Accordingly, Chinese fashion production is now on par with that of Euro-America, be it from mass market to high street, the luxury sector or custom-made tailored fashion. Echoing this was the Chinese government's re-appraisal of the exchange rate of their currency, RMB, in 2005, followed by a rise in national wages. Gone were the days when the 'Made in China' label represented low cost and cheap quality products. The reality is that international labels now outsource their production to countries such as Vietnam and Malaysia, where the cost can be lower than in Mainland China.

The strength of multiple production levels aside, a young generation of fashion designers has actively participated in symbolic production, as seen through Wu's careful analysis of their retail operations (Chapter 4). This chapter unveils not only the numerous approaches to fashion retailing but also the various agencies at play when it comes to defining an authentic Chinese identity within. For the new generation of fashion designers, The diverse educational background of the new generation of fashion designers, the co-creation between them and foreign

collaborators and the integration of international trends and the global media, players and consumers underline their creative operation that makes it all the more irrelevant to speak of a collective fashion identity for contemporary PRC fashion. The co-existence of material and symbolic production illustrated in the respective chapters by Zhao and Wu lay the ground for Gu to discuss fashion as the creative economy; a way for the Chinese government to move up the value chain from 'made in' to 'created in' China (Chapter 5). The pressure that they faced from local and global competition is evident from a handful of case studies of Shanghai-based fashion designers. The close proximity of the luxury fashion consumption market and the solid manufacturing sector within Mainland China highlighted the tremendous transglobal exchange of knowledge, skills and trade within the domestic fashion industry. Under the rubric of transglobal networks designers are expected to constantly engage in a complex negotiation of their roles as both cultural intermediaries and cultural entrepreneurs. That their different perceptions of, and relationships with, China's global fashion industry could not be summarised collectively reveals just another layer of their creative operation.

THE OTHER CHINAS AND THE FABRICATION OF CHINESE FASHION

The landscape of Chinese fashion cannot be completed without the inclusion of the other Chinas. Featured here in the second part of the volume are Hong Kong, Taiwan, Macau and Singapore, where Chinese settlements are the most populated outside of the PRC. The unfolded multiplicity of customary practices, aesthetics knowledge and, more importantly, Chineseness, is the result of the varied historical, political, economic and socio-cultural trajectories that these Chinese regions have undergone. All of this has set them apart from contemporary fashion in the mainland, challenging the fundamentals of Chinese fashion. Which Chinese fashion are we referring to? Which (part of) China? How do we make sense of the fashion produced in these Chinese regions? What is its relationship with that in the mainland?

If contemporary designer fashion in the mainland is seen as having an international outlook, the translocal and transcultural interaction

between Hong Kong and the mainland, as Ling (Chapter 6) illustrates, reveals another dimension of its reading. Heated political debates in these regions have recently accelerated, given the opposing views on their authoritarian regime from their motherland. Sentiments that this arouses have partly been channelled into the creative operation, where a distinctive image and unique identity are part of the successful formula for a fashion label. The pressure of commercial viability in a transglobal marketplace via a distinctive brand that can represent its affiliated region implies a battlefield in which Chinese politics is engaged. There is no one way of making Chinese fashion nor can fashion in these Chinese cities be regarded as the same. The multiple façades of fashion-making are further enforced in Peirson-Smith's account of cosplay, when more differences in customary habits, perception and the reception of fashion practices in Beijing, Hong Kong and Macau are registered (Chapter 6). Underneath such differences and diversity are inter-East-Asian cultural exchange and its impact on fashion production, circulation and consumption in all Chinese regions, which has subsequently opened up a whole new episode for future examination. When the geography of China spread to Singapore, the dimension of Chinese (fashion) identity was once again called into question. Even the quintessential *qipao* cannot be read as a linear Chinese garment. In particular, different Chinese cities claim their own fragments of Chinese history; hardly can the *qipao* born out of these reclaimed histories be considered the same, let alone that from the multi-ethnic population in Singapore. As much as it has come to represent Chineseness with sartorial characteristics distinctive to each different Chinese region, represented here is a variety of Chineseness attached uniquely to each of these regions. The result in Singapore is, as Chung neatly presents, a hybrid Chinese-West-ethnic *qipao*; one that can speak for its own distinctive history, multi-ethnicity and Singaporean Chineseness (Chapter 7). The essence of such an identity cannot be easily overlooked, for it has the ability to evoke belonging and resonate sentiment that necessitated the agenda at both the macro and micro level, such as nation building and fashion branding.

China in the multiple may not have been anticipated by the Beijing government but if Chinese diasporas do not operate in isolation from their ethnic origin, nor, even more, does diasporic creative labour.

In particular, the making of Chinese fashion is a transcultural and transglobal project that can only be operated with the interplay between China and the West, if not the rest of the world. While the West, or the world, has come to (re)define Chinese fashion, it has also become part of the DNA of its making. Even the definition of a 'Chinese designer' today is not straightforward. As Clark observes through a fashion design contest in Beijing, there is tremendous pressure on Chinese designers to develop a cosmopolitan self-presentation (Chapter 8). The demand for this is often based on time spent, contacts and reputation made outside of China. While Chinese designers aspire to 'become international', Chinese-made labels have fought hard to increase occidental desire for their designs, as seen in Segre Reinach's case of Romeo Gigli (Chapter 9). Yet raised here are more complex questions about Chinese fashion identities. Originating in Italy, in recent years the brand has been reconfigured by Hong Kong Chinese. The association of a stereotype by using an Italian designer name has become part of the commercial operation in the attempt to expand the Chinese consumer market. What is in fact 'made in China' has once again been problematised with the new cultural construct.

The study of contemporary Chinese fashion offers a compelling example to unpack the complexity of the process of fashion-making in the transglobal landscape. The necessity to go beyond post-colonial theory towards a more diverse interdisciplinary approach in the study of contemporary fashion is evident in the case of China. Although there is no single or easy answer to the configuration of identity formation in contemporary fashion, the proposed conceptual framework raises more questions on the intricate process, which uncovers the interwoven economic, political, geographic and socio-cultural dynamics, and hopefully leads to more research in this direction.

NOTES

1 Andrew Bolton, *China Through the Looking Glass* (New Haven, CT: The Metropolitan Museum of Art/Yale University Press, 2015).

2 Minh-Ha T. Pham, *Asians Wear Clothes on the Internet* (Durham, NC: Duke University Press, 2015).

3 Simona Segre Reinach, 'Chinese fashion in the making: essays, books and films', *International Journal of Fashion Studies* 2/2 (2015), pp. 307–19.

4 Sandra Niessen, Ann Marie Leshkowich and Carla Jones, *Re-orienting Fashion: The Globalization of Asian Dress* (Oxford: Berg, 2003).

5 Agnès Rocamora and Anneke Smelik (eds), *Thinking Through Fashion: A Guide to Key Theorists* (London: I.B.Tauris, 2016); Heike Jenss (ed.), *Fashion Studies. Research Methods, Sites and Practices* (Oxford: Bloomsbury, 2016); Stella Bruzzi and Pamela Church Gibson (eds), *Fashion Cultures Revisited: Theories, Explorations and Analysis* (London: Routledge, 2013).

6 Simona Segre Reinach, 'Italian and Chinese agendas in the global fashion industry', in Giorgio Riello and Peter McNeil (eds), *The Fashion History Reader* (London: Routledge, 2010), pp. 533–55.

7 David Gilbert, 'A new world order? Fashion and its capitals in the twenty-first century', in Stella Bruzzi and Pamela Church Gibson (eds), *Fashion Cultures Revisited: Theories, Explorations and Analysis* (London: Routledge, 2013), pp. 11–30.

8 Joanne Entwistle, *The Aesthetic Economy of Fashion* (Oxford: Berg, 2009).

9 Wessie Ling, '"Fashionalisation": urban development and the new-rise fashion weeks', in Jess Berry (ed.), *Fashion Capital: Style Economies, Sites and Cultures* (Oxford: Inter-Disciplinary Press, 2012), pp. 85–96.

10 Angela McRobbie, *Be Creative: Making a Living in the New Creative Industries* (London: Polity Press, 2015).

11 Michael Keane, *Created in China. The New Great Leap Forward* (London: Routledge, 2007); Michael Keane, (ed.), *Handbook of China's Cultural and Creative Industries* (Cheltenham: Edward Elgar, 2016); Tiziana Ferrero-Regis and Lindgren, Tim Lindgren, 'Branding "Created in China": the rise of Chinese fashion designers', *Fashion Practice: The Journal of Design, Creative Process and the Fashion* 4/1 (2012), pp. 71–94.

12 Juanjuan Wu, *Chinese Fashion from Mao to Now* (Oxford: Berg, 2009).

13 Antonia Finnane, *Changing Clothes in China: Fashion, History, Nation* (New York: Columbia University Press, 2008); Paola Zamperini, 'Making fashion work: interview with Sophie Hong Taipei, Sophie Hong Studio', *positions: east asia cultures critique*, Special Issue: *Fabrications* 11/2 (2003), pp. 511–20; Tina M. Chen, 'Proletarian white and working bodies in Mao's China', *positions: east asia cultures critique*, Special Issue: *Fabrications* 11/2 (2003), pp. 361–94.

14 Eugenia Paulicelli and Hazel Clark (eds), *The Fabric of Cultures: Fashion, Identity, and Globalization* (London: Routledge, 2009).

15 Joanne Entwistle, *The Fashioned Body: Fashion, Dress and Modern Social Theory* (London: Polity Press, 2000); Elizabeth Wilson, *Adorned in Dreams: Fashion and Modernity* (London: I.B.Tauris, 1985).

16 M. Angela Jansen, *Moroccan Fashion: Design, Culture and Tradition* (Oxford: Bloomsbury, 2014); Joanne Eicher, 1999.

17 Wessie Ling, Harmony and concealment: how Chinese women fashioned the qipao in 1930s China', in Maureen Goggin and Beth Tobin (eds), *Material Women, 1770–1950: Consuming Desires and Collecting Practices* (Farnham: Ashgate, 2009), pp. 209–25.

18 Antonia Finnane, 'Looking for the Jiang Qing dress: some preliminary findings', *Fashion Theory* 9/1 (2005), pp. 3–22.
19 Ibid., p. 4; cf. Djurdja Bartlett, *Fashion East: The Spectre that Haunted Socialism* (Cambridge, MA: MIT Press, 2010); Chen, 'Proletarian white and working bodies in Mao's China'.
20 M. Angela Jansen and Jennifer Craik (eds), *Modern Fashion Traditions: Negotiating Tradition and Modernity Through Fashion* (Oxford: Bloomsbury, 2016); Lise Skov, 'Dreams of small nations in a polycentric fashion world', *Fashion Theory* 15/2 (2011), pp. 137–56.
21 Olivier Saillard (ed.) with Cally Blackman, Tsujita Kaya, Miren Arzalluz and Anne Diatkine, *Fashion Mix*, exhibition catalogue (Paris: Flammarion, 2014).
22 Giorgio Riello and Peter McNeil (eds), *The Fashion History Reader* (London: Routledge, 2010).
23 Giorgio Riello, *Cotton: The Fabric that Made the Modern World* (Cambridge: Cambridge University Press, 2013).
24 Finnane, *Changing Clothes in China*.
25 Roland Robertson, *Globalization: Social Theory and Global Culture* (London: Sage, 1992); Mike Featherstone, *Global Culture: Nationalism, Globalization and Modernity* (London: Sage, 1990).
26 Jennifer Craik, 'Fashion, tourism and global culture', in Sandy Black, Amy de la Haye, Joanne Entwhistle, Regina Root, Agnès Rocamora and Helen Thomas (eds), *The Handbook of Fashion Studies* (Oxford: Bloomsbury, 2014), pp. 353–70; Riello and Mc Neil, *The Fashion History Reader*; Margaret Maynard, *Dress and Globalization* (Manchester: Manchester University Press, 2004).
27 Wessie Ling, 'From "made in Hong Kong" to "Designed in Hong Kong": searching for an identity in fashion', *Visual Anthropology* 24/1–2 (2011), pp. 106–23.
28 Hazel Clark, 'Chinese fashion designers – questions of ethnicity and place in the twenty first century', *Fashion Practice: The Journal of Design, Creative Process and the Fashion* 4/1 (2012), pp. 41–56; Christine Tsui, *China Fashion: Conversations with Designers* (Oxford: Berg, 2009); Wu, *Chinese Fashion from Mao to Now*.
29 Thuy L.N. Tu, *The Beautiful Generation: Asian Americans and the Cultural Economy of Fashion* (Durham, NC: Duke University Press, 2010).

Part I

PEOPLE'S REPUBLIC OF CHINA'S FASHION INDUSTRY

2

TEXTILES AND APPAREL IN THE MAO YEARS: UNIFORMITY, VARIETY AND THE LIMITS OF AUTARCHY

Antonia Finnane and Peidong Sun

Whether or not people in China all dressed the same as each other during the early decades of the People's Republic of China is a persistent theme in writings on Chinese fashion. The case for dressing 'the same' is rarely made in detail. Rather, it is presented in general works about Chinese history or politics, and consists mainly of references to the homogeneity of dress during the Mao years, often via mention of the so-called 'Mao suit'. Such references are then recruited for service as the straw man in building the case against the proposition.[1] In positive terms, the latter case rests on evidence that variety, nuance, agency, gender, class and resistance are evident in the actual clothing worn, photographed and remembered by people who lived through those years. Detailed studies by scholars engaging in this debate have in fact revealed the limits of conformity in dress at any one period of Maoist China. Although arguments continue to be mounted against the paradigm of homogeneity,[2] it is some time now since that paradigm was dismantled.

What then are we to make of strong statements about the uniformity of dress in these years on the part of eye-witnesses and participants in society? Just such a statement was made by sociologist Li Yinhe in a scholarly exchange with Harriet Evans in 2001:

> From the 1950s through the 1960s up until the end of the Cultural Revolution, the vogue was as follows: men and women were all the same, women did what men did, demanded equality between men and women, and blurred the boundary between the sexes ... Women at the time concealed their female characteristics. No women wore makeup, and they dressed on the whole in clothes devoid of any sign of the second sex. They dressed up like men, by and large showing no sexual differentiation. This was the tendency in the first thirty years.[3]

Evans, on the basis of research on women and sexuality in the 1950s, differed. 'If you look carefully at photos [of the 1950s to 1960s]', she pointed out, 'the girls all have little flowers, little pigtails and so on, and in pictures, including propaganda pictures, images of women still have a certain femininity.' Li Yinhe did not directly take up the details of Evans' response, but asked, perhaps sceptically, 'so you think that there are strong continuities between the first thirty years and the next twenty?'[4]

The exchange was between two feminist scholars, both engaged in the study of Chinese society, but there was an important difference between them. Li, unlike Evans, grew up in Mao's China. In her youth she was making decisions about what to wear in an environment that later scholars might seek to reconstruct but of which they will have had at best marginal experience. We know from the scholarly studies referred to above that Li's statement cannot be taken as an empirically accurate description of the full sum of vestimentary choices. Nonetheless, it has its own historical weight as a statement about the remembered meanings of dress practices of a time when Li, like many of her contemporaries, was probably making choices about fabric and personal adornment within the narrow limits of what was available. Clearly, these marginal choices, which have since been used by scholars as evidence of a sustained interest in femininity and beauty during the Mao years, did not remain foremost in Li's memory, and they may not have been foremost in her experience.

As late as 1983, well after many vestimentary taboos had already been broken, Hu Yaobang had this to say:

> The first item is the question of clothing, the question of what to wear. Is our current clothing situation good or not? In my view, it's not good. That includes what you [the audience] are wearing today. Our clothing now just won't do. Everyone dresses in the same colour and style: not good. All this talk of 'bizarre and outlandish clothing': again not good. To foreigners, our female comrades all wearing long pants must look like a case of 'bizarre and outlandish clothing'.[5]

There are a number of ways to explain the apparent contradiction between such representations of dress (monotonous, homogeneous, androgynous) and historical evidence of variety and gender differentiation. Among the possible formulations are: first, a drab, androgynous uniformity in fact co-existed with a subversive, gendered variety; second, memories are faulty, and fail to retain detail, or alternatively, memories are shaped more by the present than by the past, so discard inconvenient details;[6] third (and this applies to the many descriptions by foreigners of the sartorial scene in Mao's China), outsiders noticed only what was different to what they were used to, and failed to notice internal variations and fine detail. A further explanation may lie in the impact of China's engagement with the global fashion scene in the 1980s, which has led to research and publications on contemporary developments with an explicit subordination of historical knowledge to these developments. This means that information about clothing in the Mao years is often conveyed in background chapters,[7] with a corresponding simplification of terms and developments that may have been poorly understood in the first instance.

All of these explanations of the contradiction may hold, while leaving us with a rather fragmented history of dressing and clothing in the Mao years. The little field of knowledge that constitutes this history, populated through cross-fertilisation between studies in politics, social history, gender, fashion and material culture, is one in which received wisdom has been constantly circulated and advances only slowly made. Some basic periodisation has emerged over the years. The 1950s are held to be years in which a mix of clothing styles was still apparent. The Lenin suit,

or more precisely the Lenin jacket, together with the *bulaji*, is known to be a signature garment of this period, before the Sino-Soviet split.[8] The Cultural Revolution, taking place in a period when Sino-Soviet antipathies were pronounced, is strongly associated with military dress, a fashion among youth of both sexes. Many writers have been at pains to point out that greater variety existed over time, and at any one time, than might be supposed by common references to the era of the Mao suit. Nonetheless, the main features of the narrative continue to be the Mao suit and the *qipao*, which represent respectively both the invisibility and visibility of women, and the absence and presence of fashion.

Yet this was not a simple, easily explained clothing culture. Little is yet known about its production. Who made the clothes? How were skills transmitted? Over what period did the proportion of homemade to factory-made clothing change? Where did the models, patterns or inspiration come from for different sorts of pockets, different types of collars, different sorts of fabric? Answers to some of these questions are beginning to become apparent in new research by young scholars in China.[9] The answers to others will clearly vary from place to place, and require intensive local studies of a sort quite rare to date.[10] Among common factors emerging from this research, however, is that China's international relations, as expressed in trade and cultural flows, were implicated in the design, production and marketing of textiles and clothing in the Mao years, with sometimes unanticipated consequences for domestic clothing production and use. This is a well-known aspect of the 1980s, when the rise in productivity in the textiles and apparel sector was accompanied by a diversification of clothing styles. The relationship is less immediately obvious for the decades before the Reform Era, but nonetheless operative. In direct and indirect ways, what people wore and what they liked to wear was shaped by China's world context.

INTERNATIONAL RELATIONS AND FOREIGN TRADE

The most obvious feature of China's international relations under Mao was the fact of non-recognition on the part of the USA, and a corresponding closeness of relationship between China and Russia for the first decade of the PRC. Only late in the Mao era was meaningful contact

between China and the USA renewed, and diplomatic relations were not realised until after Mao's death. A host of countries followed the American lead on this issue. Although few went as far as the USA in applying punitive measures to citizens visiting China, lack of recognition meant a thinning of the lines of communication between China and the rest of the world. The American interdict on visits to China was matched by a general anti-foreignism in China itself, expressed in the expulsion of foreigners from Chinese shores in the early 1950s, widespread suspicion of foreign contacts engendered by mass campaigns against capitalist elements, close monitoring of borders for security reasons and a general Cold War paranoia on the part of the ruling Communist Party. Looked at from American shores, Mao's China seemed remote and inaccessible. It is not improperly characterised as 'autarkic'.[11]

International trade movements between China and the rest of the world during this period were limited, and in the 1950s initially involved mainly the Soviet Union and East Germany. Textiles and apparel accounted for a significant percentage of early exports, increasing from around 14 per cent on the eve of the Great Leap Forward (1958–62) to 20 per cent a decade later.[12] The base line, however, was very low. The first export of factory-made apparel to the Soviet Union from China, consisting of cotton shirts, raincoats and jackets, took place only in 1953. By 1957 the range of styles had expanded: woollen overcoats, suits, trousers and, for women, silk skirts and synthetic windbreakers.[13] Mention of these light materials in use for women's clothing provides a hint of the appeal of particular fabrics in the women's apparel sector, but for the most part these garments and the advanced fabrics from which they were made were not available to Chinese consumers. Rather, whole factories appear to have been dedicated entirely to the production of clothing for export. Nonetheless, we can imagine how these leaked into the domestic market, much as was the case with jeans factories in Zengcheng at a later date. In 1958 the Eastern Sea Clothing Factory in Pudong, Shanghai, was exporting suits and jackets, but it also supplied high-quality garments to local outlets.[14] The relatively high proportion of clothing products made for export points also to external markets as a driver in technological advances in the industry.

Learning from failure must have been among the lessons. Beginning in 1955, Shanghai's textile industry took on considerable responsibility for foreign aid. These projects tended to be plagued with problems due to lack of market research and the low level of flexibility permitted by state-controlled or -owned enterprises. An example is the setting up of the woollen textiles factory in Ulan Bator, where the dyeing process developed by the Chinese led to the production of cloth principally either navy blue, for men's clothing, or deep red, for women's. The colours liked by Mongolians were of quite a different order: men favoured brown and women a variety of bright colours. An aversion to deep red was especially pronounced, amounting to a taboo, due to its association with coffins. A similar set of cultural-cum-market insensitivities is evident in a project for Kampuchea, when spun thread was donated, but not the commonly used twisted thread; bleached white cloth was supplied, not dyed products. In fact, soldiers in Kampuchea wore grass green uniforms, civil servants wore pale green, country people wore black, monks wore yellow, and most young people liked bright colours. Only the old and a small segment of the urban population liked wearing white. Long after the conclusion of the project, stocks of bleached cloth lay in warehouses unwanted.[15]

The story of these two aid projects encapsulates the problem arising from the early PRC's preoccupation with production at the expense of consumption, supplying without sensitivity to demand. As is well known, even the supply side was beset with problems. Right up until 1983, China had to import raw cotton to maintain textile production.[16] Cloth was at a premium in the late 1950s, and coupons were introduced to control distribution. On the other hand, these aid projects tell us something about China's natural advantage in the region, and within the socialist world: it had deep experience of textile production. In 1955 Burma turned back an offer of a barter deal with the USSR for Soviet textiles worth $10,000,000 on the grounds of their drabness and poor quality. Very soon afterwards, in 1956, it imported a quantity of Chinese textiles, together with some well-priced steel.[17] In 1961, on the occasion of the signing of the Sino-Burmese border agreement, China's gift of 2.6 million metres of printed textiles was happily accepted.[18] Over this same period, Malayan buyers were responding enthusiastically to

Chinese textiles, imports of which dropped off in quantity during the famine years but recovered rapidly thereafter.[19]

During these decades, the biannual trade fairs in Guangzhou were the most important sites of import-export relations with the capitalist world. The first of these fairs was held in 1957.[20] They became increasingly important as relations with the Soviet Union deteriorated and new trading partners emerged. Exports were increasingly directed at capitalist markets and China's Third-World clients. The period of economic re-adjustment following the disaster of the Great Leap Forward featured increased attention on light industry, including the clothing and footwear industries. In 1964, a clothing trade fair was opened in Shanghai with a claimed 'full range of sizes [and] exciting new styles for all ages and all seasons'.[21] In the international press, this was greeted as a sign of 'Peking's growing confidence in the competitive strength of its goods in this field'.[22] Four more such fairs were held before the Cultural Revolution brought them to a halt.[23] Quantities of knitwear were sold to Japan,[24] and garments began to feature significantly in Sino-Canadian trade.[25] In Hong Kong, despite the Cultural Revolution, China Product stores in the early 1970s were filled with cheap, ready-to-wear clothing that was undermining local clothing production.[26] While the under-performance of China in all these respects (production, trade, impact on world markets) is a matter of record, it is important to keep in mind that trade with the outside world, involving technology transfer as well as imports and exports of commodities, was maintained through the years of relative isolation.

Cultural flows

While China cautiously sought trade relations with a variety of countries, it exercised care to prevent ideological products being imported along with the commodities. Getting rid of what was already in the country posed greater challenges. In Beijing, a surprising range of counter-revolutionary works was being sold under the very collective nose of the government. At second-hand bookstalls, readers could peruse works variously by and about Hitler, Mussolini, Chiang Kaishek, the USA and the Soviet Union, and also works in Japanese, the latter mainly about China. Inspections authorised by the Beijing municipal government in

1951 yielded 13 issues of *Newsweek* ('America's most reactionary magazine'), *This is America* (mainly photos), *Young Catholics' Friend* – presumably a publication of the American society of that name – and either a magazine or a book called *People in Fashion*. Most of these materials were objectionable on political grounds, but 'girlie' magazines or pictures were also available. 'People buy them at the Spring festival', complained a correspondent to the *People's Daily*. 'They stick them up on the wall ... treating women as commodities just as in the corrupt old society of the past ...'[27] Such images – of film stars, and 'modern girls' – had been central to the fashion industry and the cultivation of style in the first half of the century, and were clearly still pulsing away in Chinese society in the early 1950s.

In time, the decadent figure of the 'modern girl', or flapper, was displaced by her wholesome socialist counterpart. China's international position in the 1950s exposed it to cultural influence from the USSR. Such influence was indeed cultivated and welcomed in circumstances where some alternative had to be found to the so-called 'semi-colonial, semi-feudal' cultural complex that the PRC inherited from its predecessor. As indicated above, the Russians had little to teach the Chinese in terms of textile production, with the possible exception of the manufacture of synthetic fibres. Russian influence on what Chinese people wore had more to do with visual culture and the prestige of the Soviet Union as the leading socialist country than with technical exchange. That influence came in various forms, but cinema was undoubtedly the single most powerful agent. Nearly half of the 860 films imported into China between 1949 and 1964 were Russian; almost as many as were made in China itself.[28] The remainder came mainly from Eastern Europe, North Korea and North Vietnam.

A viewing of Russian films that were popular in 1950s China reveals many different possible sources of inspiration for Chinese dress. An example is Arnshtam's *Zoya* (1944), the mythologised story of a real-life partisan who was hanged by the Nazis. The film traces the young heroine from young pioneer stage (red scarf in place) through to her teens, when the girls in her class are wearing various sorts of standard Western dress, from frocks to pinafores and blouses with Peter Pan collars, styles and features that appear in various combinations during the

dress reform campaign in China in 1955–6. No single iconic garment or characteristic style is evident in the film, but the young girls look modestly well-dressed in a modern way and are presented wearing a variety of styles. The monotony of dress in Communist China emerged as a key issue in cultural circles in 1955: variety and individual choices among young women in the Soviet Union provided a counter-example that could be invoked with impunity.[29]

Less predictably a source of fashion influence was Ivan Pyriev's *The Cossacks of Kuban*, a musical comedy that opens with buxom peasant women working in the fields, singing joyfully as they shovel the grain into impossibly high mounds. Such role models might seem rather less romantic than the beautiful, martyred Zoya, but *Cossacks* was immensely popular.[30] The scenes of song and laughter under blue skies carried a promise, inherent in the bountiful harvest, of food aplenty for the year ahead. The costuming – gaily coloured print skirts and blouses for the women – was probably a factor in the popularisation of skirts and blouses and also *bulaji* (frocks) among young Chinese women in the early 1950s. The female star of *Cossacks* was also the star of an earlier film by the same director, *Tractor Drivers* (1939). Fetchingly posed on a motor bike, wearing overalls, jacket and cap, she presented in that film a picture consistent with later images of young women workers in Chinese propaganda posters and photos, and no doubt helped to inspire them.

Russian films replaced American films in China. Before 1949 Hollywood dominated the foreign film market. In the 1950s, the only American film shown to the public was *Salt of the Earth*, set among miners of 'Zinc Town', in New Mexico, far from the fashionable streets of New York or San Francisco.[31] It is possible that the few glimpses of Western society and individuals afforded to people at this time had a sharpened impact on account of their rarity. *Salt of the Earth* offers an example. Although the screen is filled much of the time by working men in their plain working clothes, the film deals powerfully with gender politics and women played prominent roles. The wives of miners assert the significance of women as agents in the historic political struggle between workers and capitalists, and they do so wearing clothes of the 1950s. They are shown sometimes doing housework and at other times in gaol, but the audience also sees them dancing, either with each other or with

their menfolk. The cast was mainly from the little town where the strike had taken place. The women, wearing their ordinary clothes, display the fashions of the time: pencil skirt, pedal pushers and a New-look A-line coat are incidentally shown. Such small bits of knowledge should not be discounted. These glimpses help explain the details of designs in 1955 and 1956, published in newspapers and magazines, and shown in exhibitions around the country during the dress reform campaign (Figure 2.1).

The Sino-Soviet split at the turn of the decade meant an end to Russian films in China. *Lenin in October* was still shown, but contemporary Russian film was deemed revisionist. China turned instead to Albania, with its small population, struggling economy and narcissistic leader. The Albanian film industry was small but strongly supported by the party state, which saw it as a valuable propaganda tool. The films were overwhelmingly Russian socialist-realist in style and increasingly shaped by Albania's own Cultural Revolution, launched in imitation of China's in 1967. This led, in the words of Smoki Musaraj,[32] to the 'purging of anything "foreign", including styles of dressing, walking, and comportment'. Yet for middle European Albania, with its heritage of bourgeois architecture and naturally 'Western' dress styles, creating a visible distance between itself and the capitalist world was more difficult than it was for China. Watching Albanian films, Chinese audiences were mesmerised by the gracious buildings on the European streets, where people drank coffee as though they had never heard the word 'bourgeois'. In a later generation of anti-Fascist war movies, Albania's Mira in the 1967 historical drama *Standing Still* replaced Russia's Zoya as the intrepid young heroine who is executed by the Nazis. Her white shirt set a fashion trend.[33] Woollen garments worn in Albanian films inspired Chinese knitters, and the Albanian stitch – still used and known by this name – became popular in girls' knitted sweaters.[34] Slouch caps worn by men in both Albanian and Yugoslav films became popular among young in China.[35]

Signifying names

The naming practices in the textile and apparel industries of the early PRC, ranging from the Lenin suit through to the Albanian stitch, mapped the outside world onto Chinese dress. Names were an important element

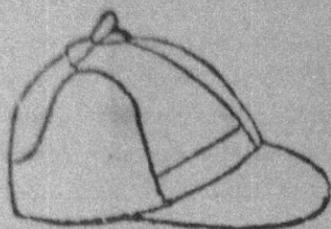

第七十八圖　宜店做裝差

第七十九圖

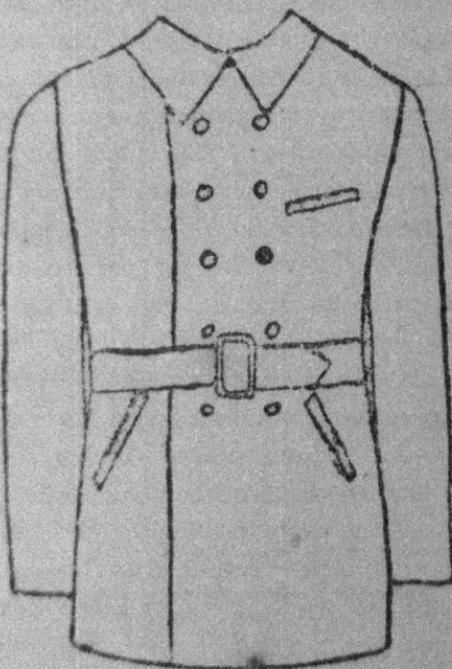

2.1　Lenin suit with hat in a Shanghai sewing manual, 1950.
Source: Guizhang Wang [王圭璋], Caijian dianfan [裁剪典范; Sewing and Cutting], 2nd edn
(Shanghai: Jinghua hanshou xueyuan, 1951), p. 57.

in the vestimentary regime of Mao's China. They coded clothes as socialist, helping their wearers to embody the spirit and style of the New China. In the 1950s, this style was one in which socialism was understood as world socialism. The Sino-Soviet split caused a retreat from this position. Names became more prosaic and descriptive. Tracking the names and what they referred to reveals a diversity of garments in the 1950s and a reduction of this diversity in the 1960s and 1970s before a revival in the early 1980s. The 'Michurin shirt' of the early 1950s and the 'Sachiko shirt' of the early 1980s effectively bookended a period of experimentation in what Chinese people should wear, before they settled for going with the flow of the world.

The term 'Mao suit' could be said to be emblematic of this naming practice. Although it was not in fact used in China, its origins and dissemination are worth mentioning here as evidence from the other side of the Cold War border of the international context of Chinese culture in the high tide of autarchy. The term began to make an appearance in the Western media in the late 1960s. It was used to describe what rarely-seen Chinese diplomats were wearing, and also to designate fashionable avant-garde Chinese-style suits. In 1971, almost immediately following Nixon's lifting of the trade embargo between the USA and China, Chinese-made 'Mao suits' were on sale in Bloomingdale's China Passage shop in Upper East Side.[36] At $25 a suit, they were snapped up. Design houses were quick to take notice and began producing upmarket variations, among which the most decadent was undoubtedly Halston's pyjama suit in white satin, costing a cool $450.[37] It was known, by anyone who cared to know, that the so-called 'Mao suit' was actually the 'People's suit' (*jenmin chuang*, or in pinyin *renminzhuang*),[38] but as images of the Mao suit proliferated, that fact was soon forgotten.

The 'People's suit' was not fully equivalent to the 'Mao suit'. The latter term is best thought of as designating a rather large category that embraces and confuses several forms of simple jacket and trousers, including the Lenin suit, the People's suit (*renminzhuang*), and the Youth suit (*qingnianzhuang*).[39] Other terms were the Cadre suit (*ganbu zhifu*), the Construction suit (*jianshezhuang*) and the Student suit (*xueshengzhuang*). The structural similarity of the garments belonging to this category was marked. Instructions for how to make one or the other not infrequently include a

comment along the lines of 'basically the same' as each other, or the same as a Western suit coat.[40] On the other hand, the details that constituted the difference, signalling distinctions in age, social status, gender and alignment with the political order, were crucial to the make-up of the vestimentary order. A Lenin coat might very well be similar to a Student coat (youth coat), but only if one excluded the 'front fastening, front edge, pocket opening, shoulder fitting, buttoning, lower pocket and collar'.[41] Juanjuan Wu explains the difference between the male Mao (Sun Yatsen) suit coat and a structurally similar garment for women in terms of numbers and styles of pockets and buttons.[42] In practice, however, the same name might be applied to very different garments, and different names in different places were used for the one style.

A good example of this instability of name and style is the Lenin suit. Almost invariably described as a double-breasted garment, the left front generously overlapping the right, with two rows of buttons and belted at the waist, this garment is widely regarded as the socialist fashion par excellence for women in the 1950s. The Lenin suit was, however, a generic name for a double-breasted coat, worn by men and women at different times and in different places. Indeed, one history of men's clothing in China describes it as originally a male garment,[43] which is in accordance with a Nanjing children's rhyme about a newly married couple (translated here with a little licence):

> In they go to the room so bright,
> The wedding bed is a pretty sight.
> The girl in a floral print blouse is dressed,
> The lad in a Lenin coat looks his best.[44]

In 1950, Shanghai sewing instructor Wang Guizhang described the Lenin suit as consisting of three items: the coat (double-breasted, jetted pockets, two rows of buttons, turn-down collar, buckled belt); Western style trousers; and a duckbill hat with ear-flaps (Figure 2.1). She explicitly refers to its suitability for both sexes, and also to its quasi-official status:

> The Lenin suit is an economical garment with a lot of advantages. It can be worn in all seasons and by both men and women. This

year, administrative organs, banks, factories, shops, schools are mostly choosing this as standard dress. It is padded with cotton in winter, lined for spring and autumn wear, and worn without lining in the summer. Unlined, it is worn over a shirt . . .[45]

The fact that it was designated dress by many employers helps explains the popularity of this garment, however it looked. Wang goes on to note that if well made, the Lenin coat really did not look all that different from the Western suit, which in Shanghai it was probably replacing in many instances.

The Lenin suit depicted by Wang can be found in identical form in other sewing manuals, and as explicitly male fashion.[46] A different version was drawn by Fu Yingfei for his students in the New Life Western Tailoring Vocational School in Beijing (Figure 2.2).[47] This is more obviously a woman's garment. With the same turn-down collar and jetted pockets, it has a front-left overlap cut fetchingly on the slant, with just a single row of buttons and a soft cloth belt tied at the waist in place of a buckled belt, although the latter appears elsewhere as an option.[48] The identical design appears in Wei Qiming's *New Style Sewing and Cutting Methods*, also published in Beijing.[49] In nearby Tianjin, a similar garment was produced with two rows of buttons, but, as in Shanghai, is described as unisex: 'The Lenin suit is more widely worn that the Sun Yatsen Suit. In spring, autumn and winter, many men and women are dressed in this style.'[50]

The Lenin suit was one of a number of clothing styles of the early 1950s that bore a name identifying it with the brave new world of socialism. Others are not as well known. The Michurin shirt (or blouse) was named for the horticulturalist and practitioner of genetic selection, I.V. Michurin. In China, Michurin's name was indistinguishable from Lysenkoism, the approved genetic science of Sino-Soviet friendship era.[51] The route by which it came to be associated with a shirt for women was probably a cinematic one: Aleksandr Dovzhenko's colour feature, *Michurin*, made in 1947, was among the many Soviet films to be released in China, and was already familiar to audiences in 1950.[52] It is difficult to find models for the shirt in the film, and since the two designs for which we have visual evidence are so unlike, it may be that the individual tailors designed the garment and gave them names derived from a popular film. Of these two designs, one is a plain long-sleeved shirt with a turned down collar and two patch pockets at chest level.[53] The other is a

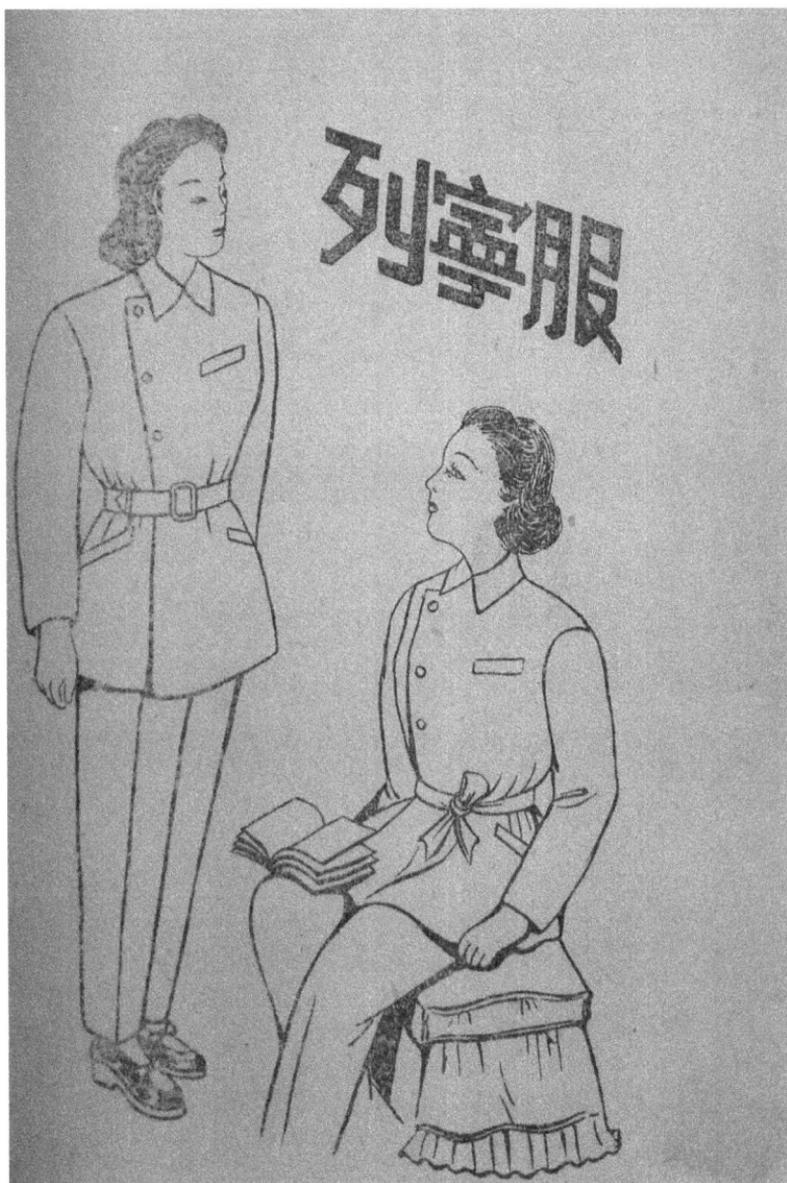

2.2　Lenin suits as depicted in a Beijing sewing manual, 1954.
Source: Fu Yingfei, *Xinfa jiancai: fengren jiaoben* [*New Method Tailoring: A Sewing Textbook*], 2 vols (Beijing: Fu Yingfei, 1954), p. 49.

各式短袖汗衫及西服褲的類型圖

(1) 米邱林汗衫

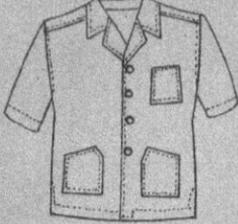

(2) 夏威亮汗衫

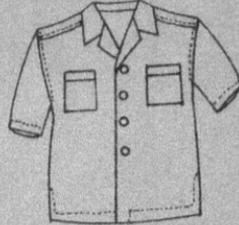

(3) 工作衫

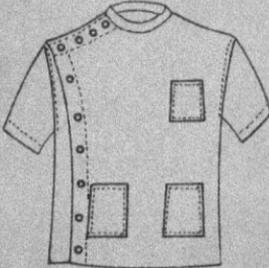

(4) 滬式衫

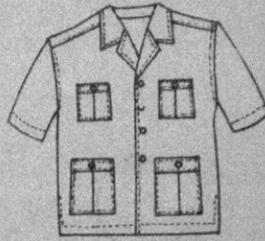

(5) 和平衫

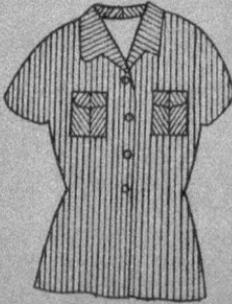

(6) 滬式女衫

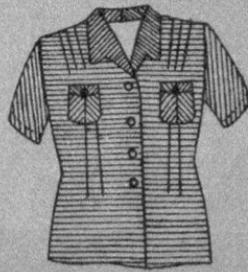

2.3 Various shirt patterns in the early 1950s: (1) Michurin shirt; (2) Hawai'ian shirt; (3) industry or work shirt; (4) Shanghai-style shirt; (5) Peace shirt; (6) Shanghai-style women's shirt.

Source: Wei Qiming [魏启明] *Xinshi fengren jiancai fa* [新式縫紉剪裁法; *New Style Cutting and Sewing Methods*] (Beijing: Beijing wenhua chubanshe, 1954), Vol. 2, p. 1.

short-sleeved shirt with two pockets at waist level, a left breast pocket and no obvious gender attribution (Figure 2.3).[54]

'Peace shirts' constituted yet another category of top (Figure 2.3). In 1951 there was a massive campaign in China to collect signatures for the World Peace Council campaign against nuclear weapons, and in October 1952 Peking hosted a peace conference, attended by delegates from 31 countries. The 'Peace shirt', embracing a variety of designs, was a product of this movement. Like 'Lenin suit' and 'Michurin shirt', 'Peace shirt' was a name fit for the socialist era, in other words appropriate to New China time. Such names effectively branded the garments as fashionable in the explicit sense of 'up-to-date'. They were situated on the front line of social progress. But there were other names, which showed that the semiotics of place and 'the West' were still operative. There were shirts branded 'Shanghai' (a by-word for cosmopolitan), 'Hong Kong' and even 'Hawai'i'. Designs for jodhpurs (ximaku) appear in a number of pattern books; so, too, does a New Wave coat for women. Fu Yingfei's two-volume sewing textbook, which went through at least four editions, even carries a design for a two-piece swimsuit.[55]

What appears in pattern books and what was seen on the street are two different matters, but these books were sold in their thousands in the early 1950s. They attest to a sustained knowledge of a variety of clothing styles even as the opportunities for wearing such clothes diminished. In 1955, this knowledge was allowed room to flourish as a group of artists and costume designers were given a brief to design a new wardrobe for socialist China: skirts, blouses and dresses in a variety of styles, with jackets and coats to mix and match.[56] The designers showed some interest in Chinese characteristics: modified qipao and Chinese-style winter jackets were in the mix of designs offered. By and large, however, the range was a modern world range, with 1950s hairstyles to match (Figure 2.4). The contemporary feel of the clothing designs attests to the permeability of China's cultural borders in the 1950s.

THE AGE OF POLYESTER

In the 1960s the range of patterns for clothes became narrower. Small-scale private enterprise in the production of pattern books and the

2.4 Women's dress patterns from the time of the dress reform campaign, showing fashionable zipper jackets.
Source: Guizhang Wang, *Funü chunzhuang* [妇女春装; *Spring Clothing for Women*] (Shanghai: Shanghai wenhua chubanshe, 1956), p. 87.

management of sewing schools ceased to be in evidence. The most notable fashion trend in this decade was the fad for military uniforms that swept the country as young people were caught up in the Great Proletarian Cultural Revolution. Fuelled by the prestige of the People's Liberation Army – 'Uncle PLA' – in the revolutionary pantheon, this fashion persisted through the 1970s. After the high tide of the Cultural Revolution in the late 1960s, a mass exodus of students from the cities to the countryside otherwise meant an easing in the politics of daily life, but with limited effects on choice, diversity and creativity. In the early 1980s, despite some edgy experiments, the street scene was still mainly one of 'old-style blue and grey suits'.[57]

In conditions of general poverty, shortages and rationing, fabric was an important indicator of style. It was evident in the armbands of the Red

Guards: to wear wool rather than flannel, silk rather than cotton, was a plain assertion of social standing in the arcane and contradictory world of 1960s youth culture, Chinese-style.[58] In the broader population, the significance of this parameter was most obvious in the rising popularity of polyester. 'Polyester shirt, polyester pants; get polyester with one hand, a sweetheart with the other'[59] – such was one of the many sayings about this new fabric that circulated in 1960s China. The look and feel of the fabric was highly distinctive, and its name rich with suggestions of power and status. During the Cultural Revolution, it was a scarcely rivalled focus of consumer desire in China. That it was a British invention, its commercial potential realised by Americans, was never openly bruited, but ultimately underpinned its prestige.

In the UK, polyester was known as Terylene. The raw material was developed in 1941 by J.R. Whinfield for the quaintly named Calico Printers Association. Imperial Chemical Industries subsequently bought the patent and commenced commercial production in 1955. American rights, in turn, had been purchased from ICI by Du Pont in 1946, and full-scale production in the USA commenced in 1953, under the name Dacron. A relatively late arrival in the family of synthetic fibres, it proved to be a superior product for clothing manufacture, especially in combination with cotton. It was hardwearing, wrinkle-resistant, washable and fast drying. Outside of the textile and apparel industries it had multiple other applications, most notably in surgical processes. By 1960, it had surpassed acrylic in volume of production worldwide, and in 1972 overtook nylon to become the world's foremost synthetic fibre.[60] It was destined to become a significant domain of competition for Chinese textiles on the world stage.

The Soviet version of Dacron was known as Lavsan, an acronym from the name of the laboratory where it was produced.[61] Development of the fibre was already under way in the Soviet Union in 1949, but its exploitation for the mass production of clothing only began in the 1960s. In 1964, more than a decade after Stalin's death, the British consortium Polyspinners Ltd commenced work on a vast Lavsan production plant in Siberia.[62] This was the year that Brezhnev replaced Khrushchev. In popular memory in Russia, Lavsan is associated with the Brezhnev era, a time marked by a modest improvement in the quality and variety of consumer items available to townspeople.[63]

Had there been no Sino-Soviet split, China would no doubt have enjoyed a 'Lavsan era', too. As it was, the polyester fad made its way into China from the south rather than the north, creeping over the Hong Kong border on the backs, probably, of people coming back on family visits to Guangzhou. In Cantonese, polyester was called di-kok-leng [的确靓]. In the north this became diqueliang [的确良], a phrase that combined a phonic relationship to the word 'Dacron' with the laudatory literal meaning of 'really fine'. The final character was early rendered as liang [凉], meaning cool, an option rejected perhaps because polyester after all was not really cool to wear.[64] One of its drawbacks was that it did not 'breathe'.

Despite China's estrangement from the USSR, its continued lack of relations of any sort with the USA, and distracting internal political problems, the foundations of a local polyester industry were laid in the 1960s. Shanghai played a leading role in its development, exploiting existing industry strengths in chemical engineering and dyeing. The Shanghai Oil Refinery at Gaoqiao, on the Pudong side of Shanghai, was a key site in the emerging industrial complex centred on the production of chemical fibres and fabrics. The refinery had been developed from the Japanese company Maruzen Petroleum, the latter a pre-war plant established in 1938 and located at Gaoqiao. In the 1950s the refinery was used mainly for fuels and lubricants, but during the Great Leap Forward began to expand into petrochemical industries. In 1965, nearly 100 million yuan was invested in the establishment of the No 2 Shanghai Artificial Fibre Factory, which, with a workforce of 855, set in train the large-scale production of polyester fibre.[65]

Dyeing, the other key industry for the development of polyester, was a traditional Chinese industry, originally located in small workshops all over the city. In 1949 Shanghai had at least 162 dyeing businesses. A few were transferred inland in 1953, while others underwent 'socialist transformation' and in some cases disappeared. Nonetheless, those early foundations helped Shanghai maintain its edge. Dyeing factories ceased merely to dye. They became the source of new sorts of cloth, some of which proved commercially viable in foreign markets. In the early 1960s, the Tianyi Yarn-Dyed Fabric Mill, a model unit that produced

velvets, seersucker and poplins for both domestic consumption and export, was producing commercial quantities of polyester for export. The mill had been in operation since 1933, using Japanese technology to produce superior woollen products. It was converted into a state–private joint enterprise in 1956, but maintained a measure of relative advantage in product innovation.[66]

The need for foreign currency was the major motivation for the development of the industry. The first industry involvement with this new fabric was in the manufacture of clothes for export, using imported polyester. Early consumer experience was mainly of seconds, or in other words, rejects from export stock. Even these rejects were very expensive. At more than 16 yuan, a man's long-sleeved shirt cost a factory worker around a week's wage in 1962.[67] But by a logic peculiar to the bureaucracy serving China's command economy, it proved possible to convert export items into coveted domestic commodities. Well-placed officials and work units established entitlements to the cloth by arguing for its suitability as a desirable cloth for the clothing of cadres who were travelling abroad or, more commonly, meeting foreign guests in China. In July 1965, export companies in Shanghai had to divert 2,000 metres of patterned polyester to Friendship stores for sale. Cadres could go to the stores, equipped with vouchers from their units, and, within the month of issue of the voucher, purchase the required amount of polyester.[68]

Polyester was quickly recognised as fashionable in a cosmopolitan way, as a fabric in touch with the rest of the world. Its association with Shanghai helped create this sense. Shanghai was China's most important international port before 1949. Through the long years of Cold War isolation it never quite lost this associated aura. Its products indirectly connected Chinese consumers with the world. In Shanghai itself, people were swept up in a perfect storm of political activity in the late 1960s, but they did not forget themselves so far as to neglect the question of what to wear. In 1968, the city was gripped in a fever of anxiety over shortages in the supply of polyester. The previous year 8 million metres of the fabric had been available for consumption in Shanghai: in 1968, less than half that amount was available, and over a million metres had already been sold in the first half of the year. At sales counters in stores, customers competed fiercely for available supplies. From July, textile ration coupons – hitherto

not in use for synthetic fabrics – were required, with every inch on a coupon valid for the purchase of one foot (*shichi*) of polyester. On two occasions, 750,000 metres were released for sale at the one time, and all sold out within two to three hours. The crisis culminated in a serious accident: on the morning of another release of the cloth, the crush outside the Hongying Clothing Store in Jing'an district was so great that a shop window shattered under the pressure, causing the death of a young woman, Yang Meiming. A number of other people were seriously injured.[69]

The combination of potential, achievements and constraints in the industry does much to explain the frenzy surrounding polyester in the 1960s. On the one hand, a rare new product was on the market. It was not cotton, so initially did not require coupons; it was made for export, so had a prestige associated with luxury goods; and it was made in Shanghai, which for much of the preceding century had been a byword for everything fashionable. Despite the gradual expansion of polyester production across the country, Shanghai polyester continued to be the most desirable product, in part because of its superior quality. In 1973, 85 per cent of output from 12 Shanghai factories was graded as first class, exceeding by a considerable margin the quality of fabric produced in neighbouring Zhejiang province.[70]

On the other hand, supplies were low and competition for the available product was fierce. Shanghai polyester was mostly sold only in Shanghai: only 15 per cent of Shanghai's local product went to the suburban, rural and semi-rural areas. In the middle of the Cultural Revolution, the revolutionary masses of workers, peasants and soldiers were queuing up to buy either the fabric or garments made from it. At the Red Cliff Clothing Store on Nanjing Road, there was a waiting period of 70 days for a polyester shirt; at the New World Clothing Store in Huaihai Road, it was 90 days. By the time the shirt arrived, it was often the case that the season had changed so that there was no fashion advantage to wearing it.[71] To the frisson of desire for the material were added considerable anxieties over the purchase and final delivery of the garment. The Hongying accident was ultimately an outcome of intense emotions fuelling mass behaviour at a time of high social tension.

In the early 1970s, China began a concerted effort to build its industrial capacity with the aid of imported technology and machinery. 'Mao's initiation of the policy', write Tiewes and Sun,

> was typically bizarre: enquiring of a maid about the fabric of her polyester clothing, the Chairman learned that it was not easily available in China and then set in motion the large-scale importation of Western technologies and production lines for scarce products . . .[72]

With the aid of machinery imports from Japan and massively expanded investment in 38 plants across 11 provinces, a goal of no less than 200 million metres of polyester cloth was set for 1973.[73] Under these circumstances, despite continued relative scarcity, polyester began to come within reach of ordinary consumers. When workers from Hubei returned home from Shanghai they would carry lengths of polyester home to distribute to friends and relatives, earning their undying gratitude.[74] In the 1980s, as China embarked on economic reforms, it became generally available. This was the decade of 'polyester, queuing to buy vegetables, cement floors and white-washed walls, and bicycles'.[75] The age of modest ambitions had arrived.

CONCLUSION

As a generalisation, the statement that everyone in China during the Mao years dressed alike is open to challenge, but it also conveys a certain truth. In How to Be a Good Communist (1939),[76] Liu Shaoqi was at pains to point out that subordination of individual interests to the Party 'by no means implies that our Party does not recognise, or brushes aside, the personal interest of its members or that it wants to wipe out their individuality'. But Mao actually did want that. During the years in which he was paramount leader, Chinese society was encouraged to abandon the careful distinctions that were the hallmark of and basis for proper human relationships in Confucian society. If these distinctions were still visible to the discerning eye – who wore polyester, for example, or who had a real military uniform – the casual onlooker could be forgiven for thinking that there was not much difference between one suit of clothes

and the next. Of all the generalisations that might be made about clothing in the Mao years this one probably contains the largest grain of truth. Even those who take exception to it most strongly are likely to recognise the foundations on which it rests.

The limitations of this generalisation as a total explanation for material culture in Mao's China are also obvious. The varieties of dress in China during the early decades were an outcome of many factors, among which the most important was difference between people with money and people who had none. That difference was in large part also a difference between urban and rural. In not-so-remote rural areas, women were still spinning and weaving their own thread and cloth, with which then to make the clothes and shoes for the whole family. But all those other spinning and weaving women, employed in factories in Shanghai, Guangzhou, and elsewhere, tell a different story: following the thread of the textile and apparel industry in the Mao years usually leads to the port city, and if the door had to be opened there to allow goods to go out, there was finally no way to prevent other things flowing in. Ultimately, the bamboo curtain was a permeable barrier. The Hong Kong–Guangdong border was particularly porous, crossed frequently by people from capitalist countries in their fashionable, variegated clothing.

'Engels never rode in a plane', said Deng Xiaoping in 1978, 'and Stalin never wore polyester'. His point was that the Party had to look to the future, and move with the times. This led to a shift in policy and practice across most domains of Chinese life, summed up in the phrase 'four modernisations'. It is common to draw sharp distinctions between the next and the preceding 30 years. Clothing offers a way both to illustrate the distinctions and to blur them. In either case, observable variables such as cut, colour and fabric provide adequate evidence to support an argument, but they only take us so far. Variations in the *experience* of dressing are more difficult to calibrate but, depending on the point of the argument, may be just as important to its outcome.[77]

NOTES

1 Hung-Yok Ip, 'Fashioning appearances: feminine beauty in Chinese Communist revolutionary culture', *Modern China* 19/3 (July 2003), pp. 329–61, p. 330;

Jianhua Zhao, *The Chinese Fashion Industry: An Ethnographic Approach* (London: Bloomsbury, 2013), p. 50.

2 Calvin Hui, 'Mao's children are wearing fashion!', in Alison Hulme (ed.), *The Changing Landscape of China's Consumerism* (Oxford: Chandos Publishing, 2014), pp. 23–56.

3 Ai Hua [艾华] (Harriet Evans) and Yinhe Li [李银河], 'Guanyu nǚxingzhuyi de duihua' [关于女性主义的对话], *Shehuixue yanjiu* [社会学研究] 4 (July 2001), pp. 118–25, p. 122.

4 Ibid.

5 Peidong Sun [孙沛东], 'Kujiaoshang de jieji douzheng – "wenge" shiqi Guangdong de "qizhuang yifu" yu guojia guixun' [裤脚上的阶级斗争 – 文革时期广东的 奇装异服与国家 规训; Class struggle over trousers: bizarre dress and state admonitions in Guangdong in the period of the Cultural Revolution], *Kaifang shidai* [开放时代: *Open Society*] 6 (2010), pp. 84–102, p. 86.

6 Maurice Halbwachs, *On Collective Memory*, trans. and ed. Lewis A. Coser (Chicago, IL: University of Chicago Press, 1992), p. 224.

7 For example, Zhao, *The Chinese Fashion Industry*; Christine Tsui, *China Fashion: Conversations with Designers* (Oxford: Berg, 2009).

8 Hazel Clark, *The Cheongsam* (New York: Oxford University Press, 2000), p. 21; Jian, 'The Soviet impact on "gender equality" in China in the 1950s', in Thomas P. Bernstein and Hua-yu Li (eds), *China Learns from the Soviet Union, 1949–Present* (Lanham, MD: Lexington Books, 2010), pp. 259–74, p. 265.

9 Shan Ren [任珊] '1949–1965 nian Shanghai fuzhuangye fazhan yanjiu' 1949–1965 [年 上海服装业发展研究; The development of the Shanghai's clothing industry, 1949–1965], MA thesis, Donghua University, Shanghai, 2013; Peidong Sun 孙沛东, *Shishang yu zhengzhi: Guangdong minzhong richang zhuozhuang shishang (1966–1976)* [时尚与政治：广东民众日常着装时尚 (1966–1976), *Fashion and Politics: Everyday Fashions in the Clothing of Ordinary People in Guangdong*] (Beijing: Renmin chubanshe, 2013).

10 Ibid.

11 Barry Naughton, 'The foreign policy implications of China's Economic development strategy', in Thomas W. Robinson and David Shambaugh (eds), *Chinese Foreign Policy: Theory and Practice* (Oxford: Clarendon, 1994), pp. 47–69, p. 49; Hao Yufan, The economic factor in Chinese foreign policy', in Allen Carlson and Xiao Ren (eds), *New Frontiers in China's Foreign Relations* (Lanham, MD: Lexington, 2011), pp. 65–90, p. 269.

12 Kym Anderson and Young-il Park, 'China and the international relocation of world textile and clothing activity', *Weltwirtschaftliches Archiv* 125/1 (1989), pp. 129–48, Table 2.

13 Ren, '1949–1965 nian Shanghai fuzhuangye fazhan yanjiu', p. 84.

14 Ibid., p. 85.

15 Shanghai fangzhi gongyezhi bianzuan weiyuanhui [上海纺织工业编纂委员会], *Shanghai fangzhi gongyezhi* [*Gazetteer of the Shanghai Textile Industry*] (Shanghai: Shanghai shehuo kexue chubanshe, 1998), p. 618.

16 Dangdai Zhongguo congshu bianji weiyuanhui (ed.), *Dangdai Zhongguo duiwai maoyi* [当代中国对外贸易; Foreign Trade in Contemporary China] (Beijing: Dangdai Zhongguo chubanshe, 1992), pp. 2, 76.

17 Maung Aung Myoe, *In the Name of Pauk-Phaw: Myanmar's China Policy since 1948* (Singapore: Institute of Southeast Asian Studies, 2011), p. 26.

18 Ibid., p. 50.

19 John Wong, *The Political Economy of Malaysia's Trade Relations with China* (Singapore: Institute of Southeast Asian Studies, 1974), pp. 7–8.

20 Devendra Prakash, 'The Guangzhou Trade Fair', *China Report* 21/6 (1985), pp. 507–11.

21 *Peking Review*, 15 August 1964, p. 40.

22 P.H.M. Jones (ed.), *Asian Textile Survey, 1969–70* (Hong Kong: Far Eastern Economic Review, 1970), p. 76.

23 Ibid.

24 Shanghai duiwai jingji maoyi bianzuan weiyuanhui [上海对外经济贸易编纂委员会] (ed.), *Shanghai duiwai jingji maoyi zhi* [*上海对外经济贸易志*; *Gazetteer of Shanghai's Foreign Economic and Trade Relations*] (Shanghai: Shanghai shehui kexueyuan, 2001), pp. 1, 825.

25 FER 1966, 534.

26 *South China Morning Post*, 7 January 1971.

27 Beijingshi renmin zhengfu xinwen chubanchu: faxinglei. Chuli Dongdan shichang, Dongan shichang shuji shoumai fandong shuji baogao [北京市人民政府新闻出版处，发行类：处理东单市场，东安市场书籍收买反动书籍报告；Beijing People's Government news and publishing division, publications: report on managing purchase of reactionary books in Dongdan and Dongan markets], Beijing Municipal Archives 8–7-426.

28 Xuelei Huang, 'The heroic and the banal: consuming Soviet movies in pre-socialist China, 1920s–1940s', *Twentieth Century China*, 39/2 (2014) p. 94.

29 Antonia Finnane, *Changing Clothes in China: Fashion, History, Nation* (New York: Columbia University Press, 2008), p. 209.

30 Tina M. Chen, 'Film and gender in Sino-Soviet cultural exchange, 1949–1969', in Thomas P. Bernstein and Hua-Yu Li (eds), *China Learns from the Soviet Union, 1949-Present* (Lanham, MD: Lexington Books, 2010), pp. 421–48.

31 James J. Lorence, *The Suppression of Salt of the Earth: How Hollywood, Big Labor, and Politicians Blacklisted a Movie in Cold War America* (Albuquerque: University of New Mexico Press, 1999).

32 Smoki Musaraj, 'Alternative publics: reflections on marginal collective practices in Communist Albania', in Andreas Hemming, Gentiana Kera and Enriketa Pandelejmoni (eds), *Albania: Family, Society and Culture in the 20th Century* (Vienna: Lit Verlag), pp. 175–86, p. 181.

33 Simon Shen and Cho-kiu Li, 'Cultural side-effects of the Sino-Soviet split: the influence of Albanian movies in China in the 1960s', *Modern China Studies* 22/1 (2015), pp. 215–31.

34 See <http://blog.wenxuecity.com/myblog/46099/201101/> (accessed 1 March 2016).

35 Yunlong.Ma [马云龙], 'Lishi cuipian: wenge shiqi de liuxing shishang' [历史碎片：文革时期的流行时尚; Fragments of history: popular fashions in the Cultural Revolution period], *Nanfang zhoumou* [南方周末; *Southern Weekend*], blog, 31 January 2015. Available at http://cul.qq.com/a/20150131/022063.htm (accessed 15 March 2016).

36 *Life Magazine*, 10 December 1971, p. 63. Available at https://books.google.co.uk/books?id=3z8EAAAAMBAJ&pg=PA59&source=gbs_toc_r&redir_esc=yv=onepage&q&f=false (accessed 15 March 2016).

37 Ibid., p. 64.

38 *Time Magazine*, 6 December 1971, p. 90.

39 Juanjuan Wu, *Chinese Fashion from Mao to Now* (Oxford: Berg, 2009), p. 4; Helen Wang, *Chairman Mao Badges: Symbols and Slogans of the Cultural Revolution* (London: British Museum, 2008), p. 130.

40 Wang, Caijian dianfan, p. 57; Wuhanshi 1956:62; Zhang 1979:41.

41 Wuhanshi sili shenghua xinqun fengren buxi xuexiao bianji weiyuanhui [武汉市私立 胜华新群补习学校编辑委员会], *Caifengfa jiangyi* [裁缝法讲义; *Teaching Material on How to Tailor*] (Wuhan: Wuhanshi sili shenghua xinqun fengren buxi xuexiao, 1956), p. 62.

42 Wu, *Chinese Fashion from Mao to Now*, p. 4.

43 Xiqiang Ding [丁锡强], *Zhonghua nanzhuang* [中华男装; *Chinese Men's Dress*] (Shanghai: Shanghai shiji chubanfen youxian gongsi, 2008), p. 261.

44 一进堂屋亮堂堂，房里摆的大花床，姑娘穿的花衣裳，小伙子穿的'列宁装. Available at http://history.news.163.com/09/0827/18/5HO9VUVO00011HJ4_2.html (accessed 15 March 2016).

45 Wang, Caijian dianfan, p. 57.

46 Wuhanshi, Caifengfa jiangyi, 61–2.

47 Fu Yingfei [傅英飞], *Yangcai jiaoben* [洋裁教本; *Primer in Western Tailoring*] (Beijing: Beijing xinsheng zhiye xuexiao. 1951), p. 28; Fu Yingfei, *Xinfa jiancai: fengren jiaoben* [新法剪裁：缝纫教本; *New Method Tailoring: A Sewing Textbook*] (Beijing: Fu Yingfei, 1953), p. 99.

48 Fu Yingfei, Xinfa jiancai: fengren jiaoben [*New Method Tailoring: A Sewing Textbook*], 2 vols (Beijing: Fu Yingfei, 1954), pp. 1, 49.

49 Qiming Wei [魏启明], *Xinshi fengren jiancai fa* [新式缝纫剪裁法; *New Style Cutting and Sewing Methods*] (Beijing: Beijing wenhua chubanshe, 1954), pp. 49–50.

50 Runsheng Cao [曹润生] (ed.), *Guohuapia fengrenji shiyongfa ji jijian tuyang* [国华牌缝纫机使用法及几件图样; *Guohua Brand Sewing Machine User's Manual and Accessories, Illustrated*] (Tianjin: Tianjinshi gongsi heying Huabei fengrenji zhizaochang, 1953).

51 Laurence Schneider, *Biology and Revolution in Twentieth-Century China* (Lanham, MD: Rowman and Littlefield, 2005), passim.

52 Chi Li [李 驰], 'Caise dianying shi zenyang shezhide' [彩色电影是怎样摄制; How to shoot films in colour], *Kexue qunzhong* [*Scientific Masses*] 10 (1950), pp. 75–9.

53 Fu, Xinfa jiancai: fengren jiaoben, pp. 1, 130.

54 Wei Xinshi fengren jiancai fa, pp. 2, 1.

55 Fu, *Xinfa jiancai: fengren jiaoben*, p. 195.

56 Antonia Finnane, 'Yu Feng and the 1950s dress reform campaign: global hegemony and local agency in the art of fashion', in Yu Chien Ming [游鑑明] (ed.), *Wu sheng zhi sheng: jindai Zhongguo funüyu wenhua, 1650–1950* [**無聲之聲**II **近代中國的婦女與社會** (1600–1950; *Silent Voices: Women and Modern Chinese Culture, 1650–1950*], Vol. II (Taipei: Academia Sinica, 2003), pp. 235–68.

57 *Beijing Review*, 22 October 1984, p. 11.

58 Xurong Kong, 'Military uniform as a fashion during the Cultural Revolution', *Intercultural Communication Studies* 17/2 (2008), pp. 287–303, p. 297.

59 Tsang Eileen Y.-H., *The New Middle Class in China: Consumption, Politics and the Market Economy* (Basingstoke: Palgrave Macmillan, 2104), p. 61.

60 Huaxian fangzhipin de xingneng yu shiyong fangfa editorial group [化纤纺织品的性能与使用方法编写组] (ed.), *Huaxian fangzhipin de xingneng yu shiyong fangfa* [**化纤纺织品的性能与使用方法**; *Properties and Uses of Chemical Fibres*] (Shanghai: Fangzhi gongye chubanshe, 1984), p. 9.

61 Larissa Ryazanova-Clarke and Terence Wade, *The Russian Language Today* (London: Routledge, 1999), p. 49.

62 Christine White, 'British business in Russian Asia since the 1860s: an opportunity lost?', in R.P.T. Davenport-Hines and Geoffrey Jones (eds), *British Business in Asia Since 1860* (Cambridge: Cambridge University Press, 2003), p. 88.

63 Natalya Chernyshova, *Soviet Consumer Culture in the Brezhnev Era* (London: Routledge, 2013), p. 1.

64 Anon, 'Diqueliang' [**的确良**, Polyester], *Fangzhi qicai* [**纺织器材**, *Materials for Textile Production*] (28 October 1979), p. 23.

65 Shanghai tongzhi bianzuan weiyuanhui [上海通志编纂委员会编] (ed.), *上海通志* [*Shanghai tongzhi; Gazetteer of all Shanghai*] (Shanghai: Shanghai renmin chubanshe and Shanghai shehui kexueyuan chubanshe, 2005), p. 2278.

66 Shanghai fangzhi gongyezhi, p. 126.

67 Shanghaishi diyi shangyeju 1963, p. 41.

68 Shanghai duiwai maoyiju [上海市对外贸易局], 'Guanyu jiedai waibin ganbu pin danwei zhengming qu youyi shangdia goumai diqueliang buliao deo tongzhi' [关于接待外宾干部凭单位证明去友谊商店购买的确良布料的通知; Notification on going to the Friendship Store and presenting identification for the purchase of dacron by cadres meeting with foreign dignitaries], 26 July 1965, p. 1, Shanghai Municipal Archives B123-6-631.

69 Jing'anqu yizhuo yongpin gongsi geweihui [静安区衣着用品公司革委], 'Guanyu zhuanfaJig'anqu Hongying fuzhuangdian gukedeng gou diqueliang chensha, jisui boli chuchuang, zaocheng yanzhong shangwang shigu de baogao de tongzhi' [关于转发静安区红缨服装店顾客等购'的确良'衬衫，挤碎玻璃橱窗，造成严重伤亡事故的报告的通知; Notification of transmission of report concerning deaths and injuries arising from the shattering of a display window through the crush of customers [seeking to] purchase dacron at the Hongying clothing store], 17 August 1968, Shanghai Municipal Archives, B123-7-35.

70 Shanghaishi fangzhiju geweihui [上海市纺织局革委], 'Baosong miandique-
liang kuojian gongcheng de kuoda chubu sheji' [报送棉的确良扩建工程的扩
大初步设计; Submission of the first stage plans for expansion in the dacron
further development project], 27 June 1973, Shanghai Municipal Archives,
B-134-7-126, p. 13; 'Shengqing zengjia diqueliang jijian touzi de baogao'
[申请增加的确良基建投资的报告; Report on the application to increase
capital investment for Sacron], 30 May 1973, Shanghai Municipal Archives,
B-134-7-133, p. 2.

71 Shanghaishi fuzhuang xitong gongren diaochazu [上海市服装系统工人调查组],
'Guanyu diquelaing fafang dui fuzhuang shichang yali yanzhong de chubu
qingkuang baogao' [关于'的确良'发放对服装市场压力严重的初步情况报告;
Report on the initial stages of severe pressure on the supply of Dacron the clothing
market], 10 May 1969, Shanghai Municipal Archives, B123-8-211, pp. 63–4.

72 Frederick C. Tiewes and Warren Sun, *The End of The Maoist Era: Chinese Politics During
the Twilight of the Cultural Revolution, 1972–1976* (London: Routledge, 2015),
p. 51n.70.

73 Shanghai tongzhi bianzuan weiyuanhui, p. 2287.

74 Xiangwen Yang [杨祥文], 'Nashi chuchai beihui sanpi diqueliang' [那时出差
背回3匹的确良; Sent away for work that time, I brought back three bolts of
Dacron], *Wuhan wanbao* [武汉晚报; *Wuhan Evening News*), 15 April 2009, p. 42.

75 Chen Kuang [旷晨] and Liang Pan [潘良], *Womende bashi niandai* [*我们的八十年
代; Our 1980s*] (Beijing: Zhongguo youyi chuban gongsi, 2006), p. 344.

76 Liu, Shaoqi *How to be a Good Communist*, 1939. Available at https://www.marxists.
org/reference/archive/liu-shaoqi/1939/how-to-be/ch06.htm (accessed
1 November 2015).

77 Research for this chapter was supported by an Australian Research Council
Discovery Project grant.

3

LOCAL PRODUCTIONS, GLOBAL CONNECTIONS: MAKING FASHION IN CHINA

Jianhua Zhao

INTRODUCTION

In the last four decades, China has witnessed tremendous economic growth. Much like elsewhere, China's rapid economic expansion began with the development of the textile and apparel industries. China's garment export grew from merely 4 per cent of the world's total garment export in 1980 to 38.6 per cent in 2013.[1] Without a doubt, China has become a global powerhouse in garment manufacturing. However, manufacturing prowess does not necessarily translate into a positive image in terms of fashion creation. In the world of fashion, China has long been associated with low-end fast fashion that lacks originality.[2] Recently, Western readers have benefited from increased academic attention to the dynamic changes of Chinese fashion in contemporary China[3] and the emergence of Chinese fashion designers.[4] These recent studies have illustrated the broad trends of fashion change in contemporary China and the general dynamics of the Chinese fashion

industry. Yet, less is known about how diverse Chinese fashions are made, and much less about how the production of Chinese fashions is connected to the global fashion industry.

In this chapter, I attempt to address this gap in the study of Chinese fashion and the Chinese fashion industry by examining how fashion is created and produced by Chinese fashion professionals in three market segments. This approach obviously cannot exhaust the myriad ways in which diverse fashions are made in China, but it will contribute to an understanding of the existence of multiple Chinas with regard to fashion production that is generally lacking in Western popular perception of Chinese fashion.[5] At the same time, this chapter examines the ways in which the production of diverse Chinese fashions is connected to the global fashion industry. In so doing, I argue that there are multiple fashion systems at work in the production of fashion in China, and that these Chinese fashion systems are not isolated from but connected to the global fashion systems in different ways. Before I get to the production of fashion in different Chinese market segments, there are some important distinctions between clothing and fashion and between fashion and the fashion industry that need to be made, which will be followed by some general background information on the rise of the Chinese fashion industry.

CLOTHING, FASHION AND THE FASHION INDUSTRY

Fashion and clothing are commonly used as synonyms except when fashion refers to accessories (or adornments). But there is something more to fashion even when it is exclusively referring to the covering we put on ourselves that we call clothing. According to Yuniya Kawamura, fashion also includes the 'additional and alluring values attached to clothing' that make clothing enticing to the consumers.[6] In other words, fashion is not just functional so as to protect the wearer from the elements, but also has an aesthetic dimension that appeals to the wearer and that is supposed to enhance his or her appearance in a way he or she desires. Associated with this attribute, fashion lends itself to a complex social dynamic of emulation and differentiation. As fashion followers seek to emulate or differentiate themselves from each other, fashion

trends evolve over time.[7] This leads to the second important distinction between fashion and clothing: fashion carries the connotation of change, while clothing does not. In fact, change is so central to fashion that some scholars take it to be the evidence of a functioning fashion industry. A personal anecdote will suffice as an illustration.

In my book,[8] I made the point that the Chinese fashion industry grew to its current scale from a near non-existence when the People's Republic of China (PRC) was founded in 1949. When the book was in the stage of peer review, scepticism about the nascent nature of the Chinese fashion industry was raised: how could a country as ancient as China not have fashion before 1949? Obviously, the reviewer is right that fashion or fashion change in China is not as recent a phenomenon as post-1949. After all, historian Antonia Finnane has demonstrated ample evidence of fashion change in contemporary China prior to the PRC.[9] But what Finnane describes in her book is about how fashion changes as a result of shifts of political power as well as the general fashion processes of emulation and differentiation in contemporary China, which is not exactly the point I made. My position is that a modern, industrialised fashion industry hardly existed prior to the establishment of the PRC. Apparently, the reviewer took the dynamics of fashion change or the fashion process to be the fashion industry itself. However, there is an important distinction between the fashion process, which exists throughout history, and the fashion industry, which is a modern phenomenon. While the fashion industry thrives on dynamic fashion changes, it takes more than just the fashion process for the industry to develop, as evidenced by the rise of the Chinese fashion industry, to which I now turn.

RISE OF THE CHINESE FASHION INDUSTRY

A fully fledged modern fashion industry requires a number of preconditions. To name but a few: developed textile and apparel industries to provide the necessary inputs and manufacturing capacity; a socially recognised group of specialists (i.e., fashion designers) who are involved in the creation and promotion of ever-changing styles; established mass media that can transmit latest fashion styles and images quickly to the consumers; an open social and economic milieu that

allows people to buy and dress freely in whatever clothing styles they choose; and a consumer base that can afford to buy latest fashion items. While the last three are sufficient to create a dynamic of fashion change, as illustrated by Finnane's account of contemporary China before 1949, they cannot give rise to a modern fashion industry without fashion designers or developed textile and apparel industries. In fact, after the Communists took over China, the social and political environment was no longer conducive to dynamic fashion changes; during much of the Mao era (1949–76), China's fashion scene was dominated by the ubiquitous Mao suit (known as Mao style *zhongshanzhuang* in China). It was not until the post-1978 reform period that the constellation of the aforementioned factors begin to take place, and consequently the Chinese fashion industry started to develop in earnest. In the following, I will briefly explain how the different pieces of the 'puzzle' of the Chinese fashion industry came together in the reform period.[10]

In December 1978, the Third Plenum of the Eleventh Central Committee of the Chinese Communist Party (CCP) was held in Beijing. At that meeting, the CCP, led by Deng Xiaoping, adopted market-oriented reform policies and opened up China for trade with the West. These policies effectively shifted the national focus from political struggles to economic development. On the economic side, the reform introduced incentives, competition and market mechanisms, which were absent in the formerly socialist planned economy, into the economic system. Subsequently, the textile and apparel industries, especially in the non-state-owned sector, thrived. Moreover, the intense competition led by the non-state-owned sector forced the state-owned enterprises to undergo further reforms in order to adapt to the market economy. Elsewhere, I have described and analysed the dynamics between the state-owned and non-state-owned sectors and the course of development of the Chinese textile and apparel industries.[11] Suffice it to say here that, over the last few decades, the Chinese textile and apparel industries have become dominated by privately owned companies and become fully market-driven,[12] and that they have not only captured the largest share of the world's export (since 1994), but have also provided inputs, accumulated technical know-how and developed an enormous production capacity, on the bases of which the domestic fashion industry can develop and thrive.

On the political side, the economic reform also marked the withdrawal of state control from people's everyday life, including their choices of what to wear. While there was no 'uniform' that was required of the general populace during the Mao era,[13] the socialist egalitarian ideology and the discourse of frugality and austerity (jianku pusu) fostered a conservative attitude of the Chinese towards dress, so much so that top Communist Party officials such as Hu Yaobang and Zhao Ziyang had to take it on themselves to promote the Western suit (xifu) in the 1980s.[14] Coupled with the relaxation of political control by the state, Chinese popular culture, with influence initially from Hong Kong and Taiwan, and then from Japan and South Korea, began to grow. Fashion styles of pop stars from other East Asian countries and regions became a major source of inspiration for the younger generation. Concurrently, fashion media, including fashion magazines (initially domestic fashion magazines and then international ones), newspapers and fashion-related television programmes began to mushroom as well. These changing currents in the social and political environment paved the way for a proliferation of styles and dynamic fashion changes, which were crucial for the rise of the Chinese fashion industry in the reform period.

The diversification of styles in the reform period, which is in sharp contrast to the staple of the Mao era − the ubiquitous Mao suit − entails a continuous process of market segmentation in the apparel industry, which demands innovation in designs from Chinese fashion professionals. To meet this demand, Chinese colleges and universities began to offer programmes in fashion design and related fields in the early 1980s.[15] By the early 1990s, the number of professionally trained fashion designers and other fashion professionals had reached a considerable size. In 1993, the China Fashion Association (CFA) was established in Beijing, with the aim of organising a major fashion event that would bring together all interested parties to promote the Chinese fashion industry. After a few years of preparation, the first ever China Fashion Week (CFW) was held in Beijing in 1997.[16] Today, CFW has become the single most important fashion event in China, primarily aiming to promote Chinese fashion designers and fashion brands. It brings together thousands of fashion designers, models, photographers, members of the media, buyers, fashion students and

celebrities[17] into this biannual event. The success of CFW not only represents the establishment of an institution and the professionalisation of fashion designers and related groups, but also vividly exemplifies the constellation of all the factors essential for a thriving fashion industry; CFW has become a microcosm of the booming Chinese fashion industry. Today, there are more than 30 fashion weeks across China, with China Fashion Week, Shanghai Fashion Week and Shenzhen Fashion Week being the most influential.

Evidently, the emergence of the Chinese fashion industry has to do with a whole host of factors outlined above. For the purpose of this chapter, I want to emphasise two points that have generally been neglected in previous studies by Chinese dress historians. One is that the rapid expansion of export-oriented textile and apparel industries has contributed significantly to the growth of the domestic fashion industry in China. As mentioned previously, Chinese textile and apparel industries have provided inputs and capacity, as well as accumulated knowledge and technology for the rise of the domestic fashion industry. In fact, the latter part requires further elaboration. Because of the Chinese textile and apparel industries were driven by exportation initially, a major source of the 'knowledge and technology' for Chinese manufacturers had been Western importers. As will be discussed further in the next section, exportation to the West (and attendant insourcing of designs) was and still is a very important connection between the Chinese and global apparel industries. The other point is that the rapid growth of the Chinese fashion industry in the reform era has to do with a continued, intensifying process of market segmentation; Chinese fashion professionals and manufacturers have continuously been expanding into niche markets as the 'old' ones become saturated. Consequently, the Chinese fashion industry today has become highly segmented. As a result, to understand how fashion is produced in China requires an examination of diverse market segments.

PRODUCTION OF FASHION IN THREE MARKET SEGMENTS

Fashion scholars have generally theorised three models or systems of fashion: fast fashion, prêt-à-porter and high fashion.[18] These three types

of fashion are hierarchically ordered in terms of the originality of the designs, with fast fashion being the least original and high fashion the most. At the same time, products of these three types of fashion generally correlate to a price hierarchy, with fast fashion being the cheapest and high fashion the most expensive. As I have discussed in detail elsewhere,[19] the reason that these three types of fashion represent three fashion systems or models is because they each entail their own economic and cultural logic. For the purpose of this chapter, I consider fast fashion, prêt-à-porter and high fashion as three market segments defined by originality, quality and price of the garments. It is worth noting that these three market segments do not represent the entirety or the only way to categorise all market segments of the Chinese fashion industry.[20] Neither do they exhaust the different types of fashion or fashion systems. At the same time, however, the goal of this chapter is not to delve into every possible market segment of the Chinese fashion industry, which is an impossible task for this essay. Rather, I use these three segments as a heuristic device to illustrate the diverse ways in which fashion is created and produced in China, with special attention paid to the global connections in each of these segments.

Fast fashion

Perhaps the most well-known Chinese fast fashion brand is Metersbonwe, a private company that was established by Zhou Chengjian in 1995. In less than ten years, the company had already established itself as a well-known brand in China. In 2011, its revenue reached over 10 billion yuan. Today, it has about 5,000 company-owned and franchised stores all over China. To explain the reasons for the company's rapid success, Zhou, the CEO of Metersbonwe, attributed it to the company's strategy of 'not taking the common path' (bu zou xunchang lu), by which he meant the company's original brand manufacturing (OBM) model.

The OBM model is related to but different from the original equipment manufacturing (OEM) model. While the OBM companies control the brand, designs and distribution, the OEM companies are suppliers who are only responsible for the production of the garments (more discussion on this in the next subsection). The OEM model is a common strategy adopted by most Chinese garment manufacturers that

do not own any brands but manufacture garments for branded companies, which were overwhelmingly Western companies in the 1980s and 1990s. In other words, the OEM model was the model associated with exportation. By choosing the OBM model, Metersbonwe was and to a large extent still is very different from most Chinese garment manufacturers. It was especially the case when the company was founded, so much so that Zhou had to build a factory in order to convince his suppliers that his company was a legitimate apparel company with its own brand, because many suppliers from whom he tried to source initially thought his company was a 'briefcase company' (*pibao gongsi*) that was only in the business of swindling others.[21] As the company became more successful, Metersbonwe abandoned manufacturing altogether and now relies on a network of 300 suppliers for production. Instead, the company focuses on product development, marketing and distribution (including retail), much like a Western branded OBM manufacturer. Given that Western OBM companies routinely sourced from Chinese garment manufacturers in the 1990s (and still do), it would not take much for Metersbonwe to learn its business model from Western OBM marketers despite the fact that its top management team have never had any experience working in Western branded companies.

In fact, Metersbonwe has learned from Western branded companies in more than one way. The reason that it is considered a fast fashion brand is that the products are very cheap and they rely primarily on marketing[22] to sell garments quickly and in large volume. While the company has a large team of designers, their designs are generally not original. According to one designer who has worked at Metersbonwe and whom I interviewed multiple times in 2004, 2009, 2012 and 2014,[23] the designers at Metersbonwe work more like merchandisers. Rather than creating their original designs, they would go in a team and tour stores of Western brands (mostly also fast fashion brands) around the world, select what they thought would be popular among Chinese consumers, and then adapt them into a collection that they call their own. In other words, the job of designers at Metersbonwe, at least according to this designer, includes picking and choosing styles, making some small changes, and ensuring garments are made in acceptable quality and in a timely manner. Like most fast fashion companies (including Western

ones), designs of this Chinese fast fashion brand are copied and adapted primarily from those of Western brands.

With the influx of Western and Japanese fast fashion brands such as H&M, Zara, Forever 21 and Uniqlo, which also source their clothes from China and usually have stores on the same streets as Metersbonwe's, Metersbonwe has seen its market share shrinking in recent years. While Metersbonwe may be a well-known Chinese fast fashion brand, the most important markets for Chinese fast fashions are the big wholesale markets in major Chinese urban centres. One such market is Qipu Road Market in Shanghai. Contrary to common belief that large retail markets such as Xiangyang Market in Shanghai (closed down in 2006) are the epicentre of fast fashion in China,[24] large whole markets such as Qipu Road Market are the source of countless small fast fashion retailers across China. In these large wholesale markets, huge volumes of garments of obscure brands but with very trendy designs are traded on a daily basis. The speed of reaction to market trends in these large wholesale markets is in fact faster than branded fast fashion companies such as Metersbonwe. They are really the ones that are setting the tempo of fast fashion in China today, even though the sources of the designs of these fast fashion 'brands' are hardly identifiable. What is clear is that these 'brand-less' fast fashions tend to have more competition with Chinese fast fashion brands than Western brands, because they tend to be sold in retail markets in smaller cities and rural areas where big Western fast fashion brands do not yet have any presence.

Prêt-à-porter

Prêt-à-porter generally means ready-to-wear garments. But compared to fast fashion, prêt-à-porter refers to branded products with original designs, of better quality and more expensive than fast fashion. Nearly all middle-ranged designer brands fall into the category of prêt-à-porter. Ready-to-wear garments became more common in the late 1980s in China. Prior to that, the Chinese would usually buy cloth and then have their garments made at home or by tailors, which correlated with the pattern that much of the production capacity of the Chinese garment industry in the 1980s and the early 1990s was devoted to exportation, as mentioned previously. As ready-to-wear garments became readily

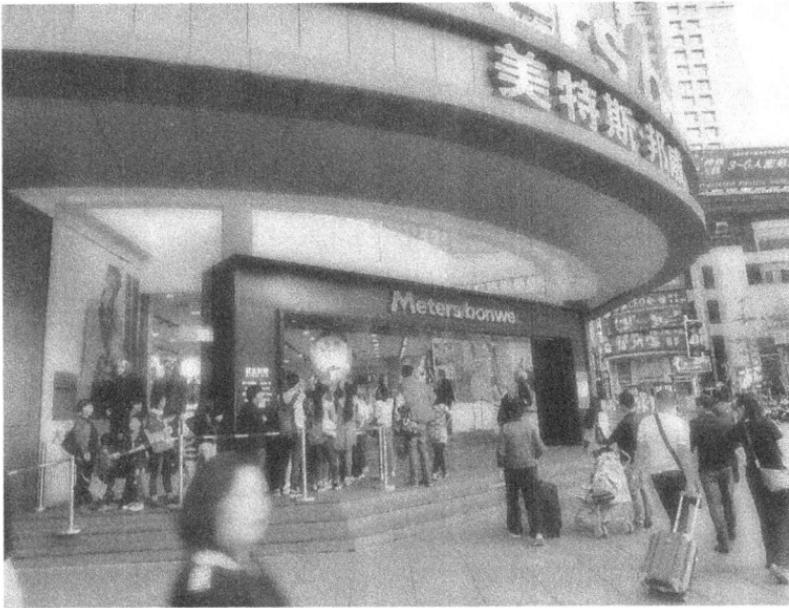

3.1 Metersbonwe uses candy floss to lure shoppers. Photograph by chapter author.

available in China, brands gained importance, and domestic designer brands began to emerge in the mid 1990s. Therefore, Chinese-made prêt-à-porter usually takes one of two routes: one destined for exportation and the other for domestic consumption, each with varying degrees of contribution from Chinese design professionals.

The most common form of garment exports for Chinese manufacturers is called a 'full-package production'. This pattern differs from the assembly production or maquiladora production pattern,[25] in which manufacturers are only responsible for assembly and Western importers/buyers (including branded marketers and retailers) are in charge of all the rest. In a full-package production pattern, Western buyers outsource all the responsibilities related to production to manufacturers (in this case, Chinese) and expect them to acquire all the inputs, complete the production and deliver floor-ready garments to the retailers. While a Chinese full-package manufacturer has full control of production, it is commonly believed that the manufacturer, an OEM, does not have any inputs to the designs of the products it makes, which lies completely in the hands of Western buyers, the OBMs. According to

Gereffi and Korzeniewicz,[26] the global apparel industry is constituted by a buyer-driven commodity chain in which the buyers (the OBMs) play the leading role and are responsible for higher value-added chains or processes of design and marketing, while the suppliers (the OEMs) are responsible for lower value-added chains of production.

However, during my research with Chinese suppliers (including the manufacturers and exporters), I found that such a view is not entirely accurate. Chinese suppliers can contribute to the designs of the products they make in two important ways. In most cases, in the full-package production process, Chinese suppliers would have to make 'samples' based on the designs or sample garments provided by Western buyers. This usually takes several rounds before the final mass-produced samples are confirmed by Western buyers. This process of sample making involves back-and-forth comments and suggestions between Chinese suppliers and Western buyers, during which Chinese suppliers can add their input to the final designs of the garments. In other cases, Chinese suppliers with their own design capacity would sometimes propose sample garments with their own designs to Western buyers in order to increase orders from them. This practice is not required of Chinese suppliers, but because it saves product development costs for Western buyers, they in fact welcome such a practice. For example, Mr Zeng, an exporter based in Shanghai whom I interviewed in 2004, told me that he and his manufacturing partner supplied sample styles designed by themselves to a multinational sportswear brand. Some of the styles were selected by this buyer and they subsequently won bigger orders than had been given to them initially. In this case, the Chinese suppliers, Zeng and his partner, made a major contribution to the designs (albeit not getting paid for them) of the garments they exported. While this may not be a widespread practice in China's full-package production for export, it is not at all uncommon for Western brands to hire Chinese designers (and designer studios) to design their products to be marketed to Chinese consumers. In both of these cases, Chinese fashion professionals and OEM exporters have made a greater contribution to the designs of Western brands than previously assumed.

In the domestic market, Chinese designer brands started to emerge in the 1990s. One of the earliest designer brands is Layefe, established by

renowned artist the late Chen Yifei in 1996.[27] While Layefe collapsed followed Chen's untimely death in 2005, its contribution to the Chinese fashion industry is much longer-lasting than the brand itself. It provided a 'training camp' (in Chen's word) for many fashion designers. A case in point is Wang Yiyang, first Chief Designer at Layefe. After leaving Layefe in 2001, Wang launched his own line of womenswear named Zuczug (Suran) in 2002.[28] While Zuczug is still a young brand by international standards, it has grown to become a premier, established designer prêt-à-porter brand in China. Today, it has about 100 stores in 40 cities across the country. It has a staff of over 30 designers and a collection of five unique lifestyle series/lines supervised by Wang. In the following, I will focus on key features of Zuczug's product lines, Wang's design philosophy and the extent of Zuczug's international connection.

When I asked Wang how he would define Zuczug, he said it was an 'original designer brand' (yuanchuang shejishi pinpai). By that, he meant that the design of Zuczug products was originally created by him and his design team, albeit with external influences. For example, in the early days of Zuczug, Wang did all the designs himself, and his style was very much influenced by the Japanese. He consistently took a deconstructionist, minimalist approach to his designs, characterised by uneven cuts, exposed seams, baggy silhouettes and solid and sober colours. Since 2008, Wang has assumed the role of Brand Director (pinpai zongjian), supervising a team of designers. Zuczug has grown from a single line to five regular lines or series, each with a team of designers responsible for its creation. Each series draws its inspiration from different facets of urban life, and consequently the styles of different series are distinct from each other and from Wang's original designs, which are mostly kept in the 'classic' Z series. In addition to the Z series, Zuczug has a line of outdoor wear, an environmentally conscious series/line (huanbao xilie),[29] a jeans line and accessories. In recent years, Zuczug has also introduced short-term culturally themed series. For example, in 2013, it made a collection called 'Vegetable Market series' (caishichang xilie), with prints of caricatured images of scenes from local vegetable markets. When I visited the company in October 2014, they were planning to launch a sheep-themed series in anticipation of the Year of the Sheep (2015).

ZUCZUG/

3.2 Zuczug Z series. Courtesy of Zuczug.

While there have been diverse styles and product lines in recent years, Zuczug maintains Wang's original design philosophy that centred on equality. To elaborate on equality, Wang says:

> We [the brand] and our customers are equals. Our brand image is that we are horizontal with our customers. We do not want to be like others who strive to be a sign for the customers to look up to [*yangshi*]. The setup of our stores reflects that; they do not look flashy or luxurious. Moreover, we do not use any professional models for any promotional materials. Our 'models' are common smiling customers.

Having visited Zuczug stores numerous times in various locations, I do think that the Zuczug store appears to be very accessible to shoppers, which is quite different from many other high-end designer brands that usually convey the high-end image through lavish store fronts that command shoppers' attention. That being said, Zuczug is by no means cheap. The stores (as well as the products) look modern, bright, organised and with nuanced details, and are usually located in high-end shopping malls, where world-class brands would also have their stores. Thus far, Zuczug only operates in China's first- and second-tier cities. Most items in the Zuczug store are priced between 1,000 and 3,000 yuan, which is in fact quite expensive for white-collar workers in China.[30]

The other major tenet of Wang's design philosophy is that the inspiration of fashion ought to come from real life instead of the runway. He believes that many of the runway fashions are too removed from real life and unwearable.[31] Wang's design philosophy is reflected in Zuczug's product series/lines. The designs of all of the series reflect the 'mood' and broadly the way of life of a particular group of consumers. As such, Zuczug is associated with different attitudes towards life rather than a consumer segment that is defined by age or occupation. Wang commented that it is quite common to see both a mother and a daughter buying Zuczug products, as they share similar lifestyle orientations. Aside from the five regular series/lines, the seasonal series, such as the 'Vegetable Market series', also reflect a certain attitude toward life. The prints of the market scenes are so unique and earthy that it would

ZUCZUG/0

3.3 Zuczug zero series. Courtesy of Zuczug.

take a certain type of person with a light-hearted attitude towards life to wear them.

Perhaps because of Wang's design philosophy and unique product lines, Zuczug is a uniquely Chinese designer brand. When I asked Wang who his main competitors were, he could not think of other any Chinese designer brands as direct competitors. He said there were perhaps international brands that were similar to Zuczug, but they did not yet have any presence in China. To him, Zuczug is using the language of design to convey a consistent message and aesthetics about a particular, not necessarily mainstream, way of life. He has never been bothered by not being mainstream. His insistence is rewarded by customer loyalty and increasing market success, much to the envy of his fellow designers.[32] Wang said that his company has seen about 20 per cent annual growth in recent years and that last year's revenue exceeded 500 million yuan.[33] If there seems to be a general lack of connection between Zuczug and international brands in terms of direct competition, then what about Zuczug's plans to go international?

In fact, over the years, I have repeatedly asked Wang the same question about his strategies to make Zuczug an international brand. In 2009, he said that it would be a dream to do a fashion show at the New York fashion week. However, in 2012, he was not at all interested in promoting Zuczug overseas but was completely focused on the Chinese market, and appeared to be very confident of the Chinese economy. He said that if the brand became very successful in China, as China rose in the global economy, successful Chinese brands would naturally become internationalised. In other words, his strategy of internationalisation was to wait for the made-in-China brand to strengthen globally, and in the meantime to further establish Zuczug in the Chinese market. In 2014, his view had not changed much from that in 2012; he still had no immediate plans to promote Zuczug internationally, but he had already started exchanges with fashion designers in other countries. In fact, when I interviewed him in October 2014, he had just come back from a trip to India, where he met with many fashion professionals and expressed interest in exchanging fashion designers with them. He was also planning to visit Brazil in 2015. Given the current development, we can say that Zuczug is a distinctly Chinese designer label with no direct

ZUCZUG/羊逍遥 2015

a collaboration with boris hoppek

3.4 Zuczug Zodiac-themed collection 2015. Courtesy of Zuczug.

international ties, but not without a vision of becoming an international brand. Time will tell when and how Wang's vision for the international markets will materialise.

To summarise, in China's prêt-à-porter sector, Chinese fashion professionals in general make a significant contribution to the designs of the garments. While the contribution of exporters like Zeng to the designing process is largely unacknowledged, fashion designers like Wang have full control of the designs of their garments. On the other hand, Chinese exporters have strong and obvious connections with international markets, whereas domestic designer brands like Zuczug do not yet have any material ties with international markets.

High fashion

High fashion is called *gaoji shizhuang* in Chinese, and is sometimes referred to as haute couture by Chinese as well as Western academics and professionals. It has to be noted that the term haute couture is protected by law in France to refer specifically to the prestigious fashion houses that meet the criteria set by the Chambre de commerce et d'industrie de Paris. Thus, it is only in a very loose sense that high fashion and haute couture are considered to be synonyms that refer to luxury, made-to-measure dresses. Compared to prêt-à-porter, high fashion had an even later beginning in China. According to Ne Tiger, a Chinese high fashion brand, Chinese high fashion originated in 2003, a time when Ne Tiger launched its made-to-measure evening wear collection, *mingyuan*, with its flagship store in the Wangfujing shopping mall in Beijing (ne-tiger. com). I have to point out that Ne Tiger's claim of introducing Chinese high fashion is not widely recognised. In terms of organised efforts to promote Chinese high fashion, however, the Shanghai New Couture Centre (SNCC) was only established at Bund 22 under the auspices of Shanghai International Fashion Federation (SIFF) on 10 October 2014. In April 2015, SNCC launched the very first Shanghai New Couture Week. While it is exciting to see these developments in Chinese high fashion, at the time of writing it is too early to call SNCC, which only houses two wedding dress stores[34] and some furniture, tea and porcelain stores, a success. Given the recent nature of Chinese high fashion, in what follows, I can only give a preliminary assessment on

how Chinese high fashion is created and its international ties by examining Ne Tiger and a rising wedding dress designer.

Ne Tiger was founded by Zhang Zhifeng, a tailor turned entrepreneur from Northeast China, in 1992. It is intriguing that Ne Tiger dates the first year of Chinese high fashion to 2003, while the company was founded in 1992. This is because Ne Tiger started as an OEM of fur garments for foreign brands, which is still its main business. With the accumulation of capital, knowledge and capacity, Ne Tiger was able to launch its own high-end made-to-measure collection. While the market for a domestic high fashion brand was perhaps next to nothing in 2003, Ne Tiger spared no expense to create the image of being the Chinese high fashion brand. It started to sponsor China Fashion Week and won the right to host the opening show of CFW. When I attended CFW in November 2004, Ne Tiger's show was evidently the most expensive one. Most of the models for its show were foreign, white models,[35] and each model only wore one dress for the show, perhaps to highlight the fact that these evening dresses were one-off made-to-measure dresses and/or perhaps simply to impress on the audience that Ne Tiger was a deep-pocketed luxury brand. In terms of designs, Ne Tiger claims to have successfully woven the best of the East and the West into its products. Yet, without a major designer at the helm (Zhang is Chairman of the company and simultaneously serves as Artistic Director), Ne Tiger's dresses range from truly exceptional and sophisticated to outright gaudy. In recent years, Ne Tiger has continued its approach of hosting high-profile fashion shows. However, with scant evidence of endorsement by Chinese celebrities, who tend to wear Western designer dresses at high-profile events, it is hard to know whether Ne Tiger has truly made it as the Chinese high fashion brand it claims to be. At the same time, having plenty of business contacts and several offices overseas, Ne Tiger has the advantage of pursuing international markets should it decide to sell its own line internationally. At the time of writing Ne Tiger seems to use its OEM business to support its brand image of a Chinese high fashion brand.

While the domestic Chinese high fashion market has yet to mature, a particular segment of this market, made-to-measure designer wedding gowns, is developing rapidly. Perhaps the best-known Chinese wedding gown designer today is Lan Yu.[36] Lan Yu is a graduate of the Beijing

Institute of Fashion Technology. She registered her eponymous studio in 2005. In 2008, she studied briefly at the Fashion Institute of Technology in New York and returned to China in 2009 to start her business in high-end made-to-measure wedding dresses. Her designs finally gained attention in 2010 when a TV celebrity asked her to design her wedding gown. To ensure high quality of the dresses, Lan Yu sources raw materials from Europe. She combines Western design techniques, such as draping, with exquisite handworks of Chinese embroidery to create artful, dreamy dresses tailored to the needs of her customers. Lan Yu also tries to ensure a high level of customer satisfaction by receiving training from a very well-known Chinese psychologist. In the past few years, she has designed wedding gowns or evening dresses for many A-listed Chinese celebrities, one of which was reportedly worth over one million yuan. In 2012, Lan Yu received the 'Stars' Favourite Designer' award from Cosmo Bride (Shishang Xingliang). Indeed, many Chinese movie stars have worn Lan Yu dresses to international (as well as Chinese) events, which gave Lan Yu important international exposure. Moreover, Lan Yu has also done fashion shows in Paris, Milan, New York and Australia in the last two years. As of now, she has two studios, one in Beijing and the other in Shanghai.[37] It is not yet clear whether Lan Yu will become an international high fashion wedding brand.

Besides both being relatively young, Ne Tiger and Lan Yu share important similarities in their approach to creating their designs. They both try to incorporate elements of Chinese tradition and Western design techniques and fabrics to create unique designs tailor-made for their customers. They also both seek greater exposure through high-profile fashion shows, with Ne Tiger at China Fashion Week and Lan Yu at major international events. While Lan Yu has been showing internationally for a few years, neither Lan Yu nor Ne Tiger had opened stores internationally at the time of writing. Their international connection remains in their 'synthesis of the East and West' in their designs. Trying to create a high fashion brand independently like Ne Tiger and Lan Yu is a major way for Chinese companies to enter the high fashion sector, but there are also Chinese companies that try to do so via acquisition, licensing of, or forming joint ventures with Western

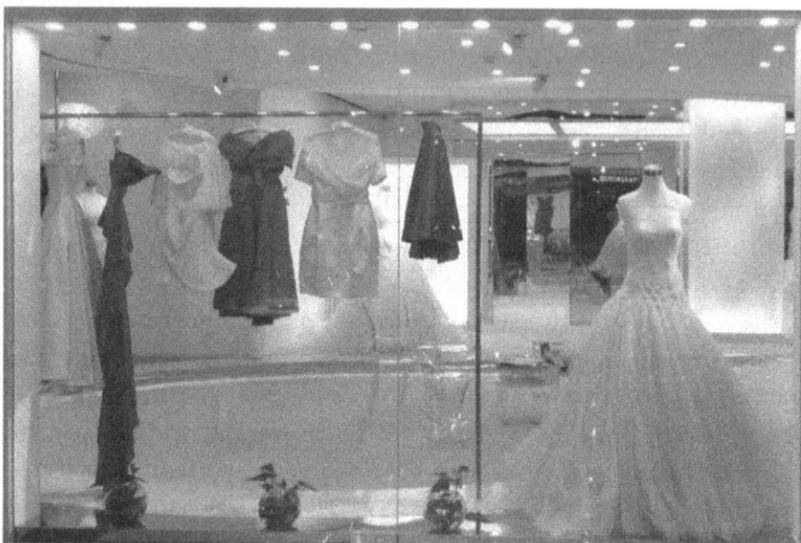

3.5 Lan Yu boutique in Shanghai. Photograph by chapter author.

high fashion brands.[38] This approach allows Chinese companies to gain a foothold quickly in the high fashion market and even to enter international markets, but these Chinese companies do not make much contribution to the designs of the products they manufacture or market and thus cannot claim to have created a high fashion brand of their own.

TOWARDS A CHINA WITH MULTIPLE FASHION SYSTEMS

Based primarily on a few case studies, this chapter has illustrated how fashion is created and produced in three market segments: fast fashion, prêt-à-porter and high fashion in China. Although these three segments clearly cannot represent the entirety of the Chinese fashion industry, they do represent a wide range of Chinese garment manufacturers. As the examples of Metersbonwe, Zuczug and Lan Yu indicate, fashions in these three sectors are created, produced and sold in very different ways. Metersbonwe is a fast fashion brand. It does not invest in original designs or production capacity, but imitates popular designs and

focuses on marketing, distribution and management of its supply chain. It relies on the popularity of the celebrity spokesperson and its marketing campaign, the affordability of its products and numerous store locations on high-traffic streets across China to achieve a large volume of sales. Zuczug is an original designer brand. The design team makes up a significant portion of the company's staff. Zuczug's success hinges on original designs and the setup of its stores in high-end shopping malls in major urban centres that communicate a distinct brand image and lifestyle to its consumers. The relatively high price of Zuczug products and small number of stores mean that Zuczug requires mass production but not a massive-scale production, unlike Metersbonwe. Lan Yu is a high-end made-to-measure designer brand. The products are unique, highly expensive wedding gowns and evening dresses tailor-made for individual clients. Lan Yu operates no retail stores, but two designer studios in two largest cities in China – Beijing and Shanghai – that provide individualised services to their customers by appointment. Evidently, Metersbonwe, Zuczug and Lan Yu represent three different types of fashion characterised by originality, quality and price of the products. Metersbonwe is a cheap, unoriginal mass-produced fast fashion brand; Zuczug is an expensive, original but mass-produced prêt-à-porter brand; and Lan Yu is a unique, highly expensive, made-to-measure high fashion brand.

However, fast fashion, prêt-à-porter and high fashion are not simply three types of fashion at different price levels. Scholars of consumption studies have long proposed a 'vertical approach' to study consumption from the perspective of a 'system of provision' that starts with production.[39] Anthropologists have used the 'commodity chains' perspective to link together sites of production and consumption.[40] The case studies of Metersbonwe, Zuczug and Lan Yu in this chapter also illustrate that not only is each type of fashion made differently by fashion professionals; they also correspond to different settings of consumption. This suggests that we ought to see production, distribution and consumption of a particular type of fashion in its totality. It is precisely because of the interconnections of production, distribution and consumption that the three types of fashion are in fact three distinct fashion systems. It is in this sense that I argue that the case studies of

Metersbonwe, Zuczug and Lan Yu demonstrate that the Chinese fashion industry is constituted by multiple, distinct fashion systems. This is important historically because, only a few decades ago, the Chinese fashion scene was dominated by the ubiquitous, drab, unisex Mao suit. Moreover, a China with multiple fashion systems also contradicts popular Western views of China as simply a purveyor of cheap, unoriginal fast fashion.

Another key finding of this chapter is that the Chinese fashion systems do not exist in isolation from the rest of the world, even though different fashion systems are connected to the global fashion industry in different ways. Fast fashion such as Metersbonwe has imitated not just designs but also the business model of its Western counterparts. Original designer brands like Zuczug do not copy their designs from their Western competitors, but as China integrates with the global economy, Chinese prêt-à-porter has to compete with Western designer brands for shopping space and customers. It is in this sense that Zuczug is a Chinese brand with an international vision. As a high fashion brand, Lan Yu is closely connected to the global fashion industry. It sources all its materials from Europe, appropriates the design language of haute couture and utilises the international stage to augment its aura of being a Chinese high fashion brand. As the diverse fashion systems in China continue to grow and mature, one can only imagine that stronger and more complex connections will develop between the Chinese fashion systems and the global fashion industry.

NOTES

1 For 1980 figures see World Trade Organization International Trade Statistics 2011, p. 130. Available at https://www.wto.org/english/res_e/statis_e/its2011_e/its2011_e.pdf; for 2013 figures, see World Trade Organization International Trade Statistics 2013, p. 56. Available at https://www.wto.org/english/res_e/statis_e/its2013_e/its13_highlights2_e.pdf.

2 Yi-Cheih J. Lin, *Fake Stuff: China and the Rise of Counterfeit Goods* (New York: Routledge, 2011); Simona Segre Reinach, 'China and Italy: fast fashion versus *prêt à porter*. Towards a new culture of fashion', *Fashion Theory* 9/1 (2005), pp. 1–12.

3 Juanjuan Wu, *Chinese Fashion from Mao to Now* (Oxford: Berg, 2009); Antonia Finnane, *Changing Clothes in China: Fashion, History, Nation* (New York: Columbia University Press, 2008).

4 Jianhua Zhao, *The Chinese Fashion Industry: An Ethnographic Approach* (London: Bloomsbury, 2013); Christine Tsui, *China Fashion: Conversations with Designers* (Oxford: Berg, 2009).

5 Western views of Chinese fashion are changing by the day, due in large part to Chinese fashion designers' increasing exposure in fashion weeks of New York, London, Milan and Paris.

6 Yuniya Kawamura, *Fashion-ology: An Introduction to Fashion Studies* (Oxford: Berg, 2005), p. 4.

7 There are many factors, such as personal charisma, uncontrolled influx of resources, rapid population change and political power shifts, which can induce fashion change (Aubrey Cannon, 'The cultural and historical contexts of fashion', in Anne Brydon and Sandra Niessen (eds), *Consuming Fashion: Adorning the Transnational Body* (Oxford: Berg, 1998), pp. 23–38).

8 Zhao, *The Chinese Fashion Industry*.

9 Finnane, *Changing Clothes in China*.

10 For details, see Zhao, *The Chinese Fashion Industry*, the background section of chs 2, 3, 5 and 6.

11 Ibid., pp. 17–40.

12 In 2000, over 80 per cent of the Chinese textile industry and over 90 per cent of the garment industry were controlled by private capital (ibid., p. 37).

13 Verity Wilson, 'Dress and the Cultural Revolution', in Valerie Steele and John S. Major (eds), *China Chic: East Meets West* (New Haven, CT: Yale University Press, 1999), pp. 167–86.

14 Zhao, *The Chinese Fashion Industry*, pp. 52–3.

15 The Central Academy of Arts and Crafts in Beijing, which merged with Qinghua University in 1999, was the first to offer a fashion programme in 1980. Donghua University in Shanghai quickly followed suit.

16 Initially, CFW was held only once a year, but since 2003 it had been twice a year, much like major fashion weeks around the world.

17 There are far fewer celebrities present than other groups and than at the four major fashion weeks in the world.

18 Zhao, *The Chinese Fashion Industry*, pp. 85–7; Segre Renaich 2005.

19 Zhao, *The Chinese Fashion Industry*.

20 Fashion companies sometimes use lifestyle or age to describe market segments.

21 He told the story at a forum that the author attended in Shanghai in 2004.

22 Its strategy has been to hire famous pop singers as spokespersons and use extensive TV commercials.

23 The author's interviews were not just focused on Metersbonwe. This designer had changed jobs many times in the previous ten years, switching back and forth between being a designer in different fashion companies and his own small design studio.

24 Lin, *Fake Stuff*.

25 Jane Collins, *Threads: Gender, Labor, and Power in the Global Apparel Industry* (Chicago, IL: University of Chicago Press, 2003), pp. 130–3.

26 Gary Gereffi and Miguel Korzeniewicz (eds), *Commodity Chains and Global Capitalism* (Westport, CT: Greenwood Press, 1994).

27 Even though Chen was the founder and owner of Layefe, he was not involved in any of the designs of his namesake line, nor was he involved in the day-to-day management of the company. The author stayed at his company as researcher and interviewed him in 2004.

28 The author interviewed Wang numerous times in 2004, 2009, 2012 and 2014.

29 It uses environmentally safe materials and emphasises safety and comfort.

30 Some items can go as high as over 10,000 yuan. These prices are considered expensive for white-collar workers in most of China outside the first-tier cities such as Shanghai and Beijing. The average white-collar worker in China earns between 5,000 and 6,000 yuan a month, while a white-collar worker in Shanghai could earn well-over 10,000 yuan.

31 Wang rarely shows at fashion shows in fashion weeks.

32 Other fashion designers in Shanghai have told the author that Wang has very faithful followers.

33 During an interview in 2014 Wang noncommittally told the author that the company's revenue in 2013 was about 500 to 600 million yuan (close to US $100 million). The author could not verify these figures because Zuczug is a private company with no obligation to release its financial statements to the public or the researcher. The author subsequently questioned a staff member in the company about its financial reports, but was told that it was not public information even to its rank-and-file employees.

34 One of which is Guopei's wedding dress line. Guo is a Chinese high fashion designer with increasing international acclaim. The store is filled with very traditionally styled, heavily embroidered, brightly coloured silk dresses. The designer and manager of the store did not reveal how its business was doing.

35 According to some fashion journalist friends of the author, most, if not all, of these foreign models were from Eastern Europe and Russia, and their wages were lower than European or American models.

36 Lan Yu is her first name. Her last name is Liu, which is rarely used in the promotional materials or the media reports of the brand and the designer.

37 The author visited Lan Yu's Shanghai studio in October 2014, but missed her by one day.

38 Examples of these companies include Red Dragonfly, Redstone Haute Couture and a Zhejiang garment manufacturer that formed a joint venture with Ermenegildo Zegna.

39 Ben Fine and Ellen Leopold, *The World of Consumption* (London: Routledge, 1993).

40 See, for example, Robert Foster, *Coca-Globalization: Following Soft Drinks from New York to New Guinea* (New York: Palgrave Macmillan, 2008); Karen T. Hansen, *Salaula: The World of Secondhand Clothing and Zambia* (Chicago, IL: University of Chicago Press, 2000).

4

DESIGNED IN CHINA: MULTIPLE APPROACHES TO FASHION AND RETAIL

Juanjuan Wu, Yue Hu, Lei Xu and Marilyn R. DeLong

INTRODUCTION

With the pace of change in the global fashion scene, the identity of Chinese fashion should not solely consist of the 'Made in China' label any more than it should be identified with China's booming luxury market. This identity issue has become increasingly complex and multi-dimensional as global integration of fashion production, distribution and consumption has blurred the boundaries that were used in the past to differentiate the Chinese from the non-Chinese or from the Western.

Over the past decade, a large number of young Chinese fashion designers have acquired fashion degrees or training overseas and returned to China to develop their own fashion labels, a group that includes Qiu Hao, Ou Minjie, Masha Ma, Vega Zaishi Wang, Zhang Na, Jiang Ling, Simon Wang, Uma Wang and Liu Qingyang. Many of them are graduates of Central St Martins in London. Some of these young fashion designers have already left their mark on the global fashion world. For example, Qiu Hao won the 2008 Woolmark Prize in Paris, joining the Woolmark hall of fame alongside the fashion world's most

reputable designers, such as Karl Lagerfeld, Yves Saint Laurent and Giorgio Armani. Uma Wang has presented her collections in the official schedule of Milan Fashion Week consecutively since spring 2014. With a few of them actively participating in the Western fashion system, the majority of this group brings in Euro-American concepts to operate in Chinese retail, which further complicates the identification of what is Chinese and what is not.

On the other hand, veteran designers, mostly in their 40s or 50s, such as Wang Yiyang, Ma Ke, Lu Xuejun and Chen Xiang, have established their labels in the domestic market and become strong competitors of Western labels. To them the concept of 'designed in China' requiring external endorsement to succeed is already outdated.[1] Success in the China fashion marketplace has real global significance in this digitised, networked world, and thus equals success in the international fashion marketplace in this sense.

The prominence of e-promotional and retail platforms in the Chinese market accelerated the shift of focus in the key competencies of the Chinese fashion industry. The key competence used to lie in quality manufacturing, as industrialised craftsmanship and fine materials were scarce resources in the 1980s. In the 1990s and 2000s, since industrialised manufacturing became more accessible, designers began to compete on the ground of creating a highly distinguishable brand image. Systematic efforts in product development, packaging, retail store design and promotion gradually became coordinated in order to construct a memorable, cohesive brand image. However, a new shift in focus to multichannel retailing seems to loom on the horizon, though there is no doubt that Chinese fashion designers still struggle with a lack of supporting systems in manufacturing, management, retailing and marketing. This new challenge of multichannel retailing relies not only on channel accessibility but also product presentation, customer relationship management and the communication of a total store image to a potential global audience that the label has little influence on.

Through interviews and field research, this chapter explores Chinese fashion designers' multiple approaches to design and retail; that is, new modes, new environments, new interactions and thus new relationships with Chinese consumers. Our primary data came from semi-structured

interviews with 15 founding designers[2] of mid- to high-end fashion labels in Beijing and Shanghai and eight interviews with fashion professionals or gatekeepers in Shanghai, such as fashion professors, fashion marketing directors or managers and leaders of fashion associations. Though designer fashion is readily available in large provincial cities its consumer base in third-tier cities and beyond is still limited. Thus, we focused our case studies on Beijing and Shanghai, the two leading fashion cities, where most influential Chinese designers reside. The interviews were audio recorded. All designer interviews were transcribed and content analysed. The researchers also visited the labels' retail stores or designer studios in Shanghai and Beijing, took photographs and notes, and gathered both written and video reports on these designers. The designers' official websites were also used as an important point of reference. The criteria in the selection of designers included: media coverage, participation in regional or national fashion shows and ownership of at least one fashion label.

BACKGROUND AND FRAMEWORK

Scholarly and critical attention to Chinese design has drastically increased over the past decade, paralleling China's economic rise. The dress code for the Met Gala 2015 was 'Chinese white tie', which was linked to the opening of the Metropolitan Museum's newest fashion exhibit, 'China: Through the Looking Glass'. The celebrities' varied but audacious interpretations of Chineseness inspired a great deal of debate in global fashion circles regarding how Chinese design should be approached and represented. For instance, Gabrielle Wilson, editor of MTV Style and MTV News, questioned the risk of cultural appropriation in some of the designs despite the event organisers' intention to bridge the cultures.[3] Within China, while social media has been cashing in on the entertainment value of cross-cultural interpretations (or misinterpretations) of Chineseness, serious minds grappled with how Chinese fashion designers might benefit from this level of global interest. The mere fact that 'all eyes [are] looking east'[4] is in itself a powerful sign of the importance of Chinese fashion, which sheds a much needed spotlight on Chinese fashion and designers.

This chapter mainly focuses on Chinese designer fashion from a retail angle. To tackle this complex issue that interweaves product, place and service we borrow the framework used by Davies and Ward to analyse store image, which helps to illuminate the multiple approaches that Chinese fashion designers take to design and retail.[5] According to this framework, store image is made up of four main facets:

1. merchandising (assortment, quality, price and brand mix);
2. retail store (location, environment, atmosphere and name/fascia);
3. service (personnel and quality); and
4. promotion (advertising, public relations and in-store).

The large amount of data that we gathered enabled us to grasp a relatively full picture of the store image of Chinese designer fashion. As the purpose of this chapter is to understand Chinese fashion designers' multiple approaches to design and retail better, we draw on examples of individual designers when discussing the four facets but do not attempt to systematically delineate the concept of store image associated with each of the 15 designers.

Merchandising

Merchandising strategy supports a designer's brand concept, which guides decisions regarding product development, pricing and the development of a total brand image. When a designer treats his or her designs as more than a commodity he or she runs into issues of balancing art and business. In fact, to some extent, the deliberate 'art' justifies designer fashion and distinguishes it from the offerings of mass fashion.

The 'art' component in fashion designer Wang Yiyang's label, Zuczug, is embodied in its connection to the vibrancy of Shanghai city life, especially to the mundane scenery of neighbourhood streets. He launched Zuczug in 2002 and the label has since become popular among educated, well-to-do urban women in China. Wang's themes have gone through major revamps from his early, non-thematic neutral colours and restrained silhouettes to his most recent vivid colours, exuberant patterns and funky characters. These changing styles are

encapsulated in various thoughtfully named themes, which is part of his creative effort to imbue 'art' in the label.

Over the past decade, many Chinese fashion designers have embraced the idea of telling label stories in themed series. They start merchandising with the search for a meaningful and memorable theme, that is, abstract brand narratives instead of physical brand materials. For example, Zuczug thematised its five series with differentiated meaning, connotation and assortment. The 'Sign Language' series, for instance, promotes sustainability, which is partly materialised in the series' use of linen, organic cotton, silk, wool and natural colours and dye. The visual logo of this series was interpreted as 'slow',[6] which implies slow consumption and slow living. All these verbal and visual creations are valuable artistic add-ons to the material productions of his series and consist of an integral part of his brand identity.

Wang's inspirations come directly from observations or memories of Chinese living instead of international trends. One of his 2012 themes was named 'Vegetable Market' (cai shichang). Graphics for this series came from the imagery of local wet markets, depicting fish, butchers' knives, hanging ducks, carrots or cabbage.[7] The juxtaposition of high-end fashion and down-to-earth wet markets creates a strong contrast and an artistic feel. Over the years the featured themes of Zuczug seem to touch on a variety of ideas but all are pertinent to Chinese everyday living.

Collaboration with the applied arts fields is an approach shared by many of the designers interviewed. This approach reflects the changing demands of young, well-to-do Chinese consumers in the twenty-first century. These consumers are characterised by their rich global experiences through travel, study or work. Their familiarity with the world's high fashion status symbols that their parents' generation longed for urges them to search for new inspirations. The new status symbols they seek are artsy, edgy and somewhat socially risky. Most importantly, these symbols offer differentiation from the status symbols manufactured by the well-known world of luxury fashion and thus offer a sense of renewed exclusivity. When consumed cross-culturally, with nuances of meaning mostly lost in translation, luxury status symbols seem to possess a singular, widely recognisable differentiation – price – that excludes the masses from consuming them. But new locally grown status symbols

have the ability to communicate a wide array of meanings that are up-to-date, relevant to local life and sophisticated, and thus can only be deciphered or appreciated within narrow social circles.

Zheng Yi, the Chief designer and founder of The Thing (launched in 2005), similarly gathers graphic artists around him and produces themed collections. His two early collections, The Fourth Dimension and Geek, both appear to be quirky, funky and geeky – all keywords associated with a technologically advanced social circle and intentionally secluded urban living. He illustrates that the citizens living in this dimension maintain an appropriate distance from the outside world.[8]

The Geek menswear catalogue features a stubbled, thin, pale and somewhat nerdy-looking model, wearing black round glasses. On the front cover, this model is parking a red bicycle on a green lawn with a puppy sitting in the front basket of the bicycle (Figure 4.1). In the sky there is an upside-down world with cars neatly parked in a circular parking lot next to buildings, trees and a baseball field – alluding to an unconventional but ideal place to escape to for eccentric minds, personified in perhaps the typical IT figure depicted in the pages of the Geek catalogue.

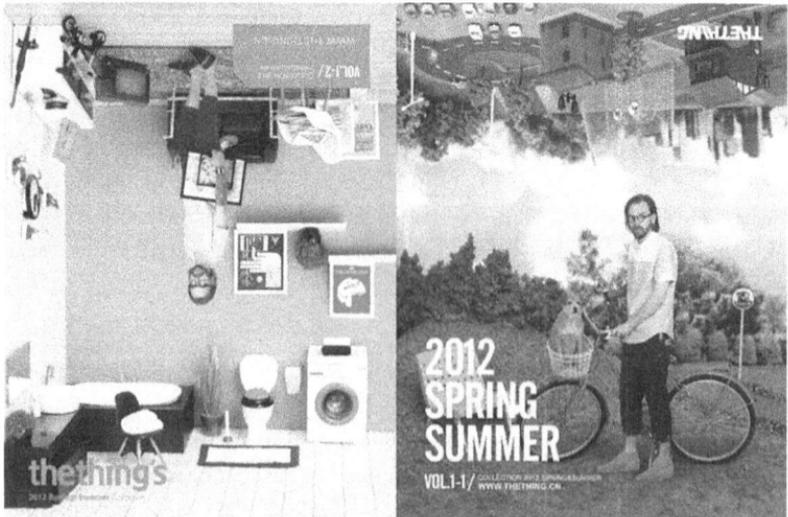

4.1 The front (right) and back (left) covers of the Geek menswear series catalogue. Courtesy of Zheng Yi.

The differentiation that Chinese designers have been pursuing, especially through collaborations with graphic artists in thematised collections, has resulted in both novel forms and meanings that are authenticated through their local relevance. Wang Yiyang argues that everyday life in large cities in China has already been internationalised and plays a role in influencing trends elsewhere; being observant of the daily happenings around him plus a dash of imagination is how Wang and his collaborative artists create new fashions, new forms and new meanings.[9] Most of the designers that we interviewed have identifiable areas of visual interest into which they dig deeply to create new imagery for their labels. This visual creation, matched with an explicitly narrated brand philosophy, constitutes the dual core of a designer label's identity.

In other cases, although the raw materials of a collection – such as inspirational sources or imagery – originate outside of China, the collection's final incarnation can still be rich in Chineseness. In this case, the designer's Chinese identity and upbringing act as a filter through which only the culturally relevant materials pass. The key to local relevance in this case thus relies heavily on the designer's skill in translating his or her personal aesthetic response to the foreign material into a design language that is understood by an affluent local audience. For example, Vega Zaishi Wang, a graduate of Central St Martins who is now based in Beijing, launched her 2012 spring/summer collection entitled 'Heart of Gold'. This collection was inspired by tattoos and imagery found in Russian prisons (Figure 4.2). It exemplifies the spirit of her eponymous label, depicting a female image that is independent, rebellious and adorns herself for herself and not for others or for social status.[10] She dares to seek inspiration from the dark side of society, from which she unearths its touching soft spots. She urges the young generation to adopt a global vision and not to be confined by what is inside China.

Another such designer whose design inspirations are explicitly articulated in the imagery of her collections is Liao Xiaoling, an architect-turned-fashion designer. Her inspirations come from both within and outside China, but all from non-fashion worlds. Her label, CONTENT, launched in 2008, is characterised by the crossing of boundaries of art forms. The imagery of her digital prints comes directly

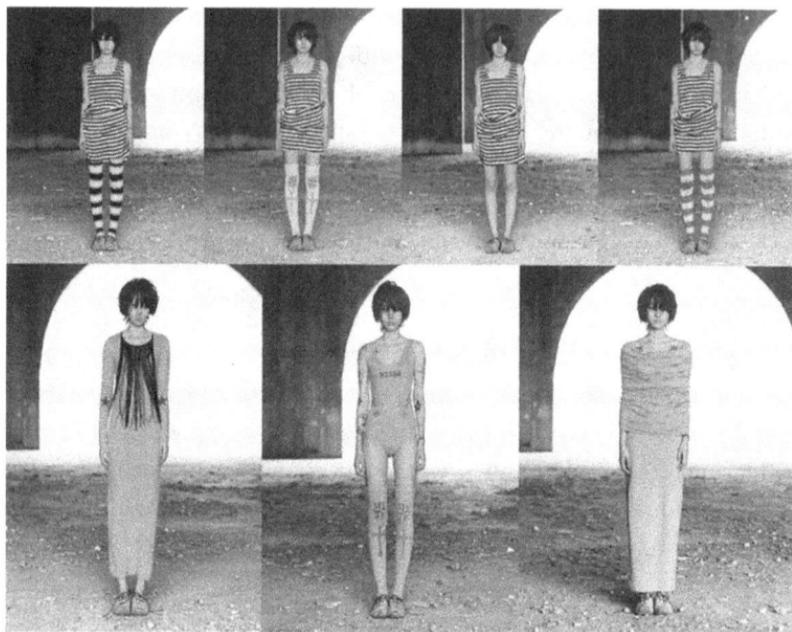

4.2 Vega Zaishi Wang 'Heart of Gold' series in spring/summer 2012. Courtesy of Vega Zaishi Wang.

from films, such as Quentin Tarantino's *Death Proof* and *Paris, Texas* by Wim Wenders, and from Chinese modern art, such as Li Juchuan's experimental documentary, *The Watching/Watched* — a film that addresses Chinese political life, a sensitive subject that some Chinese modern artists dare to explore. Her collections highlight the instantaneousness and ephemeral nature of life.

Like many other designers, Liao opposes the categorisation of fashion designers by geography, as a designer's education, work and consumer base have become globalised. She argues that it should be the label's DNA that differentiates design and designers.[11] CONTENT's DNA is embedded with novel contrasts between fashion and other art forms that are topical and attract fans. Furthermore, when a piece of clothing is consumed, its interactions with the wearer add another layer to the label's image mix. Though the designer has very limited control over how the clothing is worn once sold, the wearer's body image, ways of mixing and matching and living environment all influence the public appearance of the label.[12]

Designer Qiaoqiao contends that Chinese designers are competing with their international colleagues on the same ground in China – in reality perhaps with more constraints and limitations in terms of access to marketing and retailing resources.[13] The familiar story of how Japanese designers, that is, Issey Miyake, Yohji Yamamoto and Rei Kawakubo, revolutionised the Western fashion aesthetic and became leading fashion innovators in the world may not repeat itself with Chinese designers, at least not in the same way. Skov has pointed out that the success of this revolution depended not only upon the innovative Oriental aesthetic created by these three designers at a personal level but also upon a cultural shift in the West that favoured the notion of 'de-centering and fragmentation' as well as Japanese popular culture.[14] The feeling of sensational novelty of their designs can also be attributed to Western unfamiliarity with the Orient at large. Today's fashion worlds are no longer so isolated. In some sense, the relatively free flow of information and sharing of human and material resources at a global level has taken away from Chinese designers taken the opportunity to shock the West with an unfamiliar cultural aesthetic and a sense of otherness.

Chinese designers, although sharing Chinese identity, employ truly diverse approaches to design. As previously discussed, Wang Yiyang imbues his designs with a sense of local relevance with imagery developed out of Chinese styles of urban living. Zheng Yi, Vega Zaishi Wang and Liao Xiaoling skilfully process inspirations from non-fashion fields, either from within China or abroad. Many other designers, such as Ma Ke, Zhang Da, Qiu Hao, Chen Ping and He Yan, excel in conveying a sense of Chineseness or a traditional aesthetic in their works without using any recognisable Chinese visual symbols. Their designs either display a fluid structure that suggests alternative wearing possibilities or are nostalgic in the use of colour palette or ways of preparing raw materials. There are also designers whose works take on an international appearance but with details that are characteristically personalised, such as Jiang Ling, Ye Qian, Zhang Na, Liu Canming, Ou Minjie, Qiaoqiao, Simon Wang and Lu Xuejun.

The label DNA or identity governs the expression and communication of the label at the various points of the supply chain. While the label DNA is visually distinctive in Liao's digital prints, in other cases it

may not be as visually noticeable. Instead, it dictates a designer's whole notion of how design should be approached or consumed. For example, He Yan embraces the idea of slow design and thus only supplies limited editions in each collection. Vega Zaishi Wang uses environmentally friendly fabrics, and Zhang Da uses vegetable dyeing. Designer Zhang Na's 'Reclothing Bank' redesign series promotes the idea of fabric recycling to consumers who prefer eco-friendly and unique fashions. Zhang Na is also engaged in reviving near-extinct craftsmanship in her label Fake Natoo.[15] In these ways, Chinese fashion designers have been experimenting with various possibilities in design.

Retail store

Retail opportunities had been extremely limited for independent Chinese fashion designers, which perhaps partially explains why there had not been a large cohort of them until recently. Traditionally, the only feasible retail channel has been through the department store system, operated as a shop in a shop or as a franchise. Over the past decade or so, designer boutiques have appeared on the horizon. More recently, fashion designers have begun to retail at collective designer shops, which have sprouted up in large cities. One of the forerunners of the designer boutique is Qiu Hao, a Central St Martins graduate, and his partner, Wang Chuqiao (Qiaoqiao). They opened a street shop, ONEBYONE, on Shanghai's Chang Le Road in 2003 and gained immediate media attention and commercial success, with similar designer shops in similar styles opening on the same road on the heels of their success.

Only then did Chinese fashion designers fully embrace the idea of a total store image including retail as a critical component. With a background in interior design from Soochow University, Qiu fashioned his retail space as distinctively sleek and modern in white and light neutral colours with subtle contrasts of different textures. Edgy merchandise is hung on long racks along the walls, leaving the main space open, which provides a luxurious feel. This store layout and interior look entirely different from a typical street store crowded with unlabelled merchandise, and quickly attracted the eyes of trendy consumers walking along the street looking for leftover merchandise originally intended for export.

Because of this congregation of designer boutiques, Chang Le Road became a landmark for original Chinese fashion. Its unique designer culture, grown out of an entirely new retail format, became a hot topic of the Chinese fashion press at the time. This culture highlights the importance of a store design, which expanded the previous singular focus on the product. It also highlighted the newly discovered collective power of designers. Due to the intense competition of designer stores in similar styles, product counterfeits and rising rents, many designers moved away from Change Le Road in 2009.[16] However, the concept of the designer boutique has been widely adopted and a few other nearby streets in Shanghai have become the new homes of designer labels, such as Jin Xian Road, Xin Le Road and Fu Min Road.

Though designer boutiques reflect different label identities, overall they take on a more designed or artistic look than the average store. For example, the interior decor in Wang Yiyang's Zuczug stores depicts a consistently youthful, clean style with brand graphics that are shared by his catalogue, websites and packaging materials (Figure 4.3). His stores predominantly use racks or shelf spaces along the walls, leaving generous aisles or open spaces in the middle – smartly engineered for laid-back traffic – suggesting a sense of exclusivity. This display method, along with the use of wood fixtures and the colour palette of the walls in white or light grey tones, de-emphasises the hierarchy that characterises traditional stores, as Wang stated. And the clothes are hung at a height that is comfortable to reach, which is different from the method of hanging clothes high that intentionally creates a sense of power in a typical store.[17]

Likewise, Zheng Yi thoughtfully orchestrates his store image by collaborating with graphic artists. The works of non-mainstream

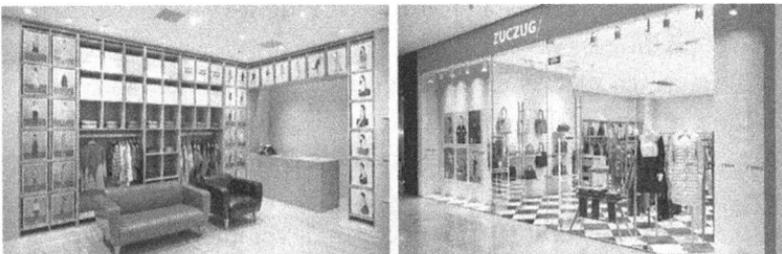

4.3 Zuczug Beijing Sanlitun retail store. Courtesy of Wang Yiyang.

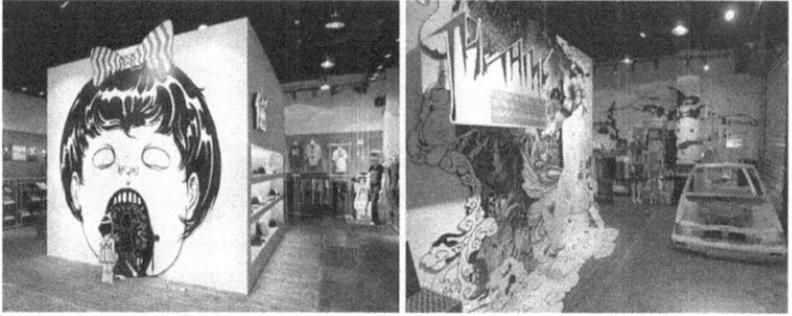

4.4 The entrances of The Thing retail store. Courtesy of Zheng Yi.

illustrators create an atmosphere that fits well with the quirky spirit of his label. Extra large-scale panels that extend nearly from the ceiling to the floor at the store entrances serve as a canvas for artistic creations that mix matched graphics with crafted, three-dimensional constructions (Figure 4.4). He even brought in and hand painted a used car as a display prop in one of his stores, where space was generously allocated for the construction of a store image.

The distinction among fashion designers' store designs appears even more noticeable than their product designs. In a sense, space offers more creative freedom than the body-confined framework of clothing and the effect of the design on space can be more visually compelling because of the scale involved. Vega Zaishi Wang's Beijing boutique is another such space that is uniquely fashioned. She gathered and used antiques as store display fixtures and props, such as wooden boxes, an old sewing machine and bicycle, and Chinese medicine cabinets, with their original yellowed labels with Chinese medicine names attached to each drawer. The clean and bright interior contrasts with the warm and rare display fixtures and props, creating a visually rich, sensory arousing selling space.

The emergence of collective designer shops such as Brand New China (BNC) and Dong Liang further diversified retail options for Chinese fashion designers. BNC is strategically located in the Sanlitun village, where avant-garde art galleries, luxuries fashion labels, high-end restaurants and world-class services and commercial developments congregate. The founder of BNC, Hong Huang – a renowned publisher

and chief executive of iLook magazine and also an influential writer, TV host and celebrity – promoted up-and-coming Chinese fashion designers in her fashion glossy, iLook, and via social media platforms before the opening of BNC in 2010.

With the goal of providing retail space and visibility to fashions created in China, the 540 m² BNC probably houses the largest collection of Chinese designer labels under one roof, commissioning over 150 Chinese fashion designers today.[18] Designed by Yung Ho Chang, an architecture professor at MIT, BNC features an inviting glass façade allowing a view into the store's interior and customised displays. The architectural details of the ceiling were deliberately left unfinished, with all the beams and piping systems painted white, which complements the deconstructionist look of the entire store. The designer clothes are hung one after another on built-in racks along the walls, which are highlighted with track lighting. Designer accessories are displayed on customised wooden tables or mannequins. Though each designer has a different style, pieces of clothing or accessories are not separated into their own departments. The casual feel of the store starkly distinguishes it from structured department stores. However, the challenge for BNC is the way in which various label identities can be effectively communicated to the consumer in a single space.

BNC has attracted a great deal of domestic media interest not only because the business concept of selling isolated Chinese designer labels under one roof was new to China but also because of Hong Huang's personal influence, being a celebrated writer and a social celebrity who comes from a family well-known under Mao's regime. Though this mix of large investment, a prestigious retail location, media attention and Chinese design has yet to turn a profit, it seems to be an appealing means of promoting original Chinese design. Collective designer shops have been rapidly growing and have expanded into second-tier cities in only a few short years.

Dong Liang, another influential collective designer shop, was founded in Beijing in 2009 and opened in Shanghai in 2011. Dong Liang Shanghai is located on Fu Min Road in the same area that other designer shops are located. The building is an old but well-maintained single-family residence of three levels, with over 200 m² in total.[19]

Within the shop each designer occupies a unique spot or room fashioned according to his or her style. This unusual setup offers an ideal space for differentiation among the designers and diverse shopping experiences under one roof. The furniture and plants are carefully selected to serve as display fixtures or props and at the same time to unify the various spaces. Dong Liang's display space extends into a backyard and gazebo, where small-scale promotional events are occasionally hosted. The unusual contrast between designer fashion and an old house may seem odd at first, but in essence it aligns with the approach that many designers employ: that is, to create visually provocative hybridity by merging two seemingly unrelated art forms, objects or concepts.

Increased media attention and consumer demand for home-grown fashion gave birth to a variety of collective designer shops all over the country. Many of these shops adopt an online-to-offline (O2O) business model and integrate their online retail with offline try-on service, fans' activities or entertaining experiences. For example, D2C (Designer to Customer), based in Hangzhou and launched in 2011 as an online retail platform, aims to bring to Chinese consumers selected designers and designer labels around the globe although currently it mainly collaborates with Chinese designers.[20] Not only does it attempt to provide designers with supportive visual, branding and marketing services, D2C also launched many physical stores that encourage experiential shopping.

Besides these relatively large establishments, collective designer shops are also run on a smaller scale by successful designers, such as ONEBYONE, now operated by Qiaoqiao, which sells several designer labels that Qiaoqiao deems China's best, such as Qiu Hao and Masha Ma. As both a store and designer label owner and manager, Qiaoqiao is concerned with the influx of designer labels from abroad that are often backed by a mature fashion system and are favoured by Chinese retailers.[21]

Although profitability has yet to be achieved, both domestic and international investments have continued to make Chinese designer fashion accessible to the marketplace. Mandy Tang, Senior Manager in the Market Development Department at the joint-venture international trade mart Shanghaimart, stated that Shanghaimart started its Fashion Valley project in 2005, attracting outstanding fashion designers to occupy a designated area of 3,000 m^2 within one of its buildings.[22]

Channels for retail have been continually increasing for Chinese fashion designers, thanks to the explosion of e-commerce in China over the past few years. For example, Wang Yiyang had no online retail outlets in 2012 but by 2015 his online stores were in full bloom. His Zuczug online outlet is hosted at Tmall.com (*tianmao*) under the Alibaba Group, China's king of ecommerce. According to the *Wall Street Journal* the Tmall site controls nearly half of China's business-to-consumer online sales and its Taobao virtual bazaar claims a 95-per cent share of China's consumer-to-consumer online sales.[23] Tmall launched a 'Design Cat Flagship Store' on 12 September 2014. With a strategic collaboration agreement with Beijing International Design Week, Tmall plans to integrate online retailing with offline sensory experiences to panoramically promote Chinese fashion design labels.[24] Additionally, BNC's website offers products from over 100 designers, which includes many of the designers we interviewed. In fact, a variety of online retail platforms co-exist to promote designer fashion. For instance, Zhang Na's FAKE NATOO, Ye Qian's Ye's and Wang Yiyang's Zuczug are all selling through elleshop.com.cn.

The current momentum of e-commerce in China is similar to the momentum of designer labels in the late 1990s and early 2000s, when sales really soared. For example, designer Lu Xuejun's LEVU'SU, which launched in 1998 and has gained notable market success operating nearly 300 stores nationwide, started its own website mainly to dispose of warehouse stock. But by 2013 new products began to be exclusively developed for its online store as sales growth became promising. For instance, its single day online sales on 11 November 2014 reached 30 million renminbi (RMB) (approx. US$4.8 million).[25] LEVU'SU's large quantity of styles in each season is advantageous in maintaining an attractive price. Furthermore, the comparatively long history of the label ensures a level of comfort for consumers to purchase online without trying items on. Designer labels with a cult following that are cultivated through traditional retail seem to also do well online.

Service

Service is critical in small designer boutiques as the quality of human interaction can change the overall impression of one's shopping experience. A keen shopper with an educated fashion sense may be able

to spot the thoughtful details hidden in the pleats or linings of garments, but the average affluent consumer, even with adequate experience of consuming designer fashion, may still rely on the sales associate to appreciate a new design twist and the label story, or for styling ideas. Most designers train their sales staff so that they can act as effective fashion communicators and persuaders on the selling floor. However, more personal connections or intimate relationships with consumers depend upon more extensive investments and the personality or will of the designer.

When operated on a small scale, the customers of a designer label sometimes become friends of the designer. Designer Chen Ping, who produces high-end womenswear in small quantities in her studio, became close friends with many of her customers.[26] With customers like these, designers can get first-hand feedback and services can be customised to individual needs. However, designers who agree to make fitting modifications usually draw a clear line between fitting and style modifications and consider the latter to be in the realm of services provided by tailors.

Although services are provided at the basic level, designer boutiques or collective shops generally lack a systematic approach to provide value-added services both during and after purchase. Donghua University Professor Bian Xiangyang,[27] also a renowned fashion critic, attributes the lack of attention to service to the fact that 'things can be sold very easily in China'. He is concerned that service could be a limiting factor in the further maturation of designer labels. 'The one-child generation does not know how to serve others', he warns. Customer service is a lost tradition in the Shanghai apparel industry, which, between 1949 and 1979, used to be able to provide individualised services based on customer's needs.[28]

Designer Liu Canming,[29] also a professor at Donghua University, agrees with Bian that satisfactory service is generally lacking at designer shops. He states that many designer stores set out to create the atmosphere of an international luxury label with a fraction of the budget that those labels allocate for store environments and services. He argues that the kind of service that Chinese fashion designers can provide is also constrained by the designer's own experiences of services elsewhere and lifestyle, that is, knowledge about service. Liu urges the study and

development of a methodology that focuses on systematic and scientific research on the topic of service environment. Liu indicates that a few Chinese fashion labels excel in service, such as Yaying, a popular fashion label based in Zhejiang province, with approximately 240 stores around China.[30] According to Liu, Yaying diligently maintains its VIP system and pays attention to detail when interacting with customers. They even send out handwritten birthday cards to loyal customers.

Another critical aspect of service is the store's return and exchange policy and how that policy is implemented. Product return after purchase has been a struggle between the consumer and fashion retailers in China. But Tmall courageously implements a return and exchange policy that allows the consumer to return or exchange a product for any reason within seven days for a full refund. The Zuczug Outlet on Tmall even promises to pay for shipping if the return and exchange is due to quality defects or inaccurate descriptions on its website. Thus, e-commerce has been a catalyst for service improvements in the industry.

As most small merchants on Tmall's Taobao rely heavily on securing positive feedback from their customers, they meticulously maintain their level of customer service, down to their use of endearing language, calling each of their customers 'qin' (darling). They are also responsive to consumer needs or complaints. This service culture has now permeated other online platforms, including those used by Chinese fashion designers. Burgeoning business models that stem from internet innovations are opening doors to new forms of service, though their effects are yet to show.

Promotion

Most Chinese fashion designers take a reactive instead of a proactive approach to promotion. Designer and Professor Liu Canming considered self-promotion the weakest suit of Chinese fashion designers.[31] The few promotional activities that Chinese fashion designers typically engage in are fashion shows, interviews with the fashion media and overseas academics, cultural exchanges and exhibitions. Their labels may also provide fan activities and in-store or online sales promotions. None of the designers seems to invest in any form of offline advertising on TV or in print or outdoor media. More established designers, such as Wang

Yiyang and Zhang Da, are selective in their media exposure and, to some extent, tend to avoid such exposure so that they can focus their time and effort on the products and consumers in their stores, which they find most effective. Sometimes designers are even reluctant to organise or participate in fashion shows in China as they consider those merely for showing instead of selling, given that the audiences are mainly composed of bureaucratic leaders, media professionals, fellow designers, design students and casual onlookers.

Nevertheless, fashion shows remain a major platform for Chinese fashion designers to launch new collections and communicate their aesthetic and design capabilities. For example, Shanghai Fashion Week (SFW), initiated by the Shanghai Municipal Government and the SFW Organising Committee since 2003, provides a highly visible platform for local designers to attract media attention, though it is often criticised for failing to attract international buyers. The majority of the 15 interviewed designers have participated in SFW. In 2013, SFW, along with the Shanghai Fashion Designer Association, launched a 'Design by Shanghai' programme during London Fashion Week (LFW) to promote young Chinese fashion design talent to international buyers and consumers.

Though governmental support is rarely geared towards supporting any individual, it is in many ways used to build platforms that aim to promote Chinese design on a large or global scale.[32] Another government-supported multi-entity, the Shanghai International Fashion Federation, organised the first Shanghai New Couture Week, 10–16 April 2015, which is an important part of the city development plan. New Couture Week is also supported by the Shanghai Promotion Centre of Design, whose goal is to aid the establishment of Shanghai as a world centre for design and creativity, which is in line with the central government's call for an economic transformation from a labour-centred, industrialised and environmentally unsustainable economy to one driven by service, creativity and personnel. Besides governmental support, fashion foundations and collective designer shops and showrooms are also strong forces in discovering and showcasing China's future fashion shapers. For example, in 2015 the fashion foundation Crossover East brought four independent Chinese fashion designers directly from China to London Fashion Week to

present their collections, after its previous participation with London-based Chinese fashion designers.[33]

Domestically, fashion shows organised by independent designers have taken on a completely novel look and no longer feature the familiar aloof faces of professional models. Many designers, including He Yan, Zheng Yi, Wang Yiyang and Zhang Da, prefer to use friends or ordinary consumers to walk down the runway in natural poses and with natural facial expressions. The locations of the shows also seem to be intentionally obscure, using bars, deserted factories, old houses or concert halls. Breaking the long-established formality of a runway show seems to be a courageous, clever move. Besides significantly cutting down the cost, the inevitable uncertainty associated with using non-professionals to present a new collection in unconventional spaces brings excitement and freshness to the audience. Anything is possible with a show of this kind: unexpected, bold ideas or someone breaking a leg in those fashionable high heels in an unusual runway space.

Despite the fact that fashion shows bring little direct financial reward, He Yan is one of the few who persistently produces them. She treats the show as a venue for self-expression and building friendships.[34] Being somewhat detached from a direct financial goal, that is, orders from buyers, the art quality of He Yan's show seems to stand out, which is perhaps what won her contracts with Dong Liang and BNC. At He Yan's 2014 autumn/winter show, a collaboration with a modern dance troupe for Shanghai Fashion Week, dancers clad in her latest creations danced across the stage and even laid down on the runway. As in the West, fashion shows have slowly become is a hybrid event, merging with performance art or other art forms, bordering on entertainment.

Experimentation with the format and venue of a fashion show can make the details of the show topical and is just as important in artistic value as the clothes. For example, CONTENT designer Liao Xiaoling works with different artists to enrich the content and presentation of every collection. Her 2014 spring/summer fashion show, entitled 'Integrated Machine', simultaneously kicked off a multimedia art exhibit that encompassed background motion pictures and music for the show produced by a renowned artist, Qiu An Xiong. Being a former architect, Liao deeply values the intellectual stimulation from interdisciplinary

collaboration and the beauty of merging art forms into a holistic visual experience. The runway has gone far beyond merely functioning as a path on which to display clothes, to a stage with deliberately orchestrated theatrical effects that are meant to provide the audience with a multisensory experience. This in turn establishes a multi-dimensional and memorable brand image.

As a critical venue to connect designers with buyers and other fashion distributors – extending the previously widely-criticised, merely promotional function of fashion shows – designer showrooms have mushroomed over the past few years in China. Many of these showrooms accompany major fashion weeks, though a few are operated year-round. As a showroom pioneer in China, the Fashion In Life (*faxinshichang*) organisation collaborates with both the France Haute Couture Association and the China National Garment Association, and focuses on creating promotional and retail platforms for Chinese design. Its 'China in Paris Showroom' brings fashion collections and modern artworks from China to international buyers. According to *Women's Wear Daily*, the 'China In Paris Showroom' 'attracted a wealth of retailers including Macy's, Bloomingdale's and Opening Ceremony'.[35]

However, it was not until 2014 that a new breed of showroom began to attract the attention of China's key industry leaders, bringing new players of varied size and style to the fashion market, including the Danube Fashion Office (DFO), headquartered in Budapest, Hungary.[36] DFO represented 40 contemporary designer labels from all over the world during Shanghai Fashion Week. While companies like DFO, Via Della Seta (VDS), and ProjectCrossover tend to focus on introducing foreign designer brands to the Chinese market, China's leading designer consortiums, such as Ontimeshow and Showroom Shanghai, attract designer labels from both within and abroad.[37] The market demand for designer fashion has been astounding. According to Ian Lin, a cofounder of Showroom Shanghai, with no offline advertising the number of participating brands in the 2015 spring/summer season tripled compared to the previous season, with an estimated total sales reaching somewhere between US$12.5 and US$14.7 million for Showroom Shanghai, which was also triple the sales of the previous season.[38]

Although many of these promotional concepts are still in an experimental stage in China, they greatly diversify promotional and retail choices for Chinese fashion designers. Extremely popular online social networking platforms, such as Sina Weibo (the Chinese version of Twitter) and WeChat (a popular mobile texting, calling and photo sharing application), with the largest user base in China, play a critical role in brand promotion and communication for all fashion players, ranging from international multi-branded showrooms to small single-label operations. As promotion costs on large retail platforms such as Taobao – which can account for 20 per cent of the retail price – creep up,[39] in order to be financially viable, it becomes imperative that designers find their own sustainable methods to promote their labels and design philosophies. One exemplary case is how crowdsourcing has been localised by Chinese fashion designers. For instance, Zuczug's nostalgic sounding Photo Studio (*zhaoxiang guan*) features photos submitted by fans dressed in Zuczug travelling around the world. Many designers use Weibo and WeChat on a nearly daily basis to communicate with and create fans. These social networking sites seem to be highly effective, as they are where Chinese consumers actually spend their spare time.

CONCLUSION

Collaborations with artists on merchandising, design of retail environments and promotions are used as an effective strategy by some Chinese fashion designers to introduce fresh ideas and looks and to inject a sense of uniqueness into their label offerings. But many more still rely on their own contemplation and interpretations of a wide variety of inspirations from both within and outside China. Despite the challenges involved in operating a designer label in securing investment, team building, marketing and retailing, a large number of young Chinese fashion designers are devoted to developing their own labels that cater to a changing consumer in China. The Chinese consumer's taste for fashion has gradually shifted from a binary market that mainly consisted of luxury and mass productions to a market that includes local creations that can provide a seemingly distinctive, authentic Chinese identity.

What matters to the new consumer is the authenticity embodied in a recognisable style – mostly within a somewhat narrow circle, or reflected on the chief designer's Chinese identity; what does not seem to matter is the process of identity construction or origins of design inspiration. This mindset frees Chinese designers to borrow inspirations from other art forms or cultures or hire foreign professionals, such as photographers, models or marketers, to construct a desired brand identity that is claimed to be Chinese. The construction of a Chinese identity is, in today's reality, inseparable from global influence and the integration of global fabrics, visual materials or workforce as China today is internationalised in every aspect of fashion creation, communication and consumption. Meanwhile, local success may gain global visibility as the Chinese market is so deeply permeated with global media, players and consumers. The mindset that thinks Chinese designers need recognition from Paris, New York or London already sounds outdated to Chinese design leaders. With its unfathomable potential, the Chinese market alone can legitimise and publicise the creativity of Chinese fashion designers domestically. However, Chinese designers' pervasive global influence may only surface when China becomes more influential politically and culturally, not just economically.

Because designers have such diverse backgrounds and multiple approaches to design and retail, it becomes unrealistic to try to attribute a collective identity to them. They may share aesthetic and consumption values with different Chinese consumer cohorts but less so with each other. Chinese consumers' interpretations of what is fashionable and what is not become an important factor that shapes designer fashion in China as the influence of elite fashion culture and its affiliated fashion media is clearly on the wane.

Since the Chinese fashion industry is internationally integrated on a large scale, designers' ability to discover or create local relevance for their labels becomes critical to a distinguishable identity. The fashionability and market acceptance of designers' themed series are largely determined by whether the themes resonate with the nuances in consumer cohorts' styles of life. To do so, many designers consciously maintain a distance from collections presented at international fashion weeks when searching for design inspirations. The new edge of Chinese

design seems to lie in the mundane scenery of neighbourhood streets, roads, anti-mainstream films or music, and cross-disciplinary integrations of art forms. This edge coincides with the mood of a society that is in constant search for outlets for democratised self-expression and ways to mock the established elite culture.

The e-commerce boom ushered in a new period, massively transforming and accelerating Chinese fashion production, distribution and consumption. On the one hand, intensified competition is brought about by an influx of international designer labels that have a similar anti-mainstream appeal. These international designer labels, supported by more mature fashion systems, especially in brand identity development and marketing, to some extent, force Chinese fashion designers to compete on the same level, to create differentiable new styles at demanding speed. As sharing information online becomes easy, any direct copying of someone else's design can be quickly spotted; a distinguishable visual identity is no longer a preferred asset but a necessity for the survival of a designer label. Thus, on the one hand, authenticity in a pure sense no longer exists; on the other, authentic creations with local relevance become the new market essential.

The nascent consumer-centric e-service culture in China also has had a profound influence on how fashion is presented and sold, not only on e-platforms but also in fashion boutiques, collective designer shops and showrooms. Attention to detail, generous return and exchange policies and effective management of consumer inquiries and feedback are all key to developing a rewarding relationship with consumers. Personalised relations or friendships, consumers' desire for artistic self-presentation or their pure appreciation or admiration of a designer's work can be the foundation for a cult following, which justifies the premium price charged by designer labels.

NOTES

1 Personal communication with Zhang Zhaoda, Vice Chairman of China Fashion Designers Association and Chairman of Asia Fashion Federation, July 2012.

2 The designers interviewed included Chen Ping [陈平] (Label: Pari Chen), He Yan [何艳] (Label: He Yan), Jiang Ling [蒋翎] (Label: May J.), Liao Xiaoling [廖晓玲] (Label: Content), Liu Canming [刘灿明] (Labels: ZIGE; CM·Loose), Lu

Xuejun [卢学军] (Label: LEVU'SU), Ou Minjie [欧敏捷] (Label: Ricostru), Wang Chuqiao [王楚翘] (Label: Neither Nor), Wang Qingfeng [王庆峰] (Label: Simon Wang), Wang Yiyang [王一扬] (Labels: Zuczug; Cha Gang), Wang Zaishi [王在实] (Label: Vega Zaishi Wang), Ye Qian [叶谦] (Label: Ye's), Zhang Da [张达] (Label: Boundless), Zhang Na [张娜] (Label: Fake Natoo), and Zheng Yi [郑一] (Label: The Thing).

3 Telephone interview with author, May 2015.

4 Linda Welters and Arthur C. Mead, 'The future of Chinese fashion', *Fashion Practice: The Journal of Design, Creative Process and the Fashion* 4/1 (2012), pp. 13–40, p. 37.

5 Barry J. Davies and Philippa Ward, 'Exploring the connections between visual merchandising and retail branding: an application of facet theory', *International Journal of Retail and Distribution Management* 33/7 (2005), pp. 505–13.

6 Interview with Wang Yiyang, July 2012.

7 Laurie Burkitt, 'What China's trendsetters are wearing', *The Wall Street Journal*, 14 November 2012. Available at http://online.wsj.com/article/SB10001424127 8873245563045781188913372840 14.html (accessed 15 July 2015).

8 Interview with Zheng Yi, July 2012.

9 Interview with Wang Yiyang, July 2012.

10 Interview with Vega Zaishi Wang, July 2012.

11 Interview with Liao Xiaoling, July 2012.

12 Marilyn R. DeLong, *The Way We Look: Dress and Aesthetics* (New York: Fairchild Publications, 1998).

13 Interview with Qiaoqiao, July 2012.

14 Lise Skov, 'Fashion-nation: a Japanese globalization experience and a Hong Kong dilemma', in Sandra Niessen, Ann Marie Leshkowich and Carla Jones (eds), *Re-Orienting Fashion: The Globalization of Asian Dress* (Oxford: Berg, 2003), pp. 215–42, p. 219.

15 Interview with Zhang Na, July 2012.

16 Interview with Qiaoqiao, July 2012.

17 Interview with Wang Yiyang, July 2012.

18 BNC official website, http://www.brandnewchina.cn.

19 Dong Liang's official website, http://www.dongliangchina.com.

20 D2C's official website, http://www.d2cmall.com.

21 Interview with Qiaoqiao, July 2012.

22 Interview with Many Tang, June 2015.

23 Kathy Chu, 'Alibaba's Tmall global site stumbles', *The Wall Street Journal*, 22 December 2014. Available at http://www.wsj.com/articles/alibabas-tmall-global-site-stumbles-1419274439 (accessed 15 July 2015).

24 Yi Li, 'The collaborative Design Cat between Beijing International Design Week and Tmall', *China News* website, 5 May 2014. Available at http://finance.chinanews.com/it/2014/05-05/6135350.shtml (accessed 28 October 2017).

25 Interview with Yang Shu, LEVE'SU co-owner, June 2015. Use of currency exchange rate of US$1=6.26361 RMB on 29 June 2015. XE currency converter. Available at http://www.xe.com/currencyconverter/.

26 Interview with Chen Ping, July 2012.

27 Interview in June 2015.

28 Interview with Bian Xiangyang, June 2015.

29 Ibid.

30 See Yaying's official website, http://www.elegant-prosper.com/.

31 Interview with Liu Canming, June 2015.

32 Interview with Mandy Tang, June 2015.

33 Crossover East's official website, http://www.projectcrossover.com/aboutus/.

34 Interview with He Yan, July 2012.

35 Alex Wynne, 'China in Paris resonates with buyers', *Women's Wear Daily*, 28 September 2014. Available at http://wwd.com/fashion-news/fashion-scoops/china-in-paris-resonates-with-buyers-7954243/ (accessed 15 July 2015).

36 Aroma Xie, 'In China, showrooms blossom', *Business of Fashion*, 19 January 2015. Available at http://www.businessoffashion.com/articles/global-currents/showrooms-blossom-china (accessed 15 July 2015).

37 Ibid.

38 Ibid.

39 Interview with Bian Xiangyang, June 2015.

5

'CREATIVE ECONOMY' IN CHINA: A CASE STUDY OF SHANGHAI'S FASHION INDUSTRIES

Xin Gu

INTRODUCTION

The narrative of 'creative economy' can be found in much of the literature about 'culture-led urban regeneration' and 'post-industrial' cities. Central to its narrative have been claims for the role of the 'cultural' or 'creative industries' as replacements for traditional manufacturing. In fact, the opposition between the new 'ideas-driven', 'weightless', intangible economy and the utilitarian, material-driven manufacture of the past has been a defining feature of creative industries narratives. According to this, from the 1980s European and North American cities moved forward to a new developmental stage by replacing manufacture with finance, insurance and real estate (FIRE), cultural and creative industries, and tourism.[1] Henceforth, developed economies would produce 'creative'- or 'knowledge'-intensive services and developing countries would provide outsourced manufacturing along global supply chains.[2]

Another key aspect of the cultural/creative economy narrative is the notion of 'reflexive modernisation'. Scott Lash and John Urry, for example, considered the cultural industries as a 'cutting edge' case of

reflexive modernisation, as creativity becomes dispersed across a complex configuration of reflexive micro-businesses and individuals.[3] In particular, this reflexivity was as much aesthetic as rational in content. The combination of culture and business has been held to be central to the way in which cultural industries operate. For some – in particular McRobbie and Wittel[4] – these two logics can be seen not as happy partners but as one dominating the other. The business logic of the cultural industry has undermined the cultural dimension. They point to the imperative of profit trying to impose itself on 'creatives' through new forms of management, labour discipline and technology. The demands of the modern fragmented freelance cultural economy lead, in this view, to self-exploitation.[5]

Can we understand the emergence of Chinese cultural economy through these two frameworks developed from the West? To answer this question, we need to first understand how the Chinese government adopted the creative industries as part of its attempt to move up the value chain from manufacture to other forms of high-value-added economic activity. This was a process of catch-up with which China had been familiar since the late nineteenth century. In this latest round many Western theorists saw immense barriers to its ability to do so, as exemplified by Will Hutton's The Writing on the Wall.[6] He argued that China could never catch up with the West in these cultural/creative areas because it lacked 'enlightenment values'. These values were fundamental to the establishment of democratic states allowing the free circulation of knowledge, the emergence of self-reflexive individuals, and a public sphere balancing the power of the state. Therefore, Hutton announced that China can be very good at 'copying' ideas from the West, but it can never develop an advanced knowledge economy as in the 'creative industries'. Such an emphasis on 'culture' as reflexive individuation embedded in the Western development history does not allow for an alternative framework for a Chinese cultural economy coming from a quite different social-economic, cultural and political trajectory. More directly, it does not take into account the persistence of an extensive manufacturing economy juxtaposed to an emergent 'creative sector'. In the Chinese fashion industry, the link between 'creative services' and manufacturing is still in place, unlike in the West. Seeking these out has been a growing preoccupation as fashion entrepreneurs look to develop

niche products but also to link their creativity to China's strong manufacturing bases.

Many have suggested that the creative industries are crucial if China is to move up the value chain from 'Made in China' to 'created in China'.[7] These writers tend to focus on 'innovation' rather than 'cultural' values. Such thinking was inherited from a policy anxiety in post-industrial cities in the West where the decline of labour-intensive manufacturing industry has left a significant vacuum in these cities.[8] They become advocates for the economic potential of a knowledge-intensive industry. DCMS's mapping document was the first to link creativity with wider economic development and urban regeneration agendas, and many cities followed by developing their own creative industries, creative cities narrative.[9] In Asia, Hong Kong was among the first to pick up the idea, followed closely by other Asian countries.[10] Shanghai was at the forefront of the adoption of creative industries in Mainland China.[11]

Scholars both in the West and in China were critical of such an emphasis on creativity as a primarily economic output. Chinese scholar Jing Wang questioned 'how far creative industries can travel' in a country lacking real social and cultural democratic transformation.[12] Huang's analysis of the government's focus on big business whilst ignoring the small entrepreneurs provided a useful insight into how creative industries were promoted in China.[13] As Justin O'Connor argued, China has promoted the large-scale creative industries that, in Western writing at least, have been seen as the last innovative sector of that economy.[14] The support for large-scale industry is not just about suppressing free expression and autonomy; it also freezes out the small enterprises and their associated networks, thus reducing innovation.[15] It might just be naive wishful thinking for China to move up the value chain if its cultural workers are treated not that much differently to those working in the new media factories growing in China and elsewhere in Asia.[16] This makes Florida's creative class theory unthinkable in the Chinese context.[17] Although in Shanghai the creative economy agenda has been used to boost its image as a globalised modern city, unlike Florida's emphasis on 'bohemianism' embedded in urban cultural milieu, the Chinese approach was a systematic grouping together of cultural workers in bounded 'creative clusters'. But without the knowledge essential to manage these kinds of industry networks, questions have arisen as to

whether the government's promotion of these creative clusters has been successful.[18]

In this chapter, I use the fashion industry in Shanghai as a way to explore some of the themes outlined above. In particular, I use Allen Scott's concept of the 'creative field' to describe the creative 'infrastructure' or 'ecosystem' within which contemporary creative production takes place.[19] In the case of fashion, the 'materialisation' of the product is only one segment of the creative process alongside the production of a range of other cultural aspirations, activities and industries. This notion of creative infrastructure or ecosystem is key in the Western cultural industries understanding of how innovation takes place. It is in this context that fashion clusters need to be understood. They are about business knowledge but they are also about the protection of the cultural self.[20] Fashion clusters have become a key strategy in supporting the 'soft' infrastructure for the industry. But for such a strategy to succeed, it is crucial to understand that their inter-business relationships are not to be reduced to instrumentalised 'networking' but involve a range of non-instrumental social values and embedded aesthetic meanings. This becomes particularly challenging for policy support as the Shanghai case study demonstrates.

The local Shanghai government's support focuses on the notion of 'creative clusters' and how fashion as a creative industry sub-sector can contribute to the global cosmopolitan image of Shanghai. This has resulted in policy makers attempting to support the creative sector as businesses whilst ignoring the 'soft infrastructure' (social and cultural connections) that have the potential for these industries to link more effectively with other high-value service sectors. To contrast with this top-down policy, I use two small case studies of Shanghai-based fashion designers to reflect on the working practices of local designers caught between a highly competitive market and state control. Fashion designers began to see a unique opportunity to position themselves as the 'cultural intermediary' between state and market in an immature fashion economy. However, I argue that often leads to designers having an uncritical relationship with this market. These cases will provide insight into the contradictions or frictions between cultural and economic development. That is, the lack of distinct aesthetic or cultural values outside the market logic has meant that, increasingly, the identity of local

fashion designers is dependent on market success only. I explore some of the consequences this brings.

This chapter is based on a three-year Australian Research Council Linkage Project (2010–13) investigating creative clusters in Australia and China. Qualitative interviews (15) with fashion designers, cluster managers, manufacturers and other maker businesses, including fabric suppliers, pattern cutters, stylists, machine operators and tailors, during 2010–13 have informed this chapter. Other evidence, including spatial mapping of clusters and photographs recorded during the site visits, has contributed to its findings.

FASHION AS 'CREATIVE ECONOMY' IN SHANGHAI

The fashion industry has never completely conformed to the models or periodisation of Fordism or post-Fordism. Although there are variations in different contexts, what essentially sets fashion apart from the orthodox economic model is the fact that fashion is not only about innovation and creativity but also the speed of these innovations.[21] Though the decline of the textile industry in the West has been commonly called 'de-industrialisation', the increased separation of in-house design from outsourced manufacture, described as 'flexible specialisation', did not entail the end of mass production. It was simply reorganised, through new technologies of information and logistics coupled with new global trade laws, into a new international division of labour.[22] In light of this, the re-structuralisation of the Chinese textile and apparel industry in recent years is not hard to understand. The decline of export figures, rising labour cost and increasing competition from cheaper labour countries in China's immediate Asian neighbourhood have necessarily led to a more stringent push towards high-value-added production and expanding domestic consumption.[23]

Despite Shanghai's history as China's largest textile and garment manufacturing city, its manufacturing industry has witnessed a significant decline since the 1990s, when it was shifted to cheaper labour locations in nearby Zhejiang and Jiangsu provinces.[24] In its place, the intention was to build 'creative clusters' with a focus on the core, value-added creative services. Shanghai's textile and garment manufacturing industry

witnessed a rapid emptying out of traditional industries from the inner city to the urban fringe. However, as has been noted by writers in a range of different creative sectors, creative industries do not just innovate by the co-location of their 'creative core' but also through that of 'material' services (including technical knowledge of logistics and material sourcing). In the field of fashion, innovation is closely related to (and dependent on) traditional making sectors.[25] The lack of connection to manufacturing could seriously hamper designers' ability to innovate. Crucially, the connections between designing and making in these sectors are not merely economic transactions but are embedded in a local socio-cultural context. This has been a key claim of the 'cultural economy' tradition in the West[26] but was increasingly played down by the one-dimensional emphasis on creative inputs and economic outputs in China.[27]

As in the West, the rise of the 'creative industries' narrative provided an opportunity for a career in which self-expression and economic independence could be achieved together.[28] The rise in the social status of the independent fashion designer in Shanghai attracted many aspirants who had limited connections with either the global fashion network or the local supply chains. The contemporary fashion sector emerged from a declining textile city, but their relationship to this sector was limited.[29] The current policy setting at municipal and local district levels in Shanghai tends towards a deliberate separation of creative and manufacturing aspects. For Shanghai, becoming a cosmopolitan city meant relocating economically vibrant (but 'dirty and unsightly') manufacturing further inland, leaving a service-sector oriented Central Business District (CBD) marked by a 'disembodied' creativity.[30]

The special feature of 'creative field'[31] is the social networks that creative people develop with others who share the same values and identities, especially the importance of social and cultural values in doing businesses as central to the creative character of their work. In the West this sets it at a distance from 'high street' design and the traditional textile sector. As we will see from the case study below, this 'soft infrastructure', essential for the development of a creative field, was largely missing in Shanghai. This has consequences for the sustainability of the independent fashion sector as it faces increasing local and global competition.

The formal fashion courses out of which many local fashion designers emerged were more akin to the art school tradition than an industrial training programme.[32] This had consequences for their business and technical skills, but it also underlined the difference between their aspirations to high fashion design and the local textile industry's focus on cheap, mass-produced mainstream fashion. Despite the fact that designers in Shanghai are immersed in a complex field of global and local fashion ideas, they have limited access to these local, highly organised production services favouring foreign direct investment (FDI) fashion companies. Most will have to seek out manufacturers and suppliers outside of Shanghai.

Fashion scholar Wessie Ling argued that 'homegrown fashion' can be crucial in contributing to local cultural identity in place like Hong Kong where fashion consumption and production were largely dominated by global fashion industry.[33] Segre Reinach echoed this view by suggesting that the major setback for the revival of local Chinese fashion industry is a combination of conflicting conditions inherited by post-colonial and post-socialist societies.[34] Fashion designers in Shanghai are highly business-oriented and the projection of the cultural self in this context is through their ability to intermediate between the cultural and business worlds. The validation of market success works as way of enhancing their creative knowledge — knowing what works and what sells — but it is also the only space within which their 'culturalised self' is able to operate and expand. However, without alternative value systems, spaces and values of creativity not directly coupled with market, their pursuit of innovation and creativity can only rely on the instrumental values of chasing profit.

Pierre Bourdieu used the term 'restricted production' as a way to explain the operation of a cultural or artistic field as a rejection of 'the market' and an elaboration of 'pure art'.[35] In the 'independent' sector in the West, designers' wish to distinguish themselves *qua* designers from the local industry manufacturers, textile suppliers, wholesalers and their distrust of the high street and the 'mainstream' fashion are exemplars of this view. There are parallels in Chinese fashion designers' attempts to deal with the 'Made in China' label, signifying 'low quality', by focusing on high-quality craftsmanship and high-quality materials suppliers that may nevertheless put them in a very insecure economic situation.

Looking at many of Shanghai's fashion designers it can seem that they are attempting commercial success on their own terms. But we have to

remind ourselves that they work within a 'field' in which economic reward is often the sole criterion of success and respect. The excitement and glamour of the 'creative field' play their part, obviously, but the lack of a clear sense of a 'scene', an alternative field, in which their identities can be justified other than through the market, means that their aesthetic/cultural ambitions are rapidly scaled down in times of economic difficulties. There is no source of pleasure, respect and identity other than that of businesses success.

This idea of a 'scene' or field has often been projected onto a city in the form of a wider creative milieu. Like the fashion scene centred around the notion of 'Madchester' in 1980s England,[36] the fashion industry in Shanghai has clearly co-evolved with the city's ambitions to become a preeminent global city. From the first modern fashion icon of the 1930s cheongsam and qipao, to Shanghai Tang's contemporary global stardom, there is a sense in which the promotion of the city and the fashion's economic success go hand in hand – an instrumental relationship promoted through 'urban boosterism' and growth coalitions. The local fashion industry clearly benefits from the economic advantage this brand of 'Shanghai modern' would bring. In the West, it is commonly acknowledged that creative spaces are not simply 'business parks' in which entrepreneurs do their work; these are also cultural spaces that contribute to the identifiable local character of the product. These socio-cultural benefits have been called 'untraded interdependencies' or even 'public goods'.[37] This has evolved very differently in China, where the separation between public goods (under the categorisation of cultural affairs) and economic goods (creative industries) was clearly marked.[38] Since as early as 2000, the Shanghai municipal government has invested in the development of fashion clusters in order to exploit the economic potential of the fashion industry. Such developments, as with the explosion of such creative clusters after 2005, were conceived as purely business ventures with no connection to the wider cultural system of the city. There are different views as to the success of these clusters. Some argue that the proliferation of these fed into the burgeoning images of Shanghai as a global cultural city and helped to launch the city's global status,[39] while others question how sustainable this strategy is and, most importantly, to what extent can we assess its contribution to the development of local creative industries such as fashion.[40]

In order to answer this question, I first examine the development of fashion-related creative clusters in Shanghai. This reveals a creative-led urban regeneration strategy incorporating a mixed agenda of promoting 'creativity' and economic outputs. This provides the context within which we can start to understand why a business like Zuczug has tried to pursue market success, for there is no alternative value system in which to provide space for a relative autonomy of creativity vis-à-vis the economy. Despite Zuczug's market success, the lack of creative recognition has set its designer Wang Yi Yang apart from internationally renowned fashion designers. This lack of creative space was further underlined when newly established designers such as Cai He struggled to survive in the market place. Cai's case proved that there is limited space for creativity to act as a yardstick for success amongst local fashion designers. I conclude by identifying new directions in the development of the cultural/creative economy in Shanghai, which might be very different to that of the Western narrative.

FASHION CREATIVE CLUSTERS

Shanghai – the 'head of the dragon' – has mobilised the creative industries in a state-instigated process of de-industrialisation and urban regeneration across the Yangtze Delta region. As mentioned before, in China the creative industries agenda tended to be interpreted not as a development of the culture but as part of a wider innovation strategy.[41] The term fed into a post-WTO (World Trade Organization) interest in intellectual property (IP) and in high value-added, 'ideas-driven' production. Worried by the absence of major Chinese brands despite their pre-eminence in manufacture, moving up the value chain – 'from Made in China to created in China', as the slogan had it – was a key concern.[42]

Creative clusters provided a pragmatic solution to the problem. The term evolved from Michael Porter's model of industrial clusters focusing on embedded knowledge exchange.[43] It was combined with European and North American notions of 'organic' creative quarters, such as SoHo in New York, Wicker Park in Chicago or Soho in London. Though the Shanghai government has attempted to invoke this organic urban creative milieu, it was, from the beginning, linked to a real estate project involving

the re-use of old buildings for high-rental service sector business in Shanghai's highly charged real estate market.

Shangjie, or 'Loft', was established as a fashion cluster for the local industry, located in the former 'Three Gun' Clothing Factory Southwest of Shanghai. It occupies $41,000 \text{ m}^2$ and was managed by Shanghai Textile Co. Ltd – a state-owned enterprise. Since its opening as a fashion cluster in 2010, Loft has hosted many high-profile industry events, including the launch of an incubator-style retail space for young designers. It also hosted the launch of the Enjoy Young brand, a label designed exclusively by local emerging designers. The management company had an ambitious plan of promoting young designers by sponsoring them through Shanghai Fashion Week and other promotional events. However, these initiatives are often dominated by local government, who have limited connections with the industry and little knowledge about how fashion works. Since its launch in 2008, Enjoy Young has remained a less-than-successful brand. Few designers offered a space within the Loft space managed to sustain themselves, due to the high rent and lack of industry connections. After a brief encounter with the independents, Loft turned its eyes towards more established labels. The manager blamed young designers for their inability to cope with market pressure. At the same time important doubts have been raised as to the capacity of 'creativity' to grow in isolation from related industries and skills – ranging from bespoke material supplies to large-scale manufacture. But this second aspect was unpopular amongst those policy makers promoting creative industries as service sector replacements for manufacture.

800 Show is one of a handful of creative clusters aimed at attracting FDI. Profiled as a fashion cluster, it was Huangpu district government's star project in promoting local fashion industries. Being in the CBD, 800 Show was conveniently located from a retail point of view. Unlike Loft, 800 Show was not interested in attracting local firms. Their target was foreign fashion retail companies. On my last visit, they had secured leases with H&M and Zara, with an agreement for reduced rent and a significant tax incentive. All the amenities are designed exclusively for international consumers. Without having any connection with local industry, 800 Show remained exclusive and mostly empty (the rent was too high even for global brands). 800 Show exemplifies how FDIs were clearly favoured by local government

5.1 Boutique shop in Shangjie Loft. Autumn 2011. Photograph by chapter author.

in their modernisation process. However, the sustainability of such a strategy in promoting the wider creative economy in Shanghai is highly questionable, as this global flow of knowledge and networks becomes increasingly separated from the local practice and local construction of meanings.

For many locals, Qipu market is the real mecca for fashion. It is resonant of the many negative values associated with 'Made in China' – poorly made, many goods are in fact the 'copies' of global brands. But it has also been a source of inspiration for the local fashion industry. Fashion design student Yvonne showed me around the market in 2011 and taught me how to spot new global fashion trends from this vastly chaotic fashion market. Yvonne knew a few suppliers in the market who have been manufacturing for international brands:

> they deliberately over-produce the order they were given and keep it as a secret, and then sell them at Qipu market as 'tail order'. Local customers know they are copies from well-known foreign brands, they don't mind.

5.2 Fashion showroom within 800 Show. Autumn 2011. Photograph by chapter author.

In some cases, wholesalers will order a reproduction based on the designs from these tail orders but with cheaper fabric or less complicated detailing. 'They will ask the label to be modified a little too so that they don't get into trouble [with intellectual property].' The majority of the street-level independent fashion boutiques are now supplied on this model, according to Yvonne, who has done a survey of independent

boutiques in Shanghai. She concluded that the role of trend setting played by Qipu market through their 'copying' of global fashion trends was very significant for local designers. Qipu market's innovation model is based on cost cutting. It promotes an important message, that creativity will not be rewarded in terms of 'research and development' but only as a way into the market – in this case, a very bad kind of market. It is not difficult to see then why Qipu market could be the biggest obstacle for local designers in overcoming China's creative crisis – copying can lead to financial success but will prevent one from thinking outside of the box.

The development trajectories of these clusters reveal some of the key issues surrounding the adoption of the creative economy agenda in the Chinese context.

First, 'creativity' as a new kind of human capital, whilst more in-tune with the Western 'bohemian' or 'counter-cultural' tradition, was not easily interchangeable with traditional cultural and social values in China. In the context of fashion, this issue played out in various ways, projecting independent designers' struggle with alternative values in sustaining a self-directed, unpredictable creative career independent of market demand. I will explore this further below. Second, with the principle of culture-led urban regeneration well understood amongst local governments, the appetite of the local entrepreneurial state for cultural production was clearly expanding. However, there is a big problem

5.3 Qipu Market. Autumn 2011. Photograph by chapter author.

when the economic departments become increasingly dominant in promoting culture as business. This is as much a problem in fashion as in other creative industries where market success is the only justification for government support, resulting in a few high-profile designers receiving most state funding and the smaller players receiving nothing. This issue materialised in the prioritisation of urban space in the inner city for use by big fashion labels and luxury brands whilst smaller designers were pushed to the urban edge. Third, the creative industries stressed the role of SMEs (small and medium-sized enterprises) as central to the creative economy rhetoric. Caught between local mass-manufactured fashion goods and global luxury brands, the coming of small businesses and freelancers into creative industries was not attractive to local consumers in any straightforward way. This presents a unique challenge to independent fashion designers in Shanghai, where they face fierce local and global competition in their aspiration to develop a niche audience.

WANG YI YANG: A SUCCESS STORY OF THE LOCAL FASHION INDUSTRY?

Wang Yi Yang started his own label, Zuczug, at the end of 2001, specialising in womenswear. The success of Zuczug has seen it being stocked in many high-end fashion retailers such as Xin Tian Di. Zuczug now has 60 retail spaces across China. Zuczug's success can be attributed to Wang's ability to understand how the fashion business works in Shanghai – the importance of high street fashion retailers at one end and the luxury fashion market at the other – and his ability to learn from and work with both.

Designers like Wang see themselves as occupying a very important space in interpreting culture and aesthetics. Unlike many other cultural critics, Wang does not resist the Chinese love for luxury fashion goods. Wang believes that the arrival of luxury goods opens Chinese consumers up to a larger variety of fashion markets – allowing them to reassess their own consumption behaviour. He accepts the fact, like many other designers in China, that cultural consumption is unlikely to be driven by highly self-reflexive behaviour. There is limited consumer loyalty to

brands; but he is also positive that this will give designers a lot of space to shape and mould consumer tastes to become more reflexive about their own consumption behaviour. With that understanding, Wang was able to make Zuczug a niche brand focusing on high-quality material and craftsmanship, attractive to middle-class consumers.

Wang Yi Yang works in collaboration with a team of designers. In his own words, he is a visionary and his team of designers incorporate detailed design work. Zuczug has its own in-house manufacturing team for sample making. The samples are then dispatched to factories on the outskirts of Shanghai to be manufactured in quantity. Most of the people he works with have been with him since the beginning. Wang does not host seasonal fashion shows but will organise small special shows to exclusive clients, celebrities and VIPs. 'This model works in a Chinese market but if we are to be more internationalised we have to do more to follow the seasonal trends.'

Zuczug was a bold move for Wang, who graduated from Donghua University, Shanghai's top fashion college. There not many designers in 1995, when he started his career as an independent fashion designer, but there were many new opportunities opening up. It was during that time that he met his business partner and started to link fashion with the increasingly open market. However, Wang thinks that being a fashion designer in Shanghai is not easy.

> Most labels started small and their only way of becoming a 'name' in this business is to grow bigger – either through selling their labels to large companies or growing into a large companies themselves. Even when your design has been made known through media, there is still no guaranteed success.

Wang has learnt from this experience that size matters in the local fashion industry. In the last ten years, Zuczug has been trying to expand into major fashion retailers in Shanghai as well as grow the number of boutiques. This is a very different strategy of balancing designers' own cultural status as 'taste maker' in society and the need to acquire market success compared to their Western counterparts. Here, economic and cultural values have converged – cultural success is understood in market terms and vice versa. In the West, an intensification of commercialisation

in the fashion industry has resulted in a breaking away from market-focused operations within the independent sector – those who cannot make money are thus not interested in making money.[44] This was possible because of the existence of an alternative value system in the West, what Pierre Bourdieu called 'autonomous art' and 'restricted production', which continues to provide a key space within the Western cultural production system.[45] The lack of such an alternative value system in China has meant that market success is the best bet for any creative labourer who wants to sustain themselves both economically and aesthetically in the fashion industry.

Wang does not pin his hope on going to fashion shows as a way of exploring financial reward through creative work: 'Fashion shows can help to establish your reputation in the industry, but it cannot sustain your success. The only way [to success] is to understand how to convert your short lived fame into sustainable market potential.' He was quick to read market signals and create ideas that fitted new trends. To diversify Zuczug's market share, in 2005 Wang Yi Yang started another label, Cha Gang, focusing on street wear, sold through a fashion boutique on Yong Fu Road in the old French Concession area of Shanghai, in anticipation of the rise of street fashion at the time.

However, the market that Wang envisaged was not the mass market that was supplied by China's vast manufacturing sector. In fact, it was the opposite of what this manufacturing has become associated with – lack of creativity, quality and skill. Wang believes that to break away from this reputation is as much about creativity as about craftsmanship: 'It is difficult for China to have a sophisticated small-scale fashion manufacturing industry like those operating in Italy. Our plants are used to large quantity and poor quality. But this cannot be overcome just by good craftsmanship.'

Affected by the negative images of China's manufacturing industry, designers in the fashion industry have had to prove themselves both in creative conception and in quality craftsmanship. This is a shared view amongst local designers, most of whom have embarked on a process of working with manufacturers to help them improve their making skills. Zuczug's manufacturer is in constant communication with the designers in quality control. Wang is hopeful about the future of making: 'Obviously Chinese tailors work differently to the Italian fashion

workshops, but we do have high-end making, if this capacity can be linked to local design, it will be magical.'

But such synergy between making and creating requires close proximity in order to facilitate the complex communication involved. The relocation of manufacturing industries to the outskirts of Shanghai has increasingly become a problem since late 1990s, when large-scale urban regeneration happened. Many large firms (mostly state-run) closed down. Shanghai Tex – the state-owned enterprise representing the whole textile and garment industry in Shanghai – is now the largest equity owner of the remaining empty factories and warehouses. The closing down or relocation of the large manufacturing sector has allowed some small and medium-sized clothing firms to emerge in the city. But these new making industries are more linked to the new urban service industries (such as the tailor making and customised shoe industry in French Concession) than to the local fashion industry, where the profits are higher. The majority of the designers I interviewed have opted out of using the inner-city manufacturers.

Even the designers' own presence in the city is threatened by increasing land values in the past ten years. Wang chose a rundown factory near his old university (outside of the inner-city ring road) for his business, for its cheap rents and the presence of local know-how. Wang believes that government support can be important in the sustainable development of local fashion industry – such as through rent reduction, tax incentives and providing a platform for developing industry links with fashion retailers. However, these things are not on the policy agenda.

> Most of policies and schemes relating to the fashion industry focus on the administrative role of the government in 'managing' us. These are useless. Even the Fashion Designers' Association (FDA), does not connect with the real industry and promote industry relevant activities.'

To many local designers, government support is the last resource to which they will turn for help. Instead, Wang has to rely on his own industry networks – client referral is the most important source of information. Whilst for a medium-sized business like Zuczug such

opportunities are easily available, for smaller independent design firms this networking is even harder to develop.

Compared to other creative industries, the fashion industry seems much more ambiguous about 'success', according to Wang. To become successful, you have to become a known 'name' in the industry; however, it does not guarantee you the market success that has become the dominant measurement of success in China's creative economy. The divergence of creativity and financial success in the local fashion industry has presented a thorny boundary between the successful entrepreneur and the not-so-successful designers. Whilst many look upon Zuczug as a success story, Wang has never made it to the top of any national or international fashion shows. He prefers the title of fashion entrepreneur these days, by working effectively with suppliers, manufacturers, retailers and venture capitalists within Shanghai's complex fashion industry.

THE INDEPENDENT DESIGNER SECTOR

In Shanghai, small independent firms are closely integrated into the global circulation of knowledge, skills and trade. This has many implications for the formulation in Shanghai of a unique set of industry practices very different from those of the independent sector in the West. The strategies employed by these designers, caught between a local mass market and globally operated luxury fashion chains, is not as simple as seeking a niche audience. For newly established designer like Cai He, the solution to the problem is for designers to be flexible, to work with both the mass market and the global fashion industries, at the same time, making adjustments in order to cultivate increasingly diversified local markets.

Cai was also a fashion graduate from Shanghai's Donghua University. In contrast to Wang's lack of interest in fashion competitions, Cai has won numerous national designer awards and received a scholarship to study fashion in Japan. On returning to China, he started his own independent fashion business in Shanghai, collaborating with his former classmate. Cai focuses on womenswear and his friend on men's wear. In 2010, Cai started a small exclusive label with investment from a local entrepreneur after winning a nationally prestigious designer

award. It was then stocked by a well-known fashion retailer. But Cai retrieved his label after six months under pressure from the retailer: 'they want fast profit but my label targets a niche market. Most people who come to the shopping mall were the mainstream and not interested in designer wear.'

However, Cai thought that it was an important learning experience for him and made him think more about how to turn his high design concepts into more wearable fashion garments. In order to stay in business, Cai has had to pick up subcontracted design work for other labels. During this period, Cai observed many of his fashion classmates giving up on being independent designers. He carried on with very few resources available to him. He uses a small factory (fewer than 20 employees) in Chang Zhou, near Shanghai, to manufacture his clothes (for orders of 50–200 in volume). At the time of writing, Cai is also preparing for the launch of his label through online retailers like Taobao.

Shanghai's local independent designers are more likely to work with the mass market not because of the market pressure from the high street, but, rather, the opposite. It is the lack of market pressure from the high street that has provided a unique opportunity for the independent sector. Cai recalls the period between 1997 and 2006 as a golden era for independent fashion designers – anything sold because 'the luxury brands were already there, but not many people could afford them, and local high street retailers were still lagging behind the fashion trends'. This left a significant market gap for independent fashion designers. But things are changing fast. Now there are many specialised fashion retailers. Plus there are more international high street brands. The competition is much fiercer than it was ten years ago for independent designers.

Aside from increasing competition from both local and global fashion industries, saving costs has become an almost impossible task for smaller independent designers in a city like Shanghai. Cai commented that there were not many solutions to the problem except that, 'many designers will try to use the "tail order" material from big plants, and if you have friends that own manufacturing factories in Zhejiang and Jiangsu Province, that will be very helpful obviously'. One of the key problems for the independent sector in the West has been the issue of 'making',

both in terms of material sourcing and manufacturing. Whilst having significant disadvantages compared to the bigger players, Chinese designers like Cai were still able to access some of the overproduction capacity of China's vast manufacturing industry nearby. But with increasing urban regeneration pushing manufacturing further away from the urban core, where most independents are located, such relationships will be harder to maintain.

Despite the many disadvantages, Cai still wants to stay in Shanghai. Finding the workshop in Jiu Ting provided him with the opportunity to sustain his fashion business in the city. It is a two-storey building within Youth City – an incubator for young graduate entrepreneurs. Cai uses the top floor for his studio and the bottom floor space for selling his clothes. The cheap rents and the atmosphere of being amongst other university graduates proved beneficial in sustaining Cai's own creative activities. Compared to the other fashion capital – Beijing – Cai thinks that 'Shanghai is a better place to be for designers wanting to learn the industry aspect of the fashion businesses' and 'many graduates from Beijing Fashion Institute' have come to Shanghai looking for opportunities because the atmosphere in Beijing was too 'arty'.

This 'art-versus-business' take on fashion can be attributed to China's fashion education, which has long maintained the arts education tradition. Many independent designers I interviewed identified themselves as artists rather than business people. Many still prefer to work in isolation to polish and refine their own aesthetic message than to learn the business of fashion. The lack of knowledge of the industry has contributed to the 'invisibility' of the independents as an industry sector. As Cai observed, 'there is no sense of a sector nor community even though there are quite a lot of us in the same city'. Without the network, it is hard to develop a cohesive voice for the industry. And, more critically, it is impossible to form bargaining power when negotiating with manufacturers, suppliers and retailers.

The lack of industry knowledge was also clear in designers' attitude towards intellectual property rights. It was surprising to me that Cai does not consider intellectual property rights as a major issue for independent designers. Although he acknowledges the shared practice of 'copying' in the fashion industry, Cai thinks that it has only become a problem for

well-known designers. 'Our label is not well known hence nobody is interested in us. I guess I will be happy one day if I found out my design has been copied because it would mean that my label has achieved market recognition.' This was a key issue for China's creative industries, where the reward system through the guardianship of intellectual property does not work the same way as in the West.[46]

Policy support does not cover small firms like Cai's unless they become 'known' names. Cai told me that one of his friends who won a reality TV talent show featuring young fashion designers (Mo Fa Tian Cai) received overwhelming financial support from the local government. 'If you are not a "name", you are completely on your own.' Cai said that he would not even consider asking for funding from the various government schemes, it would simply be a waste of time. However, he believes that with proper arrangements, government support can be key to the success of the independent sector, as proved by the Japanese fashion industry – something he learnt during his time in Japan.

Local government is not uninterested in promoting the fashion industry. The problem is that they do not have the knowledge of how to promote cultural and creative industries, as proved by their preeminent focus on criteria such as 'how many official fashion shows have you attended a year' as a condition by which designers are to be endorsed by grants to go to fashion shows. Cai commented:

> There are some official fashion associations in China which do this kind of ranking. They organise their own fashion shows to promote themselves and ask designers to participate. But not many people are interested in them because they are not organised by the industry people. Wang Yi Yang [of Zuczug] will be one of the worst performed designers in China according to this ranking.

CONCLUSION

Shanghai has a highly globalised fashion and manufacture sector, with emergent niche designers operating around the edges. Zuczug, by highly celebrated and successful designer Wang Yi Yang, is a brand focusing on high-quality material and craftsmanship, in protest against the culture of

'Made in China' – poor quality, unethical practices and so on. At the other end of the spectrum there are many emerging Chinese designers like Cai He who have limited contact with the high street and have set up their own fashion studio after graduating from the local fashion college. Designers like Cai have limited capacity to access China's highly capitalised and global-facing fashion industry. This has forced them to source local customisation services located at the urban fringes.

All of these firms have different perceptions of, and relationships with, China's global fashion industry, represented by the consumption of luxury fashion goods and the vast fashion manufacturing sector. The close proximity to both provides a vital context in which to understand China's domestic fashion industry, which is simultaneously affected by the global flow of knowledge, skills and trade.

This chapter shows how complex it is for local fashion designers to negotiate their roles both as cultural intermediaries (taste makers) and cultural entrepreneurs in Shanghai. They are pressured by local and global competition, but when there is no alternative value system for them to hold on to, designers (large and small) chose to work with the market – such as working with the high street fashion retailers – and adapt their designs to appeal to a mass market. But the question is how far they can go when their business situation worsens as the fashion industry continues to disadvantage those with limited resources and connections.

Aside from market pressure, the local fashion industry is faced with the official cultural creative industries development strategy, such as developing fashion clusters aimed predominantly at attracting FDI. This further disadvantages smaller companies by separating them from manufacturing services (many are now located outside of Shanghai) and threatening their presence within the inner city. At the same time, government departments adopt the role of industry representative and promoter through various trade shows. Despite that fact that these policies are largely ignored by the local industries, they have had significant impact on the value system surrounding the creative economy narrative in Shanghai – based on the principle of supporting the 'named' designers whilst ignoring the 'unknown'. This was further complicated by the exclusive measurement of success in pure market terms. This chapter has explored the interchangeable nature of 'creativity' and

'economic success' in such a creative economy narrative, and argued that the future vision for the creative economy needs to take into account the development of a cultural scene in Shanghai, for a number of reasons.

Firstly, as Chinese cities are increasingly deindustrialised, we need to think about material production in a broader and more progressive sense in relation to design and other value added inputs. The potential for the creative core, in this case fashion design, to connect with the skills and qualities embodied in China's manufacturing industry cannot be ignored. We need to pay more attention to how these connections might be updated.

Secondly, it is also important to note that culture-led urban regeneration does not imply just an anthropological rooting of (often tacit) knowledge and skills in place[47] but also a co-creation of values and ethics associated with 'communities of practice'.[48] Local production ecologies have to rely on the nurturing of local talent and the development of social networks amongst them as a correction to the exploitation of creativity as economic output – the focus on big businesses and foreign direct investment.

China's creative industries sector is worth over US$10 billion and is growing at a rate over 6 per cent higher than the general economy. It is not surprising that the Chinese government has prioritised the creative industries as one of the country's core GDP contributors by 2020. Taking into account the feasibility of a borrowed cultural economy narrative from the West, the Chinese development model has emphasised the economisation of culture whilst leaving the other side of the debate – 'the culturalisation of economy' – to one side. The latter has been increasingly picked up as a core concern for the sustainable future of cultural economy in many developed countries. Whilst China is playing a catch-up game with the West, the imbalance between culture and economy will be a real test of Hutton's verdict of no through-road.

NOTES

1 Andrew Tallon, *Urban Regeneration in the UK* (London: Routledge, 2010); Sharon Zukin, *The Cultures of Cities* (Malden, MA: Blackwell, 1996); Barry Bluestone and Bennett Harrison, *The Deindustrialization of America* (New York: Basic Books, 1982).

2 Deborah Leslie and Norma M. Rantisi, 'The rise of a new knowledge/creative economy: prospects and challenges for economic development, class inequality and work', in Trevor J. Barnes, Jamie Peck and Eric Sheppard (eds), *The Wiley-Blackwell Companion to Economic Geography* (Oxford: Wiley-Blackwell, 2012), pp. 158–71.

3 Scott Lash and John Urry, *Economies of Signs and Space* (London: Sage, 1994).

4 Angela McRobbie, *British Fashion Design: Rag Trade or Image Industry?* (London: Routledge, 1998); Andreas Wittel, 'Towards a network sociality', *Theory, Culture and Society* 18/6 (2001), pp. 51–76.

5 Mark Banks, *The Politics of Cultural Work* (Basingstoke: Palgrave Macmillan, 2007).

6 Will Hutton, *The Writing on the Wall: China and the West in the 21st Century* (London: Little, Brown, 2007).

7 Cf. Jason Potts, 'Do developing economies require creative industries? Some old theory about new China', *Chinese Journal of Communication* 2/1 (2010), pp. 92–108; John Hartley and Lucy Montgomery, 'Creative industries come to China (MATE)', *Chinese Journal of Communication* 2/1 (2009), pp. 1–12; Michael Keane, *Created in China. The New Great Leap Forward* (London: Routledge, 2007).

8 Justin O'Connor, 'Economic development, enlightenment and creative transformation: creative industries in the new China', *Economiaz* 79 (October 2011), pp. 108–25.

9 Department of Culture, Media and Sport (DCMS), *Creative Industries Mapping Document* (London: Department of Culture, Media and Sport, 1998).

10 Desmond Hui, *Baseline Study on Hong Kong's Creative Industries (For the Central Policy Unit, HK Special Administrative Region Government)* (Centre for Cultural Policy Research. Hong Kong: University of Hong Kong, 2003).

11 Shanghai Creative Industry Centre (SCIC), *Shanghai Creative Industries Development Report* (Shanghai Creative Industry Centre, 2006).

12 Jing Wang, 'The global reach of a new discourse: how far can "creative industries" travel', *International Journal of Cultural Policy* 7/1 (2004), pp. 9–19.

13 Yasheng Huang, *Capitalism with Chinese Characteristics: Entrepreneurship and the State* (New York: Cambridge University Press, 2008).

14 O'Connor, 'Economic development, enlightenment and creative transformation'.

15 Justin O'Connor and Xin Gu, 'Creative industry clusters in Shanghai: a success story?', *International Journal of Cultural Policy* 20/1 (2012), pp. 1–20 and 'Shanghai: images of modernity', in Helmut Anheier and Yudhishthir Isar (eds), *Cultures and Globalization: Cities, Cultural Policy and Governance* (London: Sage, 2012), pp. 228–300.

16 Andrew Ross, *Fast Boat to China: High-Tech Outsourcing and the Consequences of Free Trade: Lessons from Shanghai* (New York: Vintage Press, 2007).

17 Richard Florida, *The Rise of the Creative Class* (New York: Basic Books, 2002).

18 O'Connor and Gu, 'Creative industry clusters in Shanghai'.

19 Allen J. Scott, 'Cultural economy and the creative field of the city', *Human Geography* 92/2 (2010), pp. 115–30.

20 Xin Gu, 'Developing entrepreneur networks in the creative industries – a case study of independent designer fashion in Manchester', in Elizabeth Chell and

Mine Karatas-Özkan (eds), *Handbook of Research on Small Business and Entrepreneurship* (Cheltenham: Edward Elgar, 2014), pp. 358–73.

21 Elizabeth Wilson, *Adorned in Dreams: Fashion and Modernity* (London: I.B.Tauris, 1985).

22 Peter Braham, 'Fashion: unpacking a cultural production', in Paul du Gay (ed.), *Production of Culture/Cultures of Production* (London: Sage, 1997), pp. 119–77.

23 Sheng Lu and Marsha Dickson, 'Where is China's textile and apparel industry going?', *China Policy Institute: Analysis*, 24 July 2015. Available at http://blogs.nottingham.ac.uk/chinapolicyinstitute/2015/07/24/where-is-chinas-textile-and-apparel-industry-going/ (accessed 20 September 2015).

24 Ding Zhang, Shengqing Zhu, Weidong Cao and Ying Yang, 'Spatial pattern evolution of textile and garment manufacturing in Shanghai', *Tropical Geography* 33/6 (2013), pp. 720–30.

25 Norma M. Rantisi, 'The local innovation system as a source of "variety": openness and adaptability in New York City's garment district', *Regional Studies* 36 (2002), pp. 587–602.

26 Andy Pratt, 'The cultural economy', *International Journal of Cultural Studies* 7/1 (2004), pp. 117–28; Allen J. Scott, *The Cultural Economy of Cities* (London: Sage, 2000).

27 O'Connor and Gu, 'Creative industry clusters in Shanghai'.

28 McRobbie, *British Fashion Design*.

29 Banks, *The Politics of Cultural Work*.

30 Xin Gu, 'The art of re-industrialisation in Shanghai', *Culture Unbound: Journal of Current Cultural Research* 4 (2011), pp. 193–211.

31 Scott, 'Cultural economy and the creative field of the city'.

32 Ming Bao, Xin Deng and Bian Zhu (eds), *Fashion Photography Art* (Chinese Edition) (Hong Kong: China Textile University Press, 2000); Juanjuan Wu, *Chinese Fashion from Mao to Now* (Oxford: Berg, 2009).

33 Wessie Ling, 'From "made in Hong Kong" to "Designed in Hong Kong": searching for an identity in fashion', *Visual Anthropology* 24/1–2 (2011), pp. 106–23.

34 Simona Segre Reinach, 'Chinese fashion and the new relation with the West', *Fashion Practice: The Journal of Design, Creative Process and the Fashion* 4/1 (May 2012), pp. 57–70.

35 Pierre Bourdieu, *The Field of Cultural Production: Essays on Art and Literature* (New York: Columbia University Press, 1993).

36 Dave Haslam, *Manchester, England: the Story of the Pop Cult City* (London: Fourth Estate, 1999).

37 Pratt, 'The cultural economy'.

38 Xin Gu, 'Cultural economy and urban development in Shanghai', in Kate Oakley and Justin O'Connor (eds), *The Routledge Companion to the Cultural Industries* (London: Routledge, 2015), pp. 246–56.

39 Anna Greenspan, 'The power of spectacle in culture unbound', *Culture Unbound: Journal of Current Cultural Research* 4/1 (2011), pp. 81–95.

40 O'Connor, 'Economic development, enlightenment and creative transformation'.

41 Keane, *Created in China*.

42 Simona Segre Reinach, 'Italian and Chinese agendas in the global fashion industry', in Giorgio Riello and Peter McNeil (eds); *The Fashion History Reader* (London: Routledge, 2010), pp. 533–55.

43 Michael Porter, 'Clusters and the new economics of competitiveness', *Harvard Business Review* 76/6 (1998), pp. 77–90.

44 Gu, 'Developing entrepreneur networks in the creative industries'.

45 Bourdieu, *The Field of Cultural Production*.

46 Laikwan Pang, *Creativity and Its Discontents* (Durham, NC: Duke University Press, 2012).

47 Allen J. Scott, *The Cultural Economy of Cities* (London: Sage, 2000).

48 Banks, *The Politics of Cultural Work*.

Part II

FASHION IN OTHER CHINAS

6

BENEATH THE CO-CREATED CHINESE FASHION: TRANSLOCAL AND TRANSCULTURAL EXCHANGE BETWEEN CHINA AND HONG KONG

Wessie Ling

INTRODUCTION

Ever since the Open Door Policy (1978), China has made economic reform a priority. Its export-oriented economy saw the growth of a gigantic clothing and textile industry, which subsequently has turned the country into the factory of the world. Through joint ventures with and investment from Euro-America and neighbouring Asian regions, the industry has speedily adopted the skills and know-how to produce fashion for all price ranges; from mass markets to the high street, to the luxury market.[1] The 'Made in China' label has its presence in almost every wardrobe across the globe. The flourishing industry also created the rapid

growth of a solid industrial workforce, supplied by the mushrooming fashion institutions across the country. Among them, many well-trained fashion labourers are keen to take clothing to the next stage, that is, fashion created by the Chinese. Notwithstanding its status as a manufacturing powerhouse, the country has, in recent years, recognised the revenues that the cultural and creative industries could bring to China, with reference to those in Britain and Japan. The initiative from 'Made in' to 'Created in' China has therefore been one of the country's development goals since 2005. Regional museums, music centres, design weeks, artist villages, biennials, cultural districts, book fairs, film institutions and so on have proliferated across the country. As part of the creative industries, China has actively constructed its own fashion system, which included the aspiration, albeit unachieved, to portray Shanghai as the world's sixth fashion capital by 2008.[2] The government supported fashion design operations,[3] joint ventures between foreign labels and local designers – for example, Shang Xia[4] – and joint retail establishment with global luxury brands and department stores in metropolitan cities, among many others. China's endeavours to be a well-respected global fashion centre of production, with circulation and consumption that has the capability to legitimise its own creative talents and endorse new styles and trends. The country has the ambition to match the dominant Euro-American fashion capitals by legitimising its own fashion talents. The result is the endorsement of fashion designers as stars, often starting with overseas graduates from world-renowned fashion institutions.[5]

Geographic proximity and cultural similarity to the neighbouring industrialised regions, and in particular the success of the Four Asian Tigers (Hong Kong, South Korea, Singapore and Taiwan) has made them major sources of influence on China. Since the days of colonialisation, Hong Kong has been the window of trade, exposure and international interaction for the mainland in view of the inland Communist regime and the Cultural Revolution (1966–76). As a testing ground for the mainland, Hong Kong has not disappointed the motherland. Its fast-paced industrialisation, from a tiny fish port to the Asian financial centre, from a blue-collar city to first-rate consumer city, within 50 years is a remarkable achievement for the region. Hong Kong's industrial success and economic powerhouse give pronounced references

to the mainland. The city once held the world's largest clothing and textile industry, and it is the first Asian city to launch a seasonal Fashion Week, which remains one of the region's key fashion events. The profitable operation of Hong Kong Fashion Week as the Asian fashion hub, and the successful Hong Kong label Shanghai Tang, have become models for the mainland counterparts to follow.

The reopening of China has permitted numerous opportunities for trade, jobs, collaboration and joint ventures, given the close geographic proximity of Hong Kong to the mainland. Since the 1980s there have been overt collaborations between the two regions from manufacturing to trade, education, design consultancy and fashion events. Since 2000, Hong Kong's fashion labour has increasingly moved north to pursue greater job opportunities. The mainland actively seeks support and collaboration, and recruits Hong Kong's professionals to build, strengthen and enforce its own fashion operation. Through such interaction, the translocal and transcultural experiences of Hong Kong's creative fashion labourers with their mainland counterparts reveal much about the making of Chinese fashion; in this case, fashion in the mainland and Hong Kong. Chinese fashion has neither been made, nor can it be understood unilaterally, as Reinach[6] skilfully put it, through the Sino-Italian relationship in fashion. We are reminded that when referring to Chinese fashion, the education background and ethnic origin of the designers involved are additional cases in point.[7] To the eyes of mainlanders, Hong Kong is considered a distant region due to its autonomous regime, legislative governance, freedom of speech and movement of people. Given the socio-cultural, economic and political divide between the mainland and Hong Kong, the translocal and transcultural interactions between the fashion labourers of these two regions further infiltrate the making of Chinese fashion.

This chapter first examines the interrelation of structural development of the fashion industry between Hong Kong and the PRC. It then discusses the translocal and transcultural experiences of Hong Kong fashion labour with the mainland, through which the making of Chinese fashion in both regions is unveiled. My informants are ten Hong Kong creative fashion labourers who have taken key roles in the operation of mainland fashion but are based in Hong Kong. They frequently travel to

work with their mainland partners, many of whom, apart from their role in mainland fashion operations, maintain a visible presence in Hong Kong's fashion industry. Their industrial experience ranges from eight to 40 years. The selected informants based in Hong Kong enabled the fashion operations of the two regions to be uncovered. Although the findings point to the practice of co-creation, ethical differences within unveil another side of the making of Chinese fashion.

Based on empirical materials, trade figures and in-depth semi-structured interviews, the chapter will begin with a macro account of the interaction between the mainland and Hong Kong through the historical development of Hong Kong's textile and clothing industries. The beneficiaries of its development to the mainland will be highlighted. A microanalysis of the experiences of Hong Kong creative labourers working with their mainland counterparts follows. Revealed within are intriguing connections, beneficiaries, socio-cultural differences and mutual exchange between the two regions.

THE HONG KONG TEXTILE AND CLOTHING INDUSTRY IN FOUR PHASES, AND THE INFILTRATION INTO THE PRC

It took only three decades for the PRC to become the world's factory. Prior to that, the 'Made in Hong Kong' label was a common tag in many wardrobes. It took a similar length of time for Hong Kong to become the world's biggest apparel exporter in 1984. Many lessons were learned on the mainland from the speedy development of Hong Kong's textile and clothing industry. How infiltration into the mainland occurred can be understood from the history of Hong Kong's textile and clothing industry and its fashion's development in four phases.

Phase 1: pre-industrialisation

The textile industry started with an influx of migrants to Hong Kong from the mainland in 1950s, owing to the rising Communist power inland. Some of them were brought from substantial financial capitals with labour expertise in textile manufacturing. They began to set up textile mills and factories in the tax- and debt-free port city. The industry provided half of

the city's employment, including many skilled tailors. Those who adhered to their own trade opened tailor ateliers, which at their peak mushroomed to more than 200 across the city. In the 1950s, Hong Kong was regarded as a place filled with crouching tigers and hidden dragons, which in the Chinese idiom refers to people with special hidden talents and skills. In the textile and clothing industry, many of these 'tigers' and 'dragons' were tycoons who owned substantial capital, *guanxi* (i.e., the close-knit network of individuals and organisations) and industrial know-how. Working for their corporations was seen as a promising career and a reliable step up the social ladder, in particular for the Hong Kong labourers, most of whom fled from the mainland aiming for nothing more than a better future. Their eagerness to achieve a better life through hard work, frugality and diligence – the principle values of the Confucian system[8] – contributed much to the industry's growth. Remarkable economic success in Confucian-based Asian societies is highlighted in many scholarly works,[9] pointing to the inter-relationship among harmonious human relationships, social structure and work ethics, and their intriguing link to economic growth. The Confucian principles are believed to contribute to the economic rise of Hong Kong; as much has also been said to that of modern China.[10] As a Confucius saying goes: 'Follow what is of profit to the people and profit them', and the economic measurements were in accordance with Confucian governance. When industrialisation was earmarked as the key economic reform after reopening, the PRC's government demanded labour from the people in a proper manner, for their own good. Following suit was a devoted national workforce that transformed the country into a gigantic manufacturing site.

Phase 2: industrialisation

The textile sector; the major pillar of 1950s' Hong Kong's industry, was gradually diversified into clothing, plastics, electronics and other labour-intensive production, mainly for export in the 1960s. The Hong Kong Brands and Products Expo (HKBPE; est. 1965), a large-scale outdoor expo and carnival featuring both international and Hong Kong brands ranging from accessories to household items and electronic products, was set up to promote trade and consumption as a means of modernisation. Design awards, booth competitions, a Miss Exhibition

Pageant and many giveaways formed part of the activities to entice the public. The early popularity and endurance of HKBPE set an example for the mainland regarding public events, with many fashion shows presented as public entertainment in which speech, singing and talk shows form a part.

Following the longstanding HKBPE was the establishment of the Trade Development Council (HKTDC; est. 1967), which has promoted Hong Kong's trade and export business by means of trade fairs and launched and has held Hong Kong Fashion Week since the early 1970s. The foundation for the city's clothing and textile trade was solidly laid down by the HKTDC, with annual increased trade figures and ever-expanding international business stalls. It was therefore assigned to co-organise CHIC shows (China International Clothing; est. 1993), the first international fashion group show in Beijing (now a trade fair based in Shanghai) featuring Valentino and Gianfranco Ferre, among others. Industrial knowledge, experience in organising fashion shows, and the business network brought along by the HKTDC to CHIC enabled mainland counterparts to gain ground in this activity. Further discussion of the interactions between the two regions on the organisation of CHIC is included in a later section. While HKTDC has not invented fashion activities from scratch, the export-oriented clothing and textile business meant that foreign input and interaction were prevalent in the process. Colonial Hong Kong was a melting pot for foreign creative fashion labour from production to design, to marketing, to media circulation. Such transnational interaction characterises early Hong Kong fashion, which was geared towards the export market. The city relied on foreign input for the clothing and textile trade to flourish, so much so that Hong Kong was taken as a manufacturing site catering for the fashion of the world.[11] Recognising foreign input as essential, it was taken to endorse CHIC in the mainland. In the absence of local designer fashion, international labels were thus invited to grace the façade of the nation's first international fashion event.

Another key reference for the mainland is the fashion design contest. Ever since the Hong Kong Young Designers' Contest was introduced (est. 1976), the HKTDC has taken the opportunity to promote its own event and forge external collaboration. Internationally known designers, at

times renowned brand professionals, were invited as judges to build friendship and potential business partnerships. Design contests, wine collections and the presence of fashion celebrities generated extensive media coverage. The massive publicity enabled HKTDC to promote not only the creative individuals but also their own masterful event. Reference has been made to the mainland's promotion of its own fashion system. Since the late 1980s, design contests supported by PRC government institutions and the fashion industry have multiplied rapidly. The Brother Cup China International Young Fashion Designers Contest (est. 1993), named after its major sponsor, Brother Industry Ltd of Japan, is one of the earliest, with international partnership and the most influential design contests in the mainland. Initiated by the Garment Design and Research Centre of China, it provides guaranteed media coverage and extensive publicity.[12] Victorious designers acquired overnight fame and were sought by large clothing companies, given the state-owned Chinese fashion industry. Increased migration of people between the mainland and Hong Kong in recent decades has meant that many mainland designers of later generations became known in the field by winning design awards in Hong Kong, and the reverse practice was observed in Hong Kong's designers for mainland design awards. The participation of Taiwanese designers (for example, the Taiwanese winner of Beijing's design contest)[13] highlights the transcultural exchange in three Chinese regions: Taiwan, Hong Kong and the PRC, within which cross-fertilisation is underlined by institutional collaboration, business partnership and professional networks. For these Chinese societies, where the personal code of ethics is often placed before law, it is believed that business will follow building a relationship (guanxi).

Phase 3: the stage of blossoming

The Open Door Policy of the PRC in late 1978 meant that the mainland regained its traditional role as the country's main provider of commercial and financial services. This stage saw increased economic and cultural interaction between the two regions; trade between Hong Kong and the PRC grew at a steady rate of 28 per cent per annum from 1978 to 1997.[14] The 1980s and 1990s were considered a golden era for Hong Kong's clothing and textile sector, which reached its peak in 1984–5 to become

the world's largest exporter of apparel, employing a total of around 300,000 workers.[15] Following China's Open Door Policy, labour-intensive operations were then moved from Hong Kong to the mainland, to take advantage of low-cost labour,[16] thus boosting the total value of apparel domestic exports from HK$1.01 billion in 1960 to HK$77.156 billion in 1992.[17]

Hong Kong's blossoming textile and clothing industry required skilled fashion designers in its workforce, with many being trained at the Hong Kong Technical College, later the Hong Kong Polytechnic (est. 1972; with full university status since 1994, henceforth HKPU) with its accredited fashion design course. The majority of the early generation of fashion designers were engaged in export-oriented trade, given the export economy on which the city was maintained. These skilled creative labourers gained worldwide reputation for their professional expertise, sensitivity to current trends and ability to blend commercialism with innovation. Their skills, knowledge and experience in the manufacturing sector were an asset to their mainland counterparts, given the nation's fast-paced industrialisation. In the 1980s and early 1990s, Hong Kong's creative labour was in huge demand for the clothing sector of the mainland.

Most Hong Kong fashion graduates aspire to have their own labels and collections, although this is usually wishful thinking. With less than 18 per cent of the population earning a university degree in 1980s Hong Kong, an overseas degree guaranteed a promising career in well-funded and long-established corporations. Many graduates were destined for a salaried job. Those who took up freelance consultancy benefited from the numerous design opportunities that sprang up from the blossoming clothing industry in Hong Kong as well as the mainland. Only a handful of independent fashion designers engaged in fashion retail, branding and the creation of labels. The conditions are similar to today's China, with thousands of home-grown and overseas fashion graduates year-on-year. The majority take up an economically viable job with the guarantee of a comfortable lifestyle that Chinese society would expect for the educated elite.

Alongside the growing economy of scale, Hong Kong's clothing industry saw popular demand in overseas fashion education. In the 1980s, education partnerships between Hong Kong and overseas

institutions permitted some HKPU undergraduate courses to progress to overseas postgraduate degrees. For instance, many pursued the route of studying at the Royal College of Art (London), Kingston University (UK) and Domus Academy (Milan), amongst others. Along with these graduates, tangible skills and new ideas were brought to the sector. Many took up teaching posts disseminating European frameworks and fashion operations to local students. The dominant fashion capitals remained the most favoured choice for Hong Kong's graduates in the pursuit of further fashion education; however, training at these European capitals did not necessarily fulfil the needs of the export-oriented trade that occupied the city at the time. This resulted in conflicts between the young generation of fashion designers, who aspired to own brand names, and the city's economic position in the export trade. Fashion education in these capitals simultaneously enforced Euro-American fashion ideas and frameworks in Hong Kong. The same could be said of other countries outside of these fashion capitals.[18] A process of Euro-American 'fashionalisation' was at play through fashion education. How the later generation of creative individuals understands fashion today has arguably been shaped by Euro-American discourse; the extent to which fashion graduates have implanted it as normal is beyond measurement. Rarely had Chinese pattern making been taught at Hong Kong or Chinese fashion institutions; rather, European fashion histories and culture were enforced in the curriculum, especially in the fashion courses accredited by European fashion institutions. Owing to the wide dissemination and acknowledgement of the Euro-American fashion system, its structure and conditions, which are primarily from the twentieth century, have often been taken as the current role model for the periphery to follow. Examples are the endless acquisition of Euro-American endorsement for Hong Kong's fashion design through overseas exhibitions and fashion shows or the insistence of Hong Kong fashion labels on retail operations when the trend for twenty-first-century fashion businesses has moved from bricks and mortar to the virtual environment.[19] This has an enduring impact on the development of Hong Kong's fashion and the way fashion is disseminated via Hong Kong to the mainland. Despite the transcultural bricolage in the making of Chinese fashion, any new and innovative style emerging from which has often been taken as

unoriginal if not a copy of those in the dominant Euro-American capitals. This only imposes excessive limits on interpreting Chinese fashion.

Recent moves witnessed the international expansion of Euro-American fashion institutions across Hong Kong and China. In Hong Kong, there are the Savannah College of Art and Design (SCAD), the London College of Fashion accredited fashion degree course at Hong Kong Design Institute and Central St Martins, London accredited fashion course at HKU Space (Hong Kong University, School of Professional and Continuing Education). Branches of renowned fashion institutions in the mainland also exist; for example, the Institut Française de la Mode (IFM) Shanghai (est. 2002) in partnership with the Shanghai University of Engineering Science (SUES), Esmod Guangzhou (est. 2014) with Guangzhou University, College of Textile and Garments and the Istituto Secoli Guangzhou (est. 2016). The fluidity of staff from home and local countries underscores the deliverance of these programmes. A balance of local and European knowledge and the methods of operation are to be expected, given the geographic location and the locality involved. It might be too soon to draw any conclusions about such interaction, which implies the need for further examination of transnational fashion education and its impact on the interpretation, making and operation of fashion.

On the translocal level, the long-established Institute of Textiles and Clothing at HKPU offers an MA in Fashion and Textile Design, caters exclusively to the mainland subscriber and is delivered by a team of staff with transnational education profiles (Hong Kong, UK and/or US fashion degrees) and professional experience (Hong Kong, PRC and overseas). Upon completion of the course, students are expected to have acquired an in-depth understanding of global fashion trends and requirements from Hong Kong's perspective. Studying in Hong Kong is an aspiration for those mainland students who have a desire for 'overseas' experience but would not or could not travel far for various reasons. The one-year programme generates alumni from various parts of the country. In return, the profile of the institution is raised via the acquisition of apprenticeships, graduate employability, business partnerships, professional networks and students' professional relationships and experience. The socio-cultural and political differences they bring to the

course cannot be underestimated. Such dynamic translocal and transcultural interaction is mutually beneficial, albeit perhaps more so to the PRC, as it offers a way for Hong Kong to gradually assimilate into the mainland, and for the mainlanders to progress and modernise, given Hong Kong's legislative governance and its relative autonomy.

Phase 4: post-industrialisation

The period of the 1980s and 1990s also signified the rise of Hong Kong as a major financial centre in Asia. Rising property and land prices pushed many manufacturing operations away from the financial city. From the 1990s, the move increased the relocation of manufacturing plants to the mainland. In spite of relocation, Hong Kong's clothing sector had transformed from low-cost, labour-intensive production into a knowledge-based, high value-added manufacturing activity. The comprehensive knowledge of Hong Kong's clothing manufacturers about sourcing and products enabled them to cater to the preferences of the dispensed customer bases. It developed into a world sourcing and trading centre, actively engaged in re-export activity. As a global sourcing hub in Asia, international trading houses and major retailers sourced clothes in Hong Kong through their buying offices or other intermediaries. These international buyers ranged from American and European department stores (e.g., Macy's, JC Penny, C&A) to speciality chains (e.g., Gap) to e-retailers (e.g., Zalora and YOOX) and premium designer labels such as Calvin Klein, Donna Karen, Ralph Lauren, Tommy Hilfiger and Yves Saint Laurent.[20] However, the sector began to diminish, with export figures dropping from HK$329 billion in 2007 to HK$214.9 billion in 2014.[21] Hong Kong's total clothing exports decreased by 12 per cent year-on-year in the first four months of 2016, after a 10-per cent decrease in 2015. Even re-exports fell by 11 per cent, and domestic exports slumped by 41 per cent from January to April in 2016.[22] Relinquishing the manufacturing base to the mainland opens up otherwise boundless business opportunities for Hong Kong's fashion industry in view of the expanding domestic Chinese market. Operational exchange between Hong Kong and the mainland at this stage has reached equilibrium, where Hong Kong manufacturers have partnered with their mainland counterparts to set up factories, or some

have merely located their operations inland, training Chinese labour for the discerning markets. The creative workforce of Hong Kong has increasingly moved north to pursue better job offers. Many are engaged in consultancy projects and fashion media, collaborating simultaneously with their mainland counterparts.

The changing conditions of Hong Kong's manufacturing sector proliferated higher value-added activities such as design and brand development, quality control, logistics and material sourcing. A handful of well-established local manufacturers such as Baleno, Bossini, Crocodile, Moiselle, JEANSWEST, I.T. etc. have entered into the retail business either locally or in overseas markets. Labels such as Episode, Esprit, G-2000 and Giordano have retail networks around the world, including in Beijing, Shanghai, London, New York, San Francisco, Singapore, Bangkok, Taipei and Tokyo. Hong Kong's rising economy and household income stimulated consumption appetite, alongside the rise of the middle class. Although many desire Western labels, these low- to mid-range labels have made inroads into the wardrobes of many Hong Kong households. The development of these retail labels is almost simultaneous with that in the PRC. The comprehensive manufacturing knowledge shared between Hong Kong and mainland manufacturers enabled low- to mid-range, home-grown retail labels to flourish in both regions.[23]

TRANSLOCAL AND TRANSCULTURAL EXCHANGE BETWEEN HONG KONG AND THE PRC

Within the speedy industrialisation process of Hong Kong and the PRC lies endless exchange and interaction between them; both prioritised export and manufacturing activities for a strong and efficient economy. Their factories have swallowed up all the workforce in their respective regions, leaving an unfulfilled gap in personnel skilled in fashion branding, marketing and retailing. Professionals with expert knowledge in the symbolic production of fashion are now in demand.[24] One result is the highly sought-after fashion marketing and management programmes from both national and international institutions. The campaign to move up the supply chain from 'Made in' to 'Created in' China fashion was

6.1 Guangdong embroiderers' work on Virginia Lau's spring/summer collection 2003. Courtesy of Virgina Lau.

subsequently launched, with emphasis on promoting star designers who can make a global impact. It has not taken long for the PRC to acknowledge fashion as a soft power for nation building. As a prosperous creative industry, evident elsewhere, for instance, Britain, France, Japan and more recently Korea,[25] the PRC sees its own fashion industry as an enduring business and an opportunity to interact with global partners, one that would embrace national pride and ambition simultaneously.

The situation has not been the same in Hong Kong. Decades of discontent from local fashion designers because of the lack of supportive mechanisms were dismissed. The city has engineered itself towards trade and business irrespective of the growing aspirations of their creative talents to own brand-name fashion.[26] Business profits and financial returns have consumed the talents of the creative labourers in the city. Hong Kong's fashion designers were historically geared to serve export markets, manufactured contracts and, more recently, fashion operations in the mainland. Despite sufficient vacancies in the fashion sector, support for Hong Kong designer fashion has always been overlooked. The city has long desired a home-grown star designer, but no one with global impact has emerged. It is only recently, in view of the sunset clothing and textile industry and the necessity for structural change in the

sector, that government financial support has been given for the first time. The Financial Secretary, John Tsang disclosed HK$500 million in the 2016−17 budget announcement to be earmarked for the rejuvenation of Hong Kong's fashion industry through a three-year pilot programme.[27] As part of the policy to support the development of Hong Kong's creative industries as a whole, this initiative should not be confused with the PRC's campaign of 'Created in' China. Despite the fact that Hong Kong is now part of China, the ambition to be the next world fashion capital is a separate entity as both regions shore up more of their translocal and transcultural differences. Given the correlation between national and fashion identity,[28] even if either one of these Chinese regions takes the title it would not necessarily affect the other. The ongoing political tension between the two regions only intensifies their divide and differences. There has been movement in Hong Kong to restore indigenous (i.e., colonial) culture, preserve core moral values and reinforce legislative procedures. Hong Kong's people took pride in their economic advancement, global connection and (albeit limited) political autonomy over the mainland governance. In terms of the relationship between the city and fashion, Hong Kong has been a cosmopolitan, fashion-conscious and fast-rate consumption society for the past few decades, characterised by high consumption power, global connectivity and sensitivity to global trends and world events. Given the Hong Kong population's taste and lifestyle, they often hold superiority over the retrograde mainland.

Training via Hong Kong to the mainland

Although Hong Kong's designer fashion has struggled to make its mark on the global fashion map, the consensus from many Hong Kong creative labourers towards mainland designer fashion is too much external attention and too little to providing remarkable designs. Their considerable envy and bitterness towards mainland designer fashion were noted in my fieldwork. Many could not or were reluctant to name a designer who has come up to their standard. Some even avoided discussing their projects with their mainland counterparts seriously. When it comes to working collectively with them, 'training' is the buzzword in their operation. 'The time and effort invested in training

these embroiderers were huge. Once they were trained, they became highly sought after. Either their price increased or they were head hunted by other enterprises. Every new encounter required a new set of training.'[29] Knowledge exchange typified by skill set delivered via Hong Kong to the mainland is commonplace; a condition that arose when Hong Kong's manufacturers relocated their factories to the mainland. Hong Kong manufacturers' comprehensive knowledge, having worked for the export markets for a long time, means that training for their employees – from operation to managerial level – is mandatory for newly recruited mainland labourers.[30] Speed and enormous volume are the production criteria in which Chinese workers have to learn and hone their skills, which they have done, and it has only been in recent history that 'Made in China' products evoked low-quality cheap products. Now the label embodies quality garments at all price levels. More importantly, since the PRC re-valued their currency in 2005, labour and production costs have increased. 'Made in China' clothing is now too costly and Vietnam and Malaysia have had to stand in for low-cost manufacturing. Manufacturing experience aside, the mainland counterparts pay close attention to the success story of Hong Kong's manufacturing-based retail brands, many of which have penetrated the mainstream consumer markets from China, to Asia, and to Europe. Many low- to middle-range national brands are in the pipeline for international expansion, following in the footsteps of those in Hong Kong.

Gaining translocal network and experience

The hard-earned skill and knowledge of the Mainland Chinese manufacturers enabled China's industrialisation to progress at speed. This was not exclusive to manufacturing experience. The same story was told in event management and public relations, when the HKTDC co-organised CHIC in 1993, which was the first international group fashion show in Beijing and one of the biggest fashion shows in China, featuring international brands such as Valentino and Giofranco Ferre, and hundreds of models on stage. Industrial connections gained from the HKTDC's lengthy experience in organising Hong Kong Fashion Week enabled the presence of key international fashion journalists such as Suzie Menkes, Elsa Klensch and Hilary Alexander. However, chaotic personnel

arrangements by the mainland organisers were reported. The absence of translators and photographic support was an experience that troubled top fashion journalists. The major flaw in the mainland's organisation was their inexperience in public relations:

> Klensch was not sent an invite. When she turned up to the show, she was not allowed in. No one in the show came to greet her. No one instructed anyone to look out for key figures and journalists. As the security only admitted physical invite but the face, Klensch was refused entry![31]

According to my informant, Judy Mann, one of Hong Kong's first generation of fashion model-turned-fashion designers, and a key active figure in the field since the 1970s: 'I came with a fashion friend to the show who happened to speak French and Mandarin. Suzie and Elsa ended up taking him as their free interpreter as the mainland organiser had no translator arranged.'[32] Against all odds, the show was accordingly 'fantastic' and 'spectacularly dramatic'.[33] The mainland organisers set out on a mission to make it 'the biggest fashion show ever'; each invited international designer was thus asked to bring ten European models, which resulted in a total of 200 European and Chinese models showing sumptuous fashion from Europe to Hong Kong on the runway. Huge economy of scale is often regarded as a standard feature in China, given the country's population and geographic spread. Its national ambition shares similar capacity too. The mission of the event – to make a significant mark in the international fashion map – was crystal clear. The reason for the absence of mainland designer fashion in the first international fashion show in China was therefore unarguable. The whole point was to announce China's readiness to take its place on the world stage, to take part in global partnership and competition, and to spread its wings into the international communities. Such intention is echoed by the rising number of fashion weeks from numerous self-proclaimed fashion centres across the globe.[34]

Seeking Hong Kong's professional connections and support is a way for the mainland to learn and gain ground in fashion operations. Judy Mann, the first Hong Kong fashion designer invited to open retail outlets in China, was involved in an outlet in the Lufthansa Centre

[燕莎购物中心] in 1993, the first Western-style departure store in Beijing. Within two years, 14 more of her retail outlets opened in the capital. She noted at the time that China lacked the economic power for consumption and the pressure to cope with multiplying retail outlets at speed. 'It was hard work. They didn't have the experience in retail operations. Lots to explain. I'd to train everyone, including the shop floor manager and staff, how to present a collection, how to hang clothes in a presentable way.'[35] On reflection, she recorded the humbleness of the mainland at the time in inviting many other brands to their establishment. Yet, 'they squeezed our brains; they invited overseas, Hong Kong professionals to learn from them. They hired French designers and afforded to pay for each an exclusive translator. They were hungry for success.'[36]

Co-creation and co-production

Aiming for success was, on the other hand, an attitude appreciated by some retail buyers who have an appetite for Chinese designer fashion.

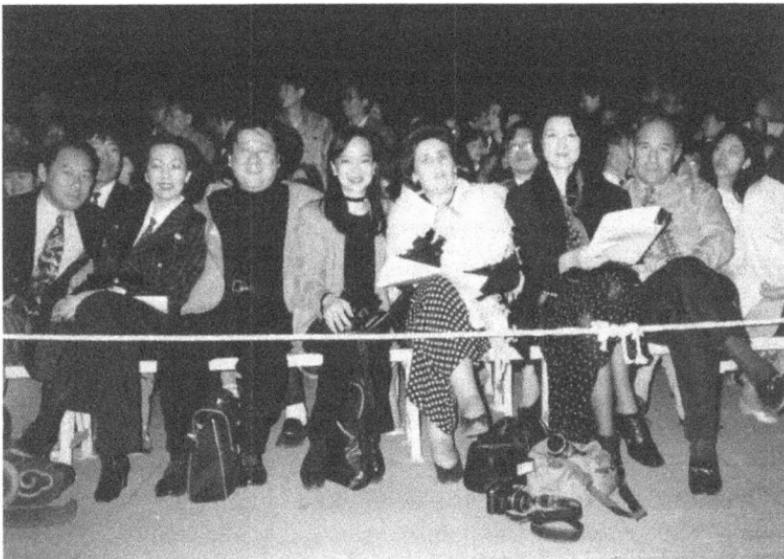

6.2 Front row at CHIC 1993, Beijing; from left to right: Richard Loh (Bag designer from New York), Judy Mann (Hong Kong fashion designer), KentSou (designer from Montreal), Lucia Carpio (Fashion Department of Hong Kong Trade Development Council), Suzy Menkes (fashion journalist of *International Herald Tribune*), Ellen Liu (Hong Kong model), a representative of an Italian brand. Courtesy of Judy Mann.

In recent years, Lane Crawford (LC), a longstanding Hong Kong first luxury multi-label store featuring predominantly high-end Western brands, launched a 'Created in China' programme (est. 2013).[37] Selected emerging designer labels were invited to co-create a capsule collection with LC to sell in store. It was the first time since 1850 that LC had taken such an initiative. To the dismay of Hong Kong's designers, their selection included exclusive designer fashion from the mainland: 'the middle-class Hong Kong designers are very spoiled. They cannot take criticism and are reluctant to revise their style. They easily give up. Mainland designers are hungry for success. They are more eager to make it work', according to a representative of LC.[38] Given the store's reputation and social standing in the fashion consumer market, selling in LC instantly added symbolic capital to the designers. The bitter remarks made by Hong Kong's fashion creative labourers to their mainland counterparts were unsurprising, and merely uncovered the dilemma of their working relationship.

Nevertheless, translocal and transcultural influence between the two Chinese regions is rarely a one-way street. There are mutual exchanges and benefits between them, which partly explains the growing number of Hong Kong's fashion professionals working and living in the PRC, and partly explains their gratitude when they are given the opportunity to take up a role and/or projects by Hong Kong-based creative labour. The economy of scale in many PRC establishments and the Chinese domestic market presented crucial opportunities for Hong Kong's creative individuals to exercise their creativity. The design of a retail outlet can be as small as 25 m^2 in Hong Kong, 100 times the measurement that would be considered standard in the mainland.[39] The country is undergoing an economic revolution in which fashion plays a key part in the façade of change; fashion consultancy projects in the mainland include not only collection design but also a full package of branding, retailing, media communication, visual merchandising, styling, photography, event management and public relations. To Hong Kong's creative individuals, these are lucrative opportunities to take their creativity to the next level. Given the (English) language skill, overseas experience, well-rounded fashion knowledge, global connectivity and up-to-date fashion insight of Hong Kong's creative labourers, they

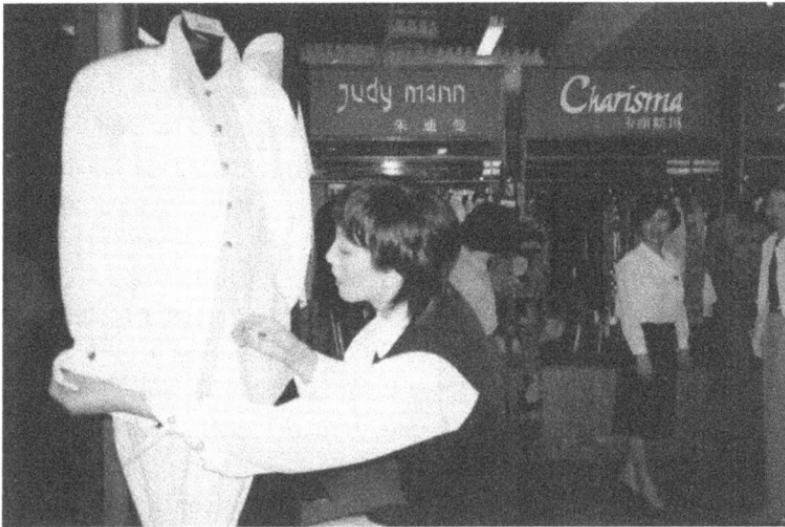

6.3 Judy Mann retail outlet in the Lufthansa Centre, Beijing 1994. Courtesy of Judy Mann.

serve the thriving fashion wave of the PRC. In particular, Hong Kong's distinctive creative individuals are highly sought after in the mainland.

Renowned Hong Kong artist-designer Stanley Wong is one who pervaded mutual exchange with his translocal and transcultural experience with the PRC. Having photographed a fashion collection for the mainland label, Exception de Mixmind, in 2000, Stanley, a home-grown graphic designer with overseas experience in advertising, took on a further role as the artistic director for the brand, working closely with mainland brand founder, Ma Ke, who was in charge of fashion design at the time. A champion of distinctive Chinese characters in design, Stanley insisted on the incorporation of Chinese elements into the brand. The experience to oversee its artistic direction and development across a country that has made changes to people's lives inspired him to popularise indigenous culture through artistic creation.[40] His exhibition 'Building RedWhiteBlue' (2004), in Hong Kong's Heritage Museum, mobilised Hong Kong's community to reflect on issues such as local identity, belonging and indigenous culture.[41] His work earned him an international reputation and a place representing Hong Kong in its pavilion at the 51st Venice Biennale (2005). He went on to advise Ma Ke's debut collection, 'Wuyong', in Paris Fashion Week (2007) with a dramatic mis-en-scène. Their mutually

beneficial exchange launched Ma Ke; history says that a second invitation from Paris followed, this time to Paris Haute Couture Week (July 2008),[42] and more recently, her appointment as the fashion adviser for the Chinese First Lady, Peng Liyuan. The collaboration of Wong and Ma pointed to the co-creation of Chinese fashion. Highlighted within is the making and creation of most fashion in many cities across different continents. Belgian designer Martin Margiela has long reminded us of the teamwork behind his label, and it has become apparent that most French designer labels as early as in the turn of the twentieth century employed a multinational skilled workforce – from Jewish to Turkish to Moroccan – in the sewing and pattern-cutting room.[43] Segre Reinach's scholarly analysis of Sino-Italian joint fashion ventures further unveiled the complexity of the country of origin when it comes to design.[44] There is no single creative genius in fashion design and innovation, and the case of China shows just how many agencies are involved in the making of fashion.

GUANXI AND WORK ETHIC

Whilst the example of Wong and Ma may be an exception, the mixed bag of translocal and transcultural experiences from Hong Kong's

6.4 'Created in China' collection at Lane Crawford, Hong Kong. Photograph by chapter author.

fashion creative labourers uncovers further unrest. A handful of studies on PRC-based Hong Kong creative labour have highlighted the work ethic of their mainland counterparts that affected their working experiences;[45] a case in point for further examination of Chinese creative labour. Similar concern was raised in my fieldwork. The fact that all my informants choose to be based in Hong Kong implies their reservation about relocation, despite a variety of reasons. A few described their discomfort with being asked personal favours when filling job vacancies. One reported a case as follows:

> This mainland girl's portfolio is lousy. She could not even write a proper CV. She wanted to work for that Hong Kong company and asked me to introduce her because I know the boss. I already explained to her the practice in Hong Kong. But then her father called me up from the mainland asking for the same thing. I told him Hong Kong didn't work like this. But he didn't seem to get it. They thought knowing someone is everything.[46]

A society relying solely on *guanxi* inevitably comes into conflict with Hong Kong. Luo pointed out the contrast made between the Chinese and the Westerner; while the legal environment is crucial to an organisation

6.5 Wuyong in Paris Fashion Week, 2007. Getty Images.

with Western roots, the Chinese viewed legal matters and laws as a sign of bad faith.[47] Because traditional China placed emphasis on personal relationships, the legal environment in China today remains relationship-based and differs greatly from the Western environment. Hong Kong's Chinese society has moved on from a relationship-based network to a legal-based system. The city promotes reward and respects hard work. In contrast, guanxi in China is a standard practice. Many business deals are secured through strong guanxi, of which, in recent years, Hong Kong's entrepreneurs have also played an active part. It is a clash of customs, yet one that may permeate, one to another, in no time.

Perhaps the most disturbing experience for Hong Kong's creative labourers is widespread corruption and money laundering in the fashion industry. The customary practice was frequently reported in the fashion media; for example, 'journalists won't show up to fashion events if not received "the envelope" [i.e., a bribe]. They have nothing to be ashamed of. Everybody knows the game.'[48] Before the establishment of the Independent Commission Against Corruption (ICAC) in 1974, corruption was unregulated in Hong Kong. 'Red money' was used to buy personal favours and launder money. This is now a thing of the past and the latest generation of Hong Kong's creative individuals are following their moral principles to resist temptation. 'There, money laundering and massed corruption prevail. Unlike China, it takes ten times harder for one to succeed in Hong Kong.'[49] Some stepped up to criticise the excessive media attention on mainland fashion, pointing the finger at the ethical practices of the inland fashion media: 'Those young journalists will just take it. They want it for new clothes and accessories anyway. I saw some girls shamelessly asked for it. They won't write for the brand without the envelope.'[50] Criticism goes further, to the lack of media attention for Hong Kong's fashion: 'Even if not the envelope, big labels buy up magazine pages with the return of editorial features on their brand. There is no scope to write about Hong Kong fashion. Now with the envelope in China, what space is left for it?'[51]

CONCLUSION

Translocal and transcultural interaction between Hong Kong and the PRC underlies the infrastructure of the fashion system in both regions.

Hong Kong's industrial and economic advancement led the mainland to progress in its own. By and large it is taken as a testing ground for the PRC to construct its kingdom of manufacturing and henceforth, a fashion empire with global recognition. Serving the mainland are professional trainers ranging from manufacturing to operational to design to managerial level, business connections, professional networks and comprehensive knowledge in the fashion industry. The niche of Hong Kong's creative labour grants them plenty of access to the mainland's fashion operations. Many are aware of the favourable conditions that exist for mainland fashion: media and worldwide attention, state support, vast financial investment, the economic power of the nation, China's position in the world and the question of how much longer Hong Kong can sustain its niche. The unparalleled support and attention given to their respective designer fashion adds bitterness and resentment to the mix. Underneath the practice of co-creation lie socio-cultural differences in the work ethic. Opening up is a geopolitical dimension to dissect the making of Chinese fashion.[52]

NOTES

1 Jianhua Zhao, The Chinese Fashion Industry: An Ethnographic Approach (London: Bloomsbury, 2013); also see ch. 3 in this volume.
2 (Gilbert, 2006).
3 Gu, ch. 5 in this volume.
4 Shang Xia is a luxury Chinese label backed by the French luxury brand, Hermès, which owns 75 per cent of the label. Meaning 'up and down' in Chinese, traditional Chinese craftsmanship, materials and motifs are revitalised in fashion and accessories, furniture and dècor, and jewellery and gifts. Chinese businesswoman Jiang Xuanyi, who has long been promoting cultural exchange between France and China, is the CEO and artistic director of the brand. Shang Xia has stores in Paris and Shanghai, and a pop-up store in Beijing (2016); Vivien Chen, 'Jiang Qionger of Hermès-backed Shang Xia brings Chinese aesthetics to the international stage', South China Morning Post, 1 September 2016. Available at http://www.scmp.com/magazines/style/tech-design/article/2008466/jiang-qionger-hermes-backed-shang-xia-brings-chinese (accessed 15 September, 2016).
5 Ranked twice (2016, 2015) as the number one global fashion school for both undergraduate and postgraduate courses by The Business of Fashion (The Business of Fashion, 'Global fashion school rankings 2016'. Available at https://www. businessoffashion.com/education/rankings/2016 (accessed 15 September

2016), Central Saint Martin (CSM) fashion graduates are the most sought-after fashion labourers in China as well as in most Asian countries. Many are given instant exposure and prosperous job offers upon graduation. CSM has become a golden label for creative fashion labourers in China. Most designers equip their creative profile with the institution's name, some even use it to define their creative styles. Because of the reputation of the institution and the instant credit it brings, many barely complete a short course there but aim to affiliate with it. The 'claim' of being a CSM fashion graduate is widespread in China (and Asia), and it is almost impossible to detect its accuracy.

6 See ch. 10 in this volume.

7 Clark, ch. 9 in this volume.

8 Xinzhong Yao, *An Introduction to Confucianism* (New York: Cambridge University Press, 2000).

9 Alana Connor, 'It's not about the work ethic', *Stanford Social Innovation Review* 7/4 (2009), p. 1; George Hicks, 'Explaining the success of the Four Little Dragons: a survey', in Seiji Naya and Akira Takayama (eds), *Economic Development in East and Southeast Asia: Essays in Honor of Professor Shinichi Ichimura* (Singapore: Institute of Southeast Asian Studies; Honolulu: The East-West Center, 1990), pp. 20–37; Hung-Chao Tai (ed.), *Confucian and Economic Development: An Oriental Alternative?* (Washington, DC: The Washington Institute Press, 1989); Geert Hofstede and Michael H. Bond, 'Confucius and economic growth: new trends in culture's consequences', *Organizational Dynamics* 16/4 (1988), pp. 4–21.

10 Greg Mastel, *The Rise of the Chinese Economy: The Middle Kingdom Emerges* (New York: M.E. Sharpe, 1997); S. Gordon Redding, *The Spirit of Chinese Capitalism* (New York: De Gruyter, 1993).

11 Wessie Ling, 'From "made in Hong Kong" to "Designed in Hong Kong": searching for an identity in fashion', *Visual Anthropology* 24/1–2 (2011), pp. 106–23.

12 Juanjuan Wu, 'Shaping Chinese fashion identity: inter-Asian influences in the case studies of six fashion designers', in Yuko Kikuchi, Wendy Wong and Yunah Lee (eds), *Reader in East Asian Design* (Leiden: Springer, forthcoming).

13 See Clark, ch. 9 in this volume.

14 Jingyi Lu, 'Creative industry in Hong Kong', unpublished report for Hong Kong Polytechnic University, September–December 2011. Available at http://www.innovhub-ssi.it/c/document_library/get_file?uuid=8b875c19-26e1-44d5-9dbc-38bed90082c0&groupId=11636 (accessed 27 July 2016).

15 Felix Chung, 'Proposal for the establishment of "Fashion Hong Kong"', Hong Kong: Legislative Council, unpublished, 2013. Available at http://www.felixchunghk.com/Content/upload/20141111-104345.pdf (accessed 15 June 2015).

16 Catherine Schenk, 'Economic history of Hong Kong', in Robert Whaples (ed.), *EH.Net Encyclopedia*, 16 March 2008. Available at https://eh.net/encyclopedia/economic-history-of-hong-kong/ (accessed 27 July 2016).

17 Chung, 'Proposal for the establishment of "Fashion Hong Kong"'.

18 Peter McNeil (ed.), *Fashion: Critical and Primary Sources* (Oxford: Bloomsbury, 2009).

19 Against the backdrop of the sunset clothing and textile industry, the local fashion industry saw the three-year (2015–18) investment of HKD$500 million (equivalent to US$64.46) from the Hong Kong Special Administrative Region's (HKSAR) government. On a pilot basis, a series of measures are planned to support the development of the fashion industry. This includes the promotion of Hong Kong's fashion designers and brands through improving local fashion events and participating in those held overseas; the roll out of an incubation programme for up-and-coming fashion design start-ups, with reduced rental space and production subsidiaries; the provision of overseas internships and study opportunities for fashion design graduates, and participation subsidies for international competitions and exhibitions. It is believed that these measures will pin Hong Kong on the world fashion map.

20 Daniel Poon, 'Clothing industry in Hong Kong', TDC Research, 30 June 2016. Available at http://hong-kong-economy-research.hktdc.com/business-news/article/Hong-Kong-Industry-Profiles/Clothing-Industry-in-Hong-Kong/hkip/en/1/1X000000/1X003DCL.htm (accessed 27 July 2016).

21 Chung, 'Proposal for the establishment of "Fashion Hong Kong"'.

22 Poon, 'Clothing industry in Hong Kong'.

23 Lawrence Leung, interview with author, Hong Kong, May 2015.

24 Cf. Wu, ch. 4 in this volume.

25 Wessie Ling, 'Korea vs Paris: there is no fashion, only image or how to make fashion identity', in Roy Menarini (ed.), *Cultures, Fashion and Society's Notebook* (Milan-Turin: Bruno Mondador, 2016), pp. 1–14.

26 Lise Skov, '"Seeing is believing": world fashion and the Hong Kong Young Designers' Contest', *Fashion Theory* 8/2 (2004), pp. 165–93.

27 Sarah Karacs, 'Fashion faux pas: why Hong kong designers struggle to make a global impact', *South China Morning Post*, 7 July 2016. Available at http://www.scmp.com/news/hong-kong/economy/article/1986777/fashion-faux-pas-why-hong-kong-designers-struggle-make-global (accessed 27 July 2016).

28 Javier Gimeno-Martinez, *Design and National Identity* (Oxford: Bloomsbury, 2016); M. Angela Jansen and Jennifer Craik (eds), *Modern Fashion Traditions: Negotiating Tradition and Modernity Through Fashion* (Oxford: Bloomsbury, 2016); Simona Segre Reinach, 'National identities and international recognition', *Fashion Theory* 15/2 (2011), pp. 267–72.

29 Virginia Lau, interview with author, Hong Kong, May 2015.

30 Lawrence Leung, interview with author, Hong Kong, May 2015.

31 Judy Mann, interview with author, Hong Kong, May 2015.

32 Ibid.

33 Ibid.

34 Wessie Ling, '"Fashionalisation": urban development and the new-rise fashion weeks', in Jess Berry (ed.), *Fashion Capital: Style Economies, Sites and Cultures* (Oxford: Inter-Disciplinary Press, 2012), pp. 85–96.

35 Judy Mann, interview with author, Hong Kong, May 2015.

36 Ibid.

37 Vivian Chen, 'How young Chinese fashion designers are making their mark in the global industry', *South China Morning Post*, 2 June 2016. Available at http://www.scmp.com/magazines/style/article/1955200/young-contemporary-fashion-designers-are-stamping-their-mark-global (accessed 15 September 2016).

38 Vicky Ho, interview with author, Hong Kong, May 2015.

39 Camille Kwan, interview with author, Hong Kong, May 2015.

40 Stanley Wong, interview with author, Hong Kong, May 2015.

41 Wessie Ling, 'A bag of remembrance: a cultural biography of the red-white-blue, from Hong Kong to Louis Vuitton', in Regina Blaszczyk and Véronique Pouillard (eds), *Reinventing European Fashion: The Post War Transformation of a Creative Industry* (Manchester: Manchester University Press, 2018), pp. 282–301.

42 When the invitation for the brand Exception de Mixmind to Paris Fashion Week arrived, Stanley Wong and Ma Ke shared a similar view – to present something distinctive and uniquely Chinese. Hence, a new collection named Wuyong (est. 2007) was conceived. The earthy-toned collection consisted of garments of hand-dyed sustainable materials, hand-sewn and embroidered by a group of redundant skilled craftswomen from a provincial Chinese town. The collection was destined neither for sales nor a target market. The showpieces were employed for Ma Ke to express her concern over the country's rapid urbanisation and its inevitable impact on ordinary people's lives (Ma Ke, interview with author, London, June 2008). The show was staged in the gymnasium of the Lycée Stanislas in Paris, and Stanley ensured a dramatic *mis-en-scène* by instructing the models of the new collection to stand still on a plinth for the duration of the show. Audiences were invited to walk around them to preview the clothes. Shortly after the show, Wuyong became the subject of an award-winning documentary directed by Zhangke Jia (Venice Film Festival, 2007). The following year, it was featured at the Victoria and Albert Museum in London and Ma Ke was invited to present Wuyong's second collection in Paris Haute Couture Week (July 2008).

43 Nancy Green, *Ready-to-Wear and Ready-to-Work: A Century of Industry and Immigrants in Paris and New York* (Durham, NC: Duke University Press, 1997).

44 Simona Segre Reinach, 'Fashion and national identity: interactions between Italians and Chinese in the global fashion industry', *Business and Economic History 7* (2009). Available at http://www.thebhc.org/sites/default/files/reinach.pdf (accessed 15 July 2016).

45 Yiu Fai Chow, 'Hong Kong creative workers in Mainland China: the aspirational, the precarious, and the ethical', *China Information* 31/1 (2016), pp. 43–62; Anthony Fung and John Nguyet Erni, 'Cultural clusters and cultural industries in China', *Inter-Asian Cultural Studies* 14/4 (2013), pp. 644–56.

46 Edith Cheung, interview with author, Hong Kong, May 2015.

47 Yadong Luo, 'Guanxi: principles, philosophies, and implications', *Human Systems Management* 16/1 (1997), pp. 43–51.

48 Judy Mann, interview with author, Hong Kong, May 2015.

49 Ibid.

50 Jing Zhang, Keynote speech, Fashion in Fiction: Style Stories and Transglobal Narratives Conference, City University of Hong Kong, Hong Kong, 12–14 June 2014.

51 Ibid.

52 The author would like to thank the following individuals for their contributions to this chapter: Edith Cheung, Felix Chung, Vicky Ho, Camille Kwan, Virginia Lau, Lawrence Leung, Ma Ke, Judy Mann, Caroline Roberts, William Tang and Stanley Wong.

7

MULTIPLE FACES OF COSPLAY: RAIDING THE DRESSING-UP BOX ACROSS THE CHINA REGION

Anne Peirson-Smith

INTRODUCTION

This chapter examines the practice of cosplay, the trend for young adults in Hong Kong and Southeast Asia to dress up in themed costumes assuming the persona of characters from Japanese comic books (manga), animated cartoons (anime) and video game characters, as a means of exploring the motivations behind this activity across multiple locations in China and Asia. The various practices that make up this rapidly spreading phenomenon will be examined from the players' own perspectives, questioning why dress is used as a catalyst for escaping the boundaries of self and acquiring multiple identities. It will also address how the transcultural similarities and differences of this practice manifest themselves in different geographic places, given the political, economic and social disparities in each. The outcomes of this ethnographic study will be presented based on interviews and focus groups conducted with a selection of cosplayers in Hong Kong, Macau, Tokyo and Beijing who

regularly dress in a range of costumes in public places and at organised, themed events. The visible, often mediated, adherence to a defined and reassuring style tribe collective seems to fill an affective void and offers solace from the pressures of urban life in the China region that essentially takes on a range of localised cultural appropriations and hybridised agendas across geographic spaces and places within the China context.

The following examination of the cosplay trend in the China region aims to determine the underlying motivations as to why and how individuals become involved in cosplay activity across the region by accounting for variations in the way that this dress-up practice is implemented, given the cultural and structural differences of the country of origin. In doing so, the chapter will identify the transcultural and social influences underlying this 'fantastic presentation of self',[1] and the communication of costumed identity amongst particular groupings of spectacular neo-style tribes within the varied urban spaces of sites across the China region as ground zero for this practice.[2]

Firstly, the chapter will present the background concepts underpinning the transcultural flows of popular culture in the region across borders, followed by an analysis of cosplay as a situated practice illustrated by ethnographic data, as a way of accounting for the similarities and differences of this costumed activity in terms of play across the China region.

TRANSCULTURAL FLOWS OF POPULAR CULTURE IN ASIA

The exponential transnational flow of mediated images and commodities is a hallmark of the late twentieth century as media conglomerates fully utilised their production and promotional systems to create and disseminate cultural outputs globally. The cultural globalisation of largely American/Western media products has been well covered and much debated as the driving force behind a neo-imperialist cultural world takeover.[3] More recently, the intra-cultural, regional circulation of Asian-grown popular culture products has followed similar trajectories in fashion from Japanese streetwear[4] to Hallyu culture.[5]

Whilst youth situated in Southeast Asia constitute a notable market for globalised media offerings such as Hollywood movies, Western pop music and high street fashion, since the 1970s they have also been increasingly consuming Japanese popular culture outputs such as manga, anime, video games, popular music and TV programmes. This intra-cultural trend was heightened in the past decade with Japanese popular cultural products offering Asian youth an alternative, and perhaps a more relatable, consumption space to Western popular culture offerings. Across the twentieth century, non-Western cultures may have consumed Western cultural products as 'other' cultural forms, given that expressions of their own lived modernity were not encouraged, allowed or accommodated in view of the dominant Western cultural, military, political and economic influences exercised across the globe and within imperial spaces. This was true for Hong Kong, Singapore and Macau under the respective long-term sovereignty of Britain and Portugal. Whilst China and Japan, in contrast, largely retained their political, economic and cultural autonomy over millennia, albeit subject to domestic upheaval and external military takeovers, engendering a strong sense of nationhood through cultural output.

In the past, a global cultural hegemony represented a one-way flow of influence and an embodied form of cultural control that was more ego-centred than autocratic. Hence, the colonial powers dominating the Asian political landscape at the time largely failed to pay attention to, or recognise the validity of, other non-Western cultural forms, other than in an orientalising manner[6] when appropriating Japanese kimonos and oriental signifiers, for example, into their own art-forms and consumer worlds in a uni-directional manner.[7] However, maybe this cultural neglect actually and unwittingly accommodated a cultural space in which local cultures could and would develop their own versions of cultural output, albeit sometimes as a facsimile of Western outputs, to make sense of the difference in their ideologies, world views and different ways of being. This was the case with the early Japanese manga of Tezumi that was originally inspired by Disney cartoons, for example. The emergence and popular take-up of Asian cultural forms, such as Japanese anime and manga and their creative

expression and appropriation in youth practices such as cosplay, evoke forms of Asian modernity for its participants. In doing so, they highlight the similarities and differences of Asian cultures, given their essential heterogeneity in a more nuanced form, that have an obvious appeal in terms of enabling them to make sense of lived experiences based on mediated narratives possessing cultural and geographic proximity that are largely familiar. Yet, at the same time the intra-regional cultural flow of such content also contains references, practices and heritage that offer alluring cultural linguistic, stylistic and historic differences, whilst representing a decentring trend for Western cultural outputs.

Hence, the centre-periphery model of cultural flows and the cultural appropriation from West to non-West no longer prevail when examining aspects of cultural borrowings. A reworked perspective is needed, given the considerable complexity and fracturing of transglobal flows of goods and ideas across multiple-scapes[8] in terms of Japanese fashion;[9] Indonesian street style[10] or Hong Kong lifestyle retail.[11] This would more accurately represent the newer range of cultural outputs, such as cosplay, that have recently emerged. In doing so, it serves to highlight the relative shift in Western cultural power embodying the reduced impact, absorption and reworking of Western cultural products at the local level and the evolution of a localised intra-cultural exchange and adoption of popular culture outputs.

Cosplay represents this trend for the decentring of Western cultural dominance in the wake of its replacement by the rise of Japanese soft power reflecting the economic strength of the 1990s in the form of a newly dispersed transnational cultural flow – a phenomenon that we have also seen in the early twenty-first-century fashion system. In parallel, this inter-Asian cultural exchange is equally evident in the local Hong Kong fashion scene, where Japanese fashion in the 1990s and, more latterly, Korean fashion are hugely influential in affecting contemporary youth style trends.

The cosplay development represents the evolving entertainment landscape in Southeast Asian cities, where players are expressing themselves as active pro-consumers of manga and anime in the entertainment economies of China, Hong Kong, Indonesia, Singapore,

Thailand and Malaysia, for example. As such, it has been affected by the activities and outputs of Japanese media producers making their cultural products, such as manga and anime, available locally, regionally and globally as an outward 'glocalised' cultural flow. Yet, this push of product cannot purely explain the nuanced pull of consumer popularity that these cultural outputs have enjoyed, nor can it totally account for their transnational impact and different manifestations across the Asian region in particular. Hence, this chapter will examine the popularity of cosplay as a creative practice across Asia with the intention of understanding how cosplayers, as active agents of production and consumption, create new imaginaries that are re-worked and re-imagined across a range of varied local Asian cultural contexts. It will be argued that cosplayers are not essentialising Japanese cultural characteristics and attributes embodied by the characters in their activity, because of a mere alignment with 'cultural proximity'[12] or the representation of familiar Asian values, but rather are drawn to the activity because it offers to sense-make, using narrative content as a reference point that is familiar to them. At the same time, it represents a culture that is suitably different, open to interpretation and consequently alluring.

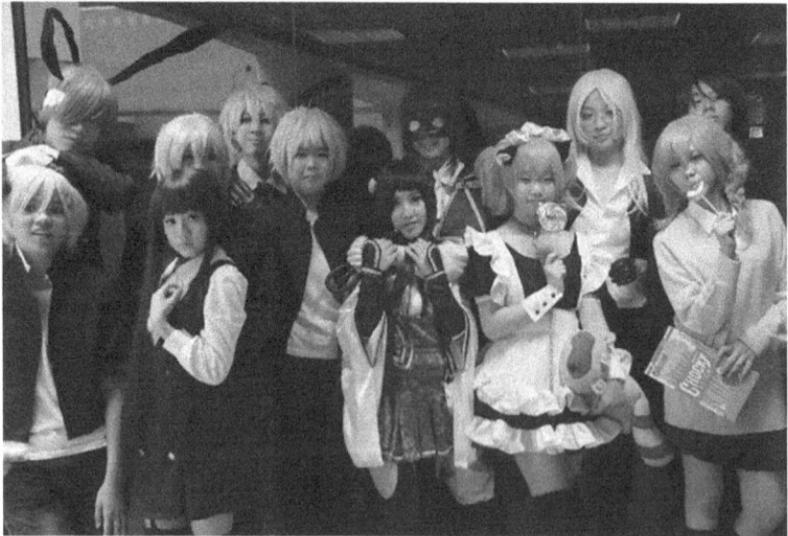

7.1 Cosplayers at Hong Kong University cosplay event. May 2013. Photograph by chapter author.

THE COSPLAY LANDSCAPE

Cosplay involves young adults dressing up in themed costumes and taking on the persona of characters from Japanese comic books (manga) and animated cartoons (anime), including other mediated sources such as fantasy film, television shows and video games. It is currently a popular trend across Southeast Asia, with evidence of a growing global expansion. Throughout Asia, Japanese comics or graphic print narratives (manga) and animated images (anime) have gained in popularity beyond their Japanese source from the 1970s onwards.[13] This cultural transfer, founded largely on a significant global marketing push by the Japanese animation and publishing houses[14] and the Japanese government's investment in promoting soft power, has exercised a significant influence on the indigenous comic and animation industries where it has taken root in the local popular cultural landscape in terms of narrative content, artwork design and format. The manga and anime subculture has also impacted on the lives of the young consumers avidly following mediated cultural products, suggesting a close alliance of interests and predispositions based on shared experiences across demographic groups of young people in Asia despite, and perhaps in spite of, criticism from older demographic sources and media industry representations fearful of a Japanese cultural takeover[15] or insensitivities to past historical events. The significant quantity of narrative content across the past 40 years of Japanese anime and manga production has provided a large resource of characters to choose from, whether from science fiction or romantic space fantasy genres. This 'flying geese trend'[16] and the appropriation of cultural processes are also evident amongst the dressing-up activities of cosplayers. These similarities and differences of cosplay across the China region will be examined next.

MAPPING COSPLAY CULTURE: SIMILARITIES AND DIFFERENCES

It is useful to map the similarities and differences accounting for the appropriation of cosplay culture as a way of understanding its appeal and to determine whether this is based on distinct local takes on the practice,

rather than unifying principles facilitating its spread across cultural spaces and places. As Appadurai noted, 'the most valuable feature of the concept of culture is the concept of difference, a contrastive rather than a substantive property of certain things ... that can highlight points of similarity and contrast between all sorts of categories: classes, genders, roles, groups, and nations'.[17] Cosplay is a practice with a cultural dimension based on an amalgam of influences and uneven flows creating a multiplicity of cosplay cultures wherever it takes root. Hence as a cultural practice it can usefully be understood in terms of its being a 'situated difference ... in relation to something local, embodied and significant' with the proviso that 'culture is not usefully regarded as a substance but is better regarded as a dimension of phenomena, a dimension that attends to situated and embodied difference'.[18]

On the one hand, it would seem that there is a universality that the players share in terms of exercising dressing-up habits, affective character connections, the notions of escapism and shared play experiences based on familiarity with the narratives. Whilst, on the other hand, discernable differences occur in the practice of cosplay across this region in terms of how costumes are constructed, the characters chosen, and the way it is played, plus the content and settings of the practice.

Each of these perspectives will now be examined in turn and will be accounted for in terms of a differentiated demographic value system across youth cultures. Basically, this can be located in the representation of relative agency and power amongst cosplayers based on the political, economic and cultural characteristics of their given geographic habitus in terms of having access to the economic ability to produce and distribute cultural goods; the cultural ability to produce and circulate form and meaning and the latitude for shaping desire, fantasy and imagination against the backdrop of prevailing political ideologies.

This study draws on ethnographic data generated from observational field research at cosplay conventions and interviews across Hong Kong, Beijing, Macau and Tokyo. The sample comprised a mixture of over 40 participants, either students or professionals located in the creative and communication industries located in the China region of Hong Kong, Macau, Beijing, and in Tokyo as the original source of the activity. The ethnographic, qualitative research approach adopted here is intended to

reflect the lived and subjective realities of the cosplayers themselves as an informative source.[19]

Varied presentation of the costumed self

One of the common requirements of cosplay is that the characters physically dress up and make up as their chosen persona. The costumed player appears to be projecting the latent self into the public domain, adapting Eicher's typology of the three selves as manifested through dress via the public, private and secret self.[20] The public persona openly communicates the demographic features and professional garb of the wearer, whilst the private self, familiar to friends and family, is based on the clothing of relaxation and leisure, with the secret self being a restricted zone reserved for the individual wearer and intimates, often featuring fantasy dress. Across all of the regions studied, cosplay appeared to comply with this model of cosplay representing the secret self in a quasi-public context. Yet, in more culturally conservative cities such as Hong Kong, Macau and China, the prospect of appearing in public streets in full garb was not so appealing, as cosplayers appeared more self-conscious about limiting their appearances to the official zones of conventions or official events. Hence, cosplayers in Hong Kong, Macau, and Beijing typically carry costumes and props in suitcases to the site of the events, dressing up in washrooms or in quiet corners of the cosplay event space. This contrasted with the Tokyo players who are more inclined to blur the lines between revealing the secret, private and public self by often walking though the streets of Harajuku district in full costume, alongside the diverse range of street fashion referencing subcultural styles across time and place.[21] Whilst this may be due to the fact that cosplay has been practised for longer, a pragmatic view was also provided by Tokyo respondents, who suggested that they were more prepared to appear in costume in public spaces because they had no option and that this was accommodated in a city renowned for street fashion on overt display.

However, once dressed at the event location all cosplayers proceed to finalise their appearance in semi-public view in the manner that Barthes observed of Bunraku puppetry, which also 'separates action from gesture, it shows the gesture, it lets the action be seen, exhibits simultaneously the

art and the labor'[22] with a blurring of the back- and front-stage preparation at the site of practice. The costume itself appears to invest all wearers across cultures with agency, transforming their behaviour and empowering them.

DIY costume construction

Consistently, cosplay character costumes are often localised through the process of do-it-yourself (DIY) costume making, where authenticity of replicated character is a critical part of the endeavour. This DIY construction of costumes parallels the improvised approaches to other material forms of subcultural style, such as the punk and Goth movements.[23]

A sliding scale of creative practice operates, as players ideally make their own costumes, have them tailored or purchase them from online Japanese sites, or cheaper, lower-quality Chinese vendors and further modify them. The players interviewed in Tokyo seemed to suggest that all types of costumes and their sourcing and construction were acceptable as long as players wanted to cosplay. In Hong Kong and Macau many respondents insisted that an authentic costume was critical, suggesting that there was no excuse in terms of ensuring the absolute authenticity of costumes and accessories, given that they resided in the world's garment production hub. As one participant explained:

> It's so convenient to go to the garment district of Sham Shui Po for cloth and trims or to go to Shenzhen to source accessories – swords, wigs, boots, coloured lenses and all that and it's not too expensive really. I didn't realise how easy it was until I was chatting online to a Canadian cosplayer who was desperately trying to find an affordable wig and she told me how hard it all was to get her costume and so costly (Jett, Hong Kong, female cosplayer, age 22).

One respondent in Hong Kong also told 'a really sad story' of seeing cheap online ordered garments dumped in a bin after an event, which they considered to be unacceptable behaviour, suggesting that the affective connections were not established unless someone had actually sourced and made the garment themself. This adherence to authenticity

establishes a form of connoisseurship and display of cultural and economic capital amongst players in Hong Kong and Macau that may reflect the need to demonstrate their deep understanding of the imported cultural form and their validated right to membership of the cosplay club. The producer-consumer relationship also varies in alignment with the economic capital of the players. In Hong Kong, entrepreneurial fashion students offer their tailoring services to cosplayers and often family and friends help out in their sourcing and construction. Equally, both male and female participants in Hong Kong actively made their own costumes, contradicting the traditional gendered notions of dressmaking, yet reflecting the demographic of the fashion design system in a former centre of garment production. In the more traditional culture of Beijing, cosplayers also tapped into the local tailoring tradition by outsourcing the construction of their costumes to a local female dressmaker, submitting sketches or photos of the required costumes, followed by a fitting, with the finalised outfit being ready for collection within a week. Hence, the demand for costume production, whilst outside of the fashion system, creates and supports creative micro-economies across the China region and shares sourcing platforms with the system in terms of small runs of fabric and trims. In this sense, cosplay is a form of 'fashioning' the body and provides players with creative skills well suited to the fashion business.

Affective character connections

Players in all locations consistently explain that the activity is all about expressing a deep devotion, or möe,[24] to a chosen character representing their core self and inner feelings through presentation of self in character costume where dressing up is dressing into an ideo-culture[25] as a material expression of devotion. Furthermore, the participants in Beijing stressed that cosplay demonstrated a visible aspect of the deep devotion that they had for Japanese culture, despite discouragement from older generations with a collective memory of the mid-twentieth-century Japanese incursion. Hong Kong participants were more sanguine about the level of their devotion to Japanese cultural output as a whole, given that they have had free access to it for most of their lives. Nevertheless, they all signalled a personal, participatory fan-based devotion to a

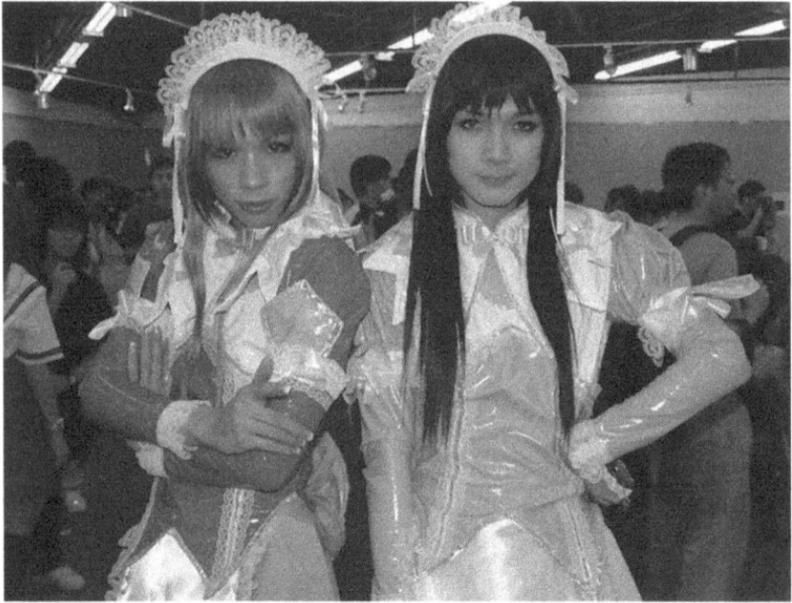

7.2 Male cosplayers at Hong Kong University of Science and Technology cosplay event. July 2012. Photograph by chapter author.

fantasy-driven universe where manga, anime or super heroes reside, which they have often followed since childhood, whilst expressing their affective connection with specific characters and their bond with a likeminded fan cohort.[26] These connections are played out amongst an audience who are familiar with, and actively encode and decode, cosplay in the light of their interpretative frameworks based on shared memberships of 'webs of significance',[27] and knowledge communities. Here they enact identities grounded in cultural products that are simultaneously culturally specific and globally recognised.

Inspirational sources

Significantly, a common theme in anime stories is the successful yet ongoing challenge to, and overthrow of, corrupt, controlling, sinister regimes that are usually overcome in the end by resourceful mini-heroes, often in the form of women or children in possession of magically invested outfits and accessories. The creation of a fantasy utopia mimicking miniscule superheroes who constantly triumph over evil

could be a comforting and controlling zone to inhabit, whereby a young cosplayer can be in constant command of their virtual destiny. This is possibly symbolic of the colonial and global economic and political struggles that Asian countries have historically endured. Cosplayers in China can relate to these narratives in terms of the universal struggle for Asian youth to achieve academically and financially under considerable pressure and expectations from their parents. Hong Kong youth, meanwhile, are relating it to their struggle against the Beijing government for preservation of democratic freedoms, universal suffrage and an assured future in the wake of the Occupy Central protests, and the Scholarism and Localism movements.[28] Given the liberalised school curriculum, which has latterly introduced topics of study such as popular culture and fashion studies, Hong Kong youth have experienced the latitude to freely access and consume these cultural forms for enjoyment and sense-making, unlike their peers in Mainland China, perhaps.

The situational contexts of the manga and anime narratives range from those culturally situated in Imperial Japan to mythic dystopian futuristic landscapes. On the one hand, storylines are quintessentially recognisable as representing Japanese culture, which may be a large part of their appeal. Western superheroes and narratives such as Star Wars and Harry Potter are very popular in post-colonial Hong Kong and Macau, compared with other urban Chinese locations and many of the futuristic or European-based narratives, such as Rozen Maiden, could also be considered as culturally 'odourless'.[29] This universal narrative appeal could also be seen to account for their draw in cosmopolitan places such as Hong Kong, given its construction as a global trading hub, by enabling the recreation of and referencing to a world of princesses and heroes appearing to have Western or even Disneyfied undertones, which players admitted they had often dressed up as when children. As Mitzuki in her Rose of Versailles crinoline explained:

> I've always dressed up as a Disney type princess from being small after seeing those cartoons like Sleeping Beauty so for me it's a continuation of that and I loved the Rozen Maiden stories and characters as I felt like I belonged in that world (Mitzuki, female Hong Kong cosplayer, age 21).

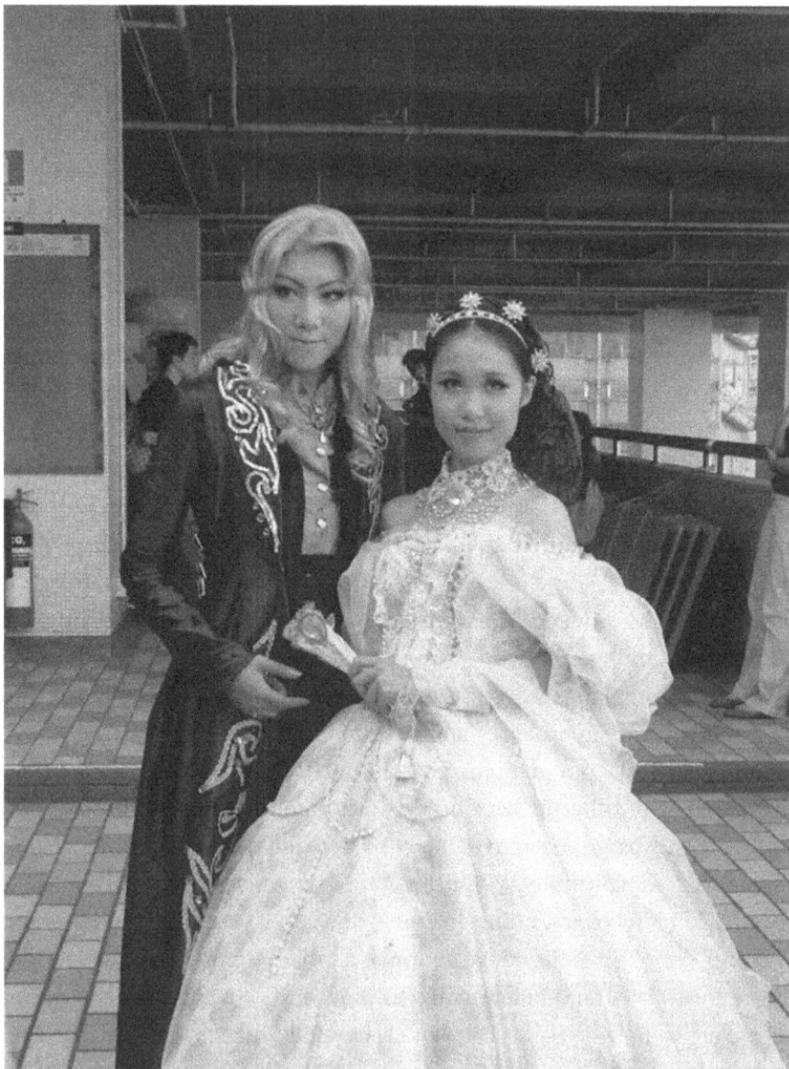

7.3 Cosplayer Mitsuki in Marie Antoinette anime outfit with cosplay partner. December 2009. Photograph by chapter author.

THE COSPLAY FAMILY AS CREATIVE PRODUCERS

Across the Asian cosplay scene the production and consumption cycle involves a range of people cooperating at different points and in different ways, with varying levels of agency. One informant explained how

cosplay had changed her whole approach to life, connecting her to a community of like-minded players creating a 'cosplay family' offering unconditional support and filling the affective gap in Asian cities where the traditional nuclear family is increasingly fragmenting under the demands of post-industrial lifestyles:

> I always was shy at school and didn't think that I was good at anything. I had no real friends actually. Then I started to cosplay ... five years ago when a classmate invited me along ... I was part of a group doing the same story. When we got to the place we all started to help each other get ready – putting on make-up and combing out wigs. It was friendly and about caring for each other (Tine, female Hong Kong cosplayer, age 25).

Interestingly, as a point of cultural specificity, the players in China appeared to work more cohesively as a group from costume and prop sourcing and production to performance, as a reflection of perhaps stronger collectivist tendencies in the culture. In addition, it may afford China-based players the wider familial structure that China's one child policy has denied them. In Hong Kong and Macau, where large families are common, yet where social policy findings consistently highlight the breakdown of the nuclear family under the strain of long working hours at the expense of family relationships, young people often claim to be closer to their peers than their actual relatives. This highlights the social capital of the activity as supported by multiple feedback from cosplayers in all regions emphasising that this is a space to make real friends based on shared passions and creative or craft skills as prosumers[30] responsible for designing, making or customising their costumes.

COSPLAY RULES

From observation, the notion of cosplay as a form of playful, fun-based activity in costume appears to be a universal trend across the China region, yet differences of practice appear in the type and form of play reflecting the different value systems that prevail and the varied forms of power relations on display between players and institutional actors.

The play aspect of cosplay can be differentiated in terms of the ways in which the process of play[31] manifests itself on a sliding scale from the unstructured, improvised 'paida' style of play, to the more rule-based and arbitrary conventional 'ludic' approach.[32] Cosplay appears to cover both of these types of play activity in different parts of the China region. Given the relatively liberal economies, quasi-democratic leanings and post-colonial heritage of Hong Kong and Macau, there is more scope for open types of play, manifesting itself in the free choice and range of characters that a player can choose to inhabit at public conventions, university anime society meetings, cosplay cafes or private gatherings. By way of contrast, and indicative of its longevity, in Tokyo the cosplayers gathered at Harajuku Bridge seemed to 'play' differently. Here they are arranged in a free-form way, clustering territorially in small groups in the corners of the open public area, reminiscent of the school playground without much active contact with each other as a meeting point, a tourist attraction or a cultural showcase. Meanwhile, in China, where cosplay appears to be more controlled and is mainly organised around competitive, regionally based local government-run or large commer-cialised events such as the ChinaJoy national and regional competitions, it is ritualised in a more traditional sense and controlled by the 'ludic' rules of local and national competitions run by the authorities or commercial operators. Typically, in China, teams of players enact their favourite anime plot or traditional Chinese legends such as The Monkey King, preferred by the local authorities over Japanese cultural texts, as would a Peking Opera theatre troupe. Familiar characters and storylines are used, inspired by homegrown myths and legends or selected 'fragrant' Japanese sources such as *Final Fantasy V*, for example. In the form of a 'skit', the scripts and soundtrack are composed by the group and evolve over months of rehearsals, right up to the point of competitively staged performances at various junctures of the competition in front of a seated audience and judging panel. The notion of controlled play in terms of content and structure is more evident in China, where agency is more negotiated between the players and the authorities, as exemplified when the Chinese authorities banned overly revealing costumes in the interest of preserving moral values at the 2015 ChinaJoy competition,[33] which Hong Kong or Macau have not yet experienced. In Hong Kong mild

social regulation is limited to negative coverage of cosplay as a time- and money-wasting hobby that youth should avoid, or where parents make the activity conditional on attaining good grades in school.

Capturing and controlling the costumed moment

Recording and mediating the cosplay experience in the form of photo-taking is also critical across all of the geographic communities investigated and is equally subject to prescriptive etiquette controlled by the players themselves. Across all of the locations studied, players reserve the right to refuse potential photographers within the cosplay 'code' of rules. When permission is granted they respond with full concentration and assume the multiple poses of a session model. There are strong feelings regarding the boundaries of control between player as 'spectacle' and photographer as 'voyeur', and care is taken to respect and enforce these limits within the etiquette of practice. Personal observations at Hong Kong- and Macau-based events where the presence of significant numbers of hobby photographers (almost as many as the players themselves) and friends or other players taking photos of the players seemed to validate the player's role as they enact static poses and frozen scenes from their heroic character-based narratives. The large presence of hobby photographers in Hong Kong and Macau contrasted with their relative absence in Beijing, a possible reflection of the relative lack of economic capital for this group in comparison to their peers in Hong Kong. The rules of engagement and directives from players also took on a different twist with onlookers at Harajuku, as some groups were seemingly protected by a non-costumed male minder in t-shirt and jeans who persistently demanded money from onlookers before photographs could be taken, which again suggested that the activity was at a more advanced, commercialised stage of evolution.

TRANSGRESSIVE COSPLAY SPACES

The appeal of cosplay perhaps also lies in a shared need across the Asian youth demographic to create a space to which they can escape physically, as well as psychologically, away from the pressures of everyday life or small, densely populated, shared living experiences in Asian cities.

In their stylised presentation of fictional selves cosplayers also appear to reinterpret and re-appropriate the normal usage of public city spaces in which they regularly appear in character costumes. While a minority of players interviewed in Hong Kong and Macau did admit to dressing up and practising character poses at home in the secret spaces of their bedroom or in private parties, most considered the practice to have its rationale in the public spaces and places of the city, though usually at an event, in a group, or at a private meeting. Hence, Hong Kong cosplayers often seek out older buildings such as disused World War II gun emplacements and disused troop barracks for photo shoots and private meets, or choose fantasy settings, such as Hong Kong Disneyland. This public display is less common in China, yet one group of Beijing players tracked during research fieldwork in May 2010 also regularly chose historic locations in the city such as the 798 Art District. This disused 1950s East German designed electronics factory zone on the edge of the city, complete with warehouses and a disused old steam train, was the improvised setting in which to conduct cosplay photo shoots. The players observed during this photo-shoot relished recording the visually incongruous juxtaposition of the formalist architectural backdrop with their post-modern cartoon costumes. In addition, the transgressive nature of their activity possibly added to the liminoid experience[34] given that this free-form style of cosplay is not encouraged in China, as one of the informants said:

> We aren't really meant to do this but we've found the perfect place to be cosplayers against these historical buildings with lots of ghosts of the past so it really works for us and it's a special location to bring our character and costume alive (Fran, female Beijing cosplayer, age 19).

This also underlines the importance of actively re-appropriating spatial settings both within the architecture of the modern Asian city, and of manipulating and aligning its surface meaning as an extension of costume and as a space for the creative expression of cosplay.

The blurring of gender roles when cosplaying or 'cosing' a chosen character is also good example of the interpretative and transgressive aspect of cosplay as the narrative content of some manga and anime texts seem to openly legitimise the androgyny and homosexual, romantic

tendencies of the central characters. In response, many female players in Hong Kong and Macau dress up as male characters, while some male players also dress as females, highlighting the gender fluidity, masquerading[35] and performative aspects of this dress-up practice where identity and gender is performed.[36] Perhaps as a reflection of China's deep-rooted conservatism or 'anxiety, ambivalence and pleasure'[37] towards issues of gender, sex and sexuality in post-colonial Hong Kong, these players across all spaces were often adamant that cross-dressing players were not expressing an alterative sexuality. Yet, this undoubtedly enables them to explore and objectify their sexuality in a safe collective, as one female player said:

> I love the male character in the anime Naruto, and will dress as him even though he is a boy and I'm a girl. This isn't the point. We're not interested in what sex they are because I'm more interested in being him and his world as the best I can be (Rain, female Beijing cosplayer, age 23).

7.4 Cosplayer in photo shoot at 798 Artist Village Beijing. June 2009. Photograph by chapter author.

COSPLAY ENGAGEMENT VIA ONLINE SPACES

For all informants across the region, cosplay is increasingly being extended into a virtual domain through online discourse channels via the 'internet playground'[38] to sustain real-time relationships and connect with new audiences in a wider geographic and cultural reach. By engaging in this activity they are seeking valorisation of their transformed self, by opening up transglobal channels for verbal interaction and responsive commentaries on authenticity of costumes and presentation of self. When sharing photographs and sending updates, information-seeking about costume construction or chatting about past and future events, personal websites and blogs and social networks such as MSN, Facebook, YouTube, Cosplay.com, cosplayfu.com and renren.com in China, for example, are all important sites for virtual cosplay. These exchanges continue the embodied performance in the virtual sphere as 'a text-based, simulated world might be an extension of the corporeal, as well as the physical, a refiguration or perhaps rather an incarnation of the textual'.[39] It also recognises the player as an authority on costume making or accessory sourcing. When questioned about the rationale for sharing images either on personal websites or by linking into social networking sites, one respondent said:

> It's exciting because you wanna see what others say about you. You make friends that way too – with other cosplayers or people interested in doing it . . . I sometimes go on cosplay forums and talk with Chinese overseas who want to do it and like my images or ask questions about how to make my costume or a sword as I do it all myself (Ran, female Hong Kong cosplayer, age 22).

The pressure to display post-event photos of a high quality often motivates players in Hong Kong and Macau with more economic capital to hire a studio and commission professional photographs for this purpose, practices that were absent in Beijing as the pursuit seemed to have a more amateur hobbyist orientation, given reduced resources.

Yet, there is also a contested side to this collaborative interface between the many players, from 'cosers' themselves to photographers and their interpretation of cosplay connoisseurship and the levels of cultural, social, and economic capital on display. Some respondents also

shared tales of photographers redigitising photographs and re-appropriating them on pornographic websites, while others were highly concerned about the tendency for players to be hypercritical of each other's costumes on forums such as Cosplay.com. As one respondent said:

> They complain your costume does not look like the original character or your wig is too long, or short or is the wrong shade of blue … And the new thing they say is that younger cosplayers don't understand their character and are not really into it for the right reasons. Some say young, pretty girls only want to be discovered as models and be very famous which gives it a bad name (Krystal, female Hong Kong cosplayer, age 23).

Discursive conflict scenarios such as these in Hong Kong reveal the latent power struggles that exist amongst the highly competitive players and an evaluative taste-based system[40] or community of practice.[41] Yet, rather than being a destructive force, this critical feedback can stimulate new approaches and coping strategies. Some players in Hong Kong admitted that they found this negative feedback to be increasingly stressful. Yet, others in China pointed out that when faced with any criticism from other players or anonymous commentators, their friendships actually became closer as they would often be verbally defended by their peers in person at an event, or online, creating a stronger sense of attachment and commitment amongst the team members.

CONCLUSION

This opportunity to playfully and creatively transform and control the remediated self by assuming the material persona of a fictional character from commercial comics or cartoons from another culture may explain why cosplay is increasingly becoming popular in China-based youth cultures.

The popularity of this practice offers latitude to engage in localised interpretations representing the decentring of Western cultural dominance for post-colonial places such as Hong Kong and Macau.

In addition, it enables empowered social media Generation Z, with uneven access to relatively uncontained social networks and mediated sources, to play with costumed identities as an outlet for life's pressures in Asia's urban centres. It also provides escapist fun for Mainland China's increasing consumer base, albeit within a controlled and socially structured 'enlightened socialism'.

It further creates a creative space in which the player, irrespective of gender, can craft costumes and accessories or have them commissioned, representing a flourishing DIY craft-making culture. Interestingly, cosplayers across the China region were adamant that cosplay did not represent fashion production, unlike the non-cosplay Lolita trend, despite the fact that fashion students in Hong Kong and Macau did sell outfits to order. Whilst it could be argued that Japanese street fashion has globally influenced fashion collections and youth aesthetics, as evidenced by Gwen Stefani's Harajuku Girls fragrance collection and onstage persona, cosplay is largely outside of this remit for participants in China. However, this may not be the case in a Western context, where the Oriental other is a consistent source of design inspiration. The DIY crafting of cosplay costumes across the China region is perhaps evidence of creative skill, ingenuity, entrepreneurship, tailoring, social media communication and interpretative competencies, all of which are transferable to the fashion system and careers in the design industries. Significantly, in Hong Kong and Macau many cosplayers were also fashion design students or worked in the beauty and creative industries, and one Hong Kong player was making a profitable business selling high-quality wigs sourced in Shenzhen.

Cross-cultural exchange through popular cultural flow is unprecedented[42] due to the access to electronic mediation and technology.[43] Yet this is not without contestation, as cultural flows can be fragmented and the creation an imagined self, based on cultural imaginaries and re-appropriated sources, is always going to be illusionary, representing uneven power relations when the search for identity amongst a youth demographic is largely based on consumption practices[44] as a reflection of the socio-economic status and ideological freedoms experienced by players in their country of origin. Clearly, players in China had less economic capital to spend on the creation or

photographing of costumes as compared with their Hong Kong counterparts and are restricted in terms of the characters they can choose and the ways in which they dress, given a renewed focus on the public expression of moral values in the entertainment sector by the current Chinese leadership.

The similarities and differences of doing cosplay highlighted in this chapter validate the existence of multiple Chinas based on manifold imaginaries that are expressed and represented in myriad ways from Tokyo to Beijing using the same media sources as inspirational sites. On the one side, cosplayers are unified in actively participating in the activity and materially expressing affective connections with mediated characters and narratives, based on familiar and well-established consumption practices. Whilst on the other, differences emerge in terms of the creation of costumes and the manner in which they play, in addition to chosen characters, sources and locations, as governed by circumstance. These similarities and differences are often influenced by political and economic considerations that legitimise or censor the imaginary or empower or control the practice. The more liberal economy and culture of Hong Kong enables players more freedom to costume and present the self compared to China's more restrictive, traditional culture – although this is now changing.

Overall, for its youth demographic cosplay practice in the China region represents a multiplicity of options for intra-Asian transcultural borrowings from the dressing-up box. This is driven by a fascination to embody cultural offerings that are familiar, relatable and accessible, yet suitably different in content, offering an alternative, from existing in the 'real' world to inhabiting imagined places and spaces that are borderless, offering empowered opportunities to create and communicate multiple costumed identities wherever the location of play is situated.

NOTES

1 Anne Peirson-Smith, 'Fashioning the fantastical self: an examination of the cosplay dress-up phenomenon in Southeast Asia', *Fashion Theory* 17/1 (2012), pp. 77–111.

2 Michael Maffesoli, *The Time of the Tribes: The Decline of Individualism in Mass Society* (London: Sage, 1996).

3 Koichi Iwabuchi, 'Introduction: cultural globalization and Asian media connection', in Koichi Iwabuchi (ed.), *Feeling Asian Modernities: Transnational Consumption of Japanese TV Dramas* (Hong Kong: University of Hong Kong Press, 2004), pp. 1–22.

4 Yuniya Kawamura, 'Japanese teens as producers of street fashion', *Current Sociology* 54/5 (2006), pp. 784–801.

5 Yasumoto Seiko, 'Korean wave: towards regional cultural diffusion', *Journal of Literature and Art Studies* 3/2 (February 2013), pp. 101–12.

6 Jennifer Craik, *The Face of Fashion: Cultural Studies in Fashion* (London: Routledge, 2002).

7 Anne Peirson-Smith, 'Wishing on a star: promoting and personifying designer collections and fashion brands', *Fashion Practice: The Journal of Design, Creative Process and the Fashion* 5/2 (2013), pp. 171–201.

8 Arjun Appadurai, *Modernity at Large: Cultural Dimensions of Globalization* (Minneapolis, MN: University of Minnesota Press, 1996).

9 Kawamura, 'Japanese teens as producers of street fashion'.

10 Brent Luvaas, *DIY Style: Fashion, Music and Global Cultures* (London: Bloomsbury Publishing, 2012).

11 Wessie Ling, 'From "made in Hong Kong" to "Designed in Hong Kong": searching for an identity in fashion', *Visual Anthropology* 24/1–2 (2011), pp. 106–23.

12 Koichi Iwabuchi, *Recentering Globalization: Popular Culture and Japanese Transnationalism* (London: Duke University Press, 2002).

13 Susan J. Napier, *From Impressionism to Anime: Japan as Fantasy And Fan Cult in the Mind of the West* (New York: Palgrave Macmillan, 2007); Roland Kelts, *Japanamerica: How Japanese Pop Culture Has Invaded the US* (New York: Palgrave Macmillan, 2006); Fusami Ogi, 'Gender insubordination in Japanese comics (manga) for girls', in John A. Lent (ed.), *Illustrating Asia: Comics, Humor Magazines and Picture Books* (London: Curzon Press, 2001), pp. 171–86; Anne Allison, 'Sailor Moon: Japanese superheroes for girls', in Timothy J. Craig (ed.), *Japan Pop! Inside the World of Japanese Popular Culture* (New York: M.E. Sharpe, 2000), pp. 259–78; Frederik L. Schodt, *Dreamland Japan: Writings on Modern Manga* (Berkeley, CA: Stone Bridge Press, 1996).

14 Sharon Kinsella, *Adult Manga: Culture and Power in Contemporary Japanese Society* (London: Curzon Press, 2000).

15 John A. Lent, *Animation in Asia and the Pacific* (Bloomington, IN: Indiana University Press, 2001).

16 Peirson-Smith, 'Fashioning the fantastical self'.

17 Appadurai, *Modernity at Large*, p. 12.

18 Ibid., pp. 12–13.

19 Paul Willis, 'Notes on method', in Stuart Hall, Dorothy Hobson, Andrew Lowe and Paul Willis (eds), *Culture, Media, Language* (London: Hutchinson, 1980), pp. 88–95, p. 91.

20 Joanne B. Eicher, Suzanne Baizermann and John D. Michelen, 'Adolescent dress', in Mary Ellen Roach-Higgins, Joanne B. Eicher and Kim K.P. Johnson (eds), *Dress and Identity* (New York: Fairchild Publications, 1995), pp. 122–9.

21 Kawamura, 'Japanese teens as producers of street fashion'.

22 Roland Barthes, 'On Bunraku', *The Drama Review* 15/2 (Spring 1971), pp. 76–80, pp. 54.

23 Matt Hills, *Fan Cultures* (London: Routledge, 2002); Paul Hodkinson, *Goth: Identity, Style, Subculture* (Oxford: Berg, 2002); Milly Williamson, 'Vampires and Goths: fandom, gender and cult dress', in William J.F. Keenan (ed.), *Dressed to Impress: Looking the Part* (Oxford: Berg, 2001), pp. 141–57.

24 A Japanese colloquial word denoting feelings of strong affection, particularly towards characters in manga, anime and video games.

25 Gary Alan Fine, *Shared Fantasy: Role Playing Games as Social Worlds* (Chicago: University of Chicago Press, 1983).

26 Napier, *From Impressionism to Anime*.

27 Clifford Geertz, *The Interpretation of Cultures* (New York: Basic Books, 1973), p. 5.

28 Benson Wong and Sanho Chung, 'Scholarism and Hong Kong Federation of Students: comparative analysis of their developments after the umbrella movement', *Contemporary Chinese Political Economy and Strategic Relations: An International Journal* 2/2 (2016), pp. 865–84.

29 Iwabuchi, *Recentering Globalization*.

30 Philip Kotler, 'The prosumer movement: a new challenge for marketers', in Richard J. Lutz (ed), *Advances in Consumer Research*, vol. 13 (Provo, UT: Association for Consumer Research, 1986), pp. 510–13.

31 Brian Sutton-Smith, *The Ambiguity of Play* (Boston, MA: Harvard University Press, 1979).

32 Roger Caillois, *Man, Play and Games*, trans. Meyer Barash (Urbana and Chicago, IL: University of Illinois Press, 1958).

33 Shen Lu and Katie Hunt, 'China cracks down on cleavage at cosplay convention', CNN, 22 May 2015. Available at http://edition.cnn.com/2015/05/22/asia/chinajoy-cleavage-crackdown/ (accessed 12 November 2015).

34 Victor W. Turner, *From Ritual to Theatre: The Human Seriousness of Play* (New York: PFA Publications, 1982).

35 Efrat Tseelon, 'From fashion to masquerade: towards an ungendered paradigm', in Joanne Entwistle and Elizabeth Wilson (eds), *Body Dressing* (Oxford: Berg, 2001), pp. 103–17.

36 Judith Butler, *Gender Trouble: Feminism and the Subversion of Identity* (New York: Routledge, 1990), pp. 9–11, 45–9.

37 Rozanna Lilley, *Staging Hong Kong: Gender and Performance in Transition* (Honolulu: University of Hawai'i Press, 1998), p. 285.

38 Ellen Seiter, *The Internet Playground: Children's Access, Entertainment and Miseducation* (New York: Peter Lang, 2004).

39 Jenny Sundén, *Material Virtualities: Approaching Online Textual Embodiment* (New York: Peter Lang, 2003), p. 109.

40 Pierre Bourdieu, *Distinction: A Social Critique of the Judgement of Taste*, trans. Richard Nice (London: Routledge, 1984).

41 Jean Lave and Etienne Wenger, *Situated Learning: Legitimate Peripheral Participation* (Cambridge: Cambridge University Press, 1991).

42 Iwabuchi, 'Introduction'.

43 Laurie Cubbison, 'Anime fans, DVDs, and the authentic text', *The Velvet Light Trap* 56 (Fall 2005), pp. 45–57.

44 Ien Ang, 'Culture and communication: towards an ethnographic critique of media consumption in the transnational media system', *European Journal of Communication* 5/2 (1990), pp. 239–60.

8

HYBRID FASHION: A STUDY OF SINGAPORE'S COSMOPOLITAN IDENTITY FROM THE 1950S TO THE PRESENT

May Khuen Chung

INTRODUCTION

According to Singaporean sociologist Chua Beng Huat, the culture of the daily lives of Singaporeans is the enduring result of the mixing, or hybridisation, of the cultures of people who came to Singapore in search of a living. From commercial transactions to chance encounters between strangers, interactions among Singaporeans involve extensive ethnic and linguistic code mixing.[1] Indeed, this same observation could be applied to the study of women's fashion in Singapore. Despite its huge Chinese population, the fashion of the country is neither confined to Chinese influences nor homogeneous. Instead, it is shaped largely by the cosmopolitan nature of the city and the presence of the various ethnic communities in Singapore. This chapter seeks to shed light on the origins

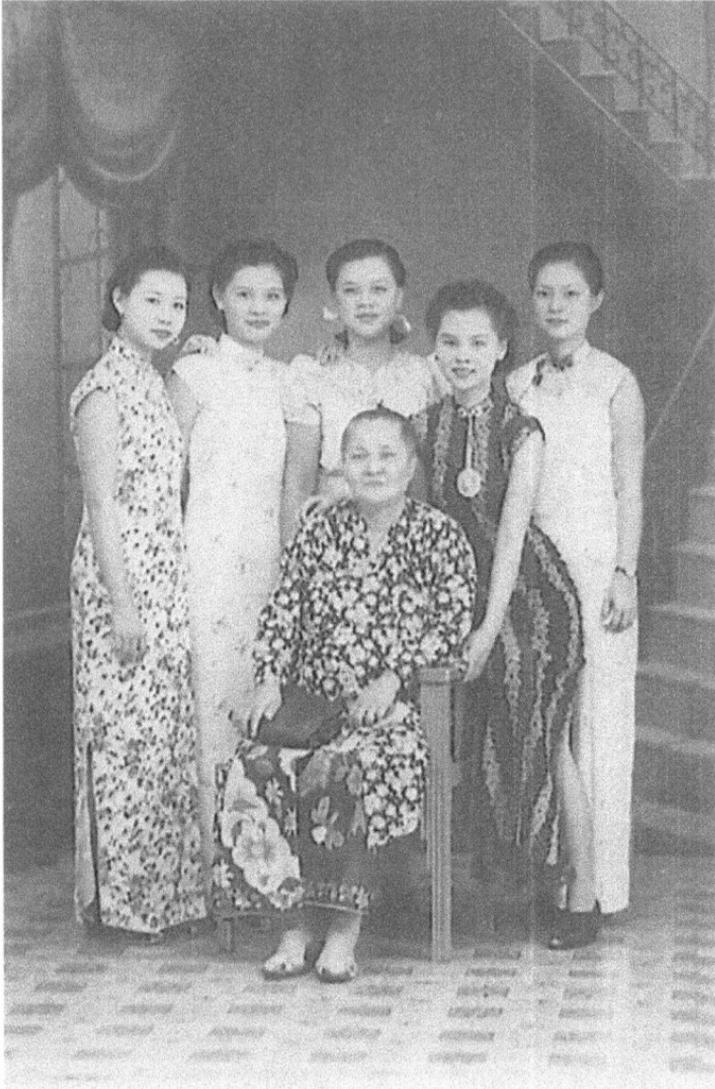

8.1 Sylvia Kho, one of the five daughters of Won Hin, a Peranakan businessman who owned rubber estates and tin mines in Kuala Lumpur, Malaysia. Here, she and her sisters are dressed in the 1930s slim fitting modern cheongsam while her mother (seated) is in the traditional Baju Panjang, 1938. Courtesy of Mrs Sylvia Kho.

and development of hybrid fashion in Singapore, vis-à-vis the country's socio-cultural movements, from the 1950s to the present. Evidence of a strong cross-cultural influence in fashion became more apparent during the postwar period of the 1950s and 1960s, as women began to use dress to

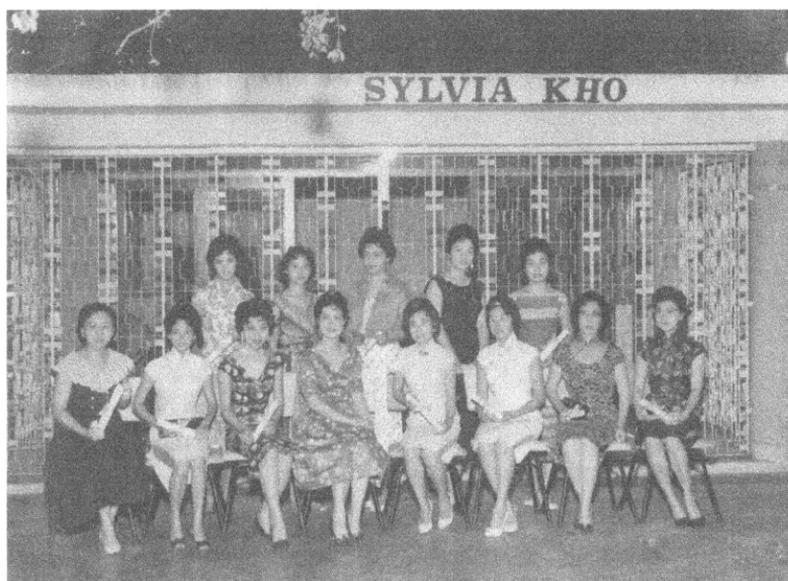

8.2 A group of ladies from the graduating class of Sylvia Kho's Bridal Salon, late 1950s. Courtesy of Mrs Sylvia Kho.

express their modern identity rather than just as an ethnic marker. To highlight this characteristic, I shall be referring in this chapter to examples from In the Mood for Cheongsam: Modernity and Singaporean Women, an exhibition I curated at the National Museum of Singapore in 2012. Despite the influx of mass-produced Western fashion and the increased popularity of Western garments in the 1970s, Singapore's hybrid fashion continued to develop, as seen in the creative process and work of its contemporary designers such as the late Tan Yoong, Thomas Wee and Priscilla Shunmugam, amongst many others. It is this unique feature of incorporating cross-cultural influences across different ethnic communities and the globalised world that makes the work of Singapore's fashion designers distinctive from the others in the region and their counterparts in other Chinese regions.

SINGAPORE'S FASHION IN THE EARLY TWENTIETH CENTURY

The city is ablaze with colour ... every Oriental costume from the Levant to China floats through the streets – robes of silks, satin,

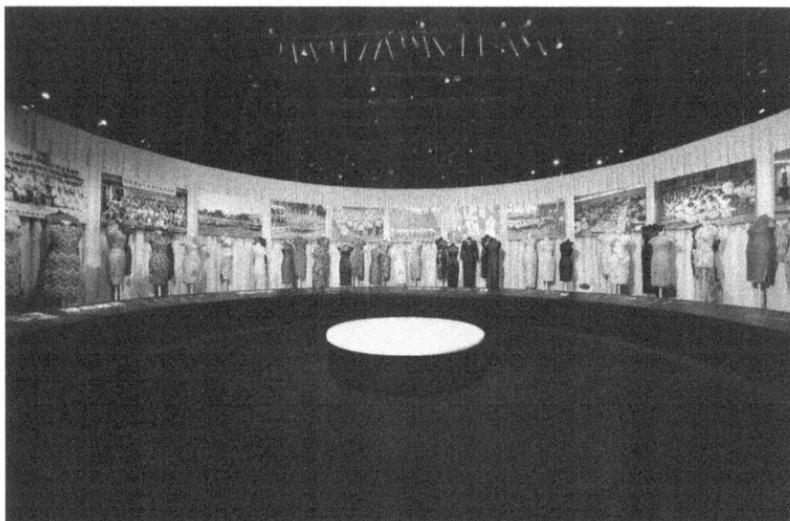

8.3 *In the Mood for Cheongsam: Modernity and Singaporean Women* held at the National Museum of Singapore in 2012. Courtesy of the National Museum of Singapore.

brocade, and white muslin ... and Parsees in spotless white, Jews and Arabs in dark rich silks; Klings in Turkey red and white; Bombay merchants in great white turbans, full trousers, and draperies, all white, with crimson silk girdles; Malays in red sarongs; Sikhs in pure white Madras muslin ... and Chinamen of all classes, from the coolie in his blue or brown cotton, to the wealthy merchant in his frothy silk crepe and rich brocade, make up an irresistibly fascinating medley.[2]

Singapore was already a multicultural and cosmopolitan port city by the turn of the twentieth century. There were more than 185,000 inhabitants by 1911; nearly three-quarters of the population was Chinese, but there were sizeable minorities of peninsular Malays, Sumatrans, Javanese, Bugis, Boyanese, Indians, Ceylonese, Arabs, Jews, Eurasians and Europeans. The population was male-dominated, and the 1911 census stated that men outnumbered women by eight to one.[3]

The 1920s was a period that witnessed a surge in the number of Chinese female immigrants who came to join their husbands or to find work in Singapore.[4] There were a few reasons for this. Firstly, their arrival was welcomed by the colonial authorities, who believed that more women in

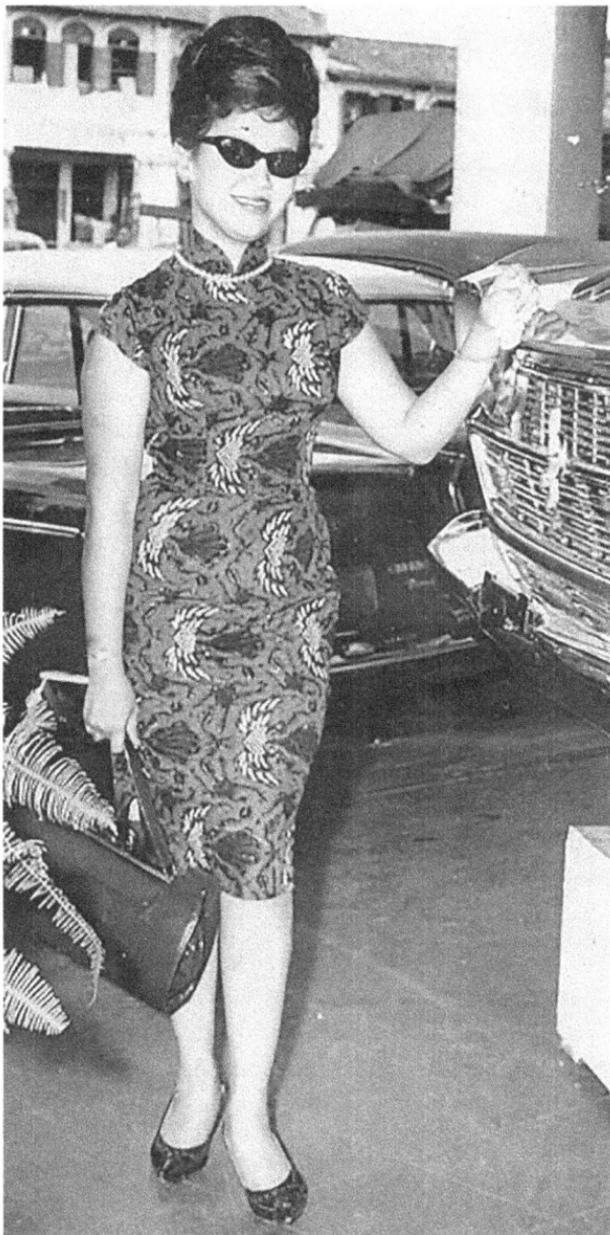

8.4 Mrs Nancy Lim started wearing the batik cheongsam in the 1960s as the fabric became more affordable as a result of its mass production. Courtesy of Mrs Nancy Lim.

Singapore would mitigate the social evils that came with a predominately bachelor population.[5] Secondly, the slump in trade caused by the Depression meant that the silk industry, which was powered mostly by Cantonese women from the Pearl River Delta in Guangdong, was severely damaged. These women, who were accustomed to seeking employment outside the home to support their families, began to look for job opportunities overseas to replace their loss of income. It is believed that between 1934 and 1938 close to 200,000 of these women arrived in Singapore and Malaya.[6] By this time, there were two main groups of Chinese community in Singapore, the *sinkeh*, or newcomers from China, and the Peranakan, or the Straits-born Chinese. As the female population within the Chinese community increased, the garments they wore became an important tool for expressing their ethnic identity in the multiracial colony.

For the majority of these Chinese communities in Singapore and Southeast Asia, China was their motherland, and Shanghai was considered the most fashionable and modern capital of the East for the overseas Chinese, including Singapore, in the early twentieth century. Fashions such as the scooped hem blouses with wide sleeves and gathered black skirts, also known as the *Wenming Xinzhuang*,[7] and later the cheongsam were worn by the daughters of the wealthy Chinese businessmen, including the Peranakans in Singapore, as it symbolised modernity. The cheongsam was a reflection of their modern status following the emancipation of women in Singapore at the turn of the twentieth century. Boys as well as girls were encouraged to attend school through the efforts of the rich Chinese and Peranakan businessmen in Singapore. While their daughters attended schools, the women at home were increasingly tasked with playing host to their husband's visiting business associates and attending social functions. For the women from the rich Peranakan families, the cheongsam soon replaced the *sarong kebaya* as the appropriate dress for formal occasions.

Baju Shanghai: an early product of hybrid fashion

Besides the wearing of the cheongsam, and the *Wenming Xinzhuang*, all of which were direct imports of Chinese fashion, there emerged a new hybrid garment known as the *Baju Shanghai* in the 1910s and 1920s. It is a two-piece ensemble that comprises a Chinese blouse ending at the hip

and an ankle-length pleated skirt, which drew inspiration from the Chinese skirt-and-blouse ensemble. The blouse and the skirt are usually made from the same material. Except for the long-sleeved silk tunic, which looked like that of the *baju panjang* (a long blouse with a front opening that was worn by Peranakan women), the rest of it resembled a Chinese garment – high collar, asymmetrical side-fastening secured by knotted buttons and embroidery. The skirt is long and pleated at the front, apart from the central panel. The materials used included Chinese, Japanese and European silk damasks, and even fine European cottons. Sometimes, hybrid elements such as lace trims and edges, flounces, piping and appliqued elements were incorporated into the dress.[8] Ms Betty Seow[9] recalled that in the 1920s many of the prominent women in Singapore, including her mother, would dress themselves in the skirt-and-blouse outfit when they attended special functions. To complete the modern look, they would wear Western high-heeled shoes and white stockings. Although the *Baju Shanghai* was eventually replaced by the fashionable cheongsam in the 1930s, it was probably one of the earliest manifestations of hybrid fashion to incorporate both Chinese and Peranakan influence in colonial Singapore before World War II. This penchant for hybrid fashion soon became a notable feature of Singapore's fashion, especially after the war.

POSTWAR SINGAPORE

The development of hybrid fashion in Singapore reached its peak after World War II, encouraged by the emancipation of Singaporean women, which had resumed in the 1950s. Set against the backdrop of changing political, economic and social conditions, women's role and their wardrobe became more varied as a reflection of their evolving identity. With the continuous influx of Western ideas and the increased interaction amongst women from different ethnic groups, the fashion of the 1950s and 1960s was evidently more diverse, a reflection of the amalgamation of various influences from the West and the East. This section will introduce the changes in the political, economic and social conditions of Singapore, their impact on the identity of women, and the consequences for the development of hybrid fashion during the 1950s and 1960s.

Women and politics

The identity of Singaporean women underwent a remarkable change during the postwar period of the 1950s as the nation entered a new era of political, economic and social transformation. Against the backdrop of rising anti-colonial sentiments, the emancipation of Singaporean women that had been interrupted by the war resumed at a great pace, first with the mobilisation of women in politics. From the late 1940s onwards, the political voice of Singaporean women was being increasingly heard. In 1948, they were given the right to vote together with men, and some began to participate in politics. Singapore's first female opposition member was elected into the Legislative Assembly in 1959.

Women at work and school

Many women began to take on an active productive role in the nation's economy in the 1960s, in response to state-driven industrialisation policies that encouraged their participation. They were quickly mobilised into labour-intensive, low-value industries such as textiles, which required little skill or capital layout.[10] In 1957, women formed 17.5 per cent of the labour force, while a decade later this had increased to 25.8 per cent.

Besides economic policies, the government also recognised the need to update its educational policies so as to equip women with basic skills for the jobs. After the war, the government began to invest its resources into the building of schools and extra efforts were made to recruit and train teachers. Universal free education for both boys and girls was attained by the time Singapore achieved independence in 1965.[11]

Furthermore, the successful implementation of family planning services in the 1950s and 1960s encouraged and educated women to step out of their traditional role as homemakers. This in turn helped to facilitate their entry into the workforce and their ability to pursue other activities outside of home. Political emancipation, rapid economic development and social changes in Singapore provided the necessary impetus for the progression of women during this period.[12] The increased access to education opened the door to a wider range of jobs. Cultural exchanges amongst the different ethnic groups increased with the expansion of the role of women in society. It was inevitable that

women's fashion during this period came to reflect the amalgamation of influences from within its multiracial society with trends from the West.

The museum and its role in constructing national identity using its cheongsam collection

During the 1950s and 1960s, elements of Western fashion were adapted into traditional garments such as the Indian sari, the Malay and Peranakan *kebaya*, the Chinese *samfoo* and the cheongsam. While some women began to embrace the tight-fitting Western frocks that became popular as a result of the introduction of the 'New Look'[13] in Europe, there were others who chose to adapt elements that they felt would project them as modern and progressive, as required by their new role in society. As Partington noted:

> the consumer's investment in a style may or may not involve a transformation of the fashion commodity's appearance, but more like reworking of the object. They are social acts in which the object only has meaning in relation to the circumstances surrounding them. Hence a 'reproductive transformation' takes place.[14]

One of the main objectives of the National Museum is to tell the story of Singapore and its national identity through its collection. In 2012, as the fashion curator at the museum at the time, I was able to use its largely donated collection of cheongsam to curate *In the Mood for Cheongsam* to tell the historical development of the nation through the evolution of the dress over the last 100 years.[15] One of the key findings from my research showed that hybrid fashion was most evident during the 1950s and 1960s. A distinctive sense of fashion and aesthetics unique to Singapore was emerging and being incorporated into the traditional dress of women. The museum pieces reflected two levels of interpreting the cheongsam – one of which incorporated Western fashion while the other used fabrics that had been newly introduced into the market, such as synthetics, and those that were commonly associated with other ethnic communities into the dress. On both levels, these interpretations of the cheongsam reflected the cosmopolitan identity of Singapore society at that time.

The hybrid cheongsam as an indicator of modernity

For Singaporean women, the assimilation of the wasp waistline popularised by the 'New Look' into their traditional cheongsam during the postwar period was a sign of modernity and progress. Dress in everyday life is a practical negotiation between the fashion system as a structured system, the social conditions of everyday life such as class, gender and the like as well as the rules or norms governing particular social situations.[16] Women who wore the cheongsam in the 1950s and 1960s were quick to adapt the tight-fitting silhouette into their previously loose-fitting costume, adding a modern air to the representation of ethnic identity. In fact, it was observed that majority of the museum's cheongsam from the 1950s and 1960s were tight-fitting. Some of the cheongsam with the tiniest waistlines from the museum's collection are probably those belonging to Veronica Lim Kim Lian. Her cheongsam has a waistline between 21 and 24 inches. She was a sales representative at Robinsons' department store from the 1950s to early 1960s. To a certain extent, the tight-fitting cheongsam of the 1950s and 1960s can be defined as a form of hybrid fashion – one that incorporates the West and the East.

The need to incorporate trends such as the 'New Look' was not limited to female consumers but applied to the producers of cheongsam too. In this case, tailors were made aware that their consumers preferred to wear dresses with a tight-fitting silhouette and new techniques were introduced into the making of cheongsam. Master Lu, a cheongsam tailor, commented:

> Darts were introduced in the 1950s and 1960s as the fashion then was for a more form-fitting silhouette. Cheongsam became more fitted and three dimensional to the upper part of the garment to make it look like a Western dress.[17]

Hence, it was not just women as consumers who had to pick up new skills in order to dress themselves up in these modern and tight-fitting garments. The tailors who supplied them also had to acquire new knowledge in order to produce this hybrid fashion.

Besides the tight-fitting silhouette, the wearing of a Western-style jacket with the cheongsam also became popular amongst Chinese

women. Not only did this ensemble give them the more formal appearance that was required as they enter the boardroom, but the introduction of air conditioning in offices in Singapore by the 1960s also helped to popularise this trend. The practice of mixing and matching Western accessories such as handbags, costume jewellery and high-heeled shoes with the wearing of cheongsam was also adopted as a sign of updating the traditional dress.

Perhaps a more obvious representation of hybrid fashion was observed in some of these women who were seen matching the dress with jackets that looked like the *kebaya* top worn by Malay and Peranakan women. Known simply as a *kebaya* jacket, it has a short hemline that ends near the hips just like a *kebaya* blouse and is secured by a V-shaped panel on the front of the tunic. By adapting this style of jacket, which is fashioned after the same style of *kebaya* as the Indonesian national dress, the identity of women in cheongsam had shifted from one of being Chinese to that of a Malayan identity set in the regional context. This type of cheongsam was especially popular amongst the wives of Singapore's prominent leaders such as Heads of State. By representing Singapore at various state events, the dress of these women became a powerful tool in presenting the nation's cosmopolitan and multiracial identity. This form of hybrid cheongsam is distinctive to Singapore and Malaysia but not in Hong Kong, China or Taiwan.

Singapore as a regional textile hub and its impact on hybrid fashion

The development of the hybrid cheongsam in Singapore was made possible by the country's position as a textile hub in the region in the 1950s. By then, it had overtaken Bangkok as a distribution centre for textiles for the regional market because of its entrepôt trade and free port status.[18] By the 1960s, women were able to purchase the trendiest fabrics from Europe, America and Asia from Arab Street, Circular Road and High Street for their garments. To emphasise the importance of this development, I made a deliberate decision to display about 50 per cent of the cheongsam from the 1960s that showcased the variety of synthetic cheongsam that were popular in Singapore.

Besides traditional fabrics, synthetic fabrics also made their way to consumers in the 1950s and revolutionised the wardrobe of Singaporean women. These artificial fabrics quickly built up a following amongst Singaporean women because of the conveniences they offered. Synthetic fabrics were affordable, durable, lightweight and crease-resistant, with easy-to-care-for qualities. Imported cheap synthetic fabrics from Japan and later Korea were made available to women who needed affordable and trendy clothes for the office.

Synthetic fabrics soon became a favourite material for cheongsam because of the great designs they offered. Previously, cheongsam had been made of traditional silks and cottons. But with the introduction of synthetics, the wearing of brightly coloured clothes with floral, geometric, optical art illusion and psychedelic prints was not restricted to Westernised youths. Cheongsam made of polyester, jersey and lurex,[19] printed with pop art motifs associated with the fashionable West, began to emerge as an important statement in the wardrobe of the young and stylish.

Cheongsam and local fabrics

Besides employing new artificial fabrics introduced after the war from which to make the cheongsam, women in Singapore began to experiment with fabrics that had commonly associated with particular local ethnic communities, so as to update its look. One such example would be the use of batik to make cheongsam in the 1960s. It is a resist-dyeing technique used to decorate finished fabrics that are popularly used for making sarongs, particularly in Indonesia, Malaysia and Singapore. Batik was also associated with pan-Malayan identity, which advocates embracing the various races as one in the regional context of Singapore, Malaysia and Indonesia.

The popularity of batik as a fabric for cheongsam could possibly be due to the mass production of batik from the 1950s and the influence of popular films. Batik artist Shahrul Said explained:

> The period after the war can be seen as the industrial age of batiks when they were being mass produced ... First there was the popular culture – the P. Ramlee shows ... Stamps were being invented and produced. After the war, with increased affluence,

there was a demand for batiks and people were able to mass produce ... So you have production and you have traders selling – the batik industry grew.[20]

After World War II, the batiks produced in Malaysia became quite popular in Singapore because of their reasonable price. The common colonial experience and the brief merger of Singapore and Malaysia opened the Singapore market up to the newly developed batik industry in the peninsula. Furthermore, the increased interaction between the different ethnic groups encouraged by economic and education policies during the 1950s and 1960s provided the impetus for the hybrid fashion to flourish.

My research revealed that some of the important advocates of hybrid cheongsam over the years included prominent women such as war heroine Elisabeth Choy (1910–2006), business woman Mdm Zhuo Yu Chun (b.1920–) and the late Kwa Geok Choo (1920–2010), wife of Singapore's first prime minister, Lee Kuan Yew (1923–2015).

Besides batik, other popular local fabrics that were used to made cheongsam during the 1950s and 1960s included Kelantan silk or songket[21] and printed georgette, American chiffon and nylex,[22] favoured by Indian women for their saris. The status of Singapore as a regional textile centre and its free port status meant that these fabrics were readily available to the consumers.

Today, cheongsam made of batik and other local fabrics continue to be a favourite, which distinguishes Singapore consumers from those in Hong Kong, Taiwan and China. This factor continues to play an important role in shaping the hybrid works of contemporary fashion designers, some of which we shall be examining in a later section of this chapter.

CONTEMPORARY FASHION DESIGNERS: WESTERN OR HYBRID?

By the 1970s, traditional ethnic clothes such as the cheongsam were being replaced by mass-produced Western garments. Despite this, the development of Singapore's fashion continued to thrive, drawing

inspiration from various sources, just as it had been in the early twentieth century. As Professor Chua noted:

> In any given multi-racial or multi-ethnic location there is co-present a multiplicity of cultural references, each serving its respective racial or ethnic constituency, instead of a single cultural flow from any metropolitan center, particularly one in the West, dominating a local hybrid culture.[23]

The dominance of a local hybrid culture can be seen in the unsuccessful attempts to introduce a single homogeneous national dress in Singapore in the 1980s. In 1981, four young designers were invited by the Ministry of Culture to design a national costume, but the initiative soon fizzled out. Eight years later, the National Trade Union Congress (NTUC) organised a search for a Singapore dress fabric, in which most of the entries were inspired by Singapore's national flower, the Vanda Miss Joaquim orchid. But the organiser was quick to clarify that 'these fabrics can be used for saris, cheongsams, blouses, and skirts'.[24] Till today, there is not a single national unique dress that Singaporeans can agree on or call our own. Instead, we are encouraged to wear our own traditional costumes at appropriate events. This last section argues that Singapore's fashion thrives on diversity, shaped by local and international forces, as seen through the works of three fashion designers – Thomas Wee, the late Tan Yoong and Priscilla Shunmugam. All three come from different backgrounds and their design philosophies are moulded by various factors. But they share a common ground – their works, regardless of their ethnicity, are a product of the crosscultural milieu of a cosmopolitan Singapore, a characteristic that has existed since the 1920s, as I have demonstrated earlier in this chapter. In addition, all of them have a special relationship with the cheongsam and have been engaged in some form of self-orientalising throughout the course of their career.

Thomas Wee

Thomas Wee,[25] known affectionately as the 'King of Jackets', has been in the fashion industry for more than 35 years. Wee was previously a medical dispenser and had no formal training in design. He was exposed to the art

of tailoring through his mother, who was a Shanghainese seamstress, from an early age. 'My mother – she was a very good cheongsam maker – used to make many suits for my father's boss.'[26] Wee made his first cheongsam at the age of 14. He continued to hone his skills under a group of Shanghainese tailors when he joined the boutique Flair as their designer in the 1970s. There, they imparted their skills and knowledge of fabrics to Wee. The influence of the Shanghainese tailors had a huge impact on Wee's works subsequently.[27] He has been able to create a style that speaks of the Eastern and the Western influence, one that incorporates the technical skills of traditional Shanghainese tailors and embodies them in Western suits that were popular amongst working women in Singapore during the 1980s and 1990s. His labels – Thomas Wee, TWII, Mixables and Luxe – which were launched in the 1980s were distinguished by expensive linen that are crisp and chic, with no fussy details and very good cuts.[28] He eventually joined the ranks of one of the 'Magnificent Seven' group of established designers in the late 1980s.[29]

Tan Yoong

Like Wee and most of the pioneer Singapore fashion designers who arrived in the scene in the 1970s, the late Tan Yoong[30] did not have any formal training in fashion. Instead, he was trained in Fine Arts at the Nanyang Academy of Fine Arts Singapore. After graduating, Tan joined Batey Ads, which created the Singapore Girl campaign in 1975. It was a turning point in his career and had an eventual impact on his design philosophy. 'Working in Batey really opened my eyes to the world. I started to look at things with international appeal and it elevated my taste level. I don't believe in the need to keep an Eastern identity in my designs.'[31]

However, it would be presumptuous to assume that Tan did not engage in self-orientalising, since he is known for creating some of the best bridal cheongsam. In fact, he readily admitted in a 1984 interview that 'everyone has gone ethnic some time or another – Kenzo, Yves Saint Laurent . . . even I did it when I started three years ago – Chinese cloud embroidery, phoenix symbols'. Another case in point was Tan's inclination to draw upon his knowledge of Eastern traditions in his modern creations. For example, in 1989, he created the Snake Woman collection, a series of dresses that were inspired by characters from Chinese mythology, such as

the Madam White Snake. These garments, made of luxurious fabrics, celebrated the female form and are figure-hugging and fluid at the same time. For the photo shoot of this collection, he took advantage of his training as an artist and art director and created visually powerful imagery that stirs up the world of fantasy and surrealism for which he is known. However, he has pointed out that: 'What I try to do is to re-interpret Chinese dress in contemporary shapes. So a dress is only subtly ethnic in the fall of the fabric, the drape of the sleeve and the colourful print of the silk.'[32]

For Tan, the type of fabrics he used helped him to distinguish his works from other designers. He preferred to source his fabrics from Europe, especially Italy and France. Besides making annual trips to these countries, he also ordered them from agents in Singapore, sometimes on an exclusive arrangement. He attributed the availability of such 'raw materials' to Singapore's historical position as a regional textile hub and its free port status, a point that was mentioned earlier in this chapter. He felt that this gave him the advantage of accessing the fabrics he wanted and allowed him to create pieces, be it a cheongsam or a Western gown, infused with Western and Eastern influences.

> Singapore is a free port; there is no import tax at all on fabrics. All I have to pay extra is transport and insurance. I buy, for example, from Corisia, Giodarno, Etro, Gandini . . . silks, linens, then I might add an embroidery of my own.[33]

Most of the time, Tan liked to enhance the uniqueness of each piece of his work with extravagant motifs that he painstakingly hand-appliqued, embroidered, quilted or dyed. Sometimes he would take three days just to do one portion of the dress. One of Tan's earlier cheongsam best exemplified this process. Made in 2004, the multicoloured appliquéd laces featured on the dress were sourced by Tan in France. They were carefully arranged on the yellow laced fabric to create the effect of an embroidered lace patchwork sheath dress, which he claimed was inspired by French couturier Christian Lacroix.

In short, Tan's works were a confluence of various influences; he was an artist who used the art vocabulary he had learnt in school and applied it to his garments, his Chinese identity in cosmopolitan Singapore, and

the use of 'raw materials' that were available to him as a result of country's leading position as a textile centre.

Priscilla Shunmugam

Priscilla Shunmugam, a Singapore-based designer, is known for creating garments inspired by her multi-ethnic background. I first got to know Shunmugam in 2012 when she asked to speak to me about the historical development of cheongsam during the exhibition In the Mood for Cheongsam. Shunmugam, whose father is Indian and mother is Chinese, is probably one of the few Singapore designers who managed to launch a successful career using her ethnicity and her identity as an Asian in her works. Her first ready-to-wear collection, 'Orientalism' in December 2010, was inspired by Edward Said's book of the same title. A year later, she launched her first ready-to-wear cheongsam collection Guardianship. It comprised eight designs of cheongsam in 24 textures using various fabrics. Her modern interpretations of cheongsam have become a permanent feature of her collections to date. This was soon followed by the launch of 'Prints Charming', whereby the traditional costume samfoo, or the Chinese trouser suit, was given an updated look with a V-cut at the front of the tight-fitting trousers.

Since then, Shunmugam's collection can be categorised into two – the autumn/winter collection, which focuses solely on the cheongsam, and the spring/summer collection, which is about using traditional textiles to create a contemporary Asian collection (without the cheongsam). Unlike Tan, who prefers to work with European fabrics that incorporate Chinese symbols and icons, Shunmugam is known for using traditional Asian fabrics such as batik, ikat, silk and songket (Kelantan silk) to make her dresses, which is similar to what Singaporean women were producing in the 1960s. Shunmugam prefers to source these traditional textiles herself in Asia, even though the selection can be limited in terms of colours and patterns as compared to the fabrics mass-produced by large factories. As she fittingly describes it:

I let fate play its natural role, and then I make do with what I have. There's something quite magical about the process, as you find a

balance between what you can control and what you can't. It's like making different pieces of puzzles fit together.[34]

Her fondness for juxtaposing different fabrics is so that she can break down the conventions of how traditional textiles are used and worn. She believes that by doing so, it will make her works more appealing and relevant to her clients.

> My biggest problem with traditional Asian clothing is that it clings on to unnecessary restrictions and rules. For example, typically batik print is used to make a sarong so it's worn at the bottom and you rarely cut it out. Historically, it was an indication of social and financial status; but how does this apply to a thirty something year old today? I can't identify with that, even though I'm born here and 100 per cent Asia.[35]

In a way, this is quite a significant breakthrough from the fashion of the 1950s and 1960s where women would still largely keep the traditional fabrics intact even though they no longer restricted themselves to using specific types of fabrics for their garments.

Over the last few years, there has been an increasing number of designers like Shunmugam, who are engaged in self-orientalising by drawing heavily on their own heritage, mixing it with their modern interpretations of traditional garments to create something new and relevant to a younger generation. It is designers like them who helped to rejuvenate these traditional garments and extend their relevance and longevity as a choice of garment in the modern Singapore woman's wardrobe.

CONCLUSION

From the early twentieth century Singapore was already a bustling cosmopolitan port city, susceptible to influences from the East and the West. Initially, the fashion of the day for the population residing in Singapore at the time was influenced by their land of origin. However, there were also subtle signs of the emergence of a distinctive hybrid fashion amongst certain communities, such as the Chinese and the

Peranakan, which set them apart from the fashions of their homeland. At the end of World War II the interactions amongst women across different cultures increased tremendously as a result of the political, economic and social transformation of Singapore. As they began to step out of their homes and enter the work force, their expanded wardrobe included both Western fashion and pieces incorporating influences from the West and the East. Hence, the mixing and matching of Western and traditional fashions became a source of inspiration for Singaporean women. Western frocks were embraced and wasp waistlines were incorporated into traditional garments to signify their modern status. New fabrics like synthetics and traditional ones such as batik gave traditional garments such as the cheongsam, *samfoo* and sarong *kebaya* a new lease of life in the 1950s and 1960s. Since the 1970s, Singapore's fashion has continued to flourish, based on the multiple cultural references it has been exposed to historically and the types of resources that are available, while incorporating the needs of a modern woman. This is demonstrated in the creative practices and the works of the contemporary fashion designers mentioned in this chapter. For example, the availability of fabrics from all over the world since the 1950s allowed the contemporary producers of fashion such as Shunmugam and Tan to experiment and create new sets of aesthetics alongside the changing identity of Singaporean women. Finally, the government's encourage-ment of the existence of a multiracial society has meant that the mixing of cultures has become an enduring quality of the nation and its fashion. While this lack of a homogeneous style could be highly discomforting for others, Singaporeans have no issues with it. The Singapore style is different from that of its neighbours and is defined by the ability of its people to pick and choose their inspirations and freely edit or adapt ideas without been obviously ethnic or nationalistic.[36]

NOTES

1 Beng Huat Chua, *Life is Not Complete Without Shopping: Consumption Culture in Singapore* (Singapore: Singapore University Press, 2003), p. 76.
2 Bishop, Isabella L. Bird, *The Golden Chersonese and the Way Thither* (New York: G.P. Putnam's Sons, 1883). Available at http://digital.library.upenn.edu/women/bird/chersonese/chersonese.html (accessed 4 April 2015). This classic travelogue

is written by the world's most famous nineteenth-century female travel writer. It offers a unique insight into Malaysia and Singapore in the 1880s and is one of the oldest surviving travelogues written by a woman.

3 Constance Mary Turnbull, *A History of Singapore, 1819–1988* (Oxford: Oxford University Press, 1989), p. 110.

4 Mark Frost, 2009, *Singapore: A Biography* (Hong Kong: Hong Kong University Press, 2009), p. 204 Before the twentieth century, women who lived on the island were either the local Malay community or the wealthy European and Asian families. There were others who were likely to be prostitutes and servants.

5 Ibid.

6 Ibid.

7 The Wenming Xinzhuang ensemble was popularised by the female demonstrators who took to the streets in support of a reformist agenda that also advocated greater educational opportunities for women during the May Fourth Movement in 1919 China.

8 Peter Lee, *Sarong Kebaya: Peranakan Fashion in an Interconnected World 1500–1950* (Singapore: Asian Civilisations Museum, 2014), p. 255.

9 Mrs Betty Seow was born in Singapore in 1910. She is a Peranakan and received her education at the Methodist Girls' School. Oral History Centre, National Archives of Singapore, Accession No. 001048.

10 Turnbull, *A History of Singapore*, p. 281.

11 Ibid., p. 313.

12 Chor Lin Lee and May Khuen Chung, *In the Mood for Cheongsam: A Social History 1920s–Present* (Singapore: Edition Didier Millet, 2012), p. 40.

13 Valerie Steele, *Fifty Years of Fashion: New Look to Now* (New Haven, CT: Yale University Press, 1998), p. 11. Dior's 'New Look' was defined by soft sloping shoulders, a full bust, and a cinched in waist above full, long skirts that captured the immediate attention of Carmel Snow, the editor of American *Harpers' Bazaar*, who commented: 'Your dresses have such a new look.'

14 Angela Partington, 'Popular fashion and working-class affluence', in Juliet Ash and Elizabeth Wilson (eds), *Chic Thrills: A Fashion Reader* (London: Harper Collins, 1992), p. 157.

15 *In the Mood for Cheongsam: Modernity and Singaporean Women* was curated by the writer in 2012 at the National Museum of Singapore from March to June. It was the first exhibition held at the museum to explore the changing identity of women in Singapore over 100 years, using the traditional dress from its own collection. About 150 pieces of cheongsam were displayed according to different themes,

16 Joanne Entwistle, *The Fashioned Body: Fashion, Dress and Modern Social Theory* (London: Polity Press, 2000), p. 37.

17 Master Lu, interviewed by the author July 2006.

18 Hai Ding Chiang, *A History of Straits Settlements Foreign Trade 1870–1915* (Singapore: National Museum of Singapore, 1978), p. 4. Ships were exempted from the payment of import and export duties, tonnage and port dues, wharfage and anchorage dues and port clearance fees and stamp duties.

19 *The Straits Times*, 'Good news for the fair sex, glitter that won't wash off!', 14 April 1957, p. 6. Lurex was first mentioned in *The Straits Times* in 1957 as a fabric that had a new metallic yarn interwoven in it. It gives the fabric a glitter that sparkles, does not tarnish, and could be washed without damaging it.

20 Kartini Saparudin, oral history interview, 25 August 2005.

21 Kelantan silk or Songket is a luxurious gold brocade on silk fabric for the Malay sarong and *baju*.

22 Nylex is a durable strong nylon thread fabric imported from Japan into Singapore in the early 1960s.

23 Chua, *Life is Not Complete Without Shopping*, p. 91.

24 *The Straits Times*, 'NTUC picks 10 dress fabrics for May Day rally', 19 November 1989, p. 3.

25 Wee was a finalist in the first Young Fashion Designer Contest organised by *Her World Singapore* magazine in 1978. He opened his first high-end boutique in 1983 and subsequently launched his own labels – Thomas Wee, Mixables and Luxe – in the 1980s. He is often invited to show his collections in major Asian cities. After the Asian economic crisis in 1997, he left the fashion industry and joined Nanyang Academy of Fine Arts, teaching fashion design and pattern making in 1999. Nine years later, he made a successful comeback by launching his collection at the Audi Fashion Week.

26 Available at https://styleonthedot.wordpress.com/page/3/ (accessed 30 October 2014).

27 Shanghainese tailors first arrived in Singapore in the 1910s and were considered excellent because of the arduous but comprehensive apprenticeship in Chinese, Western and winter garments. The 1950s and 1960s were the golden period of Shanghainese tailors in Singapore when the tight-fitting cheongsam became the everyday wear of working women. Although the businesses of these tailors began to decline in the 1970s with the introduction of ready-to-wear Western garments, they continued to be valued for their skills and many were employed by boutique owners in Singapore.

28 *Female Magazine*, 'Our designers salute', January 1988, p. 130.

29 Michelle Tay, 'Dressed for success', *The Straits Times*, special report, 3 March 2007, p. 6. The 'Magnificent Seven' group of designers in the late 1980s include Wee, Tan Yoong, Bobby Chng, Kelvin Choo, Peter Kor, Celia Loe and Esther Tay.

30 Tan Yoong was recognised as the doyen of Singapore's fashion world. He was the first non-Japanese to win first prize at the fifth Annual Kanebo Japan Grand Prize Awards in 1974. After winning the first 'Young Designer's Contest' held by *Her World Singapore* in 1978, he joined the Silver Royal Creations, and set up his first two labels, Tze and Zhen. He decided to leave a successful career as an advertising art director in the early 1980s. In 1986, he was presented with the first Best of the Best award for his notable contribution to Singapore fashion. He died in January 2017.

31 Ashley Sim, 'Fabric of society', *The Straits Times*, 4 February 2008, p. 42.

32 *The Straits Times*, 'Why we haven't gone ethnic?', 5 August 1984, p. 3.

33 Rosemary Merenda, 'Encounter with Tan Yoong', *Donna* (September 1989), p. 12.

34 Xinying, Hong, 'Priscilla Shunmugam: "Creativity comes when you have restrictions"', Hw/*Her World*, 16 May 2014. Available at http://www.herworldplus. com/fashion/updates/priscilla-shunmugam-%E2%80%98creativity-comes-when-you-have-restrictions%E2%80%99 (accessed 4 April 2015).

35 Ibid.

36 *Her World*, December 1990, p. 168.

Part III

CHINESE FASHION AND THE WEST

9

CHINESE FASHION DESIGNERS: BECOMING INTERNATIONAL

Hazel Clark

INTRODUCTION

In her introduction to the catalogue of the *Front Row: Chinese American Designers* exhibition, held at the Museum of Chinese in America in New York in 2013,[1] Valerie Steele remarks how 'Asian American designers have become a significant presence in New York's fashion world'.[2] Yet, as she continues to note, this demographic shift has been relatively recent and a development that parallels the substantial contribution to garment production and fashion made by Jewish Americans throughout the twentieth century. Steele concludes that the full impact of fashion designers with Chinese heritage on fashion internationally is yet to be realised. These comments provide a fitting context for this chapter, which explores the work of Chinese designers based in China and members of the Chinese diaspora working overseas. It seeks to question the impact of their Chinese heritage on their designs, reputation and promotion in fashion, and to consider how being 'Chinese', that is, as ethnically Chinese and/or as a Chinese national, impacts the reception of the designers work internationally. In doing so it recognises how

'international' can be used loosely to refer to an apparently global fashion system which is actually controlled by a relatively small set of key players of individuals, organisations, brands, media and nations.

National identity remains pervasive in fashion identification today, yet it is largely mythic. Many designers who lead French couture houses, for instance, are not French, yet the legend remains of Parisian haute couture.[3] We can think back also to the 1980s, when designers from Japan attained their initial entrée into international fashion by showing in Paris (and were simultaneously set apart by the media for their otherness, while being praised for their innovative designs).[4] The real global nature of fashion in the production of garments is often overlooked, as it does not reinforce the creative myths of origin, and brings to mind the 'dark side' of manufacturing, with its potential for exploitation and waste. Fashion is not only a huge economic force around the world, but also has its own culture and design hierarchy, in which geography still prevails with Paris as leader. The reality however is that in the second half of the twentieth century in particular, fashion extended its geographic reach and played a significant symbolic and economic role in nation building.[5] Now, in the twenty-first century, the ubiquitous fashion conglomerates, fashion and social media together create a sense of fashion as 'international', while obscuring the fact that authority in the field of fashion remain within the control of certain nations, brands and individuals.

As this century progresses China will undoubtedly move from its position as a global garment producer and a burgeoning consumer market, to become recognised as a generator of fashion designs by Chinese designers. This nation where, for political reasons, fashion and thus fashion designers (as opposed to designers of garments or uniforms) did not exist until the last two to three decades has some catching up to do.[6] China could be compared to the USA after World War II when it established its fashion independence from Paris; recognising the much greater extent and complexity of 'fashion' today in design, production, consumption and promotion. The question therefore arises of how Chinese fashion designers will compete and succeed in China and beyond, in the highly competitive field of fashion?

Shared Chinese heritage and ethnicity link Mainland and diaspora designers, but their professional situations are distinct from one another, as this chapter will demonstrate. An interesting question therefore arises

as to the nature of this distinction and the likely impact it might have on the designs, markets and reputations of both categories of Chinese designers, when fashion is viewed as an international system. For example, will Mainland designers feel they need to reference their Chinese heritage in their designs by using symbolic stereotypes in the manner of overseas Chinese designers and brands, like Shanghai Tang? Or will they set themselves apart without having to resort to self-exoticisation, or without being subject to exoticisation by the media?[7] To explore these questions the chapter will begin by examining the work of some Chinese-American designers whose brands gained international reputations in the late twentieth and early twenty-first centuries. It will then consider establishment perspectives on fashion in China, and refer to Mainland designers who have, or aspire to have, fashion brands in China and seek to gain international reputations and sell their work outside of China. Comparisons and distinctions will also be made between Chinese designers working inside and outside of China.

CHINESE-AMERICAN DESIGNER I

In selecting designers to include in the MOCA Front Row exhibition, its curator, Mary Ping, a Chinese-American fashion designer with an eponymous label, was sensitive to how the work and brand identities would be expressed to the show's audiences.[8] Or to put it another way, how much might visitors to the show expect the work of Chinese-American designers to look 'Chinese', and how much did the designers selected conform to or reinforce this possible stereotype? Ping contextualised the output of the first generation of Chinese-American designers who began working in New York the 1980s, relative to American fashion designers, including Bill Blass, Geoffrey Beene, Liz Claiborne, Calvin Klein, Ralph Lauren, Anne Klein and Donna Karan.[9] She also highlighted the parallel influence of the Japanese fashion designers who made an impact in the same decade, namely Issey Miyake, Rei Kawakubo of Comme des Garçons, and Yohji Yamamoto. These examples provide important cultural and historical 'bookends' for the first generation of Chinese-American designers who, as Mary Ping points out, came to New York from quite different places. Anna Sui hailed from

Detroit, Yeohlee Teng came originally from Malaysia, via Washington, DC, Vivienne Tam from Hong Kong, David Chu from Taiwan and Zang Toi also from Malaysia.[10] Each received fashion design education in New York either at Parsons School of Design or at FIT (the Fashion Institute of Technology), except for Vivienne Tam, who studied fashion in Hong Kong, and Vera Wang, who studied art history.

Of those designers mentioned, it is only Vivienne Tam who has referenced Chinese culture and heritage consistently as part of her brand identity and incorporated it into her garment designs. She also produced a visually rich book, China Chic,[11] which explored her Chinese origins and reinforced her commitment to recognisable Chinese styles and symbols in her designs. Images of Mao Zedong, the goddess Guan Yin, cherry blossom motifs, and the colour red have all featured in her aesthetic vocabulary across the years. Likewise, some of her contemporaries have drawn from time to time upon Chinese and Asian dress history. Anna Sui has designed versions of the cheongsam, Yeohlee has created wrapped skirts that reference the sarong worn in Malaysia, and the dress shown in the MOCA exhibition designed by Zang Toi was described as a 'Chinese folk art-inspired lacquered red knit gown with hand-beaded flowers and butterflies, Spring 1991'.[12] Yet the work of some Chinese-American designers included in the exhibition did not reflect their Chinese heritage at all. David Chu in particular, the earliest of this generation to have a commercial success, co-founded the menswear brand Nautica in 1983. Its aesthetic, references a tradition of American sportswear and the nautical styles associated with a wealthy US East Coast WASP (White Anglo-Saxon Protestant) lifestyle.

This group of Chinese-American designers was in a very different position from the Japanese designers who came to international prominence in the 1980s and received international exposure on the catwalks of Paris.[13] They were subject to an exoticisation that has not been applied in the same way to their Chinese contemporaries in the twenty-first century.[14] However, as distinct from their Japanese predecessors, the Chinese designers mentioned did not challenge prevailing Western-based sartorial codes, and were of course based in the USA and working for US and international markets.[15] Some, notably David Chu and Nautica, have served to reinforce these codes. For these Chinese-American designers and their successors, any decision to reflect Chinese heritage in their designs

and brand identity appears to have been a conscious business choice. If challenged, as by Vivienne Tam, while it might affect the company's aesthetic, the colours used, or the ornamentation of womenswear, it did not necessarily impact the overall silhouette. We should not forget that the international fashion interest in Orientalism in the 1990s, coinciding with Hong Kong's 1997 'handover' to China, made Chinese and Asian design references timely,[16] whatever the origin of the designer or brand (for example, John Galliano's autumn/winter 1997/8 'China Doll' collection for Christian Dior Pret-à-Porter). It also created opportunities for brands such as Shanghai Tang and Blanc de Chine, both founded in 1994 in Hong Kong, to consciously reflect Chinese culture through Orientalist tropes.[17] Twenty years later the historical context was quite different for a second generation of Chinese-American fashion designers in New York, and so was the field of fashion.

CHINESE-AMERICAN DESIGNER 2

In the early twenty-first century, New York-based fashion designers of Asian descent were gaining recognition from the fashion press,[18] and also from the fashion establishment, in particular through election to membership of the CFDA (Council of Fashion Designers of America).[19] Those receiving greatest recognition included Richard Chai, Jason Wu and Alexander Wang, who each won CFDA Awards in June 2010, as well as Phillip Lim, Derek Lam and Prabal Gurung.[20]

While designers Phillip Lim, Jason Wu, Derek Lam[21] and Peter Som were also included in the MOCA Front Row exhibition, neither they nor the other Asian fashion designers of their generation have consistently included references to Chinese heritage in their designs. Rather, they have worked more within the tradition of American sportswear. They have self-identified, and been identified by the fashion media, as Chinese American or American-born Chinese (ABC) designers.[22] Jason Wu in particular gained substantial press and public attention, having designed the presidential inauguration dresses for US First Lady Michelle Obama in 2009 and 2013. (Mrs Obama's strong support of US fashion designers and brands gave visibility to younger designers from racially diverse backgrounds, including Thai-American Thakoon Panichgul, and

African-American Tracy Reese.) Commercially, however, as well as in the paeans of the fashion establishment, it was Alexander Wang who received the greatest press coverage and commercial success at that time.

Alexander Wang is an interesting and unique case, being the first Asian-American to head a French couture house, Balenciaga, to which he was appointed in 2012, only seven years after launching his eponymous label at the age of 19 (Wang parted company with Balenciaga in summer 2015). His appointment placed him in a powerful position in international fashion business, Balenciaga being part of Kering (formerly PPR), the French luxury goods holding company, which owns major fashion brands including Gucci, Alexander McQueen and Puma.[23] In leading Balenciaga, Wang's challenge was to retain the recognisable 'look' of the couture house opened in Paris by Cristobal Balenciaga in 1937, while creating garments to be worn in the twenty-first century. At the same time, for his eponymous brand he created men's and women's ready-to-wear and accessories, without any aesthetic or cultural references to his Asian heritage. Unlike some of his Chinese-American designer contemporaries, such as Derek Lam or Peter Som, Alexander Wang has no direct family connections to the rag trade. Nevertheless, his family has proved fundamental to his business success. His independent label is family-owned, financed and run, with his brother serving as the company's chief financial advisor and his sister-in-law as chief principal officer. He has been able to use family connections to assist having his garments produced in China.[24] Wang is therefore an example of how 'families have played a crucial role in the working lives of Asian Americans'.[25] Moreover, he has formed strong connections, and gained cultural as well as economic capital, in the upper echelons of the international fashion system, being championed early in his career by Anna Wintour, the internationally influential Editor-in-Chief of American *Vogue*.

Without intending to diminish Wang's talents as a designer, it is important to highlight the strength of his connections in the fashion hierarchy. In the twenty-first century, large luxury brands and conglomerates, such as Kering and their rival LVMH, are wielding enormous commercial power, and the fashion media is more widespread in its reach than ever before – Wang has benefited from the patronage of both. Some press reports suggested that Wang's Chinese ethnicity played a significant part in his appointment at Balenciaga; something

that Kering denied. Nevertheless, at the time of his appointment to the house, (the then) PPR had just bought a major stake in Qeelin, a Chinese fine jewellery brand, and was certainly aiming to expand its markets in China.[26] The significance, or not, of Wang's Chinese identity can also be questioned in respect of his collaboration with the fast fashion brand H&M in 2014. In this instance he was the latest in a series of fashion designers who over the previous ten years had been part of H&M's 'high/low' fashion collections, which began in 2004 with Karl Lagerfeld. The brand's huge expansion in China since 2012 should also be noted in their choice of Wang.[27]

The media hoopla that surrounded and even pre-dated the Alexander Wang x H&M collection launch was huge, including in China, where the collection was available in 16 H&M stores in nine cities as part of a global launch on 6 November 2014. Worldwide, this active wear collection, emblazoned with 'AW' or with 'Wang' and priced for the mass market, sold out in a few hours. Mainland consumers comprised fans of H&M's previous designer collections as well as a large group of followers of Wang's designs. His popularity in China has also been attributed to the fact that his parents originated in Taiwan[28] and incidentally hold a family name that is very common in the Mainland. H&M's promotion of the Alexander Wang collection was both strategic and global, and represents a particular form of fashion 'internationalism' or being 'in the know', which is assisted by the media. It was no coincidence, for instance, that pop singer Rihanna was 'strategically spotted' wearing a cropped top and leggings from the Alexander Wang x H&M collection in New York on 7 September 2014, two months before it was available to the public.[29] Nor that at the showing of Wang's own fall/winter collection in New York in February 2015, the front row was occupied by fashion luminaries, and by music and media celebrities including Kanye West, Kim Kardashian and their young daughter North West. Such a level of media attention and brand recognition internationally, and in China, could be credited to only a few young fashion designers anywhere in the world, with Alexander Wang being the only Asian-American or Asian designer in this position at the time. It highlights the importance of symbolic capital in the field of fashion, which bolsters and is bolstered by economic capital. Here the fashion show and, moreover, the fashion week play a significant role internationally. It is worthwhile therefore to

consider the position of the 'fashion week' in China as an economic and a promotional vehicle for Chinese designers.

CHINA FASHION

The week before the unveiling of the Alexander Wang x H&M collection, China Fashion Week took place in Beijing, showing the spring/summer 2015 collections (25 October–24 November 2014). Established in 1997, staged bi-annually in March and October, and since 2011 sponsored by the luxury automobile company and supporter of fashion weeks worldwide, Mercedes-Benz, China Fashion Week is modelled on conventions well established in the international fashion system. (It should be noted for context that, similarly, Shanghai Fashion Week is also staged bi-annually, supported by the Ministry of Commerce and organised by the Shanghai Textile Group.) Most of the 66 shows for China Fashion Week spring/summer 2015 were staged at one of two locations, the Beijing Hotel and 751D-PARK. The ballroom of the Beijing Hotel, located in the centre of the city, very close to Forbidden City and Tiananmen Square, has been the venue for Fashion Week for many years.[30] The grandeur of the venue serves as a metaphor for the event's link to local government power (and to central government and Party headquarters in the capital city). 751D-PARK, by contrast, is a developing design district, in the Chaoyang District in the northeast of the city, and part of the ex-industrial site that is famous as the 798 Art Zone. It housed several smaller spaces, which showed some of the lesser-known designer and brand names, including those without the huge financial support of fashion production companies.

Of the 83 designers listed as showing their work, 68 were Chinese and the remainder were 'foreign', many with geographical or political links to China. In October 2014 there was a substantial presence from Russia, led by the Russian Federation of Industry and Trade Ministry. China Fashion Week is also state-run, as already noted, and planned by the China Fashion Association (CFA), founded in 1993,[31] and now headquartered at 751D-PARK.[32] The official China Fashion Week press release drew attention to the fact that 2014 marked the tenth anniversary 'of launching the Beijing construction plan of "fashion city"'.[33] Having

attended over half of the shows in October 2014, it appeared to me that the plan for Beijing remained more aspirational than actual, much in the style of Shanghai's similar declared ambitions.[34] The invitation to be a judge for the 'China Top Ten Fashion Designers' showing their spring/summer 2015 collections provided me with invaluable insight into the concept of the fashion city and the significance of the fashion week as part of China's overall fashion development and international ambitions. It is important to note that my fellow judges were designers, journalists, stylists, teachers and fashion entrepreneurs from China and overseas (South Korea and Russia). In occupying the front rows at the fashion shows, our companions were not the 'A list' of celebrities and professionals seen at fashion weeks in Paris, London, New York or Milan (although there were some). Rather, the prime seats were occupied by senior representatives of the CFA (without whose presence no show could begin) and representatives of the brands and manufacturers who sponsored many of the collections. Of the 50 shows I attended, the vast majority were of finalists for the China Top Ten Fashion Designers competition, all of whom were Chinese, mainly from China, with some Taiwanese and Hong Kong designers. The collections were from established fashion brands as well as designers who were showing at China Fashion Week for the first time. While space here does not allow for detailed description and analysis of every show, a selection of examples gives a sense of the range of styles being displayed.

A tone was set with the first collection shown at China Fashion Week by established luxury brand NE·TIGER,[35] which reinforced its prestige in China's fashion hierarchy by opening Fashion Week.[36] Its Huafu haute couture collection was presented as reflecting 'the Chinese national spirit', and included colours, shapes and techniques recognisable from China's sartorial history.[37] Other collections took a regional approach to Chinese heritage. Cheng Yingfen, Design Director, Xinjiang Atlas Research and Development Center, uses fabrics incorporating ancient silk warp dyeing techniques from her native province (Figure 9.1). A number of collections referenced vestimentary codes current during particular moments in China's long and varied history. But the extent to which the designers and brands reflected Chinese heritage varied considerably. Some employed familiar decorative motifs, colours, techniques, and forms, such as the colour red, or garments reflecting

9.1 Chen Yingfen's collection spring/summer 2015. Courtesy of Chen Yingfen.

the *qipao*, while for others the historical and cultural references could be subtler or more conceptual. The Moho womenswear collection by designer Chen Yuan, for example, featured long, loose garments redolent of those worn during China's Republican Era (1911–49), which were described as referencing 'people's dressing in the memory or the reality (sic)'[38] (Figure 9.2). Designer and lecturer Sun Xuefei, who was showing for the first time, promoted a quite different aesthetic that, in common with several brands, featured fabric effects. Her Fei brand featured finely painted and pleated silks, some of which bore a striking resemblance to Issey Miyake's Pleats Please fabrics, and as a result drew criticism from some of the judges (Figure 9.3). This critique raises the question of the criteria being used to judge the shows. Those given to the judges were brand image, entire style, creative ideas, fashion feeling, pattern design, use of colour, tailoring techniques and fabric use. Chinese heritage was not a criterion; rather, some judges raised the extent to which designs were 'international' in the final feedback session with CFA representatives. The winner of the title of the 'Top Ten Fashion Designer' was the eponymous brand of designer Gioia Pan, from Taiwan, for a collection of black and white garments for women and men, featuring technically sophisticated customised knitwear. The collection had a strong visual appeal, but made no obvious bow to Chinese heritage.

In addition to those competing for the Top Ten Fashion Designer award, about half of the collections shown during the week were by designers and brands already well established in China. The brand that held the prestigious position of staging the final gala fashion show, White Collar, began as a share company in Beijing in 1994, with a clear target market of young educated women in or about to enter the workforce.[39] It remains a leading mass-market Chinese womenswear brand. Also showing was Jefen, founded in 2000 in Beijing by designer Frankie Xie, another brand that is well regarded in China. Described as 'one of the most commercially successful fashion brands in China', with 80 shops across China, Jefen has shown in Paris, London, New York and Milan fashion weeks, collections that reflected contemporary fashion trends, as opposed to presenting any recognisably Chinese aesthetic.[40] Frankie Xie was amongst the 'first generation' of 'pioneer' Chinese fashion designers

9.2 The Moho womenswear collection by Chen Yuan. Getty Images.

who were educated in the 1980s and 1990s, mostly in China. However, he was unusual amongst his generation in having studied fashion overseas, in Tokyo (receiving a Masters degree from the Bunka Fashion College), and having worked for Kenzo in Paris.[41] Such international knowledge and awareness by designers appears key to the development of brands for Chinese consumers (who are increasingly in touch with the wider field of fashion) and for an international market. Education is key in this process. As a result, it is not surprising that some Mainland Chinese designers also teach in university fashion design departments.

Zou You is a lecturer at the Beijing Institute of Fashion Technology (BIFT), the holder of a PhD in design, and runs his own brand, YouZ, from a studio at 751D-PARK. It was there he showed his collection in October 2014, in a small space that was packed with enthusiastic followers. Featuring bold, simple-shaped garments using neoprene fabric with abstract designs in black and neutral colours, his creations were much more reflective of contemporary international fashion than the

9.3 Sun Xuefei's collection. Courtesy of Sun Xuefei.

majority of the collections shown during Fashion Week. Having received his fashion education and then continued to practice as a fashion designer in China, Zou's profile is similar to his 'second generation' counterparts. His work is sophisticated and reflective of the aesthetic of international fashion. Bold shapes and strong colours characterise the YouZ brand; the

9.4 Zou You's 'YouZ' brand. Courtesy of Zou You.

spring/summer 2015 collection featured the use of neoprene fabric, which gave a strong form to many of the garments. It has been commented that his clothes represent Chinese philosophical thinking of 'returning to the basics'.[42] Zou has not worked outside of China, but he is well travelled with a distinguished professional career including a short time, in 2003, as Design Director of Exception de Mixmind, the brand started in 1996 by designer Ma Ke and her then-husband Ma Jihong.[43] The relationship of Chinese fashion designers to education is not unique; in Zou's generation, Wang Yiyang, chief designer for Zuczug, was a professor at Donghua University. Designer and educator Wu Hiyan, who has her own brand WHY, is at the time of writing Head of Design at the China Academy of Art in Hangzhou, where she has taught since she graduated in 1984, from the same institution, formerly known as Zhejiang Academy of Fine Arts.[44] The role and relationship of education in the professional lives of Chinese fashion designers deserves attention.

CHINESE FASHION DESIGNERS

Just as Angela McRobbie noted the significance of education in her important study of *British Fashion Design*,[45] the fashion design education of the younger generation of Chinese designers is proving significant to the establishment of their careers and reputations. There is, for example, a clear distinction between the 'second generation' of Mainland Chinese fashion designers discussed above, who were educated and have spent their professional lives in China, and the second generation of Chinese-American designers. Not only is there the generational divide but also the) distinction of the enormous social and economic changes that have taken place in China over the last two decades. The upcoming 'third generation' of Mainland Chinese fashion designers, involved in establishing businesses in China in the first and second decades of the twenty-first century, are different again. Those who have become better known internationally and commercially successful typically share the distinction of having been educated overseas. As one journalist has noted: 'China is still without an established institution for fashion education, and ambitious Chinese designers-to-be opt to attend prestigious schools abroad – namely London's Central St Martins,

New York's Parsons or Milan's Istituto Marangoni.[46] Many younger-generation Chinese designers have graduated from Central St Martins in London, which has offered undergraduate and graduate fashion design education for decades. Parsons School of Design in New York has offered fashion design education since its establishment in 1906, but only graduated its first MFA Fashion, Design and Society students in 2012. Mainland Chinese students on that programme confirmed the value of an overseas fashion education as providing them with advantages when they returned to China in search of employment.[47] Knowledge of the international field of fashion is key to the career development of young Chinese designers; more of those who can afford it are taking the opportunity of an overseas education at a well-known fashion school. It was notable that in the 2015 publication, *Fashion China*,[48] documenting the work of 41 Chinese fashion designers, the majority had received an overseas fashion education, had won international design awards, or had worked outside of China.

Of those mentioned in the above publication, Beijing-born Masha Ma is one of the better known among the new generation of Chinese contemporary fashion designers. Often spoken of in the same breath are designers Qiu Hao, Zhang Huishan and Xander Zhou, all of whom share a foreign education, modern style, and prolific activities on the international stage.[49] Ma graduated in 2008 with an MA in Womenswear from Central St Martins, London, where she interned for designers Veronique Branquinho and Alexander McQueen whilst a student. She was also chosen to participate in the CFDA/Vogue Fashion Fund China Exchange programme, between the Council of Fashion Designers of America and *Vogue* magazine. Another Central St Martins alumna to be extended this opportunity was Shanghai-based Uma Wang, who went to New York in 2012 for six weeks. In describing the designer and her work as epitomising 'understated elegance', Fashionista.com noted how she had 'caught the eye of many an international fashion editor (not the least of which include Anna Wintour) with her collections of often oversized, highly textured designs'. Wang had also gained a much-coveted invitation to the Annual Fashion Gala at the Metropolitan Museum of Art.[50] Such details are not gratuitous, but provide evidence of induction into an international field of fashion characterised by fashion weeks and galas, which is reported on by fashion media at a variety of levels, from

internationally renowned magazines like *Vogue* to national newspapers and fashion blogs. As the field of fashion becomes increasingly tangled with celebrity culture, events such as the Annual 'Met Gala' can have enormous impact on the publicity afforded to a designer. In 2015, at the event held for the opening of *China Through the Looking Glass* exhibition, the exquisite yellow silk gown designed by Guo Pei and worn by Rihanna gained a great deal of attention. Culturally specific fast food comparisons were made to its huge train, which was likened to a pizza by the US press and a pasty in the UK. Nevertheless, dressing a popular celebrity (already referred to earlier in this chapter) as well as the inclusion of her work in the exhibition has afforded considerable international publicity to Guo Pei's work.

Guo Pei is already one of the best-known fashion designers in China. She has been named 'the queen of China's haute couture' for the intricate and lavish one-off dresses that have featured in the annual CCTV Spring Festival Gala and at the 2008 Beijing Olympics.[51] The dress worn by singer Song Zuying, when she performed with Placido Domingo at the closing ceremony of the Olympics, was covered with over 200,000 hand-sewn Swarovski crystals. Such lavish displays have become typical of Guo Pei's work, which consciously reflects Chinese heritage in appearance and production. The dresses she designs, such as those in the *China Through the Looking Glass* exhibition, are exquisitely made by hand and reference recognisable Chinese artefacts, such as traditional blue and white china, or might be based on tales like the 'Legend of the Dragon'. While the garments are enormously expensive, she has described them as fulfilling. 'My goal ... to let more people see beautiful things, especially beautiful handicrafts ... We want to inspire a greater appreciation for traditional crafts, so they can continue'.[52] Guo Pei is amongst the 'second generation' of fashion designers, which includes Ma Ke, who now designs for China's first lady, and Wang Yiyang of Zuczug, all of whom were born during the Cultural Revolution and began working in the 1990s in Mainland China.[53] She began her career employed in state-funded and joint-venture corporations, including from 1995–6 serving as chief designer of the Peking Milano Fashion Company Ltd, a Taiwanese–USA joint-venture company. In 1996 she resigned from the position to establish her own brand, Meiguifang (Mayflower), and in April 1997 she was named one of China's top designers.[54] Beginning

with more contemporary designs, such as her 'loose-knit woollen jumper and woollen "hipster" shorts', for Beijing Fashion Week in 1996,[55] Guo Pei has developed haute couture designs utilising Chinese traditional aesthetics and hand skills that demonstrate how fashion can truly be an art. Even so, this is not the direction that most younger generation Chinese fashion designers wish to take, preferring to work for a broader and more commercial market in China with aspirations to extend their customer base, their reputations and their influence internationally.

CONCLUSION

Reporting on the collection of Simon Gao Yang at London Fashion Week in February 2014, the *South China Morning Post* quoted Xiang Xiaowei of the cultural section at the Chinese embassy in Britain as commenting how '[m]ore Chinese students are learning fashion and design in Britain, and more Chinese designers partook of the event. London Fashion Week is really a good platform for new Chinese designers.'[56] Xiaowei noted how Chinese fashion had moved from 'made in China' to 'created in China'. After seeing the show, Li Dangqi, chairman of the China Fashion Association, was quoted in several press reports as remarking that 'Yang is good at combining the oriental culture with the Western. In his designs this time, I can feel some Chinese elements, though it's not apparent. He also added some western elements and his own style into his design.'[57] Li's comments are particularly interesting in their reference to 'Chinese elements', even though 'not apparent'. They might also serve as a context for Li's final summing up to the judges at China Fashion Week in October 2014.[58] He noted how the China Fashion Association would make greater effort to support the young Chinese fashion designers, who had been far fewer in number on the runways in October 2014 than the more established designers and brands. Yet what the nature of that 'support' might be and whether this would be considered contingent by the CFA on the inclusion of 'some Chinese elements' in the work of young Chinese designers remains unclear. It also indicates that there are parallel perspectives at play that contextualise the work of Mainland Chinese fashion designers. Alongside the establishment voice of the CFA there exist the voices of the manufacturers who sponsor many

designer collections, as was so evident at China Fashion Week. Many of the latter could be compared to the nineteenth-century British industrialists who involved themselves in textile and clothing production simply to make money. Even anecdotal evidence indicates that there is a similar entrepreneurial situation currently in China in response to the increase in fashion consumption. But economic capital does not create cultural capital, and in fashion both are required for success, plus the symbolic capital for a designer of having gained an international reputation, or having made a 'name'. It is here that the distinction can be drawn between Chinese designers who have gained the notice and support of the wider fashion system and its key agents, and those who have not. Such recognition would presume that a designer has been active outside of China, and that their designs responded to the looks prevalent in the current fashion moment. But it does not exclude the impact, rather than the literal appearance, of 'Chinese heritage'.

The role of the fashion establishment in China's relationship to Chinese culture and heritage, as represented by the China Fashion Association, the designers themselves, and the consumer market, remains a point of tension, as it does for Chinese designers elsewhere. While China's establishment might search for signs of Chinese heritage in the work of designers and for fashion to function as a potential signifier of national identity, the designers by contrast aspire to be embraced by the international fashion cognoscenti, and to be commercially successful overseas (probably having first achieved success in China). So the distinction must be drawn between Chinese designers in China, the established Chinese diaspora, and a new younger generation of designers who have been educated overseas or have had some other foreign professional fashion experience or sustained contact. As influential Chinese media figure Hung Huang has observed: 'It is ... timely to recognise those Chinese designers working internationally, who are studying and interning abroad and choosing to start brands outside of China.'[59] This younger generation, neither confined to China nor typically diasporic, complicates further how we might attempt to define a Chinese designer. For them becoming international is less dependent on Chinese heritage and more dependent on recognition from within the field of fashion, which implies having developed a cosmopolitan self-

presentation as a designer, based on time spent and contacts and reputation made outside of China.

NOTES

1 26 April–29 September 2013.
2 Valerie Steele, 'A generation rises', in *Fashion at MOCA: Shanghai to New York*, exhibition catalogue, vol. 2 (New York: Museum of Chinese in America, 2013), pp. 2–3, p. 3.
3 For example, Karl Lagerfeld at Chanel, Raf Simons at Dior, or Phoebe Philo at Chloé and then Céline. While this is not unprecedented, the first Parisian couturier at the end of the nineteenth century, Charles Frederick Worth, being of British origin, it has been much more marked in the twenty-first century.
4 For example, Melissa Marra-Alvarez, 'When the West wore East: Rei Kawakubo, Yohji Yamamoto and the rise of the Japanese avant-garde in fashion', *DressStudy* 57 (2010). Available at http://www.kci.or.jp/research/dresstudy/pdf/D57_Marra_Alvarez_e_When_the_West_Wore_East.pdf (accessed 10 July 2015).
5 Eugenia Paulicelli and Hazel Clark (eds), *The Fabric of Cultures. Fashion, Identity, and Globalization* (London: Routledge, 2009).
6 Christine Tsui, *China Fashion: Conversations with Designers* (Oxford: Berg, 2009); Juanjuan Wu, *Chinese Fashion from Mao to Now* (Oxford: Berg, 2009).
7 Lise Skov, 'Fashion-nation: a Japanese globalization experience and a Hong Kong dilemma', in Sandra Niessen, Ann Marie Leshkowich and Carla Jones (eds), *Re-Orienting Fashion: The Globalization of Asian Dress* (Oxford: Berg, 2003), pp. 215–42.
8 Mary Ping and Christina Moon, 'A new American style', in *Fashion at MOCA: Shanghai to New York*, exhibition catalogue, vol. 2 (New York: Museum of Chinese in America, 2013), pp. 4–9, p. 5.
9 Ping and Moon, 'A new American style', p. 6.
10 Ibid., p. 5.
11 Vivienne Tam, *China Chic* (New York: HarperCollins, 2005).
12 Ping and Moon, 'A new American style', p. 39.
13 Yuniya Kawamura, *The Japanese Revolution in Paris Fashion* (Oxford: Berg, 2004).
14 Hazel Clark, 'Chinese fashion designers – questions of ethnicity and place in the twenty-first century', *Fashion Practice: The Journal of Design, Creative Process and the Fashion Industry*, 4/1 (2012), pp. 41–56: 43.
15 Patricia Mears, 'Formalism and revolution: Rei Kawakubo and Yohji Yamamoto', in Valerie Steele, Patricia Mears, Yuniya Kawamura and Hiroshi Narumi (eds), *Japan Fashion Now* (New Haven, CT: Yale University Press, 2010), pp. 141–207, p. 145.
16 Valeria Steele and John Major, 'China chic: East meets West', in Valerie Steele and John Major (eds), *China Chic: East Meets West* (New Haven, CT: Yale University Press, 1999), pp. 69–99.
17 Clark, 'Fashioning "China style" in the twenty-first century'.

18 Eric Wilson, 'Asian-Americans climb fashion industry ladder', *The New York Times*, 4 September 2010. Available at http://www.nytimes.com/2010/09/05/fashion/05asians.html?_r=1 (accessed 25 March 2015).

19 Clark, 'Chinese fashion designers'.

20 Wilson, 'Asian-Americans climb fashion industry ladder'.

21 While Derek Lam is closer in age to the 'first generation' Chinese American fashion designers, the fact that he did not start his own brand until 2002 often has him associated with the younger 'second generation' group of designers.

22 Ping and Moon, 'A new American style'.

23 Kering home page: www.kering.com (accessed 25 March 2015).

24 Alexander Wang BOF home page: http://www.businessoffashion.com/alexander-wang (accessed 15 January 2015).

25 Thuy L.N. Tu, *The Beautiful Generation: Asian Americans and the Cultural Economy of Fashion* (Durham, NC: Duke University Press, 2010), p. 33.

26 Dhani Mau, 'New evidence that Alexander Wang's Chinese connections may have helped land him Balenciaga', *Fashionista*, 10 December 2012. Available at http://fashionista.com/2012/12/did-alexander-wangs-chinese-connections-help-get-him-the-balenciaga-job (accessed 15 March 2015).

27 Jens Hansegard and Laurie Burkitt, 'At H&M, 3,000 stores and counting', *The Wall Street Journal*, 26 September 2003. Available at http://www.wsj.com/articles/SB10001424052702303342104579098522607802800 (accessed 12 August 2015).

28 Jie Chen, 'The sporting life of Wang and H&M', *China Daily*, 18 November 2014. Available at http://m.chinadaily.com.cn/en/2014-11/18/content_18931541.htm (accessed 15 March 2015).

29 Nicola Fumo, 'The Alexander Wang x H&M hype machine: a case study', *Racked*, 18 November 2014. Available at http://www.racked.com/2014/11/18/7568609/alexander-wang-hm-collaboration-collection-strategy (accessed 15 March 2015).

30 Jianhua Zhao, *The Chinese Fashion Industry: An Ethnographic Approach* (London: Bloomsbury, 2013).

31 Ibid., p. 113.

32 China Fashion Association home page: www.fashion.org.cn.

33 'Mercedes-Benz China Fashion Week (2015 S/S) opens', 26 October 2014. Available at http://english.chinafashionweek.org/xwsd_en/201410/t20141026_1857400.html (accessed 15 November 2014).

34 David Gilbert, 'From Paris to Shanghai: the changing geographies of fashion's world cities', in Christopher Breward and David Gilbert (eds), *Fashion's World Cities*, (Oxford: Bloomsbury, 2006), pp. 3–32, p. 3.

35 NE·TIGER home page: www.ne-tiger.com.

36 Zhao, *The Chinese Fashion Industry*, p. 115.

37 UPI, press release, 31 October 2014. Available at http://www.upi.com/News_Photos/Entertainment/Fashion-Week-in-Beijing/fp/8658/ (accessed 15 November 2014).

38 'Mercedes-Benz China Fashion Week (2015 S/S) opens'.

39 Claire Roberts, 'Fashioning cultures: contemporary Chinese dress', in Claire Roberts (ed), *Evolution and Revolution: Chinese Dress 1700s–1990s* (Sydney: Powerhouse Publishing, 1997), pp. 87–102, p. 98.

40 Alena Rasi, 'JEFEN by Frankie: baroque and gothic styles reborn', *gbtimes*, 7 January 2014. Available at https://gbtimes.com/jefen-frankie-baroque-and-gothic-styles-reborn (accessed 27 March, 2015).

41 Tsui, *China Fashion*, p. 91.

42 'Dr Zou You – the Beijing fashion star's spring summer 2014 collection', *A Safety Pin*, 20 March 2014. Available at http://asafetypin.com/Articles/30-dr-zou-you-the-beijing-fashion-star-s-spring-summer-2014-collection.html (accessed 20 April 2015).

43 Zou You interview, 13 December 2014.

44 Tsui, *China Fashion*, p. 65.

45 Angela McRobbie, *British Fashion Design: Rag Trade or Image Industry?* (London: Routledge, 1998).

46 Chiara Maria Sassu, 'Beijing's global fashion dynasty,' *Not Just Label*, 5 January 2015. Available at https://www.notjustalabel.com/editorial/beijings-global-fashion-dynasty (accessed 20 April, 2015).

47 MFA Fashion, Design and Society Director, Donna Karan Professor Shelley Fox, email exchange with the author, 25 March 2015.

48 Gemma Williams, *Fashion China* (New York: Thames and Hudson, 2015).

49 Vivian Chen, 'Designer Masha Ma says China needs to ditch "Made in China" concept for fashion to thrive', *Style*, 8 May 2014. Available at http://www.scmp.com/magazines/style/article/1500726/designed-succeed (accessed 20 April, 2015).

50 Anna Deutsch, 'The CFDA/Vogue Fashion Fund Chinese exchange program welcomes Uma Wang to New York', *Fashionista*, 17 May 2012. Available at http://fashionista.com/2012/05/the-cfdavogue-fashion-fund-chinese-exchange-program-welcomes-uma-wang-to-new-york (accessed 20 April 2015).

51 'Guo Pei, queen of China's haute couture', *Fashionista and Style Guru*, 18 October 2012. Available at https://fashionstyleguru.wordpress.com/2012/10/18/guo-pei-the-queen-of-chinas-haute-couture/ (accessed 20 April 2015).

52 Ibid.

53 Tsui, *China Fashion*.

54 Roberts, 'Fashioning cultures', pp. 100–101.

55 Ibid. 'Hipster' here describes shorts that were worn at hip level, not to be confused with the more current designation of the term.

56 'Simon Gao Yang presents designs at London Fashion Week', *South China Morning Post*, 19 February 2014. Available at http://www.scmp.com/news/world/article/1431190/simon-gao-yang-presents-designs-london-fashion-week accessed 20 April 2015).

57 Ibid.

58 Li Dangqi to the China Fashion Week judges, Jade Garden Hotel, Beijing, 1 November 2014.

59 Williams *Fashion China*, p. 6.

10

ROMEO GIGLI
REBORN IN CHINA?

Simona Segre Reinach

EAST AND WEST: INDIVIDUAL ENCOUNTERS

I met fashion designer Romeo Gigli in 1986 in his Milanese store at 11 corso Como, one of the hottest spots of the urban *movida*, which at the time was still a working-class area outside of the city centre.[1] I was consulting for a corduroy company and he gave me interesting insights into fashion trends. Italian designers were having international success and most fashion companies were reconsidering their strategies in order to seize the new business opportunities offered by a rising interest in fashion as a cultural industry. Italian fashion, as represented by Milanese prêt-à-porter, consisted of a fresh new look created by an apparently spontaneous and unstoppable flow of designers, whose aesthetics offered an alternative to both the anti-fashion movements of the previous decade and the bourgeois collections coming from Paris. The myth of 'made in Italy' was about to take shape and Milan had recently become a capital of fashion.[2] 'Luxury', as we refer to it nowadays – that is, power brands and huge conglomerates owning a portfolio of brands – was yet to come. The energetic simplicity of Italian fashion looked exactly what was needed in the culture of the decade.

Romeo Gigli did not really belong to this currency of designers, though. His success was extraordinary, especially among the urban elite, but he was somehow unique. He was a different cup of tea from Giorgio

Armani, Gianni Versace, Enrico Coveri and from the many others who contributed to conjure up the 'made in Italy' narrative. He wasn't energetic or simple, nor was he strong-minded and driven to success. Neither his attitude nor his family background allowed him to be so. The son of an antique dealer and book collector, who owned more than 20,000 volumes from the fifteenth and sixteenth centuries, Romeo's inner self-projection was somehow that of a historian with an eye to the future, a creative scholar and passionate traveller. He saw himself as an art collector immersed in objects for transformation, in the same way as a purposeful child is immersed in their toys. He had studied architecture in Florence. At the end of the 1970s, after ten years' traveling in many countries throughout Europe and beyond, during which he in fact collected objects, fabrics and clothing, he began to develop an interest in fashion.[3] In 1979 he went to New York, where Pietro Dimitri, a tailor who produced custom-made clothing for men, asked him to design a line for women. This was a defining moment for Gigli, and after returning to Italy and settling in Milan, he decided to enter fashion on a full-time basis. In 1983 he launched the Romeo Gigli label. Although Romeo followed all the same steps as other prêt-à-porter Italian fashion designers of the time – that is, launching a first line named Romeo Gigli, followed by a second line called GGigli, then accessories, fragrances and many other items under licence – he was clearly moving away from the cultural and production system of Italian prêt-à-porter. In 1989 he chose Paris catwalks and left Milan. This was a scandal in the fashion community and contributed to create the legend of Romeo as an unconventional Italian designer: 'Romeo Gigli is utterly charming and undeniable Italian, yet also, at times, a solitary nomad.'[4]

At a time when being an international designer meant mainly selling in the USA, the consolidated ally of Italian fashion since the 1950s, he was already pointing to the East. For Romeo the East meant mainly Japan.[5] No wonder. The construction and allure of his clothes ended up being a bridge between the two aesthetics and fashion cultures, Eastern and Western. His success in Europe, Japan and the USA was burgeoning and he became a point of reference for a sophisticated, subtle, understated but not minimal fashion, for both men and women, beyond Paris and Milan. His style and his fashion crisscrossed most

East-meets-West stereotypes[6] in a similar way that the Japanese revolution did in the early 1980s.[7] In a way he had some kind of sensibility of the Orient in his veins, being from around the city of Faenza, an area with a rich cultural and historical heritage of exchange between East and West. He was inspired by the mosaic complexity and the flat beauty of Byzantium icons. Gigli's official photographer Paolo Roversi, born in Ravenna – which, together with Venice, was perhaps the Italian city that received most Oriental influences – contributed to conveying an image of women that is not sexy but sensual, uninterested in power but sufficiently challenging to obtain it, a winner without having to fight, as if she were simply following her fate, like Galla Placidia (382–450), the Roman empress buried in Ravenna.

Romeo Gigli's professional (business) encounter with China also happened in 1986. Gigli's China was Hong Kong, one of the few advanced cities available at the time, when the city had not yet been returned to the Mainland. The complex process of translating the European luxury map in the People's Republic of China (PRC) had only just begun and the city was the keyhole through which Mainland China could capture Western fashion. Joyce Ma – the Hong Kong retailer who opened her eponymous boutique in 1970 at the Mandarin Oriental Hotel – admired Gigli's work and determined to incorporate his collections in her boutiques.[8] Later she launched an individual Romeo Gigli boutique at the Peninsula Hotel Hong Kong. The Italian designer had been in love with the city of Hong Kong since his first visit as a traveller in the 1970s. He recalls its atmosphere at that time and the great changes that had occurred in a short space of time:

> The smell of the floating market, and the overwhelming Blade Runner atmosphere of the city. The antique stalls, the objects resting on the ground on carpets, the busy street life, the food. The airplane landing almost amongst the buildings . . . When I returned in the mid-80s it had all changed: very neat, clean streets, a much richer city, still fascinating but in the different way. The new buildings were changing the topography of the old Hong Kong.

Nineteen-eighties Hong Kong suited Gigli fashion perfectly. His personal friendship with 'the retail queen of the booming Southeast Asia market'

offered him a neat, precise, happy although partial experience of what China was becoming.[9] At the time Romeo could be described as a designer moving among cities – Milan, Paris, Tokyo and Hong Kong – in the idealised life style that Wim Wenders brilliantly captured in his 1989 film Notebook on Cities and Clothes. The Hong Kong boutique lasted ten profitable years (1986–96). Then the boutique closed, as Joyce had to completely revise its distribution strategy in Asia.

LUXURY RESHAPED

In 2010, on the occasion of the 40th anniversary of Joyce's company, some celebrated European designers who had collaborated with Joyce in the 1980s and 1990s were asked by Joyce's recently appointed CEO, Andrew Keith, to select an iconic piece from their past collections to exhibit during a special event in two Joyce stores, in Hong Kong and Beijing. The embroidered purple coat from Gigli's 1989 collection was chosen and turned out to be such a huge success that it made the Joyce management think about starting a new business with him. A Romeo Gigli capsule collection was thus launched followed by a full menswear and womenswear collection in 2012, labelled 'Joyce by Romeo Gigli', exclusively for the Chinese market.[10]

By the time of Joyce's 40th anniversary Joyce Ma had already sold her stake, though she kept up its management until 2007. Diane Pernet, fashion socialite, photographer and blogger, commented that she could not imagine 'Joyce without Joyce'[11] but in fact they did quite well. From 2003 Joyce boutique – 'not so much a shop but a fashion institution'[12] – and Lane Crawford department store, the biggest distributor of fashion in China, became part of the same conglomerate that still dominates Asian luxury retail.[13] Together, the celebrated Lane Crawford Joyce Group promotes a new era of fashion consciousness in Greater China. For many reasons Diane Pernet was right, though. Things were very different from the time when Romeo Gigli and Joyce Ma met. China entered the World Trade Organization (WTO) in 2001, and the dismantling of the Multifibre Agreement had expired by 2005; both events contributed to a brand new agenda for both China and the international fashion system. Only after the Reform era (1978) did fashion in China gradually cease to

10.1 Romeo Gigli preparing for a photo shoot. Hotel Temple, Beijing 2012. Courtesy of
Lara Aragno.

be an abstract symbol of individualism deriving from foreign countries,
or an expression of capitalism to be suspicious of, but up to the 1980s
fashion remained a controversial subject, monitored and controlled by
the state.[14] The pull of the West was not without some turbulence,
creating problems in de-codifying sartorial semantics. Fashion expanded

from being mainly a form of artistic expression, as it had been in the past, into an important mode of economic production. In 1986 the Shanghai Garment Trade Association (SGTA) was founded to act as a link between Chinese and Western fashion industries and between the government and apparel companies.[15] As Antonia Finnane puts it, 'on the whole, people in reform-era China wanted to be citizens of the world';[16] and fashion, she suggests, was precisely one of the areas where the reforming country could enter into contact with the rest of the Westernised world.

If China's fashion identity and Joyce's retail identity had changed radically, so had Gigli's designer identity. A long period of conflict between his commercial and business partners had started in 1999 that had subsequently changed the designer's destiny in the business of fashion. The first area of conflict, with business partner and muse Carla Sozzani first, and later with the garment company responsible for the manufacturing of most of Gigli's collections, diverted an otherwise completely successful career. After many years of legal disputes and disagreements, Romeo Gigli the brand and Romeo Gigli the person eventually separated for good. The designer lost the legal right to use his name for commercial purposes; that is, he could never brand his collections as 'Romeo Gigli'. Wanting to continue his work as a designer, he then tried different projects: 'Rebecca Brown' (2007), 'Io Ipse Idem' (2009) and 'XII XII XLIX' (2011). Most of these brands revealed Gigli's hidden identity in many ways. 'Io Ipse Idem' was meant to express the pronouns 'me' and 'I' in different ways, while 'XII XII XLIX' refers, in Roman numerals, to Romeo's date of birth, 12 December 1949. None of these brands proved to be successful. The public and customers were confused.[17] How could a fashion designer compete in a world of regulated designer brand names without using his name?[18] More so, how could Gigli deal with products labelled 'Romeo Gigli' that are circulated in the market but were made by others? It was as if a Ferrari could no longer be called 'Ferrari' but, rather, given some awkward names for consumers to fathom whilst 'fake' Ferraris are regularly distributed and sold.

The request from Joyce seems to have come at the right time to rejuvenate the brand. Gigli was happy to seize the opportunity offered in 2012 by Joyce's newly appointed chief executive officer (CEO). Despite Gigli's disappearance from the fashion world, his brand name was still in

the minds of fashionistas. The success in and memories of the old times in Hong Kong were strong enough to successfully launch 'Joyce by Romeo Gigli'. His return to China was considered to be the happy ending for a troubled designer whose creativity has never ceased, despite legal misfortunes in Europe. By that time most Western fashion companies were finding their way to China, beyond cheap manufacturing, exporting products, introducing brands, adapting, fine-tuning and reinventing themselves in many ways:

> Global labels are attracted to the Chinese market not only because of the stunning growth that has already taken place, but also because of the huge potential for further expansion is so great: a luxury market built on a population base of 1.3 billion consumers is too tempting for any brand to bypass.[19]

An Italian manager I interviewed in 2009, researching on Sino-Italian joint ventures in China (2002–10), simply declared that he did not know any brand that was not *made* in China. This could be taken literally as the manufacturing of most branded global goods in China, which is precisely what he meant. And this remains a reality despite the fact that the label factory of the world is rapidly transforming into an old stereotype, given the new articulations of labour, the recent relocation processes of some Western fashion companies and the present profitable interest in considering China as the most important market for luxury products. But the manager's somewhat provocative declaration, in a decade when Italian companies still tended to disguise their actual outsourcing strategies, conveyed a wider truth beyond the obvious meaning of manufacturing garments and accessories. Western fashion is not only made but also produced in China in many ways.[20] As a matter of fact, the European luxury map could not simply be translated into China. Exporting luxury products in 'cultures that have historically worshipped luxury', in the words of Tom Ford, 'and haven't had it for so long'[21] was not an easy game. Brand names were too vague as a concept for most Chinese consumers to comprehend, be it brand image or philosophy. Chinese fashion socialisation with brands is a concept too recent for consumers.[22] The stratified meaning of brands and the subtle differences layered in years of marketing strategies could not be a direct

transfer to Chinese malls: 'So many international brands have entered the market that the Chinese have problems recognising the status brand hierarchy.'[23]

The type of mall, floor layout and neighbouring brands are the basic factors for any brand to master when acquiring a location in a shopping mall. Otherwise, brand names and products would simply float in an immense space, evoking a sense of vague luxury. This, however, could only be achieved by Chinese intermediaries who have the authority and ability to select cities, areas, malls, the floor of the malls and determine the allocation of brands. Malls, if badly located, might become what Welters and Mead have defined as 'ghost malls',[24] that is, empty, a complete disaster. In fact, even consolidated positions in Europe could be easily overturned in China, if the brand was not able to negotiate the right place in the mall. Opportunities and dangers went hand in hand. Mall proximity was the basis of brand positioning in China. In this context, the role of a Chinese negotiator, also called a developer, is to locate the right place in malls, which has proved to be the first step in business success. Other ways in which China contributes to producing Western fashion come directly from the factories' experience in manufacturing. Chinese factories and Chinese companies manufacturing products for Western brands are a precious repository of trends, technical skills and innovative production for many foreign entrepreneurs who have their garments made there. The process of 'fashionalisation'[25] started somewhat late in China, which, however, was never a passive receptor of European products and brands. The process of socialising with Western fashion entailed a complete rewriting of the Western luxury map and the constitution of new configurations in the global fashion arena. By contributing to reshaping the European luxury map, China somehow reproduces Western brands, giving them a new identity both in the Chinese market and on the global stage.

Romeo Oh Romeo Gigli Oh Where Were You? was the title of magazine *W* in September 2012, commenting the launch of the new brand. And the disappearance of Gigli in Europe was reinforced by his return in Asia. The 'by' between 'Joyce' and 'Romeo Gigli' apparently allowed the partners to overcome the legal ban on using Gigli's name for commercial purposes. From Joyce's point of view, the old acquaintance between Gigli

and Joyce Ma helped to refresh the identity of a historical boutique, now part of a larger system responsible for fashion dissemination in China – the Lane Crawford Joyce Group – despite its struggle in market positioning. Gigli's strategy, fine-tuned with Joyce's management, was twofold: firstly, to relaunch Romeo Gigli in China with a new brand name with the designer's name on it; secondly, to enhance the role of Joyce within the Lane Crawford Joyce Group. 'Joyce by Romeo Gigli' embodies the subtle fascination of the return of a desirable master:

> Seated in a vintage wood chair, his gauzy white shirt unbuttoned to his navel, tan torso on display and a pack of Gauloises tucked into his chest pocket, 62-year-old designer Romeo Gigli looks like he has been on a very long – and restful – vacation. And for fans of the romantically draped garments that propelled him to fame in the late eighties and nineties, that's probably where they imagine he has been since his departure from the international fashion scene in 2004.[26]

South China Morning Post called their article 'The return of a legend', and Vogue UK wrote:

> Romeo Gigli, the legendary fashion designer who rose to fame in the late Eighties and was once described by photographer Richard Avedon as 'his god', has made his comeback with a special collection for luxury retailer Joyce. The collaboration with Hong Kong's fashion-forward boutique was unveiled last week to a crowd of international guests, with an accompanying exhibition of carefully-curated pieces from Gigli's archive that will be on show at Joyce for one month.[27]

And more:

> Garnering fame at the same time as the first prolific Japanese designers were making waves in Europe, Gigli is considered to be in the same camp as intellectual design talents Rei Kawakubo and Issey Miyake. His unstructured, subversive designs touch on Renaissance grandeur (inspired by his father's job as an

10.2 Romeo Gigli fitting a model. Hotel Temple, Beijing 2012. Courtesy of Lara Aragno.

antiquarian book dealer), dishevelled street punk and Japanese conceptualism.[28]

The photographer Chen Man was chosen to execute the first campaign, as the Chinese artist shared with the Italian designer the status of being a pioneer:

Like Gigli Chen Man is a pioneer in her field. As the face of China's next generation of creatives she is the perfect person to photograph Gigli stunning designs. The campaign was shot on location in China's fashion capital of Beijing, a city that embodies the best of East and West, much like Gigli's designs. Gigli was flown in especially from Milan to oversee the project.[29]

When I visited Joyce Hong Kong in 2013, Romeo Gigli collections were splendidly laid out in the centre of the store, like a precious installation: 'Iconic cocoon coats and capes that fold over the body. Velvet dresses and tulip brocade skirts, askew knits with asymmetrical necklines and the single collar shirt.'[30]
Here is the description from the Joyce website:

The adventurous traveller has very fond memories of Hong Kong and China (he first set foot in China when everyone was still wearing Mao suits). The authentic taste of dim sum satiates his stomach, his interest for the Far East as well as his thirst for cultural diversity. He then went to the Central Joyce store to talk about his latest collection to the Hong Kong media. The collection was well received and everyone was excited to meet with the legendary designer again. The previous Joyce and Romeo Gigli collaborations re-ignited Gigli's glory and gathered his long lost fans (and friends) who had been missing the master and his artful pieces for decades. They also attracted a young following who had never had the chance to experience the Gigli romance until now. We believe the AW13 collection will re-confirm Gigli's status in fashion history.[31]

For the 2013 collection another celebrated photographer, this time the French Thomas Devaux, was in charge of illustrating Romeo's clothes. Among the models were the Chinese Leila Wang, Wang Shinning and Nan Fu Long.

Do you still remember Chen Man's series of stunning photographs for the Romeo Gigli x JOYCE Hong Kong collaboration last year? Here comes round two, with a new set of images shot in a dream-

like tone by Paris-based photographer Thomas Devaux for the Spring/Summer 2013 collection. This look book features 14 style icons that best embody the Romeo Gigli style for the new generation.[32]

With 'Joyce by Romeo Gigli' Gigli was no longer a designer who floated romantically between cities. He was about to become a Western brand in China, with all the rules, regulations, constraints and difficulties of competing in the Chinese market. The reality of the business soon proved to be out of step with the media's romantic declarations. Despite the spacious layout in store, Romeo's presence on Joyce's website faded progressively, proving that Joyce had ceased to invest in the brand. All this happened rather quickly. In 2014 Romeo Gigli was just a name among other designer names and, just a few months later, 'Joyce by Romeo Gigli' disappeared. What happened? Why couldn't 'Joyce by Romeo Gigli' survive, despite the communication efforts and the beauty of the garments? There are many reasons. According to Gigli the collection was not large enough and was too expensive to be commercially viable. All the pieces were made in Italy in small artisanal laboratories and by contract Gigli had to advance all costs of production. It would have required a much larger production for it to break even and be profitable. 'Joyce by Romeo Gigli' was targeted at young people, as required in the group's brief; however, young people were not the typical Joyce customers, they were more likely to be Lane Crawford customers, with its very many department stores throughout China The last and most crucial point was the new legal constraints on joint ventures, as the 'Joyce by Romeo Gigli' brand turned out not to be legally defendable in China.[33] By the end of 2014 the collaboration had come to an end.

CO-PRODUCING: REPRODUCING

If China failed to *produce* Romeo Gigli the brand, it certainly contributed to reproducing Romeo Gigli the designer. His activities in China, as I soon learned, were by no means limited to Joyce. The Hong Kong store was

only the visible side of erratic consulting activities taking place beneath the surface. Like many other European designers in China, Romeo was in fact much requested by Chinese companies in their quest for brands. Branding means being able to assemble a collection, express a positioning, convey an identity, control the distribution and fine-tune the very many aspects of the communication strategy. This is why Chinese entrepreneurs still prefer to hire a Western designer to supervise the production, as a Western designer is supposed to be more experienced not only in terms of the design of the product, but also in other immaterial aspects relating to the success of a brand.

From 2013, a Hong Kong entrepreneur husband-and-wife team, regular customers of Gigli's at Joyce, asked Romeo to work for them. As a matter of fact it turned out that they owned a huge factory in Mainland China, specialised in manufacturing garments for high-end European fashion companies.[34] They cherished their own leather bags and accessories brand Pernelle, and aimed at upgrading it to reach the same standard as the, by and large Italian, international luxury brands that they manufactured in their factory. They aimed for Pernelle to achieve the top rank market positioning in China. Gigli was hired precisely for this purpose – that is, to improve the quality, design and overall image of Pernelle. His consultancy had to remain anonymous, but the owners wanted to add some Italian flavour to the brand, and they therefore renamed the brand Pernelle Milano. In the early stage of this collaboration the arrangements envisaged Gigli sending sketches and drawings from Italy to China through the internet, as well as visiting China regularly to supervise production in the factory, ensuring that everything proceeded smoothly. This, however, happened very rarely. Decision making was anything but a smooth process; every single step needed to be negotiated and renegotiated incessantly and the production apparently never reached the quality and stylistic standard that both – owners and designer – had set for Pernelle. They almost got to the point of breaking the agreement, but eventually in July 2015, after three years of anonymous consultancy, I learned by surfing the internet that Romeo Gigli had been officially appointed creative head of Pernelle Milano. 'Italian luxury leather accessories brand Pernelle has named Romeo Gigli as Creative Director. Gigli, a legendary Italian fashion designer, mentor to

many young designers, among them the late Alexander McQueen, is known as a "contemporary renaissance master".[35]

A tutorial video entitled *Milano Craftsmanship and Artistry* offered a rapid bird's eye view of the city of Florence, traditionally renowned for its leather goods and artisans' shops. The Pernelle Milano video makes no explicit reference to the location of production, but the viewer is visually plunged into what has become a recognisable Italian fashion atmosphere, a mix of art, craft and designed landscape in which place names and locations do not necessarily combine.[36] The video goes on to show Gigli in navy blue jacket, confidently working side by side with someone who looks like an old Italian artisan – white apron and spectacles on his nose.[37] In the absence of verbal commentary, the classical background music conveys confidence, refinement, connoisseurship, heritage and tradition. Gigli's own words are recalled in a separate text, clarifying the nature and the reasons of his new appointment as creative director at Pernelle Milano:

> I'm very pleased to lead the brand's effort in advancing to a new stage of development, and blend our Italian design and craftsmanship experience with the heritage of culture values of PERNELLE Brand and the enthusiasm and energy of its young existing design and management team introducing this beautiful and passionate brand to the world, of fashion luxury.[38]

Interviewing Gigli again, in September 2015, I asked him to comment on his recent appointment as creative director at Pernelle Milano. He explained that the Hong Kong entrepreneurs had made a radical change in their strategy in order to reach the luxury segment once and for all. This could only mean, according to them, the transformation of Pernelle into a real Italian brand. They appointed Gigli as the creative director and asked him to find a suitable Italian artisanal workshop specialising in luxury leather products to start up a small production of Pernelle bags of higher quality, under his direction. Eventually they chose an artisan lab located in Tuscany. The new precious Italian collection of Pernelle Milano – introduced to the press during Milano Collezioni spring/summer 2016 – was now definitely produced in Italy by an Italian designer. The rest of the Pernelle production is manufactured in

the large factory in China, still supervised by Gigli. Most of the Chinese bags are tagged with Italian names – Annabella, Signora, Capri, Luna. And this, for now, is the end of the story.

GLOBALISING STRATEGIES

Pierre Xiao Lu, professor of marketing and consultant, describes three strategies for building a luxury brand in China. Number one is 'buy a brand, buy a story', number two is 'create your brand sell it big', number three is 'create your brand, build your own legend'. The third strategy is the most difficult to realise, as it 'requires a lot of hard work, talent and patience, and a great amount of courage on the part of the designer',[39] but it is the most valuable, according to Xiao Lu. Pernelle proved to be even smarter, by buying its legend directly and appointing it as creative director. Legendary Romeo acts, so to speak, as a medium for a Chinese brand to both incorporate and express a heritage that would otherwise be difficult to express. The small Italian collection reinforces the legitimacy of all Chinese Pernelle productions, connecting Hong Kong, Mainland China and Italy within the same semantic circle. But what I found most intriguing in Romeo's reported words in the Pernelle Milano video is that heritage, clearly one of the key concepts in global luxury that the West has always wanted to keep for itself – the others being retail and brand – has migrated naturally to the Chinese side, and it was able to do so because of Romeo, as if Romeo Gigli (and the Florentine artisan) were there just to reinforce Chinese creativity. One could ask if Pernelle can be considered Italian or if it is still a Chinese brand. As the economic investment is 100 per cent Chinese, Pernelle is a Chinese brand. But Pernelle is designed by an Italian designer, the top-quality part of the collection is made in Italy and exported to China, where other Pernelle bags are manufactured. Is Pernelle perhaps an Italian brand owned by a Chinese company?

My experience of researching Sino-Italian joint ventures[40] made it apparent that it was almost a rule to draw a clear-cut demarcation between Italian heritage and design on the one side, and Chinese manufacturing and craftsmanship skills on the other. This served to underline a separation between creativity and execution that was typical

of the first collaborations with foreign companies from the beginning of the 1980s. By reinforcing the Orientalist stereotype of Chinese lack of creativity,[41] Italians justified and maintained their leadership in rapidly evolving globalised companies. Whereas Italian companies used to conceal outsourcing to China, Chinese companies enhance their Italian components. But mutual exchange makes such clear distinctions between each part's contributions increasingly difficult to draw. In Sino-Italian joint ventures, a business formula that reached its momentum between 2005 and 2010,[42] the dissemination of a narrative concerning two distinct realms of fashion had the scope to strengthen the division of labour. This turned out to be not only inaccurate, as since the early times of Italians sourcing in China, the Chinese proved able to contribute in many different ways to shaping the final product, but also theoretically untenable. In the fashion system, which is not merely a manufacturing industry but a creative and cultural industry, the material and the immaterial have always been inseparable[43] and appropriation also proved, historically, seldom to be a one-sided task.[44]

The question of whether it is a Chinese or Italian brand is probably not well posed in the case of Pernelle. In the age of global fashion, the 'made in' issue conveyed by luxury brands needs to be redefined, according to the complexity of the production and the multiplicity of exchanges.

Gigli's unique history as a designer-with-no-name-but-whose-name-is-a-legend cannot nonetheless be generalised. However, it is precisely in the uniqueness of his experience that we can envisage some germinal transformations in the global fashion system of the second decade of the twenty-first century. His long journey as a Western fashion designer in China shows all the necessary adjustments made between creating, manufacturing, producing and the blurring boundaries between 'made in' and a specific country of origin.

For many reasons Romeo Gigli can be considered an example of a Western brand reborn in China, as certainly China gave him a new professional opportunity, but his experience also shows the subtler articulations the occur in the process of the globalisation of the fashion industry. During his first encounter with Hong Kong, when Western designers were confronted with a very fragmented China and the city was still shaped by its colonial past, Gigli acted as an Italian designer

representing a Western interpretation of fashion, both distant and worshipped by the Chinese, who envisaged the promises of a different world shaped by Western consumer-driven lifestyle. In the second stage of his Chinese experience, Gigli performed the return of the legend, in a Chinese fashion environment that was completely embedded in the culture of brands, an 'intricate interplay of internal brand values with external fashion trends'.[45] In the third stage of his Chinese experience, the Italian designer handed over his legendary past to China, an essential tool to ensure creativity in Chinese fashion, and his own role as a designer. But capitalising on his own heritage, Romeo Gigli was able to perform his skills. Rather than 'reborn in China' Gigli could be better defined a global designer re-born through China.[46]

NOTES

1 Romeo Gigli's store contributed to the gentrification of the area. Now the 10 Corso Como store owned by Carla Sozzani, who was also Romeo's first business partner, opposite from Romeo's original store, is one of the coolest fashion spots in town.

2 Simona Segre Reinach, 'Milan: the city of prêt-à-porter', in Christopher Breward and David Gilbert (eds), *Fashion's World Cities* (Oxford: Berg, 2006), pp. 123–34.

3 Simona Segre Reinach, 'Romeo Gigli', in Valerie Steele (ed.), *The Encyclopedia of Clothing and Fashion* (New York: Charles Scribner's, 2004), pp. 367–8.

4 Available at www.dappermagazine.com/2154/romeo-gigli-talks-to-filepmotwary (accessed 23 May 2016, no longer available).

5 In 1987 he signed an agreement with Takashimara – the Japanese department store specialising in luxury and quality goods – for the exclusive production and distribution of the women's ready to wear collection as well as men's and women's accessories.

6 Valerie Steele and John Major (eds), *China Chic: East Meets West* (New Haven, CT: Yale University Press, 1999).

7 Yuniya Kawamura, *The Japanese Revolution in Paris Fashion* (Oxford: Berg, 2004).

8 During her succesful career Joyce Ma had also brought to Hong Kong collections by Armani, Prada, Dries Van Noten, John Galliano, Yamamoto and many other celebrated designers.

9 Romeo and Joyce Ma met in Milan in 1984 during one of Joyce's European business trips.

10 Interview with Romeo Gigli and his wife Lara Aragno in Milan, 25 September 2015.

11 Available at www.dianepernet.typepad.com (accessed 14 November 2007).

12 Frey, Nadine, 1994 'The World of Joyce', *The New York Times*, 6 May.

13 The group currently operates more than 500 points of sale across 50 cities in Greater China and South East Asia.

14 Antonia Finnane, *Changing Clothes in China: Fashion, History, Nation* (New York: Columbia University Press, 2008).

15 Juanjuan Wu, *Chinese Fashion from Mao to Now* (Oxford: Berg, 2009).

16 Finnane, *Changing Clothes in China*, p. 280.

17 Meanwhile the Romeo Gigli brand was still in the market, designed and distributed by professionals other than Romeo Gigli.

18 (Ferrero Regis and Lindgren 2012).

19 Juanjuan Wu, *Chinese Fashion from Mao to Now* (Oxford: Berg, 2009), p. 163.

20 Fashion has always been both material and intangible. The production of fashion requires both a material (manufacture) and immaterial (symbolic) contribution, often expressed in a brand.

21 Dana Thomas, *Deluxe: How Luxury Lost Its Lustre* (London: Penguin, 2007), p. 300.

22 Jianhua Zhao, *The Chinese Fashion Industry: An Ethnographic Approach* (London: Bloomsbury, 2013), p. 168.

23 Welters and Mead Linda and Arthur C. Mead, 'The future of Chinese fashion', *Fashion Practice: The Journal of Design, Creative Process and the Fashion* 4/1 (2012), pp. 13–40, p. 30.

24 Ibid., p. 27.

25 Wessie Ling, '"Fashionalisation": urban development and the new-rise fashion weeks', in Jess Berry (ed.), *Fashion Capital: Style Economies, Sites and Cultures* (Oxford: Inter-Disciplinary Press, 2012), pp. 85–96.

26 Vanessa Lawrence, 'Romeo oh Romeo Gigli. Oh where were you?', *W Magazine*, September 2012.

27 Tilly Macalister-Smith, 'Romeo Gigli for Joyce', *Vogue*, 6 August 2012. Available at http://www.vogue.co.uk/news/2012/08/06/romeo-gigli-launches-joyce-comeback-collection (accessed 14 August 2016).

28 Ibid.

29 Joyce press release, http://www.joyce.com/fashion-article/romeo-gigli-x-chen-man/ (accessed 14 August 2016).

30 'Romeo returns: Joyce by Romeo Gigli', *The D'Vine*, 16 July 2012. Available at http://www.the-dvine.com/2012/07/romeo-returns-joyce-by-romeo-gigli/ (accessed 20 August 2016).

31 Lucienne Leung-Davies, 'A contemporary Renaissance master', Joyce website. http://www.joyce.com/fashion-article/a-contemporaryrenaissance-master/ (accessed 20 August 2016).

32 'Romeo Gigli X Joyce by Thomas Devaux', Rock the Trend, 21 January 2013. Available at http://rockthetrend.com/fashion/romeo-gigli-x-joyce-by-thomas-devaux/#.WeR2TsbMwo8 (accessed 20 August 2016).

33 'Joyce by Romeo Gigli' was only the name of a collection and not a brand as – for the legal reasons mentioned above – the Romeo Gigli brand was already deposited in China.

34 The factory manufactures brands for European companies of all types. The most powerful is the company to which the best premises are allocated in terms of space and machinery.

35 Available at http://www.my-lifestyle-news.com/2015/07/romeo-gigli-new-creative-director-for.html (accessed 20 October 2017).

36 Simona Segre Reinach, 'Italian and Chinese agendas in the global fashion industry', in Giorgio Riello and Peter McNeil (eds), *The Fashion History Reader* (London: Routledge, 2010), pp. 533–55.

37 Since Salvatore Ferragamo's exhibition in Shanghai's Moca Museum in 2008, the Italian artisan has become a common feature in the communication of Western heritage in fashion (cf. ibid.).

38 Available at http://www.my-lifestyle-news.com/2015/07/romeo-gigli-new-creative-director-for.html (accessed 20 October 2017).

39 Pierre Xiao Lu, *Elite China: Luxury Consumer Behavior in China* (London: John Wiley and Sons, 2008), p. 154.

40 Simona Segre Reinach, 'China and Italy: fast fashion versus prêt à porter. Towards a new culture of fashion', *Fashion Theory* 9/1 (2005), pp. 1–12; Simona Segre Reinach, 'The puzzle of fashion distinction in China', in Djurdja Bartlett, Shaun Cole and Agnès Rocamora (eds), *Fashion Media: Past and Present* (Oxford: Bloomsbury, 2013), pp. 144–54.

41 Simona Segre Reinach, 'Italian and Chinese agendas in the global fashion industry', in Giorgio Riello and Peter McNeil (eds), *The Fashion History Reader* (London: Routledge, 2010), pp. 533–55.

42 Simona Segre Reinach 'One fashion two nations: Italian Chinese collaborations', in Lisa Rofel and Sylvia Yanagisako, *Fabricating Transnational Capitalism: A Collaborative Ethnography of Italian-Chinese Global Fashion* (Durham, NC: Duke University Press, forthcoming 2018).

43 Thuy L.N. Tu, *The Beautiful Generation: Asian Americans and the Cultural Economy of Fashion* (Durham, NC: Duke University Press, 2010).

44 Adam Geczy, 'A chamber of whispers', in *China: Through The Looking Glass*, exhibition catalogue, The Metropolitan Museum of Art (New Haven, CT: Yale University Press, 2015).

45 Ho-Lun Tommy Tse, 'An ethnographic study of glocal fashion communication in Hong Kong and Greater China', *International Journal of Fashion Studies* 2/2 (2015), pp. 245–66, p. 250.

46 The author wishes to thank Romeo Gigli and Lara Aragno for their contribution to this chapter and their interest in her work.

BIBLIOGRAPHY

Ai, Hua [艾华] (Harriet Evans) and Yinhe Li [李银河], 'Guanyu nüxingzhuyi de duihua' [关于女性主义的对话], Shehuixue yanjiu [社会学研究] 4 (July 2001), pp. 118–25.

Allison, Anne, 'Sailor Moon: Japanese superheroes for girls', in Timothy J. Craig (ed.), Japan Pop! Inside the World of Japanese Popular Culture (New York: M.E. Sharpe, 2000), pp. 259–78.

Anderson, Kym and Young-il Park, 'China and the international relocation of world textile and clothing activity', Weltwirtschaftliches Archiv 125/1 (1989), pp. 129–48.

Ang, Ien, 'Culture and communication: towards an ethnographic critique of media consumption in the transnational media system', European Journal of Communication 5/2 (1990), pp. 239–60.

Anon, 'Diqueliang' [的确良, 'Polyester'], Fangzhi qicai [纺织器材; Materials for textile production] (28 October 1979), p. 23.

Appadurai, Arjun, Modernity at Large: Cultural Dimensions of Globalization (Minneapolis, MN: University of Minnesota Press, 1996).

Banks, Mark, The Politics of Cultural Work (Basingstoke: Palgrave Macmillan, 2007).

Bao, Ming, Xin Deng and Bian Zhu (eds), Fashion Photography Art (Chinese Edition) (Hong Kong: China Textile University Press, 2000).

Barthes, Roland, 'On Bunraku', The Drama Review 15/2 (Spring 1971), pp. 76–80.

Bartlett, Djurdja, Fashion East: The Spectre that Haunted Socialism (Cambridge, MA: MIT Press, 2010).

Beijing Review, 22 October 1984.

Bishop, Isabella L. Bird, The Golden Chersonese and the Way Thither (New York: G.P. Putnam's Sons, 1883). Available at http://digital.library.upenn.edu/women/bird/chersonese/chersonese.html (accessed 4 April 2015).

Beijingshi renmin zhengfu xinwen chubanchu: faxinglei. Chuli Dongdan shichang, Dongan shichang shuji shoumai fandong shuji baogao [北京市人民政府新闻出版处,发行类：处理东单市场，东安市场书籍收买反动书籍报告] [Beijing People's Government news and publishing division, publications: report on managing purchase of reactionary books in Dongdan and Dongan markets], Beijing Municipal Archives 8-7-426.

Bolton, Andrew, *China Through the Looking Glass* (New Haven, CT: The Metropolitan Museum of Art/Yale University Press, 2015).

Bourdieu, Pierre, *Distinction: A Social Critique of the Judgement of Taste*, trans. Richard Nice (London: Routledge, 1984).

———, *The Field of Cultural Production: Essays on Art and Literature* (New York: Columbia University Press, 1993).

Braham, Peter, 'Fashion: unpacking a cultural production', in Paul du Gay (ed.), *Production of Culture/Cultures of Production* (London: Sage, 1997), pp. 119–77.

Bruzzi, Stella and Pamela Church Gibson (eds), *Fashion Cultures Revisited: Theories, Explorations and Analysis* (London: Routledge, 2013).

Burkitt, Laurie, 'What China's trendsetters are wearing', *The Wall Street Journal*, 14 November 2012. Available at http://online.wsj.com/article/SB100014241278 87324556304578118891337284014.html (accessed 15 July 2015).

The Business of Fashion, 'Global fashion school rankings 2016'. Available at https://www.businessoffashion.com/education/rankings/2016 (accessed 15 September 2016).

Butler, Judith, *Gender Trouble: Feminism and the Subversion of Identity* (New York: Routledge, 1990).

Caillois, Roger, *Man, Play and Games*, trans. Meyer Barash (Urbana and Chicago, IL: University of Illinois Press, 1958).

Cannon, Aubrey, 'The cultural and historical contexts of fashion', in Anne Brydon and Sandra Niessen (eds), *Consuming Fashion: Adorning the Transnational Body* (Oxford: Berg, 1998), pp. 23–38.

Cao, Runsheng [曹润生] (ed.), *Guohuapai fengrenji shiyongfa ji jijian tuyang* [国华牌缝纫机使用法及几件图样; *Guohua Brand Sewing Machine User's Manual and Accessories, Illustrated*] (Tianjin: Tianjinshi gongsi heying Huabei fengrenji zhizaochang, 1953).

Chen, Jie, 'The sporting life of Wang and H&M', *China Daily*, 18 November 2014. Available at http://m.chinadaily.com.cn/en/2014-11/18/content_18931541.htm (accessed 15 March 2015).

Chen, Tina M., 'Proletarian white and working bodies in Mao's China', *positions: east asia cultures critique*, Special Issue: Fabrications 11/2 (2003), pp. 361–94.

———, 'Film and gender in Sino-Soviet cultural exchange, 1949–1969', in Thomas P. Bernstein and Hua-Yu Li (eds), *China Learns from the Soviet Union, 1949–Present* (Lanham, MD: Lexington Books, 2010), pp. 421–48.

Chen, Vivian, 'Designer Masha Ma says China needs to ditch "Made in China" concept for fashion to thrive', *Style*, 8 May 2014. Available at http://www.scmp.com/magazines/style/article/1500726/designed-succeed (accessed 20 April 2015).

———, 'How young Chinese fashion designers are making their mark in the global industry', *South China Morning Post*, 2 June 2016. Available at http://www.scmp.com/magazines/style/article/1955200/young-contemporary-fashion-designers-are-stamping-their-mark-global (accessed 15 September 2016).

———, 'Jiang Qionger of Hermès-backed Shang Xia brings Chinese aesthetics to the international stage', *South China Morning Post*, 1 September 2016. Available at http://www.scmp.com/magazines/style/tech-design/article/2008466/jiang-qionger-hermes-backed-shang-xia-brings-chinese (accessed 15 September 2016).

Chernyshova, Natalya, *Soviet Consumer Culture in the Brezhnev Era* (London: Routledge, 2013).

Chiang, Hai Ding, *A History of Straits Settlements Foreign Trade 1870–1915* (Singapore: National Museum of Singapore, 1978).

Chor, Lin Lee and May Khuen Chung, *In the Mood for Cheongsam: A Social History 1920s–Present* (Singapore: Edition Didier Millet, 2012).

Chow, Yiu Fai, 'Hong Kong creative workers in Mainland China: the aspirational, the precarious, and the ethical', *China Information* 31/1 (2016), pp. 43–62.

Chu, Kathy, 'Alibaba's Tmall global site stumbles', *The Wall Street Journal*, 22 December 2014. Available at http://www.wsj.com/articles/alibabas-tmall-global-site-stumbles-1419274439 (accessed 15 July 2015).

Chua, Beng Huat, *Life is Not Complete Without Shopping: Consumption Culture in Singapore* (Singapore: Singapore University Press, 2003).

———, 'Conceptualising East Asia popular culture', *Inter-Asia Cultural Studies* 5/2 (2004), pp. 200–21.

Chung, Felix, 'Proposal for the establishment of "Fashion Hong Kong"', Hong Kong: Legislative Council, unpublished, 2013. Available at http://www.felixchunghk.com/Content/upload/20141111-104345.pdf (accessed 15 June 2015).

Clark, Hazel, *The Cheongsam* (New York: Oxford University Press, 2000).

———, 'Fashioning "China style" in the twenty-first century', in Eugenia Paulicelli and Hazel Clark (eds), *The Fabric of Cultures: Fashion, Identity and Globalization* (Abingdon: Routledge, 2009), pp. 177–91.

———, 'Chinese fashion designers – questions of ethnicity and place in the twenty-first century', *Fashion Practice: The Journal of Design, Creative Process and the Fashion Industry*, 4/1 (2012), pp. 41–56.

Collins, Jane, *Threads: Gender, Labor, and Power in the Global Apparel Industry* (Chicago, IL: University of Chicago Press, 2003).

Connor, Alana, 'It's not about the work ethic', *Stanford Social Innovation Review* 7/4 (2009), p. 1.

Craik, Jennifer, *The Face of Fashion: Cultural Studies in Fashion* (London: Routledge, 2002).

———, 'Fashion, tourism and global culture', in Sandy Black, Amy de la Haye, Joanne Entwhistle, Regina Root, Agnès Rocamora and Helen Thomas (eds), *The Handbook of Fashion Studies* (Oxford: Bloomsbury, 2014), pp. 353–70.

Cubbison, Laurie, 'Anime fans, DVDs, and the authentic text', *The Velvet Light Trap* 56 (Fall 2005), pp. 45–57.

Dangdai Zhongguo congshu bianji weiyuanhui (ed.), *Dangdai Zhongguo duiwai maoyi* [当代中国对外贸易; *Foreign Trade in Contemporary China*] (Beijing: Dangdai Zhongguo chubanshe, 1992).

Davis, Barry J. and Philippa Ward, 'Exploring the connections between visual merchandising and retail branding: an application of facet theory', *International Journal of Retail and Distribution Management* 33/7 (2005), pp. 505–13.

DeLong, Marilyn R., *The Way We Look: Dress and Aesthetics* (New York: Fairchild Publications, 1998).

Department of Culture, Media and Sport (DCMS), *Creative Industries Mapping Document* (London: Department of Culture, Media and Sport, 1998).

Deutsch, Anna, 'The CFDA/Vogue Fashion Fund Chinese exchange program welcomes Uma Wang to New York', *Fashionista*, 17 May 2012. Available at http://fashionista.com/2012/05/the-cfdavogue-fashion-fund-chinese-exchange-program-welcomes-uma-wang-to-new-york (accessed 20 April 2015).

Ding, Xiqiang [丁锡强], Zhonghua nanzhuang [中华男装; Chinese Men's Dress] (Shanghai: Shanghai shiji chubanfen youxian gongsi, 2008).

'Dr Zou You – the Beijing fashion star's spring summer 2014 collection', A Safety Pin, 20 March 2014. Available at http://asafetypin.com/Articles/30-dr-zou-you-the-beijing-fashion-star-s-spring-summer-2014-collection.html (accessed 20 April 2015).

Eicher, Joanne, Dress and Ethnicity: Change across Space and Time (Oxford: Berg, 1999).

———, Suzanne Baizermann and John D. Michelen, 'Adolescent dress', in Mary Ellen Roach-Higgins, Joanne B. Eicher and Kim K.P. Johnson (eds), Dress and Identity (New York: Fairchild Publications, 1995), pp. 122–9.

Entwistle, Joanne, The Fashioned Body: Fashion, Dress and Modern Social Theory (London: Polity Press, 2000).

———, The Aesthetic Economy of Fashion (Oxford: Berg, 2009).

Featherstone, Mike, Global Culture: Nationalism, Globalization and Modernity (London: Sage, 1990).

Female Magazine, 'Our designers salute', January 1988.

Ferrero-Regis, Tiziana and Tim Lindgren, 'Branding "Created in China": the rise of Chinese fashion designers', Fashion Practice: The Journal of Design, Creative Process and the Fashion 4/1 (2012), pp. 71–94.

Fine, Ben and Ellen Leopold, The World of Consumption (London: Routledge, 1993).

Fine, Gary Alan, Shared Fantasy: Role Playing Games as Social Worlds (Chicago: University of Chicago Press, 1983).

Finnane, Antonia, 'Yu Feng and the 1950s dress reform campaign: global hegemony and local agency in the art of fashion', in Yu Chien Ming [游鑑明] (ed.), Wu sheng zhi sheng: jindai Zhongguo funüyu wenhua, 1650–1950 [無聲之聲II 近代中國的婦女與社^; 1600–1950 Silent Voices: Women and Modern Chinese Culture, 1600–1950], vol. II (Taipei: Academia Sinica, 2003), pp. 235–68.

———, 'Looking for the Jiang Qing dress: some preliminary findings', Fashion Theory 9/1 (2005), pp. 3–22.

———, Changing Clothes in China: Fashion, History, Nation (New York: Columbia University Press, 2008).

Florida, Richard, The Rise of the Creative Class (New York: Basic Books, 2002).

Foster, Robert, Coca-Globalization: Following Soft Drinks from New York to New Guinea (New York: Palgrave Macmillan, 2008).

Frey, Nadine, 'The World of Joyce', The New York Times, 6 May, 1994.

Frost, Mark, Singapore: A Biography (Hong Kong: Hong Kong University Press, 2009).

Fumo, Nicola, 'The Alexander Wang x H&M hype machine: a case study', 18 November 2014. Available at http://www.racked.com/2014/11/18/7568609/alexander-wang-hm-collaboration-collection-strategy (accessed 15 March 2015).

Fung, Anthony and John Nguyet Erni, 'Cultural clusters and cultural industries in China', Inter-Asian Cultural Studies 14/4 (2013), pp. 644–56.

Fu Yingfei [傅英飞], Xinfa jiancai: fengren jiaoben [新法剪裁 : 缝纫教本; New Method Tailoring: A Sewing Textbook] (Beijing: Fu Yingfei, 1953).

———, Xinfa jiancai: fengren jiaoben [新法剪裁 : 缝纫教本; New Method Tailoring: A Sewing Textbook], 2 vols (Beijing: Fu Yingfei, 1954).

———, Yangcai jiaoben [洋裁教本 Primer in Western Tailoring] (Beijing: Beijing xinsheng zhiye xuexiao, 1951).

Geczy, Adam, 'A chamber of whispers', in China: Through The Looking Glass, exhibition catalogue, The Metropolitan Museum of Art (New Haven, CT: Yale University Press, 2015).

Geertz, Clifford, The Interpretation of Cultures (New York: Basic Books, 1973).

Gereffi, Gary and Miguel Korzeniewicz (eds), Commodity Chains and Global Capitalism (Westport, CT: Greenwood Press, 1994).

Gilbert, David, 'From Paris to Shanghai: the changing geographies of fashion's world cities', in Christopher Breward and David Gilbert (eds), Fashion's World Cities (Oxford: Bloomsbury, 2006), pp. 3–32.

———, 'A new world order? Fashion and its capitals in the twenty-first century', in Stella Bruzzi and Pamela Church Gibson (eds), Fashion Cultures Revisited: Theories, Explorations and Analysis (London: Routledge, 2013), pp. 11–30.

Gimeno-Martinez, Javier, Design and National Identity (Oxford: Bloomsbury, 2016).

Green, Nancy, Ready-to-Wear and Ready-to-Work: A Century of Industry and Immigrants in Paris and New York (Durham, NC: Duke University Press, 1997).

Greenspan, Anna, 'The power of spectacle in culture unbound', Culture Unbound: Journal of Current Cultural Research 4/1 (2011), pp. 81–95.

Gu, Xin, 'The art of re-industrialisation in Shanghai', Culture Unbound: Journal of Current Cultural Research 4 (2011), pp. 193–211.

———, 'Developing entrepreneur networks in the creative industries – a case study of independent designer fashion in Manchester', in Elizabeth Chell and Mine Karatas-Özkan (eds), Handbook of Research on Small Business and Entrepreneurship (Cheltenham: Edward Elgar, 2014), pp. 358–73.

———, 'Cultural economy and urban development in Shanghai', in Kate Oakley and Justin O'Connor (eds), The Routledge Companion to the Cultural Industries (London: Routledge, 2015), pp. 246–56.

'Guo Pei, queen of China's haute couture', Fashionista and Style Guru, 18 October 2012. Available at https://fashionstyleguru.wordpress.com/2012/10/18/guo-pei-the-queen-of-chinas-haute-couture/ (accessed 20 April 2015).

Halbwachs, Maurice, On Collective Memory, trans. and ed. Lewis A. Coser (Chicago, IL: University of Chicago Press, 1992).

Hansegard, Jens and Laurie Burkitt, 'At H&M, 3,000 stores and counting', The Wall Street Journal, 26 September 2003. Available at http://www.wsj.com/articles/SB10001424052702303342104579098522607802800 (accessed 12 August 2015).

Hansen, Karen T., Salaula: The World of Secondhand Clothing and Zambia (Chicago, IL: University of Chicago Press, 2000).

Hao, Yufan, 'The Economic Factor in Chinese Foreign Policy', in Allen Carlson and Xiao Ren (eds), New Frontiers in China's Foreign Relations (Lanham, MD: Lexington, 2011), pp. 65–90.

Hartley, John and Lucy Montgomery, 'Creative industries come to China (MATE)', Chinese Journal of Communication 2/1 (2009), pp. 1–12.

Haslam, Dave, Manchester, England: the Story of the Pop Cult City (London: Fourth Estate, 1999).

Hicks, George, 'Explaining the success of the Four Little Dragons: a survey', in Seiji Naya and Akira Takayama (eds), Economic Development in East and Southeast Asia: Essays in Honor of Professor Shinichi Ichimura (Singapore: Institute of Southeast Asian Studies; Honolulu: The East-West Center, 1990), pp. 20–37.

Hills, Matt, Fan Cultures (London: Routledge, 2002).

Hodkinson, Paul, *Goth: Identity, Style, Subculture* (Oxford: Berg, 2002).

Hofstede, Geert and Michael H. Bond, 'Confucius and economic growth: new trends in culture's consequences', *Organizational Dynamics* 16/4 (1988), pp. 4–21.

Huang, Yasheng, *Capitalism with Chinese Characteristics: Entrepreneurship and the State* (New York: Cambridge University Press, 2008).

Huang, Xuelei, 'The heroic and the banal: consuming Soviet movies in pre-socialist China, 1920s-1940s,' *Twentieth Century China*, 39/2 (2014), pp. 93–117.

Huaxian fangzhipin de xingneng yu shiyong fangfa editorial group [化纤纺织品的性能与使用方法编写组] (ed.), *Huaxian fangzhipin de xingneng yu shiyong fangfa* [化纤纺织品的性能与使用方法; Properties and Uses of Chemical Fibres] (Shanghai: Fangzhi gongye chubanshe, 1984).

Hui, Calvin, 'Mao's children are wearing fashion!', in Alison Hulme (ed.), *The Changing Landscape of China's Consumerism* (Oxford: Chandos Publishing, 2014), pp. 23–56.

Hui, Desmond, *Baseline Study on Hong Kong's Creative Industries (For the Central Policy Unit, HK Special Administrative Region Government)* (Centre for Cultural Policy Research. Hong Kong: University of Hong Kong, 2003).

Hutton, Will, *The Writing on the Wall: China and the West in the 21st Century* (London: Little, Brown, 2007).

Ip, Hung-Yok, 'Fashioning appearances: feminine beauty in Chinese Communist revolutionary culture', *Modern China* 19/3 (July 2003), pp. 329–61.

Iwabuchi, Koichi, *Recentering Globalization: Popular Culture and Japanese Transnationalism* (London: Duke University Press, 2002).

——— (ed.), *Feeling Asian Modernities: Transnational Consumption of Japanese TV Dramas* (Hong Kong: University of Hong Kong Press, 2004).

Jansen, M. Angela, *Moroccan Fashion: Design, Culture and Tradition* (Oxford: Bloomsbury, 2014).

——— and Jennifer Craik (eds), *Modern Fashion Traditions: Negotiating Tradition and Modernity Through Fashion* (Oxford: Bloomsbury, 2016).

Jenss, Heike (ed.), *Fashion Studies. Research Methods, Sites and Practices* (Oxford: Bloomsbury, 2016).

Jing'anqu yizhuo yongpin gongsi geweihui [静安区衣着用品公司革委] 'Guanyu zhuanfaJig'anqu Hongying fuzhuangdian gukedeng gou diqueliang chensha, jisui boli chuchuang, zaocheng yanzhong shangwang shigu de baogao de tongzhi' [关于转发静安区红缨服装店顾客等购'的确良'衬衫，挤碎玻璃橱窗，造成严重伤亡事故的报告的通知 Notification of transmission of report concerning deaths and injuries arising from the shattering of a display window through the crush of customers [seeking to] purchase dacron at the Hongying clothing store], 17 August 1968, Shanghai Municipal Archives, B123-7-35.

Jones, P.H.M. (ed.), *Asian Textile Survey, 1969–70* (Hong Kong: Far Eastern Economic Review, 1970).

Karacs, Sarah, 'Fashion faux pas: why Hong Kong designers struggle to make a global impact', *South China Morning Post*, 7 July 2016. Available at http://www.scmp.com/news/hong-kong/economy/article/1986777/fashion-faux-pas-why-hong-kong-designers-struggle-make-global (accessed 27 July 2016).

Kawamura, Yuniya, *The Japanese Revolution in Paris Fashion* (Oxford: Berg, 2004).

———, *Fashion-ology: An Introduction to Fashion Studies* (Oxford: Berg, 2005).

————, 'Japanese teens as producers of street fashion', *Current Sociology* 54/5 (2006), pp. 784–801.

Keane, Michael, *Created in China. The New Great Leap Forward* (London: Routledge, 2007).

———— (ed.), *Handbook of China's Cultural and Creative Industries* (Cheltenham: Edward Elgar, 2016).

Kelts, Roland, *Japanamerica: How Japanese Pop Culture Has Invaded the US* (New York: Palgrave Macmillan, 2006).

Kinsella, Sharon, *Adult Manga: Culture and Power in Contemporary Japanese Society* (London: Curzon Press, 2000).

Kolesnikov-Jessop Sonia, 'Priscilla Shunmugam's love letter to Singapore Heritage and traditional asian clothing', *Blouinartinfo*, 14 April 2013. http://sea.blouinartinfo. com/news/story/890857/priscilla-shunmugams-love-letter-to-singapore-heritage-and (accessed 4 April 2015).

Kong, Xurong, 'Military uniform as a fashion during the Cultural Revolution', *Intercultural Communication Studies* 17/2 (2008), pp. 287–303.

Kotler, Philip, 'The prosumer movement: a new challenge for marketers', in Richard J. Lutz (ed.), *Advances in Consumer Research*, vol. 13 (Provo, UT: Association for Consumer Research, 1986), pp. 510–13.

Kuang, Chen [旷晨] and Liang Pan [潘良], *Womende bashi niandai* [我们的八十年代, Our 1980s] (Beijing: Zhongguo youyi chuban gongsi, 2006).

Lash, Scott and John Urry, *Economies of Signs and Space* (London: Sage, 1994).

Lave, Jean and Etienne Wenger, *Situated Learning: Legitimate Peripheral Participation* (Cambridge: Cambridge University Press, 1991).

Lawrence, Vanessa, 'Romeo oh Romeo Gigli. Oh where were you?', *W Magazine*, September 2012.

Lee, Peter, *Sarong Kebaya: Peranakan Fashion in an Interconnected World 1500–1950* (Singapore: Asian Civilisations Museum, 2014).

Lent, John A., *Animation in Asia and the Pacific* (Bloomington, IN: Indiana University Press, 2001).

Leslie, Deborah and Norma M. Rantisi, 'The rise of a new knowledge/creative economy: prospects and challenges for economic development, class inequality and work', in Trevor J. Barnes, Jamie Peck and Eric Sheppard (eds), *The Wiley-Blackwell Companion to Economic Geography* (Oxford: Wiley-Blackwell, 2012), pp. 158–71.

Leung-Davies, Lucienne, 'A contemporary Renaissance master', Joyce website. http://www.joyce.com/fashion-article/a-contemporaryrenaissance-master/ (accessed 20 August 2016).

Li, Chi [李 驰], 'Caise dianying shi zenyang shezhide' [彩色电影是怎样摄制 How to shoot films in colour], *Kexue qunzhong* [*Scientific Masses*] 10 (1950), pp. 75–9.

Li, Yi, 'The collaborative Design Cat between Beijing International Design Week and Tmall', *China News* website, 5 May 2014. Available at http://finance.chinanews. com/it/2014/05-05/6135350.shtml (accessed 28 October 2017).

Life Magazine, 10 December 1971. Available at https://books.google.co.uk/books? id=3z8EAAAAMBAJ&pg=PA59&source=gbs_toc_r&redir_esc=y#v=onepage&q&f=false.

Lilley, Rozanna, *Staging Hong Kong: Gender and Performance in Transition* (Honolulu: University of Hawai'i Press, 1998)

Lin, Yi-Cheih J., *Fake Stuff: China and the Rise of Counterfeit Goods* (New York: Routledge, 2011).

Ling, Wessie, 'Harmony and concealment: how Chinese women fashioned the qipao in 1930s China', in Maureen Goggin and Beth Tobin (eds), *Material Women, 1770–1950: Consuming Desires and Collecting Practices* (Farnham: Ashgate, 2009), pp. 209–25.

———, 'From "made in Hong Kong" to "Designed in Hong Kong": searching for an identity in fashion', *Visual Anthropology* 24/1–2 (2011), pp. 106–23.

———, '"Fashionalisation": urban development and the new-rise fashion weeks', in Jess Berry (ed.), *Fashion Capital: Style Economies, Sites and Cultures* (Oxford: Inter-Disciplinary Press, 2012), pp. 85–96.

———, 'Korea vs Paris: there is no fashion, only image or how to make fashion identity', in Roy Menarini (ed.), *Cultures, Fashion and Society's Notebook* (Milan-Turin: Bruno Mondador, 2016), pp. 1–14.

———, 'A bag of remembrance: a cultural biography of the red-white-blue, from Hong Kong to Louis Vuitton', in Regina Blaszczyk and Véronique Pouillard (eds), *European Fashion: The Creation of a Global Industry* (Manchester: Manchester University Press, 2018), pp. 283–301.

Liu, Shaoqi, *How to be a Good Communist*, 1939. Available at https://www.marxists.org/reference/archive/liu-shaoqi/1939/how-to-be/ch06.htm (accessed 1 November 2015).

Lorence, James J., *The Suppression of Salt of the Earth: How Hollywood, Big Labor, and Politicians Blacklisted a Movie in Cold War America* (Albuquerque, NM: University of New Mexico Press, 1999).

Lu, Jingyi, 'Creative industry in Hong Kong', unpublished report for Hong Kong Polytechnic University, September–December 2011. Available at http://www.innovhub-ssi.it/c/document_library/get_file?uuid=8b875c19-26e1-44d5-9dbc-38bed90082c0&groupId=11636 (accessed 15 July 2016).

Lu, Shen and Katie Hunt, 'China cracks down on cleavage at cosplay convention', CNN, 22 May 2015. Available at http://edition.cnn.com/2015/05/22/asia/chinajoy-cleavage-crackdown/ (accessed 12 November 2015).

Lu, Sheng and Marsha Dickson, 'Where is China's textile and apparel industry going?', *China Policy Institute: Analysis*, 24 July 2015. Available at http://blogs.nottingham.ac.uk/chinapolicyinstitute/2015/07/24/where-is-chinas-textile-and-apparel-industry-going/ (accessed 20 September 2015).

Luo, Yadong, 'Guanxi: principles, philosophies, and implications', *Human Systems Management* 16/1 (1997), pp. 43–51.

Luvaas, Brent, *DIY Style: Fashion, Music and Global Cultures* (London: Bloomsbury Publishing, 2012).

Ma, Yunlong 马云龙, 'Lishi cuipian: wenge shiqi de liuxing shishang' [历史碎片: 文革时期的流行时尚 Fragments of history: popular fashions in the Cultural Revolution period], *Nanfang zhoumou* [南方周末; *Southern Weekend*], blog, 31 January 2015. Available at http://cul.qq.com/a/20150131/022063.htm (accessed 17 July 2016).

Macalister-Smith, Tilly, 'Romeo Gigli for Joyce', *Vogue*, 6 August 2012. Available at http://www.vogue.co.uk/news/2012/08/06/romeo-gigli-launches-joyce-comeback-collection (accessed 16 August 2016).

Maffesoli, Michael, *The Time of the Tribes: The Decline of Individualism in Mass Society* (London: Sage, 1996).

Marra-Alvarez, Melissa, 'When the West wore East: Rei Kawakubo, Yohji Yamamoto and the rise of the Japanese avant-garde in fashion', *DressStudy* 57 (2010).

Available at http://www.kci.or.jp/research/dresstudy/pdf/D57_Marra_Alvarez_e_When_the_West_Wore_East.pdf (accessed 10 July 2015).

Mastel, Greg, *The Rise of the Chinese Economy: The Middle Kingdom Emerges* (New York: M.E. Sharpe, 1997).

Mau, Dhani, 'New evidence that Alexander Wang's Chinese connections may have helped land him Balenciaga', *Fashionista*, 10 December 2012. Available at http://fashionista.com/2012/12/did-alexander-wangs-chinese-connections-help-get-him-the-balenciaga-job (accessed 15 March 2015).

Maynard, Margaret, *Dress and Globalization* (Manchester: Manchester University Press, 2004).

McNeil, Peter (ed.), *Fashion: Critical and Primary Sources* (Oxford: Bloomsbury, 2009).

McRobbie, Angela, *British Fashion Design: Rag Trade or Image Industry?* (London: Routledge, 1998).

———, *Be Creative: Making a Living in the New Creative Industries* (London: Polity Press, 2015).

Mears, Patricia, 'Formalism and revolution: Rei Kawakubo and Yohji Yamamoto', in Valerie Steele, Patricia Mears, Yuniya Kawamura and Hiroshi Narumi (eds), *Japan Fashion Now* (New Haven, CT: Yale University Press, 2010), pp. 141–207.

'Mercedes-Benz China Fashion Week (2015 S/S) opens', 26 October 2014. Available at http://english.chinafashionweek.org/xwsd_en/201410/t20141026_1857400.html (accessed 15 March 2015).

Merenda, Rosemary, 'Encounter with Tan Yoong', *Donna* (September 1989), p. 12.

Musaraj, Smoki, 'Alternative publics: reflections on marginal collective practices in Communist Albania', in Andreas Hemming, Gentiana Kera and Enriketa Pandelejmoni (eds), *Albania: Family, Society and Culture in the 20th Century* (Vienna: Lit Verlag), pp. 175–86.

Myoe, Maung Aung, *In the Name of Pauk-Phaw: Myanmar's China Policy since 1948* (Singapore: Institute of Southeast Asian Studies, 2011).

Napier, Susan J., *Anime from Akira to Howl's Moving Castle: Experiencing Japanese Animation* (New York: Palgrave Macmillan, 2005).

———, *From Impressionism to Anime: Japan as Fantasy And Fan Cult in the Mind of the West* (New York: Palgrave Macmillan, 2007).

Naughton, Barry, 'The foreign policy implications of China's Economic development strategy', in Thomas W. Robinson and David Shambaugh (eds), *Chinese Foreign Policy: Theory and Practice* (Oxford: Clarendon, 1994), pp. 47–69.

Niessen, Sandra, Ann Marie Leshkovich and Carla Jones (eds), *Re-orienting Fashion: The Globalization of Asian Dress* (Oxford: Berg, 2003).

O'Connor, Justin, 'Economic development, enlightenment and creative transformation: creative industries in the new China', *Economiaz 79* (October 2011), pp. 108–25.

——— and Xin Gu, 'Creative industry clusters in Shanghai: a success story?', *International Journal of Cultural Policy 20/1* (2012), pp. 1–20.

———, 'Shanghai: images of modernity', in Helmut Anheier and Yudhishthir Isar (eds), *Cultures and Globalization: Cities, Cultural Policy and Governance* (London: Sage, 2012), pp. 228–300.

Ogi, Fusami, 'Gender insubordination in Japanese comics (manga) for girls', in John A. Lent (ed.), *Illustrating Asia: Comics, Humor Magazines and Picture Books* (London: Curzon Press, 2001), pp. 171–86.

Pang, Laikwan, *Creativity and Its Discontents* (Durham, NC: Duke University Press, 2012).

Partington, Angela, 'Popular fashion and working-class affluence', in Juliet Ash and Elizabeth Wilson (eds), Chic Thrills: A Fashion Reader (London: Harper Collins, 1992), pp. 145–61.

Paulicelli, Eugenia and Hazel Clark (eds), The Fabric of Cultures. Fashion, Identity, and Globalization (London: Routledge, 2009).

Peirson-Smith, Anne, 'Fashioning the fantastical self: an examination of the cosplay dress-up phenomenon in Southeast Asia', Fashion Theory 17/1 (2012), pp. 77–111.

———, 'Wishing on a star: promoting and personifying designer collections and fashion brands', Fashion Practice: The Journal of Design, Creative Process and the Fashion 5/2 (2013), pp. 171–201.

Peking Review, 15 August 1964.

Pham, Minh-Ha T., Asians Wear Clothes on the Internet (Durham, NC: Duke University Press, 2015).

Ping, Mary and Christina Moon, 'A new American style', in Fashion at MOCA: Shanghai to New York, exhibition catalogue, vol. 2 (New York: Museum of Chinese in America, 2013), pp. 4–9.

Poon, Daniel, 'Clothing industry in Hong Kong', TDC Research, 30 June 2016. Available at http://hong-kong-economy-research.hktdc.com/business-news/ article/Hong-Kong-Industry-Profiles/Clothing-Industry-in-Hong-Kong/hkip/ en/1/1X000000/1X003DCL.htm (accessed 27 July 2016).

Porter, Michael, 'Clusters and the new economics of competitiveness', Harvard Business Review 76/6 (1998), pp. 77–90.

Potts, Jason, 'Do developing economies require creative industries? Some old theory about new China', Chinese Journal of Communication 2/1 (2010), pp. 92–108.

Prakash, Devendra, 'The Guangzhou Trade Fair,'China Report 21/6 (1985), pp. 507–11.

Pratt, Andy, 'The cultural economy', International Journal of Cultural Studies 7/1 (2004), pp. 117–28.

———, 'The cultural and creative industries: organisational and spatial challenges to their governance', Die Erde 143/4 (2012), pp. 317–34.

Rantisi, Norma M., 'The local innovation system as a source of "variety": openness and adaptability in New York City's garment district', Regional Studies 36 (2002), pp. 587–602.

Rasi, Alena, 'JEFEN by Frankie: baroque and gothic styles reborn', gbtimes, 7 January 2014. Available at https://gbtimes.com/jefen-frankie-baroque-and-gothic-styles-reborn (accessed 27 March, 2015).

Redding, S. Gordon, The Spirit of Chinese Capitalism (New York: De Gruyter, 1993).

Ren, Shan [任珊] '1949–1965 nian Shanghai fuzhuangye fazhan yanjiu' [年 上海服装业发展研究 The development of the Shanghai's clothing industry, 1949–1965], MA thesis, Donghua University, Shanghai, 2013.

Riello, Giorgio, Cotton: The Fabric that Made the Modern World (Cambridge: Cambridge University Press, 2013).

——— and Peter McNeil (eds), The Fashion History Reader (London: Routledge, 2010).

Roberts, Claire, 'Fashioning cultures: contemporary Chinese dress', in Claire Roberts (ed), Evolution and Revolution: Chinese Dress 1700s–1990s (Sydney: Powerhouse Publishing, 1997), pp. 87–102.

Robertson, Roland, Globalization: Social Theory and Global Culture (London: Sage, 1992).

'Romeo Gigli X Joyce by Thomas Devaux', Rock the Trend, 21 January 2013. Available at http://rockthetrend.com/fashion/romeo-gigli-x-joyce-by-thomas-devaux/#.WeR2TsbMwo8 (accessed 20 August 2016).

'Romeo returns: Joyce by Romeo Gigli', The D'Vine, 16 July 2012. Available at http://www.the-dvine.com/2012/07/romeo-returns-joyce-by-romeo-gigli/ (accessed 20 August 2016).

Ross, Andrew, Fast Boat to China: High-Tech Outsourcing and the Consequences of Free Trade: Lessons from Shanghai (New York: Vintage Press, 2007).

Ryazanova-Clarke, Larissa and Terence Wade, The Russian Language Today (London: Routledge, 1999).

Saillard, Olivier (ed.) with Cally Blackman, Tsujita Kaya, Miren Arzalluz and Anne Diatkine, Fashion Mix, exhibition catalogue (Paris: Flammarion, 2014).

Sassu, Chiara Maria, 'Beijing's global fashion dynasty', Not Just Label, 5 January 2015. Available at https://www.notjustalabel.com/editorial/beijings-global-fashion-dynasty (accessed 20 April, 2015).

Schenk, Catherine, 'Economic history of Hong Kong', in Robert Whaples (ed.), EH. Net Encyclopedia, 16 March 2008. Available at https://eh.net/encyclopedia/economic-history-of-hong-kong/ (accessed 15 July 2016).

Schneider, Laurence, Biology and Revolution in Twentieth-Century China (Lanham, MD: Rowman and Littlefield, 2005).

Schodt, Frederik L., Dreamland Japan: Writings on Modern Manga (Berkeley, CA: Stone Bridge Press, 1996).

Scott, Allen J., The Cultural Economy of Cities (London: Sage, 2000).

———, 'Cultural economy and the creative field of the city', Human Geography 92/2 (2010), pp. 115–30.

Seiter, Ellen, The Internet Playground: Children's Access, Entertainment and Miseducation (New York: Peter Lang, 2004).

Segre Reinach, Simona, 'Romeo Gigli', in Valerie Steele (ed.), The Encyclopedia of Clothing and Fashion (New York: Charles Scribner's Sons, 2004), pp. 367–8.

———, 'China and Italy: fast fashion versus prêt àporter. Towards a new culture of fashion', Fashion Theory 9/1 (2005), pp. 1–12.

———, 'Milan: the city of prêt-à-porter', in Christopher Breward and David Gilbert (eds), Fashion's World Cities (Oxford: Berg, 2006), pp. 123–34.

———, 'Fashion and national identity: interactions between Italians and Chinese in the global fashion industry', Business and Economic History On-Line 7 (2009). Available at http://www.thebhc.org/sites/default/files/reinach.pdf (accessed 15 July 2016).

———, 'Italian and Chinese agendas in the global fashion industry', in Giorgio Riello and Peter McNeil (eds), The Fashion History Reader (London: Routledge, 2010), pp. 533–55.

———, 'National identities and international recognition', Fashion Theory 15/2 (2011), pp. 267–72.

———, 'Chinese fashion and the new relation with the West', Fashion Practice: The Journal of Design, Creative Process and the Fashion 4/1 (May 2012), pp. 57–70.

———, 'The puzzle of fashion distinction in China', in Djurdja Bartlett, Shaun Cole and Agnès Rocamora (eds), Fashion Media: Past and Present (Oxford: Bloomsbury, 2013), pp. 144–54.

———, 'Chinese fashion in the making: essays, books and films', International Journal of Fashion Studies 2/2 (2015), pp. 307–19.

————, 'One fashion two nations: Italian Chinese collaborations', in Lisa Rofel and Sylvia Yanagisako, *Fabricating Transnational Capitalism: A Collaborative Ethnography of Italian-Chinese Global Fashion* (Durham, NC: Duke University Press, forthcoming 2018).

Shanghai Creative Industry Centre (SCIC), *Shanghai Creative Industries Development Report* (Shanghai Creative Industry Centre, 2006).

Shanghai duiwai jingji maoyi bianzuan weiyuanhui 上海对外经济贸易编纂委员会 (ed.), *Shanghai duiwai jingji maoyi zhi* [上海对外经济贸易志; *Gazetteer of Shanghai's Foreign Economic and Trade Relations*] (Shanghai: Shanghai shehui kexueyuan, 2001).

Shanghai duiwai maoyiju [上海市对外贸易局], 'Guanyu jiedai waibin ganbu pin danwei zhengming qu youyi shangdia goumai diqueliang buliao deo tongzhi' [关于接待外宾干部凭单位证明去友谊商店购买的确良布料的通知 Notification on going to the Friendship Store and presenting identification for the purchase of dacron by cadres meeting with foreign dignitaries], 26 July 1965, p. 1, Shanghai Municipal Archives B123-6-631.s

Shanghai fangzhi gongyezhi bianzuan weiyuanhui [上海纺织工业编纂委员会], *Shanghai fangzhi gongyezhi* [*Gazetteer of the Shanghai Textile Industry*] (Shanghai: Shanghai shehuo kexue chubanshe, 1998).

Shanghai tongzhi bianzuan weiyuanhui [上海通志编纂委员会编] (ed.), *上海通志* [*Shanghai tongzhi*; *Gazetteer of all Shanghai*] (Shanghai: Shanghai renmin chubanshe and Shanghai shehui kexueyuan chubanshe, 2005).

Shanghaishi diyi shangyeju [上海市第一商业局], 'Guanyu jiangdi miandiqueliang jiage de bao gao' [关于降低棉'的确良'布价格的报告 Report on the falling price of cotton Dacron], 5 April (1963), p. 41, Shanghai Municipal Archives, B134-6-791.

Shanghaishi fangzhiju geweihui [上海市纺织局革委], 'Baosong miandiqueliang kuojian gongcheng de kuoda chubu sheji' [报送棉的确良扩建工程的扩大初步设计; Submission of the first stage plans for expansion in the dacron further development project], 27 June 1973, Shanghai Municipal Archives, B-134-7-126.

————, 'Shengqing zengjia diqueliang jijian touzi de baogao' [申请增加的确良基建投资的报告 Report on the application to increase capital investment for Sacron], 30 May 1973, Shanghai Municipal Archives, B-134-7-133.

Shanghaishi fuzhuang xitong gongren diaochazu [上海市服装系统工人调查组], 'Guanyu diquelaing fafang dui fuzhuang shichang yali yanzhong de chubu qingkuang baogao' [关于'的确良'发放对服装市场压力严重的初步情况报告 Report on the initial stages of severe pressure on the supply of Dacron the clothing market], 10 May 1969, Shanghai Municipal Archives, B123-8-211.

Shen, Simon and Cho-kiu Li, 'Cultural side-effects of the Sino-Soviet split: the influence of Albanian movies in China in the 1960s', *Modern China Studies* 22/1 (2015), pp. 215–31.

Sim, Ashley, 'Fabric of society', *The Straits Times*, 4 February 2008, p. 42.

Skov, Lise, 'Fashion-nation: a Japanese globalization experience and a Hong Kong dilemma', in Sandra Niessen, Ann Marie Leshkowich and Carla Jones (eds), *Re-Orienting Fashion: The Globalization of Asian Dress* (Oxford: Berg, 2003), pp. 215–42.

————, '"Seeing is believing": world fashion and the Hong Kong Young Designers' Contest', *Fashion Theory* 8/2 (2004), pp. 165–93.

————, 'Dreams of small nations in a polycentric fashion world', *Fashion Theory* 15/2 (2011), pp. 137–56.

'Simon Gao Yang presents designs at London Fashion Week', *South China Morning Post*, 19 February 2014. Available at http://www.scmp.com/news/world/article/ 1431190/simon-gao-yang-presents-designs-london-fashion-week accessed 20 April 2015).

South China Morning Post, 7 January 1971.

Steele, Valerie, *Fifty Years of Fashion: New Look to Now* (New Haven, CT: Yale University Press, 1998).

————, 'A generation rises', in *Fashion at MOCA: Shanghai to New York*, exhibition catalogue, vol. 2 (New York: Museum of Chinese in America, 2013), pp. 2–3.

———— and John Major, 'China chic: East meets West', in Valerie Steele and John Major (eds), *China Chic: East Meets West* (New Haven, CT: Yale University Press, 1999), pp. 69–99.

———— (eds), *China Chic: East Meets West* (New Haven, CT: Yale University Press, 1999).

The Straits Times, 'Good news for the fair sex, glitter that won't wash off!', 14 April 1957, p. 6.

————, 'Why we haven't gone ethnic?', 5 August 1984, p. 3.

————, 'NTUC picks 10 dress fabrics for May Day rally', 19 November 1989, p. 3.

Sun, Peidong [孙沛东], 'Kujiaoshang de jieji douzheng – "wenge" shiqi Guangdong de "qizhuang yifu" yu guojia guixun' [裤脚上的阶级斗争 – 文革时期 广东的 奇装异服与国家 规训 Class struggle over trousers: bizarre dress and state admonitions in Guangdong in the period of the Cultural Revolution], *Kaifang shidai* [开放时代: Open Society] 6 (2010), pp. 84–102.

————, *Shishang yu zhengzhi: Guangdong minzhong richang zhuozhuang shishang* (1966–1976) [时尚与政治: 广东民众日常着装时尚 (1966–1976) Fashion and politics: everyday fashions in the clothing of ordinary people in Guangdong] (Beijing: Renmin chubanshe, 2013).

Sundén, Jenny, *Material Virtualities: Approaching Online Textual Embodiment* (New York: Peter Lang, 2003).

Sutton-Smith, Brian, *The Ambiguity of Play* (Boston, MA: Harvard University Press, 1979).

Tai, Hung-Chao (ed.), *Confucian and Economic Development: An Oriental Alternative?* (Washington, DC: The Washington Institute Press, 1989).

Tallon, Andrew, *Urban Regeneration in the UK* (London: Routledge, 2010).

Tam, Vivienne, *China Chic* (New York: HarperCollins, 2005).

Tay, Michelle, 'Dressed for success', *The Straits Times*, special report, 3 March 2007, p. 6.

The Telegraph, 'Obituary: Elizabeth Choy', 10 October 2006. http://www.telegraph. co.uk/news/obituaries/1531003/Elizabeth-Choy.html (accessed 4 April 2015).

Thomas, Dana, *Deluxe: How Luxury Lost Its Lustre* (London: Penguin, 2007).

Tiewes, Frederick C. and Warren Sun, *The End of The Maoist Era: Chinese Politics During the Twilight of the Cultural Revolution, 1972–1976* (London: Routledge, 2015).

Tomlinson, John, 'Cultural globalization and cultural imperialism', in Ali Mohammadi (ed.), *International Communication and Globalization: A Critical Introduction* (London: Sage, 1997), pp. 170–90.

Tsang, Eileen Y.-H., *The New Middle Class in China: Consumption, Politics and the Market Economy* (Basingstoke: Palgrave Macmillan, 2014).

Tse, Ho-Lun Tommy, 'An ethnographic study of glocal fashion communication in Hong Kong and Greater China', *International Journal of Fashion Studies* 2/2 (2015), pp. 245–66.

Tseelon, Efrat, 'From fashion to masquerade: towards an ungendered paradigm', in Joanne Entwistle and Elizabeth Wilson (eds), *Body Dressing* (Oxford: Berg, 2001), pp. 103–17.

Tsui, Christine, *China Fashion: Conversations with Designers* (Oxford: Berg, 2009).

Tu, Thuy L.N., *The Beautiful Generation: Asian Americans and the Cultural Economy of Fashion* (Durham, NC: Duke University Press, 2010).

Turnbull, Constance Mary, *A History of Singapore, 1819–1988* (Oxford: Oxford University Press, 1989).

Turner, Victor W., *From Ritual to Theatre: The Human Seriousness of Play* (New York: PFA Publications, 1982).

——— [王圭璋], *Caijian dianfan* [裁剪典范 Sewing and Cutting], 2nd edn (Shanghai: Jinghua hanshou xueyuan, 1951).

———, *Funü chunzhuang* [妇女春装 Spring Clothing for Women] (Shanghai: Shanghai wenhua chubanshe, 1956).

Wang, Helen, *Chairman Mao Badges: Symbols and Slogans of the Cultural Revolution* (London: British Museum, 2008).

Wang, Jing, 'The global reach of a new discourse: how far can "creative industries" travel', *International Journal of Cultural Policy* 7/1 (2004), pp. 9–19.

Welters, Linda and Arthur C. Mead, 'The future of Chinese fashion', *Fashion Practice: The Journal of Design, Creative Process and the Fashion* 4/1 (2012), pp. 13–40.

Wee, Vivienne, 'The Ups and Downs of Women's status in Singapore: A chronology of some landmark events (1950–1987)', *Commentary: Journal of the National University of Singapore Society* 7/2 & 3 (December 1987), pp. 5–12.

Wei, Qiming [魏启明] *Xinshi fengren jiancai fa* [新式缝纫剪裁法 New Style Cutting and Sewing Methods] (Beijing: Beijing wenhua chubanshe, 1954).

Welters, Linda and Arthur C. Mead, 'The future of Chinese fashion', *Fashion Practice: The Journal of Design, Creative Process and the Fashion* 4/1 (2012), pp. 13–40.

White, Christine, 'British business in Russian Asia since the 1860s: an opportunity lost?' in R.P.T. Davenport-Hines and Geoffrey Jones (eds), *British Business in Asia Since 1860* (Cambridge: Cambridge University Press, 2003), pp. 68–91.

Williams, Gemma, *Fashion China* (New York: Thames and Hudson, 2015).

Williamson, Milly, 'Vampires and Goths: fandom, gender and cult dress', in William J.F. Keenan (ed.), *Dressed to Impress: Looking the Part* (Oxford: Berg, 2001), pp. 141–57.

Willis, Paul, 'Notes on method', in Stuart Hall, Dorothy Hobson, Andrew Lowe and Paul Willis (eds), *Culture, Media, Language* (London: Hutchinson, 1980), pp. 88–95.

Wilson, Elizabeth, *Adorned in Dreams: Fashion and Modernity* (London: I.B.Tauris, 1985).

Wilson, Eric, 'Asian-Americans climb fashion industry ladder', *The New York Times*, 4 September 2010. Available at http://www.nytimes.com/2010/09/05/fashion/05asians.html?_r=1 (accessed 25 March 2015).

Wilson, Verity, 'Dress and the Cultural Revolution', in Valerie Steele and John S. Major (eds), *China Chic: East Meets West* (New Haven, CT: Yale University Press, 1999), pp. 167–86.

Wittel, Andreas, 'Towards a network sociality', *Theory, Culture and Society* 18/6 (2001), pp. 51–76.

Wong, Benson and Sanho Chung, 'Scholarism and Hong Kong Federation of Students: comparative analysis of their developments after the umbrella movement', *Contemporary Chinese Political Economy and Strategic Relations: An International Journal* 2/2 (2016), pp. 865–84.

Wong, John, *The Political Economy of Malaysia's Trade Relations with China* (Singapore: Institute of Southeast Asian Studies, 1974).

Wu, Juanjuan, *Chinese Fashion from Mao to Now* (Oxford: Berg, 2009).

———, 'Shaping Chinese fashion identity: inter-Asian influences in the case studies of six fashion designers', in Yuko Kikuchi, Wendy Wong and Yunah Lee (eds), *Reader in East Asian Design* (Leiden: Springer, forthcoming).

Wuhanshi sili shenghua xinqun fengren buxi xuexiao bianji weiyuanhui [武汉市私立 胜华新群补习学校编辑委员会], *Caifengfa jiangyi* [裁缝法讲义; Teaching Material on How to Tailor] (Wuhan: Wuhanshi sili shenghua xinqun fengren buxi xuexiao, 1956).

WWD, 'WWD CEO summit Q&A with Alexander Wang, 30 October 2013. Available at http://www.wwd.com/fashion-news/designer-luxury/wwd-ceo-summit-alexander-wang-7254936 (accessed 20 March 2015).

Wynne, Alex, 'China in Paris resonates with buyers', *Women's Wear Daily*, 28 September 2014. Available at http://wwd.com/fashion-news/fashion-scoops/china-in-paris-resonates-with-buyers-7954243/ (accessed 15 July 2015).

Xiao Lu, Pierre, *Elite China: Luxury Consumer Behavior in China* (London: John Wiley and Sons, 2008).

Xie, Aroma, 'In China, showrooms blossom', *Business of Fashion*, 19 January 2015. Available at http://www.businessoffashion.com/articles/global-currents/showrooms-blossom-china (accessed 15 July 2015).

Xinying, Hong, 'Priscilla Shunmugam: "Creativity comes when you have restrictions", *Hw/Her World*, 16 May 2014. Available at http://www.herworldplus.com/fashion/updates/priscilla-shunmugam-%E2%80%98creativity-comes-when-you-have-restrictions%E2%80%99 (accessed 4 April 2015).

Yang, Xiangwen [杨祥文], 'Nashi chuchai beihui sanpi diqueliang' [那时出差背回3匹的确良 Sent away for work that time, I brought back three bolts of Dacron] *Wuhan wanbao* [武汉晚报 Wuhan Evening News], 15 April 2009, p. 42.

Yao, Xinzhong, *An Introduction to Confucianism* (New York: Cambridge University Press, 2000).

Yasumoto, Seiko, 'Korean wave: towards regional cultural diffusion', *Journal of Literature and Art Studies* 3/2 (February 2013), pp. 101–12.

Zamperini, Paola, 'Making fashion work: interview with Sophie Hong Taipei, Sophie Hong Studio', *positions: east asia cultures critique*, Special Issue: *Fabrications* 11/2 (2003), pp. 511–20.

Zang, Jian, 'The Soviet impact on "gender equality" in China in the 1950s', in Thomas P. Bernstein and Hua-yu Li (eds), *China Learns from the Soviet Union, 1949–Present* (Lanham, MD: Lexington Books, 2010), pp. 259–74.

Zhang, Ding, Shengqing Zhu, Weidong Cao and Ying Yang, 'Spatial pattern evolution of textile and garment manufacturing in Shanghai', *Tropical Geography* 33/6 (2013), pp. 720–30.

Zhang, Jing, Keynote speech, Fashion in Fiction: Style Stories and Transglobal Narratives Conference, City University of Hong Kong, Hong Kong, 12–14 June 2014.

Zhao, Jianhua, *The Chinese Fashion Industry: An Ethnographic Approach* (London: Bloomsbury, 2013).

Zukin, Sharon, *The Cultures of Cities* (Malden, MA: Blackwell, 1996).

WEBSITES

Alexander Wang BOF home page: http://www.businessoffashion.com/alexander-wang (accessed 15 January 2015).

China Fashion Association home page: www.fashion.org.cn

Kering home page: www.kering.com www.kering.com (accessed 25 March 2015).

NE·TIGER home page: www.ne-tiger.com.

Style on the Dot home page: https://styleonthedot.wordpress.com/page/3/ (accessed 4 April 2015).

CONTRIBUTORS

May Khuen Chung is Senior Curator at the National Museum of Singapore. Chung specialises in exploring the changing identity of Singaporean women from the 1950s and 1970s through the dressed body. She is curator of the Fashion Gallery and Modern Colony: 1925–1935 at the National Museum. Her research interests include the evolution of the cheongsam in Singapore and the study of the contribution of local fashion designers such as Benny Ong to Singapore's fashion industry. She is also the author of the book In the Mood for Cheongsam (2012). Chung is currently posted to the Heritage Conservation Centre as Deputy Director, overseeing both collections management and conservation services.

Hazel Clark is Professor of Design Studies and Fashion Studies and Research Chair of Fashion at Parsons School of Design, New York, where she initiated the MA in Fashion Studies and MA in Design Studies. In the 1990s she conducted research on the cheongsam in Hong Kong, and retains a scholarly interest in fashion and dress in China. Her publications include: The Cheongsam (2000), the co-edited Old Clothes, New Looks: Second Hand Fashion (2005), The Fabric of Cultures: Fashion, Identity, and Globalization (2009), Design Studies: A Reader (2009) and Fashion and Everyday Life: London and New York (2017).

Marilyn R. DeLong is Associate Dean for Academic Affairs and Professor of Apparel Studies in the College of Design at the University of Minnesota. Her scholarly research is focused upon design history, aesthetics,

education, perception and material culture. DeLong is the author of numerous journal articles in such publications as *Fashion Theory*, *Clothing and Textiles Research Journal*, *Senses and Society*, *Textile*, *Qualitative Market Research* and *Journal of Fashion Marketing and Management*. DeLong has been co-editor of *Fashion Practice, The Journal of Design, Creative Process and the Fashion Industry* from its inception in 2009. She has given presentations in Spain, France, England, Denmark, Korea and Brazil, and she recently travelled to China to present her research and participate in Culture Week in Xi'an.

Antonia Finnane is Professor of History in the School of Historical and Philosophical Studies at the University of Melbourne. She has written and edited a number of works on clothing and consumption in late imperial and modern China, including *Changing Clothes in China: Fashion, Nation, History* (2008). Her recent research in this area focuses on tailors and clothing production in the early PRC. Related articles are 'Cold War Sewing Machines: Production and Consumption in 1950s China and Japan' (2016) and 'Sewing manuals in 1950s China: socialist narratives and dress patterns from New Democracy to Socialist Transformation', in *Transcultural Fashion Narratives: Clothing Communication, Style Statements and Brand Storytelling* (2018).

Xin Gu is a lecturer in the School of Media, Film and Journalism at Monash University, Australia. Xin has been prominent in the attempt to contextualise contemporary Western debate around cultural economy in Asia. Her recent research investigates the interrelationship between the process of 'digitalisation' and 'material culture' through the emergence of maker culture in Australian and Chinese cities. She is currently contracted by Routledge for a joint-authored book on culture and economy in the New Shanghai.

Yue Hu is an associate professor in the College of Fashion Engineering at the Shanghai University of Engineering Science, China. His research and teaching mainly focus on innovations in apparel and accessories design.

Dr. Wessie Ling is Reader in Fashion Studies at Northumbria University. A cultural historian and visual artist, she uses academic writing and visual art practice to examine cultural identities in the production of fashion and cultural property of fashion. She is the author of *Fusionable Cheongsam*

(2007) and Co-Investigator of the Arts and Humanities Research Council (AHRC, UK) project, *Writing and Translating Modern Design Histories in East Asia for the Global World* (2012-4), ASEAN Research Fellow at the Research Institute of Languages and Cultures of Asia (RILCA) at Mahidol University (2018) and Rita Bolland Fellow for Textile and Fashion Study at the Research Centre for Material Culture in National Museum of World Cultures, the Netherlands (2018/9). She co-edited a special issue for Modern Italy on transcultural exchange between Italy and Asia, and ZoneModa Journal on Global Fashion. She has also published in *European Fashion: The Creation of a Global Industry* (2018), Visual Anthropology, World Futures. The Journal of New Paradigm Research, among others. Her artworks have been exhibited in Saint Dominic's Priory (2016, Newcastle Upon Tyne), Oxfordshire Visual Arts Development Agency (OVADA) (2015, Oxford), Danson House (2013, Bexleyheath), the Brunei Gallery (2012, London: SOAS), Saltram House (2012, Plymouth: National Trust) and the Victoria and Albert Museum (2011, London), among others.

Simona Segre Reinach is a cultural anthropologist and Associate Professor of Fashion Studies at Bologna University. She has written extensively on fashion from a global perspective in books such as *The Berg Encyclopedia of World Dress and Fashion* (2010), *The Fashion History Reader* (2010) and *Fashion Media: Past and Present* (2013). She is a member of the Editorial Board of *Fashion Theory, Critical Studies in Fashion and Beauty, The International Journal of Fashion Studies, Anthem Studies in Fashion, Dress and Visual Culture* and *China Matters*. She has done field work in China on Sino-Italian joint ventures contributing to a collaborative study in Cultural Anthropology. In Italy she authored: *Orientalismi. La moda nel mercato globale* (2006), *La moda. Un'introduzione* (2010), *Un mondo di mode* (2011), *Exhibit!* (2017) and *Biki: French Visions for Italian Fashion* (2019, Italian and English edition). She curated the fashion exhibitions *80s-90s Facing Beauties: Italian Fashion and Japanese fashion at a Glance* (Rimini Museum, 2013) and *Jungle: The Imagery of Animals in Fashion* (Torino, Venaria Reale, 2017). She is Editor in Chief of *Zonemoda Journal*.

Anne Peirson-Smith is an assistant professor at City University of Hong Kong. She teaches and researches fashion communication, public relations, advertising, popular culture and the creative industries. She has

published various articles on the cosplay phenomenon and Asian youth style and is working on a book for Intellect Books on this subject. She has a professional background in public relations and branding and is the co-author of the book *Public Relations in Asia Pacific: Communicating Effectively Across Cultures* (2010). In addition, she is an associate editor of the *Journal of Fashion, Style and Popular Culture* and is co-editor of *Global Fashion Brands: Style, Luxury and History* (2014) and *Transcultural Fashion Narratives: Clothing Communication, Style Statements and Brand Storytelling* (2018). She is also on the advisory board of the *East Asian Journal of Popular Culture* and is associate editor for *The Journal of Global Fashion Marketing*.

Peidong Sun is an associate professor in the department of History at Fudan University. Her main areas of research focus on comparative and historical sociology, the Chinese Cultural Revolution and social history and institutional change during the twentieth century. She has published 20 papers in *The China Quarterly* and other peer-reviewed journals. Her book chapter, '"When are you going to get married?" Parental matchmaking and middle-class women in contemporary urban China', was published in *Wives, Husbands and Lovers: Marriage and Sexuality in Hong Kong, Taiwan, and Urban China* (2014). Other books include *Fashion and Politics: Dress Fashion of Guangdong Province during the Cultural Revolution* (2013), a book review by Karl Gerth in *The Journal of Asian Studies* (2016), and *Who will Marry my Daughter? Parental Matchmaking Corner in the People's Square of Shanghai* (2012, 2013).

Juanjuan Wu is an associate professor in the College of Design at the University of Minnesota, USA, serving as a bridge between retail merchandising and design. Her scholarship is focused on the intersection and innovation of design and retail merchandising, as well as Chinese contemporary fashion and design. She is the author of *Chinese Fashion from Mao to Now* (2009).

Lei Xu is an associate professor in the College of Arts and Science at the Shanghai Polytechnic University, China. Xu's research has been focused on fashion and aesthetics in contemporary China. Her recent projects investigate the development of Chinese independent fashion designer brands, and have received financial support from the Shanghai Municipal Education Commission (Shanghai School of Art Research Projects C63).

Jianhua Zhao is an associate professor in the Department of Anthropology at the University of Louisville in the USA. He has researched the Chinese fashion industry since 2002. He is the author of *The Chinese Fashion Industry: An Ethnographic Approach*. His broad research interests include globalisation, capitalism, family and kinship, social change, clothing and the fashion industry. His geographical area of interest is China and East Asia. Currently, he is working on a research project on intergenerational succession in Chinese family businesses and a follow-up research project on high fashion in China.

INDEX